The Arts and the Cultural
Heritage of Martin Luther

ERRATA

to: *The Arts and the Cultural Heritage of Martin Luther*
edited by Eyolf Østrem, Jens Fleischer and Nils Holger Petersen

Unfortunately, some errors have occurred,
mainly in relation to the illustrations:

The illustrations belonging to captions no. 2 and 9
have been interchanged.

The illustrations belonging to captions no. 24 and 25
have been interchanged.

In fig. 3: for Landesarchiv, read Stadtarchiv

In fig. 5: for cf. fig. 10, read cf. fig. 6.

In fig. 6: for Jn. 1:9, read: Jn. 10:9.

In fig. 8: for cf. fig. 9, read cf. fig. 10.

Not all the illustrations have been placed between p. 80-81,
as mentioned in the table of contents.
The illustrations fig. 1-9 are found between p. 64-65,
the remaining illustrations (fig. 10-26) between p. 80-81.

The Arts and the Cultural Heritage of Martin Luther

Edited by
Eyolf Østrem, Jens Fleischer
and
Nils Holger Petersen

MUSEUM TUSCULANUM PRESS
UNIVERSITY OF COPENHAGEN
2003

The Arts and the Cultural Heritage of Martin Luther
© Museum Tusculanum Press and the authors 2002
Cover: Thora Fisker
Cover illustration: Lukas Cranach the Younger (c. 1546) *The Holy Communion of the Protestants and the Infernal Tortures of the Catholics*
Typographical design: Ole Klitgaard
Printed in Denmark by Special-Trykkeriet Viborg a-s

ISBN 87 7289 788 0

Reprint of *TRANSFIGURATION*, Nordic Journal of Christianity and the Arts, Vol. 4:1
The journal is published with support from
The Nordic Publications Committee for Humanist Periodicals (NOS-H: Nordiska publiceringsnämnden för humanistiska tidskrifter);

Through further support from G.E.C. Gads Fond (G.E.C. Gad's Foundation), Jens Nørregaard og Hal Kochs Mindefond (The Memorial Foundation of Jens Nørregaard and Hal Koch), and Felix-Fonden (The Felix Foundation) it has been possible to publish this special issue of *TRANSFIGURATION* as a book independent of the journal.

Nordic Editorial Committee for the journal:
Denmark: Sune Auken (Nordic Philology, University of Copenhagen), Jens Fleischer (Art History, University of Copenhagen), Sven Rune Havsteen (Theology, Greenland), Søren Elmerdahl Hemmingsen (The Danish National Research Foundation: Center for the Study of the Cultural Heritage of Medieval Rituals, University of Copenhagen), Birgitte Bøggild Johannsen (The National Museum of Denmark), Anette Kruse (Roskilde Cathedral Museum), Johannes Nissen (The Danish National Evangelical Lutheran Church), Nils Holger Petersen (The Danish National Research Foundation: Center for the Study of the Cultural Heritage of Medieval Rituals, Univ. of Copenhagen), Eyolf Østrem (The Danish National Research Foundation: Center for the Study of the Cultural Heritage of Medieval Rituals, University of Copenhagen). Finland: Anthony Johnson (Åbo Academy University, Åbo, Finland). Sweden: Hans Lund (Cultural Studies, Lund University). Norway: Lena Liepe (Art History, University of Tromsø), Kristin Rygg (Musicology, Hedmark University College).

The following members of the committee have had special functions in the edition of this book: Eyolf Østrem, Jens Fleischer, and Nils Holger Petersen: responsible for the scholarly editorial work. Anette Kruse: pictures editor. Søren Elmerdahl Hemmingsen: sub-editor Nils Holger Petersen: responsible under the press law.
Language consultant: Neil Stanford. Editorial consultant: Signe Juul Hansen

Museum Tusculanum Press,
Njalsgade 92
DK-2300 Copenhagen S
www.mtp.dk

Table of Contents

Foreword .. 7

Introduction (Nils Holger Petersen) 9

Carl Axel Aurelius: *Quo verbum dei vel cantu inter populos maneat*:
 The Hymns of Martin Luther 19

Nils Holger Petersen: Lutheran Tradition and the Medieval
 Latin Mass ... 35

Eyolf Østrem: Luther, Josquin and *des fincken gesang* 51

Hugo Johannsen: The Writ on the Wall: Theological and Political
 Aspects of Biblical Text-Cycles in Evangelical Palace Chapels of
 the Renaissance 81

Bernhard Scholz: Religious Meditations on the Heart: Three
 Seventeenth Century Variants 99

Hanna Pirinen: Changes in the Furnishings of the Finnish Parish
 Church from the Reformation to the End of the Caroline
 Period (1527-1718) 137

Sven Rune Havsteen: Aspects of Musical Thought in the
 Seventeenth-Century Lutheran Theological Tradition ... 151

Magnar Breivik: Contexts of Hindemith's *Frau Musica* 171

Siglind Bruhn: Fear of Death in a Life Between God and Satan:
 Kari Tikka's Recent Opera *Luther* 187

The illustrations to the articles by Hugo Johannsen (fig. 1–10),
Bernhard Scholz (fig. 11–21) and Hanna Pirinen (fig. 22–26)
can be found between p. 80 and p. 81.

Foreword

The idea to present a collection of essays on Lutheran traditions in the arts as a special volume in connection with the Tenth International Congress for Luther Research hosted at the Department of Church History at the University of Copenhagen (August 2002) is a natural one for a Nordic journal associated with the Centre for Christianity and the Arts residing at this department (and also associated with a number of other Nordic universities, all ultimately being part of a Lutheran cultural heritage). This will be further elucidated in the following introduction.

As plans were beginning to take shape, the Centre for Christianity and the Arts was fortunate to receive a substantial funding from the Danish National Research Foundation to establish a temporary Centre for the Study of the Cultural Heritage from Medieval Rituals (from February 2002 to June 2006). For the opening of this Centre, we were able to combine in an arrangement the original idea of a small symposium on Lutheran musical traditions with the new opportunity to invite future grant holders at the Centre and members of its international advisory board. Such an arrangement made it possible to expand the scope of both the symposium (held on 24 January 2002) and the planned publication.

In the present volume we have, thus, emphasized a particular aspect of the Lutheran traditions: how Lutheran theology and religious practice transformed or re-shaped traditions from the ritual musical heritage of the medieval Latin Church. Four of the papers in the present volume (by Siglind Bruhn, Sven Rune Havsteen, Eyolf Østrem, and Nils Holger Petersen) were (together with a paper by Professor Heinrich W. Schwab[1]) presented at the aforementioned symposium in a preliminary version, and their inclusion in this volume is therefore due to the generous support of the Danish National Research Foundation, for which we would like to express our deep gratitude.

[1] The content of this paper will be published in an article jointly written by Heinrich W. Schwab and Nils Holger Petersen: "The Devotional Genre Hymn Around 1800: *The Hallelujah of Creation*" in: Nils Holger Petersen, Claus Clüver and Nicolas Bell (ed.): *Signs of Change. Transformations of Christian Traditions and their Representation in the Arts, 1000–2000* (in preparation).

Introduction

The present collection of essays is concerned with the cultural heritage of Martin Luther in regard to what in modern times is usually referred to as the arts: music and poetic texts (including opera) as well as visual representations in pictures and architectural forms. To make an overall assessment of the influence of Martin Luther, as well as the Lutheran Reformation and other reformations in its wake, on the arts in general, would be a task far surpassing the modest claims of this collection, which – as stated in the foreword – was brought together for a particular occasion. Its contributions reflect the interests and areas of specialization of the scholars involved.

Martin Luther never formulated a detailed theological doctrine about what modern man would call aesthetic questions. This is not surprising, since no general aesthetic quest was voiced in Western culture at that time. In Luther's day, education was still deeply rooted in the tradition of the liberal arts, i.e. based on a curriculum comprising the rhetorico-logical *trivium* and the mathematical *quadrivium*. The latter included music among other (and for the modern observer more obviously) mathematical topics. The concept of *musica* did not in the first place denote performed music but a more abstract and mathematically delimited foundation for music through numbers and proportions. This concept of *musica* belonged to the heritage of the philosophy of the early Church (not least St Augustine) and even to Greek philosophy, although the theories of the early periods also dealt with the effects of the sounding music on the human mind.[1] What modern man normally refers to as "art" or "the arts" – a concept which owes its existence to eighteenth-century philosophers, most prominently Charles Batteux, Alexander Baumgarten and Immanuel Kant – would not have constituted a coherent topic at Luther's time. Both music (as something to be performed) and the visual arts would at the time have been considered more as crafts than as something close to the modern (post eighteenth-century) concept of the arts. At the same time – during the later Middle Ages – music was gradually detached from its position as

[1] Concerning the study programme of the "liberal arts" which Luther – as everyone else – had to go through first (before the higher faculties of theology, law, or medicine), see Martin Brecht: *Martin Luther: Sein Weg zur Reformation 1483-1521* (Stuttgart, 1981), 39-43.

a part of the *quadrivium*, especially in the context of Renaissance Humanism.[2]

Luther's main concern throughout his mature life was, of course, the struggle with the Roman Church and the theological issues connected to this conflict, as well as those arising within the circles seemingly supporting his reformation ideas. It is well-known, on the other hand, that Luther was genuinely interested in music, that he himself composed, and that he uttered thoughts in various situations – mostly (but not always) from the point of view of a theologian – about the use of music and other media which we nowadays associate with "the arts".[3]

The historian, H.G. Koenigsberger, has summarized Luther's view on music to the effect that Luther was "the one great theologian of the Renaissance period" to have an unqualified positive attitude to the use of music.[4] In general, Luther has been famous for distinctive statements on music like the following:

> Wer die Musicam verachtet, wie denn alle Schwärmer thun, mit denen bin ich nicht zufrieden. Denn die Musica ist ein Gabe und Geschenke Gottes, nicht ein Menschen-Geschenk. So vertreibt sie auch den Teufel, und machet die Leut fröhlich; man vergisset dabey alles Zorns, Unkeuschheit, Hoffart, und anderer Laster. Ich gebe nach der Theologia der Musica den nähesten Locum und höchste Ehre. Und man siehet, wie David und alle Heiligen ihre gottselige Gedanken in Vers, Reim und Gesänge gebracht haben, *quia pacis tempore regnat musica*.[5]

> I am not satisfied with anyone who holds the *musica* in contempt, as all the "enthusiasts" do. For the *musica* is a gift and donation from God, not a human donation. Thus she also drives away the Devil and makes people glad. One forgets thereby all anger, immodesty, haughtiness, and other vices. After theology I give to *musica* the next place and the highest honour. And one

[2] See for instance Claude V. Palisca: *Humanism in Italian Renaissance Musical Thought* (New Haven and London, 1985), esp. 15-17

[3] See for instance Walter Blankenburg: "Luther und die Musik", in: Walter Blankenburg: *Kirche und Musik* (Göttingen, 1979), 17-30 (this article is a re-print from 1957); and Carl Dahlhaus und Hermann Danuser (eds.): *Neues Handbuch der Musikwissenschaft* vol. 3 (Laaber, 1989/90), re-issued (Darmstadt, 1997), 57 and 343-47.

[4] H.G. Koenigsberger: "Music and Religion in Modern European History", in: J.H. Elliott and H.G. Koenigsberger (eds.): *The Diversity of History: Essays in Honour of Sir Herbert Butterfield* (London, 1970), 35-78, (51).

[5] *D. Martin Luthers Werke. Kritische Gesamtausgabe. Tischreden.* Vol. 6 (Weimar, 1921), 348, no. 7034. My English translation. *D. Martin Luthers Werke. Kritische Gesamtausgabe* henceforth referred to as WA.

notices how David and all the Holy Ones have expressed their devout thoughts in verses, rhymes and songs, because music reigns in times of peace.

Luther here, as also in many other places, treats music in a seemingly "modern" way, i.e. as something performed, something emotionally engaging.

It is well known that Luther did not endorse the "enthusiast" iconoclastic riots which occurred as a result of the radical reformation movements in the early 1520s. His response to these actions was sharp and shows that he did not accept violent destruction of outward religious (pictorial) representations whether or not they had in fact been used for devotional purposes, which, of course, he would not endorse either. His basic point was that destroying the representations did not change anything. The problems lay in the hearts of the faithful, not in the pictures as such.[6] In *Wider die himmlischen Propheten, von den Bildern und Sakrament* (1525) he goes on to say:

> Auch hab ich die bildstürmer selbst sehen und hören lesen aus meyner verdeutschten Bibel, So weys ich auch, das sie die selbigen haben, lesen draus, wie man wol spurt an den wortten, die sie furen, Nu sind gar viel bilder ynn den selbigen büchern, beyde Gottes, der engel, menschen und thiere, sonderlich ynn der offinbarunge Joannis und ym Mose und Josua. So bitten wyr sie nü gar freuntlich, wollten uns doch auch gonnen zu thun, das sie selber thun, Das wyr auch solche bilder mügen an die wende malen umb gedechtnis und besser verstands willen, Syntemal sie an den wenden ia so wenig schaden als ynn den büchern, Es ist yhe besser, man male an die wand, wie Gott die wellt schuff, wie Noe die arca bawet und was mehr guter historien sind, denn das man sonst yrgent welltlich unverschampt ding malet, Ja wollt Gott, ich kund die herrn und die reychen da hyn bereden, das sie die gantze Bibel ynnwendig und auswendig an den heusern fur ydermans augen malen liessen, das were eyn Christlich werck.
>
> So weys ich auch gewiss, das Gott will haben, man solle seyne werck hören und lesen, sonderlich das leyden Christi. Soll ichs aber hören odder gedencken, so ist myrs unmüglich, das ich nicht ynn meym hertzen sollt bilde

[6] See Luther's *Wider die himmlischen Propheten, von den Bildern und Sakrament* in: WA vol. 18 (Weimar, 1908), 62–125 (first part), 67–84, and "Eyn brief an die Fürsten zu Sachsen von dem auffrurischen geyst", in WA vol. 15 (Weimar, 1899), 210-21, especially pp. 219-20. See also Peter-Klaus Schuster: "Abstraktion, Agitation und Einfühlung. Formen protestantischer Kunst im 16. Jahrhundert", in: Werner Hofmann (ed.): *Luther und die Folgen für die Kunst*, a catalogue from the exhibition in the Hamburger Kunsthalle, 11 November 1983-8 January 1984 (München, 1983), 115-266, especially 115-16 and 128.

> davon machen, denn ich wolle, odder wolle nicht, wenn ich Christum hore, so entwirfft sich ynn meym hertzen eyn mans bilde, das am creutze henget, gleich als sich meyn andlitz naturlich entwirfft yns wasser, wenn ich dreyn sehe, Ists nü nicht sunde sondern gut, das ich Christus bilde ym hertzen habe, Warumb sollts sunde seyn, wenn ichs ynn augen habe? Syntemal das hertze mehr gillt denn die augen und weniger soll mit sunden befleckt seyn denn die augen, als das da ist der rechte sitz und wonunge Gottes.[7]

I have myself seen and heard the iconoclasts read out of my German Bible. I know that they have it and read out of it, as one can easily determine from the words they use. Now there are a great many pictures in those books, both of God, the angels, men and animals, especially in the Revelation of John and in Moses and Joshua. So now we would kindly beg them to permit us to do what they themselves do. Pictures contained in these books we would paint on the walls for the sake of remembrance and better understanding, since they do no more harm on walls than in books. It is to be sure better to paint pictures on walls of how God created the world, how Noah built the ark, and whatever other good stories there may be, than to paint shameless worldly things. Yes, would to God that I could persuade the rich and the mighty that they would permit the whole Bible to be painted on houses, on the inside and outside, so that all can see it. That would be a Christian work.

Of this I am certain, that God desires to have his works heard and read, especially the passion of our Lord. But it is impossible for me to hear and bear it in mind without forming mental images of it in my heart. For whether I will or not, when I hear of Christ, an image of a man hanging on a cross takes form in my heart, just as the reflection of my face naturally appears in the water when I look into it. If it is not a sin but good to have the image of Christ in my heart, why should it be a sin to have it in my eyes? This is especially true since the heart is more important than the eyes, and should be less stained by sin because it is the true abode and dwelling place of God.

Luther's pragmatic, craft-oriented way of understanding pictures as such is expressed in one of his table talks, where he comments on the abilities of painters to imitate nature:

> [...] sie könnten der Natur so meisterlich und eigentlich nachfolgen und nachahmen in Gemälden, dass sie nicht allein die rechte natürliche Farbe und Gestalt an allen Gliedern geben, sondern auch die Geberde, als lebten und bewegten sie sich. [...][8]

[7] *Wider die himmlischen Propheten* ... (see above, n. 6), 82-83. English translation by Bernhard Erling in: *Luther's Works* vol 40, (ed. Conrad Bergendorff), (Philadelphia, 1958), 99-100. *Luther's Works* henceforth referred to as LW.

[8] WA. *Tischreden* vol. 6, (Weimar, 1921), 349, no. 7035. My English translation.

[...] they could follow and imitate Nature so masterly and truly in paintings that they do not only give the true natural colour and form to all parts, but also the gestures as if they lived and moved. [...]

In order to exemplify Luther's attitude towards what modern man would describe as an artistic use of media for the embellishment of religious services, I will briefly consider the so-called liturgical dramas, the staged representations of biblical narratives. Such performances were widespread during the Middle Ages.[9] The most common of such practices are usually referred to as *visitatio sepulchri*, ceremonies based on the Gospel narratives about the women who came to the sepulchre of Christ on Easter morning and were met by an angel announcing the Resurrection. These traditions go back to the tenth century in the surviving Latin liturgical manuscripts. Such traditions have been understood as the medieval beginnings of a European theatre, although modern scholarship has tended to be critical of the anachronisms involved in such interpretations.[10] It is well known that these practices lasted well into the eighteenth century in certain parts of (Catholic) Europe, but that, in general, they disappeared immediately in the protestant areas of Europe after the Reformation and gradually in most Catholic areas after the Tridentine council (1545-63).[11]

Interestingly, it seems likely that Martin Luther participated in such "dramatic" representations during his time as a schoolboy in Magdeburg (1496-97). He probably attended the cathedral school and therefore participated in the cathedral liturgy.[12] Four sources of a *visitatio sepulchri* practice have been preserved from Magdeburg, undoubtedly reflecting traditions of the cathedral: one manuscript of the fifteenth century, and three printed breviaries of 1491, 1513, and 1514 (the latter three giving identical ceremonies).[13] It is reasonable to assume that Luther participated

[9] The classic account of this practice is Karl Young: *The Drama of the Medieval Church* 2 vols (London, 1933). Its historical theories, however, have been challenged. See C. Clifford Flanigan: "Medieval Latin music-drama", in: Eckehard Simon (ed.): *The Theatre of Medieval Europe: New Research in Early Drama* (Cambridge, 1991), 21-41.

[10] See also Glynne Wickham: *The medieval theatre* third revised edition (Cambridge, 1987), especially part I, 11-54.

[11] See the editions in Walther Lipphardt (ed.): *Lateinische Osterfeiern und Osterspiele* 9 vols (Berlin, 1975-90).

[12] Concerning Luther's time in Magdeburg, see Brecht (1981), 27-28.

[13] *Lateinische Osterfeiern* vol. III, 1031-36, nos. 608, 609, 610 and 611. See also the comments in vol. VI, 225 (for no. 608) and the general comments about the Magdeburg ceremonies in vol. VII, 518-21.

in this Easter practice in the cathedral of Magdeburg during Easter 1497.

Luther does not seem to have commented very much on this particular tradition. He does, however, mention Easter plays (in general) in passing in a sermon on the Resurrection which he may have given in Torgau in April 1533.[14] At the beginning of this sermon, he refers to Christ's descent into Hell and states that he will keep to the simple words of the apostolic Creed (which he has just quoted) and use them in his imagination. He goes on to say:

> Dem nach pflegt mans auch also an die wende zu malen, wie er hinunter feret mit einer Chorkappen und mit einer fahnen inn der hand, für die Helle kompt und da mit den Teuffel schlegt und veriagt, die Helle stürmet und die seinen eraus holet, Wie man auch inn der Oster nacht ein spiel für die kinder getrieben hat, Und gefellet mir wol, das mans also den einfeltigen für malet, spielet, singet odder sagt, Und sols auch da bey bleiben lassen, das man nicht viel mit hohen, spitzigen gedancken sich bekomere, wie es möge zu gangen sein, weil es ja nicht leiblich geschehen ist, sintemal er die drey tage ja im grabe ist blieben.[15]

> Accordingly, one has also used to paint on the walls, how he descended wearing a choir cloak and with a banner in his hand, how he arrived to Hell and fought with the Devil, chasing him away, assaulted Hell and collected his own ones. In the same way a play has been performed for children during Easter night. It suits me well that one paints, plays and sings for the simple-minded in such a way. To put it differently: One should preserve it this way so that one does not assert oneself through lofty, subtle thoughts concerning how this might have happened, since it did not happen literally, as he remained those three days in the tomb.

Luther's attitude towards the so-called Passion Plays is made clear in some remarks in his *Sermon von der Betrachtung des heiligen Leidens Christi* (1519).

[14] WA vol. 37 (Weimar, 1910), 62-72, see introduction, ibid, xxi-xxiii.

[15] Ibid., 63. My English translation. It seems likely that Luther is referring to the Magdeburg *visitatio sepulchri* practice which included the antiphon *Cum rex gloriae* (describing Christ's entry into Hell) in the mentioned manuscript (of the fifteenth century) which gives a longer (and fuller) version than the printed breviary. See also *Lateinische Osterfeiern* vol. IX, 904–905, where this antiphon is edited (as A 43). Concerning practices of a Harrowing of Hell tradition in general, see Young (1933) vol. I, 149-77 and 561-65. The editorial remark in WA vol. 37, 674 about Luther's alleged mistake in placing the *spiel* during the night is clearly unfounded (the similar remark about such plays not being for children alone less so; Luther, on the other hand, may simply be referring back to his childhood experience).

In this text, he criticizes the theological abuse of such Passion Plays. Luther remarks that they stir up emotions against the Jews, and he claims ironically that it seems to be more important to contemplate the evilness of Judas and the Jews than the passion of Christ.[16] Luther discusses in what way a Christian may profit from the passion of Christ. He focuses on the exposure of the personal guilt of the observer and on how God graciously has freed man from his sin. His criticism is directed against the idea that participation in particular ceremonies may secure a better position towards God. That is the main abuse of such plays. Apart from this, Luther's main complaint is that the plays may lapse into violence and attitudes which do not accord with the passion which it was their purpose to contemplate.

In addition, two letters from, respectively, 1530 and 1543, show that Luther, at least in his later years, and apparently in the context of his engagement in devotional teaching, endorsed the practice of biblical plays (especially about the life of Christ) in schools and congregations.

The second of april 1530 Luther wrote to Nikolaus Hausmann, vicar in Zwickau, mentioning a book which may have been written or compiled by Hausmann, "volumen tuum digestum", which may have contained a play about the life of Christ. His comment is as follows:

> Nam & ego non illibenter viderem gesta Christi in scholis puerorum ludis seu comoediis latine & germanice, rite & pure compositis, repraesentari propter rei memoriam, & affectum rüdioribus augendum.[17]

> For even I would like to see the deeds of Christ being represented in boys' schools in either Latin or German comedies composed properly and in a pure way in order to augment the memory and the emotion for the uninformed.

On 5 April 1543 Luther wrote a letter of support for the schoolmaster Joachim Greff from Dessau. Greff had written a number of dramatic texts, among them an Easter play (printed in Freiburg in 1542), which he tried to get performed in his church in Dessau in 1543, against which two clergymen, Severinus Star and Johannes Brusch protested. Greff travelled

[16] "Eyn Sermon von der Betrachtung des heyligen leydens Christi", in: WA vol. 2 (Weimar, 1884), 136-42. An identical attitude is found in Luther's "Ein Sermon von dem Gebet und Procession in der Kreuzwoche" (1519) about rogation processions. Ibid, 175-79. Compare also Brecht (1981), 335-37.

[17] WA *Briefwechsel* vol. 5 (Weimar, 1934), 271-72 (272). See the editorial discussion of the "volumen tuum digestum" (272, n. 2). My English translation.

to Wittenberg, where he obtained letters of support from both Luther and Melanchthon. Luther writes that Greff presented him with the criticisms and accusations of the clergymen (for tomfoolery and wantonness, "Narren werck vnd Lotter"). Luther's own attitude to the use of such dramas and songs (which would also have come in for the negative judgment of the aforementioned clergymen) as it is formulated in the letter is that "such *neutralia* should be accepted since they do not harm or vex".[18]

The few disparate pieces of information cited here about Luther's attitude towards representational practices in the church seem to underline his pragmatism and his basic interest in simple kinds of devotion and edifying practices. As long as such devotions were not (ab)used in a way that would make people believe that participation in them automatically granted spiritual advantages, he was not opposed to them. Music, on the other hand, seems to have held a different, in fact a very special, place in his mind, much closer to an idea of "the artistic" than any of the other possible media. It is possible, in other words, to see in Luther's attitudes, as they have been discussed here, and as they are discussed in some of the essays of this book, a certain ambivalence. The use of media in religious services belongs to the *neutralia* and is judged pragmatically. Such usages were not criticized, nor considered essential. Music, on the other hand, was deemed close to the heart of the Christian message and anyone dealing seriously with theology would necessarily also encounter music according to Luther's judgement.[19]

It seems that later Lutheran traditions to a certain degree have been informed by – and kept to – an ideology of a pragmatic use of "the arts" for edifying and educational purposes, although the traditions of the seventeenth century to some extent modify such a conclusion (see especially Bernhard Scholz' and Sven Rune Havsteen's contributions in this book). This may be seen as a secularizing influence on the cultural traditions of "the arts" in protestant Europe. The exhibition "Luther und die Folgen für die Kunst" which opened on Luther's fivehundredth birthday at the Hamburger Kunsthalle in 1983 commemorated especially this side of Luther's cultural heritage. In the foreword to the catalogue, Werner Hofmann wrote:

[18] "Solche *neutralia*, weil sie ynn vnschedlichen brauch vnd nicht ergerlich, Solt man lassen gehen" in: WA *Briefwechsel* vol. 10 (Weimar, 1947), 286. See introductory comments 284-85.

[19] Blankenburg (1979), 20-23.

[...] wurde deutlich, dass Luthers abwägendes Kunsturteil, welches die Bilder dem Kult entbehrlich macht, in alle Bereiche der Moderne hineinreicht, in die Kunstpraxis ebenso wie in deren Vermittlung (Ästhetik, Museen, Ausstellungen), wobei Gewinn und Verlust einander die Waage halten. [...]
 Mit der These, dass die entscheidenden Strömungen der um 1500 anbrechenden Moderne vom religionskonflikt geformt sind, wird zugleich die Frage nach der religiösen Kunst als einer Sondergattung neu gestellt. In dem Masse, in dem der protestantische Bereich auf religiöse Gebrauchskunst verzichtet, macht er die profanen Bildbereiche für Aussagen in Richtung auf eine innerweltliche Religiosität durchlässig. Dabei ist freilich im Hinblick auf das 20. Jahrhundert Vorsicht geboten. [...][20]

[...] it became clear that Luther's balanced judgement concerning art, which made pictures dispensable in worship, reaches into all areas of the modern: into the practice of art as well as into the presentation of art (aesthetics, museums and exhibitions). In all this, the gains and the losses keep their balance. [...]
 The thesis that the crucial currents of the modern which emerge around 1500 are shaped by the religious conflict also raises the question about religious art as a special genre anew. In the same measure in which the Protestant area renounces the use of applied religious art, profane visual art is made transparent for statements in the direction of an immanent religiosity. However, concerning the twentieth century, caution is called for. [...]

In a similar way, it would be interesting to reconsider the well-known important developments in the ideas about music, which began to appear around 1800 and which during the nineteenth century led to the notion of absolute music and *Kunstreligion*, in the light of Luther's special relationship to music. Emphasizing music as an independent and especially "spiritual" art form has often been thought of as a particularly "romantic" construction. In any case, it certainly occurred primarily in the protestant, even Lutheran areas: Germany and the Nordic countries. It has not turned out to be possible to review the music philosophy of the nineteenth century – for instance Schleiermacher's music thinking – in the light of Luther's ideas for this volume, but the topic is indeed of central importance for the Lutheran cultural heritage and "the arts".[21]

[20] Hofmann (1983), "Vorwort", 18. My English translation.

[21] The main discussion of the music philosophical idea connected to the rise of the notion of "absolute music" is Carl Dahlhaus: *Die Idee der absoluten Musik* (Kassel, 1978). See also Eyolf Østrem: "Music and the Ineffable", in: Siglind Bruhn (ed.): *Voicing the Ineffable: Musical Representations of Religious Experience* (New York, 2002), 287-312, and Heinrich W. Schwab and Nils Holger Petersen: "The Devotional Genre Hymn Around 1800: *The*

The present collection of essays does not primarily deal with Luther and "the arts" but with individual topics within the Lutheran cultural heritage and "the arts". This heritage is often decisively marked by a reception of Luther's attitudes. This comes to the fore in most of the contributions in the present book. Luther's special relationship with music is discussed primarily by Eyolf Østrem ("Luther, Josquin and *des fincken gesang*"). What may be called "Lutheran" doctrinal statements about music in the seventeenth century is dealt with by Sven Rune Havsteen ("Aspects of Music Thought in the Seventeenth-Century Lutheran Theological Tradition"). Magnar Breivik and Siglind Bruhn consider Lutheran receptions in the twentieth century ("Contexts of *Frau Musica*" and "Fear of Death in a Life Between God and Satan: Kari Tikka's Recent Opera *Luther*") through very different types of materials. Similarities and dissimilarities in the uses of words and pictures in some examples of Catholic and Protestant devotional publications of the seventeenth century form the subject matter for Bernhard Scholz ("Religious Meditations on the Heart: Three Seventeenth Century Variants"), whereas the uses of Lutheranism in church arrangements are dealt with by Hugo Johannsen and Hanna Pirinen ("The Writ on the Wall: Theological and Political Aspects of Biblical Text-Cycles in Evangelical Palace Chapels of the Renaissance" and "Changes in the Furnishings of the Finnish Parish Church from the Reformation to the End of the Caroline Period (1527-1718)"). The volume commences with discussions by Carl Axel Aurelius and myself of Luther's own contributions to the liturgy, his German Mass and the hymns he wrote for such a context ("*quo verbum dei vel cantu inter populos maneat…*: The Hymns of Martin Luther" and "Lutheran Tradition and the Medieval Latin Mass").[22]

Nils Holger Petersen

Hallelujah of Creation" in: Nils Holger Petersen, Claus Clüver and Nicolas Bell (eds.): *Signs of Change: Transformations of Christian Traditions and their Representation in the Arts, 1000-2000* (in preparation).

[22] Eyolf Østrem, Jens Fleischer, and Sven Rune Havsteen have read earlier versions of this introduction. They have all given very useful suggestions for its improvement and I am most grateful for their help. For any shortcomings of the text, I am, of course, myself responsible.

Quo verbum dei vel cantu inter populos maneat
The Hymns of Martin Luther[1]

Carl Axel Aurelius

Introductory Remarks
Luther's hymn-writing is generally recognized as an important factor in the propagation of the Reformation (see, e.g., Martin Brecht's exhaustive biography). One could, for good reasons, talk of a "singing Reformation" in the same spirit as with the recent "singing Revolution" of the Baltic States. Luther's hymns, however, receive scarcely any comment in books about his theology. Thus, they are seemingly of no theological significance. I would rather claim the opposite: Luther's hymns have deep theological significance.

Our failure to recognize this is caused by the way we are used to understand theology in general. Our concept of theology determines our perspective on Luther's theology. But the way we understand theology and approach theology is not necessarily the way Luther understood it and approached it. Theology today is formed by certain patterns of thought belonging to Modernity rather than the Reformation era. These patterns of thought prevent us from discovering how things came together for Luther – as for example theology and music, which we nowadays tend to keep apart. I will return to this issue at the end, since it might provide us with a good subject for discussion. But first, there is a story to tell.

How It All Began
We know of 36 hymns by Luther. Two thirds of these were written in less than one year, from the autumn of 1523 to the summer of 1524. Already at Wartburg, the castle where Luther was held in custody by Frederick the Wise after the diet at Worms, he had started several projects

[1] This paper was originally presented at the Anglo-Nordic-Baltic Theological Conference in Århus 2001. Quote, see note 3 below.

with the purpose of reforming the life of the congregation. He translated the New Testament, and he wrote exemplary sermons for the pastors, biblical commentaries, prayers, etc. In his *Formula Missae et Communionis* (*An Order of Mass and Communion*) (1523) he also expresses the need for evangelical hymns:

> Cantica velim etiam nobis esse vernacula quam plurima, quae populus sub missa cantaret, vel iuxta gradualia, item iuxta Sanctus et Agnus dei. Quis enim dubitat, eas olim fuisse voces totius populi, quae nunc solus Chorus cantat vel respondet Episcopo benedicenti? Possent vero ista cantica sic per Episcopum ordinari, ut vel simul post latinas cantiones, vel per vices dierum nunc latine, nunc vernacula cantarentur, donec tota Missa vernacula fieret. Sed poetae nobis desunt, aut nondum cogniti sunt, qui pias et spirituales cantilenas (ut Paulus vocat) nobis concinnent, quae dignae sint in Ecclesia dei frequentari.[2]

> I also wish that we had as many songs as possible in the vernacular which the people could sing during mass, immediately after the *Gradual* and also after the *Sanctus* and *Agnus Dei*. For who doubts that everybody sang these songs originally, which the choir now sings or responds to while the bishop is consecrating? But wanting among us, or not yet known are poets, who could compose evangelical and spiritual songs, as Paul calls them (Col. 3:16), worthy of use in the Church of God.

For Luther, however, it is neither merely a question of what used to be the practice of the early church, nor what Paul happens to say to the Colossians. This becomes clear from Luther's letter to Spalatin – who was Frederick's advisor – from 1523/1524. Here Luther expresses the same need for evangelical hymns, but he also explains *how* it should be done and, furthermore, he gives a hint *why* it is important:

> Gratia & pax. Consilium est, exemplo prophetarum & priscorum patrum Ecclesię psalmos vernaculos condere pro vulgo, id est spirituales cantilenas, quo verbum dei vel cantu inter populos maneat. Quę rimus itaque vndique poetas. cum vero tibi sit data & copia & elegantia linguę germanicę, ac multo vsu exculta, oro, vt nobiscum in hac re labores, & tentes aliquem psalmorum in cantilenam transferre, sicut hic habes meum exemplum. Velim autem nouas & aulicas voculas omitti, quo pro captu vulgi quam simplicissima vulgatissi-

[2] *D. Martin Luthers Werke. Kritische Gesamtausgabe* vol. 12 (Weimar, 1891), 218. *D. Martin Luthers Werke. Kritische Gesamtausgabe* henceforth referred to as WA. English translation by Paul Zeller Strodach in: *Luther's Works* vol. 53 (ed. Ulrich S. Leupold), (Philadelphia, 1965), 35. *Luther's Works* henceforth referred to as LW.

maque, tamen munda simul & apta verba canerentur, deinde sententia perspicua & psalmis quam proxima redderetur. Libere itaque hic agendum & accepto sensu, verbis relictis, per alia verba comoda vertendum.[3]

Grace and peace. [Our] plan is to follow the example of the prophets and the ancient fathers of the church, and to compose psalms for the people [in the] vernacular, that is, spiritual songs, so that the Word of God may be among the people also in the form of music. Therefore we are searching everywhere for poets. Since you are endowed with a wealth [of knowlegde] and elegance [in handling] the German language, and since you have polished [your German] through much use, I ask you to work with us on this project; try to adapt any one of the psalms for use as a hymn, as you may see [I have done] in this example. But I would like you to avoid any new words or the language used at court. In order to be understood by the people, only the simplest and the most common words should be used for singing; at the same time, however, they should be pure and apt; and further, the sense should be clear and as close as possible to the psalm. You need a free hand here: maintain the sense, but don't cling to the words; [rather] translate them with other appropriate words.

Let us leave the questions of principles for translation, even though it would have been interesting to compare these with the ones Luther argues for in his *Open Letter on Translation* from 1530. We will focus on two things: Luther's short answer to the question why – *quo verbum dei vel cantu inter populos maneat* – and his choice of the Psalter as the source for the hymns.[4] It might be fruitful to concentrate on his use of the Psalter before trying to understand what he means by his claim that the Word of God remains among the people through singing. Perhaps his exposition of the Psalter can provide us with a hermeneutic key to his hymn-writing.

The Book of Psalms
The enclosed attempt by Luther himself in his letter to Spalatin was *Aus tiefer Not schrei ich zu dir* (From Trouble Deep I Cry to Thee), which is Ps 130, *De profundis clamavi*. Besides this one, Luther turned five other psalms

[3] WA *Briefwechsel* vol. 3 (Weimar, 1933), 220, no. 698. English translation by Gottfried G. Krodel in: LW vol. 49 (ed. Gottfried G. Krodel), (Philadelphia, 1972), 68.

[4] Luther gives a similar answer to the question *why* in his Preface to the Wittenberg Hymnal 1524: "St. Paul himself instituted this in I Corinthians (14:15) and exhorted the Colossians (3:16) to sing spiritual songs and psalms heartily unto the Lord so that God's Word and Christian teaching might be installed and implanted in many ways." See WA vol. 35 (Weimar, 1923), 474–75. English translation by Paul Zeller Strodach in: LW vol. 53 (Philadelphia, 1965), 316.

(12, 14, 67, 124 and 128) into Evangelical songs at this time. Later on he added another one, Ps 46 (*Deus Noster refugium et virtus*): *Eyn feste burg ist unser Gott* (Our God He Is a Castle Strong).

Luther's insights into the Book of Psalms[5] were profound. He worked with no other book in the Bible as much as he did with the Psalter. He simply lived by it. His first major work was a Commentary on the Psalter, *Dictata super Psalterium* (1513–1516). It was soon followed by another one, *Operationes in Psalmos* (1519–1521). Already in 1517 he had translated the penitential psalms into German, and in 1524 he had accomplished a complete new translation of the Psalter.

Why the Psalter? Luther gives a good answer in his *Preface to the Psalms*. He calls the Psalter "a little Bible", summarizing everything that is truly Christian:

> SVmma, Wiltu die heiligen Christlichen Kirchen gemalet sehen mit lebendiger Farbe und gestalt, in einem kleinen Bilde gefasset, So nim den Psalter fur dich, so hastu einen feinen, hellen, reinen, Spiegel, der dir zeigen wird, was die Christenheit sey. Ja du wirst auch dich selbs drinnen, vnd das rechte Gnotiseauton finden, Da zu Gott selbs vnd alle Creaturn.[6]

> In a word, if you would see the holy Christian Church painted in living color and shape, comprehended in one little picture, then take up the Psalter. There you have a fine, bright, pure mirror that will show you what Christendom is. Indeed you will find in it also yourself and the true *gnothi seauton*, as well as God himself and all creatures.

The experience of finding oneself in the psalms has been shared by many Christians throughout the ages. Luther articulates something well known in saying:

> Daher kompts auch, das der Psalter aller Heiligen Büchlin ist, Vnd ein jglicher, in wasserley sachen er ist, Psalmen vnd wort drinnen findet, die sich auff seine Sachen reimen, vnd jm so eben find, als weren sie allein vmb seinen willen also gesetzt, Das er sie auch selbs nicht besser setzen noch finden kan noch wündschen mag.[7]

[5] Henceforth referred to as the Psalter.
[6] WA *Die Deutsche Bibel* vol. 10, 1 (Weimar, 1956), 105. English translation by E. Theodore Bachmann in: LW vol. 35 (ed. E. Theodore Bachmann), (Philadelphia, 1960), 256f.
[7] WA *Die Deutsche Bibel* vol. 10, 1 (Weimar, 1956), 103. English translation as in the previous note.

> Hence it is that the Psalter is the book of all saints; and everyone, in whatever situation he may be, finds in that situation psalms and words that fit his case, that suit him as if they were put there just for his sake, so that he could not put it better himself, or find or wish for anything better.

Luther perceives the psalms in contrast to the legends of saints and martyrs, and to other books of examples and prayers. At the end of the Middle Ages, it had come about that these other books, not the least *The Golden Legend* (*Legenda Aurea*) by Jacobus de Voragine had supplanted the prayers of the Psalter.

These legends and other books of the same kind draw an image of speechless people. We do not hear them speak. We do not look into their hearts. Instead, their deeds are presented and praised as worthy of imitation. This results in people being misled to seek comfort where there is none, which in its turn leads to despair or hypocrisy. The good model is not lacking, but the word by which people can call on God in various life situations is missing.

Concerning the psalms, however, now let us look into the hearts of the faithful – i.e., into the center of personality where both thoughts and feelings have their abode – and give the right words for different situations:

> WAS ist aber das meiste im Psalter, denn solch ernstlich reden, in allerley solchen Sturmwinden? Wo findet man seiner wort von freuden, denn die Lobpsalmen oder Danckpsalmen haben? Da sihestu allen Heiligen ins hertze, wie in schöne lustige Garten, ja wie in den Himel [...]WIderumb, wo findestu tieffer, kleglicher, jemerlicher wort, von Trawrigkeit, denn die Klagepsalmen haben? Da sihestu aber mal allen Heiligen ins hertze, wie in den Tod, ja wie in die Helle.[8]

> What is the greatest thing in the Psalter but this earnest speaking amid these storm winds of every kind? Where does one find finer words of joy than in the psalms of praise and thanksgiving? There you look into the hearts of all the saints, as into fair and pleasant gardens, yes into heaven itself [...] On the other hand, where do you find deeper, more sorrowful, more pitiful words of sadness than in the psalms of lamentation? There again you look into the hearts of all the saints, as into death, yes, as into hell itself.

[8] Ibid.

From Lament to Praise

The various psalms reflect the conditions that gain the upper hand in various situations. The movement between sadness and joy, lament and praise, reflects nothing but the course of Christian life:

> Oportet enim tribulatos interdum consolari, ut possint sustinere, ideo et psalmos nunc laetos nunc tristes, vario ordine misceri, ut haec ipsa diversorum psalmorum mixtura et confusa ordinatio (sicuti putatur) exemplar esset vitae Christianae, quae inter varias tribulationes mundi et consolationes dei exercetur.[9]

> For those who are tempted must at various times be comforted so that they may endure. Therefore joyous psalms and psalms of lament are mixed with each other in different order, so that the mixture of various Psalms and this confused order, as one thinks, is an example and an image of Christian life, which is exercised under many afflictions of the world and comforts of God.

A seemingly confused order characterizes some psalms in particular. I am thinking of Psalm 6 or 13, which begin with lament and then change into praise. Luther clearly recognizes this shift of tone: "What a completely different emotion (*affectus*) this is…" The saddened person is, all of a sudden, comforted – and affliction and lament change into joy and gratitude. What takes place? What happens? And how does Luther comment on this?

The first parts of Psalm 6 and 13 do indeed provide insight into the situation of the assailed person, into the emotions – or better still: how his or her senses are moved. We become aware of the thoughts and feelings that eddy in their interior. They all attest that here the most difficult of battles has to be waged, the battle against death and hell. In distinction to lighter suffering (expressed in other psalms) all enemies here disappear from the scene, and the person under assault (Anfechtung) experiences himself as opposed by God. In his wrath God rejects eternally. The words show and describe existence from the point of view of the one assailed, a condition where comfort is not to be found anywhere. Like the mystics, Luther speaks of this condition as a "darkness". What he means is shown by the two words of the Bible that he quotes together: Genesis 1:2 and Romans 8:26. Obviously what is meant here is the darkness of Chaos,

[9] WA vol. 5 (Weimar, 1892), 287. My translation.

which "covered the face of the deep". The Spirit which at that time "moved upon the face of the waters" is the Spirit that now becomes effective in the person under assault and "intercedes with sighs too deep for words". The Spirit brings it about that prayers – granted in the form of lament – rise to God from inside the one under assault. Luther, in other words, understands this sole sign of life, not as the result of a last-ditch effort of the one under assault, but as evidence of the fact that the Spirit lives and prays in the person concerned. Furthermore, the Spirit is operative in the intercessions of the faithful for the person concerned. The person can in this way overcome the assault. Such a change happens for Luther only through a word from the outside: "… non tamen nisi per verbum dei et Ihesum Christum" (not in any other way but through the Word of God and through Jesus Christ). [10]

In this way Luther explains the sudden transition in the psalms from lament to praise. To summarize: Luther reads out of the psalms an act of creation that, like the first creation, takes place *ex nihilo* and through the Word. Creation and salvation move closer to each other, and they almost become one and the same. The creative Word is the Word of God's mercy, i.e., Jesus Christ. He comes to the person who now interprets the situation completely differently. Luther can say that God has changed for the person praying. Now they can again hope for everything from God:

> At nunc factus dominus, deus meus, esto non tantum conversus, ut audias, sed etiam exaudias, nihil aliud facturus quam me servaturus, ut sic pro irato iudice clementissimum deum habeam[11]

> But now since you have become my Lord and my God, so turn to me, not onlyin order to hear me but also in order to hear me favorably and to do nothing else except to save and preserve me so that I may have a most merciful God in the place of a wrathful judge.

God appears quite different to the praying person, and their entire conception of reality is changed. The real enemy, the Devil, becomes manifest again; he uses, finally, a false proclamation to keep the person under assault in order to bring that person to despair.

[10] Ibid., 216. My translation.
[11] Ibid., 388. My translation.

In Luther's interpretation, the overcoming of temptation, as it is reflected in the Psalter, becomes a thoroughly *creative and salvific drama with a Trinitarian character*: the prayer of the Spirit, the arrival of the Son, the mercy of the Father. This transition – from darkness to light, from death to life – is illuminated by the psalms through the change of emotions that they express. The pattern that appears is but the pattern of Good Friday and Easter and the pattern of baptism. As we shall see, this pattern is also to be found in Luther's hymns.

From Trouble Deep I Cry to Thee

Traditionally the biblical psalm *From Trouble Deep I Cry to Thee*[12] belongs to the seven penitential psalms. By repentance or doing penance Luther understood not an isolated but a lifelong activity, as he states already in the first of his 95 theses:

> Dominus et magister noster Iesus Christus dicendo "Penitentiam agite &c." omnem vitam fidelium penitentiam esse voluit.[13]

> When our Lord and Master Jesus Christ said, "Repent" (Matt. 4:17), he willed the entire life of believers to be one of repentance.

The psalm lets us see into a truly repentant heart that disregards any merits of its own and solely clings to "the true treasure of the Church", i.e., "the most holy Gospel of the Glory and Grace of God" (Thesis 62). The structure is similar to the one found in Psalm 6 and 13. The person crying "from trouble deep" is cut off from the realm of life, but continues to hope for Jahve, for his Word. Luther follows the words of the psalm closely, while at the same time he gives it a typical Pauline character, as for example in the second verse:

> Bey dyr gillt nichts den gnad und gonst,
> die sunden zu vergeben.
> Es ist doch unser thun umb sonst
> auch ynn dem besten leben.
> Fur dyr niemant sich rhumen kan,

[12] WA vol. 35 (Weimar, 1923), 419–420: Aus tieffer not schrey ich zu dyr.

[13] WA vol. 1 (Weimar, 1883), 233. English translation by C. M. Jacobs in: LW vol. 31 (ed. Harold J. Grimm), (Philadelphia, 1957), 25.

des mus dich furchten yderman
Und deyner gnaden leben.

With thee counts nothing but thy grace
To cover all our failing
The best life cannot win the race,
Good works are unavailing.
Before thee no one glory can,
And so must tremble every man,
And live by thy grace only.

Words like these certainly seem to be truly Lutheran – and that applies to the whole hymn. Nevertheless, it found its way into the first Roman Catholic hymnal of 1537 and also into later Roman hymnals, where it can be found to this day. Of course the second verse in particular caused problems, especially the line "Es ist doch unser thun umb sonst auch ynn dem besten leben" (Our deeds are worthless even in the best of lives). The problem has been solved in different ways: either the second verse has been omitted, or an additional remark has been made in a footnote explaining the "proper meaning" of the line, such as "Leistungen und persönliche Verantwortung werden in dem Lied (Strophe 2) nicht ausgeschlossen, sondern vorausgesetzt" (Good deeds and personal responsibilities are not excluded in this hymn, but rather presupposed).[14]

In the fourth verse there is a slight change in the wording which prompts certain associations. In the psalm it is said that the soul waits for the Lord "more than the watchmen wait for the morning". In his translation of the Psalter (1524) Luther writes "Von eyner morgen wache bis zur andren." In the hymn, however, the following words are used: "Und ob es weret in die nacht und widder an den morgen, Doch sol meyn hertz an Gottes macht verzweyfeln nicht noch sorgen." (And though it last into the night, And up until the morrow, Yet shall my heart hope in God's might, Nor doubt or take to worry). A typical Hebrew way of indicating a certain period of time is turned into an indication of a difficult existential situation, a struggle in the dark until the light of dawn – just as Jakob experienced at Jabbok in Genesis 32. The rest of the verse points in the same direction: "So thu Israel rechter art, der aus dem geyst erzeuget ward und seynes Gotts erharre." (Thus Israel must keep his

[14] Markus Jenny: "Vom Psalmlied zum Glaubenslied – Vom Glaubenslied zum Psalmlied", in: *Musik und Kirche* 49 (1979), 276f.

post, For he was born of Holy Ghost, And for his God must tarry).

It might seem a little strange that this hymn immediately became a funeral hymn. It was used at the funeral of Frederick the Wise in 1525 and it was also sung by the people gathered to see Luther's body being brought back to Wittenberg from Eisleben after his death. But why not? It gives clear guidance as to how we should live and die.

Dear Christians, Let Us Now Rejoice
The same Easter pattern is to be found in *Nun freut euch, liebe Christen gmein* (Dear Christians, Let Us Now Rejoice),[15] although this hymn does not reflect a particular psalm. As a matter of fact this hymn comprises more than 50 different biblical quotations reiterated almost *verbatim* but woven together into a unit. This is obvious to anyone familiar with Luther's Bible as well as his hymns. One verse (7) may serve as an example:

> Er sprach zu myr, halt dich an mich,
> Es soll dyr itzt gelingen,
> Ich geb mich selber gantz fur dich,
> Da will ich fur dich ringen,
> Denn ich byn deyn und du bist meyn,
> Und wo ich bleyb da soltu seyn,
> Uns soll der feind nicht scheyden.

> To me he said: Stay close to me,
> I am your rock and castle.
> Your ransom I myself will be;
> For you I strive and wrestle;
> For I am yours and you are mine.
> And where I am you may remain;
> The foe shall not divide us.

From the third line onwards there are quotations from Galatians 2:20, Luke 22:44, Song of Songs 2:16, John 17:24 and Romans 8:38.

The hymn is more than a reiteration, however. It makes present what it narrates. The little word "now" is frequently repeated (although not as frequently as in the Swedish translation made by Olaus Petri, the Swedish Reformer). The same applies to all hymns by Luther. The Swedish hymn-

[15] WA vol 35 (Weimar, 1923), 422–425: Nun freut euch liebe Christen gmein.

writer Emil Liedgren has captured this in the phrase "the wonderful now of the Reformation". Luther's distinction between *factum passionis* and *usus passionis* explains how everything comes together in the present moment:

> Von der vergebunge der sünden handeln wyr auff zwo weyse. Eyn mal, wie sie erlangt und erworben ist, Das ander mal, wie sie ausgeteylt und uns geschenckt wird. Erworben hat sie Christus am creutze, das ist war, Aber er hat sie nicht ausgeteylt odder gegeben am creutze, Im abentmal odder Sacrament hat er sie nicht erworben, Er hat sie aber daselbst durchs wort ausgeteylet und gegeben, wie auch ym Euangelio, wo es predigt wird, Die erwerbunge ist eyn mal geschehen am creutze, Aber die austeylunge ist offt geschehen vorhyn und hernach von der wellt anfang bis ans ende…[16]

> We treat of the forgiveness of sins in two ways. First, how it is achieved and won. Second, how it is distributed and given to us. Christ has achieved it on the cross, it is true. But he has not distributed or given it on the cross. He has not won it in the supper or sacrament. There he has distributed and given it through the Word, as also in the Gospel, where it is preached. He has won it once for all on the cross. But the distribution takes place continuously, before and after, from the beginning to the end of the world.

In accordance with this, one will also find – throughout this hymn as well as the others – that the decisive pronouns "for us", "to me", etc. are repeated again and again. It is "der gemeine Christ" who speaks, just like in the Psalter. Friedrich Spitta has claimed that this particular psalm should be understood as Luther's autobiography. It certainly reflects Luther's own experience, as well as the experience of faithful people always and everywhere. Although this hymn is not a reiteration of a particular psalm, it was Luther's intention to make it similar to the Psalter, with words suitable for everyone.

Altogether these characteristics of an Evangelical song – the wonderful now, the personal pronouns, and the distribution of Grace through the Word of Promise – are right at the heart of the matter of the Reformation. Singing the hymn is preaching the Gospel – if preaching, as Luther says, "is nothing but allowing Christ to come to us and to draw us to himself." A single song reflects the pattern of true worship, God's encounter with man, and the joyful exchange (fröhlich Wechsel) that

[16] WA vol. 18 (Weimar, 1908), 203. English translation by Conrad Bergendoff in: LW vol. 40 (ed. Conrad Bergendoff), (Philadelphia, 1958), 213f.

occurs. The worship is, to use a phrase of Regin Prenter's, "justification by Grace through faith in function."[17] This is presumably the deepest implication in Luther's desire that "God's Word may remain with the people also through singing."

Evangelical Martyrs
According to Luther the Psalter is the true alternative to the legends. At the same time he recognized people's need for good examples and heroes. Therefore, another alternative to *The Golden Legend* (*Legenda Aurea*) was developed: a Lutheran variant of the martyrological genre. But there was no need to create fiction in order to use the history of the early church. The lives of the Fathers became substitutes for the legends. Such stories were put together by Georg Major, Georg Spalatin and others. Luther wrote prefaces to these books.

But martyrdom was not solely something from the distant past. It is well known that Luther regarded for example Jan Hus as a martyr. The same goes for the two Augustinians, Henrich Voes and Johann Esch, who were burnt at the market place in Brussels on the first of July 1523. The two men were the first blood witnesses of the Reformation. Luther wrote a hymn, or rather a ballad, about the two martyrs: A New Song Here Shall Be Begun.[18] Typical for this song, and for the Lutheran martyrology in general, is the concentration on the steadfastness in confessing their faith. They are true *confessores*. And their confession will continue to spread. Luther seems to have had the words of Tertullian about martyrs as "seed" in mind when writing the tenth verse in particular:

> Die aschen will nicht lassen ab,
> Sie steubt ynn allen landen,
> Die hilfft keyn bach, loch, grub noch Grab,
> sie macht den feynd zu schanden.
> Die er ym leben durch den mord
> zu schweygen hat gedrungen,
> Die mus er tod an allem ort
> mit aller stym und zungen
> Gar frolich lassen singen.

[17] Regin Prenter: "Das Augsburgische Bekenntnis und die Römische Messopferlehre", in: *Kerygma und Dogma* (Goettingen, 1955), 45.
[18] WA vol. 35 (Weimar, 1923), 411–415: Eyn newes lied wyr heben an.

Leave off their ashes never will;
Into all lands they scatter;
Stream, hole, ditch, grave – nought keeps them still
With shame the foe they spatter.
Those whom in life with bloody hand
He drove to silence triple,
When dead, he them in every land,
In tongues of every people,
Must hear go gladly singing.

Singing As a True Mark of the Church

There are reasons for talking about a singing Reformation and a singing Church. No wonder that Luther mentions singing when he develops his thoughts on the true marks of the Church (*notae ecclesiae*), as for example in his book *On the Councils and the Church*, 1539. In a very typical pastoral manner Luther starts by presenting a scene with a "poor confused person" asking where to find a holy Christian people in this world. The answer is sevenfold: the preaching of the Word, the sacrament of baptism, the holy sacrament of the altar, the use of the heavenly keys, the consecration or calling of ministers, prayer, and the sacred Cross. He comments on the sixth mark of the Church, prayer, in the following way:

> Zum sechsten erkennet man eusserlich das heilige Christliche Volck am gebet, Gott loben und dancken öffentlich. Denn wo du sihest und hörest, das man das Vater unser betet und beten lernet, auch Psalmen oder Geistliche lieder singet, nach dem wort Gottes und rechtem glauben, Item den Glauben, Zehen gebot und Catechismum treibet öffentlich, Da wisse gewis, das da ein heilig Christlich volck Gottes sey, Denn das gebet ist auch der theuren heiilthumb eins, dadurch alles heilig wird, wie S. Paulus sagt. So sind die Psalmen auch eitel gebet, darin man Gott lobet, dancket und ehret, Und der Glaub und Zehen gebot, auch Gottes wort und alles eitel heilthum, dadurch der Heilige geist das heilige volck Christi heiliget.[19]

> Sixth, the holy Christian people are externally recognized by prayer, public praise, and thanksgiving to God. Where you see and hear the Lord's Prayer prayed and taught; or psalms or other spiritual songs sung, in accordance with the word of God and the true faith; also the creed, the Ten Commandments,

[19] WA vol. 50 (Weimar, 1914), 614. English translation by Charles m. Jacobs in: LW vol. 41 (ed. Eric W. Gritsch), (Philadelphia, 1966), 164.

and the catechism used in public, you may rest assured that a holy Christian people of God are present. For prayer, too, is one of the precious holy possessions whereby everything is sanctified, as St Paul says (1 Tim. 4:5). The psalms too are nothing but prayers in which we praise, thank and glorify God. The creed and The ten Commandments are also God's word and belong to the holy possession, whereby the Holy Spirit sanctifies the holy people of Christ.

In Luther's perspective saying and singing, preaching and praying come very close together in the sanctification of the people of Christ and their way of living by Grace. A simple scheme of God's address and man's response certainly stresses the important pattern, but it does not take all aspects into account. The picture is far more complex, when it is "painted in living color and shape".

Concluding Remarks
I began by asking why Luther's hymn-writing seems to be of little theological significance to us. Moreover, I argued that we tend to misunderstand the way Luther approaches theology due to the modern patterns of thought which are self-evident to us. One of these thought patterns is the distinction we make between theory and praxis and the way we understand their mutual order: theory precedes praxis and shall be put into praxis. This order was essential for Schleiermacher in the reshaping of the curriculum at the Humboldt University at the beginning of the nineteenth century. The study of Theology aimed at a profession, just like the study of Law or Medicine. The studies were to give a scientific base for the praxis to follow. And this is still the case. Don S. Browning has put it thus: "To admit in a major university that one is a practical theologian has been to invite humiliation."[20] Why? Because such a person is at the periphery of scientific work.

Luther, however, seems to do theology in another way, keeping theory and praxis closely together. In an early letter he states that he works "for the sake of theology and the salvation of the brethren" (*pro re theologica et salute fratrum*). [21] By saying so he does not mean two different tasks but rather one and the same. The task is certainly not less theoretical, but

[20] Don S. Browning: *A Fundamental Practical Theology: Descriptive and Strategic Proposals* (Minneapolis, 1991, 1996), 3.
[21] WA *Briefwechsel* vol 1 (Weimar, 1930), 71, 42.

theory becomes more of a reflection upon praxis. Theology is Pastoral Theology and the theologian becomes a reflective practitioner.

This pastoral dimension is always present in the work of the Reformer, as we have seen for example in Luther's presentation of the marks of the Church. After all, the Reformation began as a pastoral problem – the trust that people put in the letters of indulgence.

The pastoral dimension of all theology has become increasingly clear to me. I would like to take a brief look at it from another angle also. I was once asked by the former Swedish archbishop, Gunnar Weman, to write a commentary for pastors on the Augsburg Confession. The normal way of writing such a book is to comment on one article after another, but I tried to do it differently, taking it seriously that the Reformers were asked by the Emperor to give a report at Augsburg, i.e., to explain and give reasons for what was already going on in the evangelical areas. In other words, the articles of faith (*articuli fidei*) reflect and protect the already existing "use of the Gospel and the fellowship at the Lord's table" (*usus Evangelii et communio mensae Domini*). In order to be able to understand the articles of faith (theory) you have to take the use of the Gospel (praxis) into consideration – and vice versa. I therefore tried a reverse order. Later on I found out that I had some support from Nathan Söderblom in his pastoral letter, where he urges the students to read the Confessions, "so that our joy may be unclouded".[22] The worship of the congregation is our joy. The articles are merely there to clarify and protect it.

I began by stressing that Luther keeps together what we tend to separate, namely scholarly work and pastoral care. The pastoral dimension is always present in the work of the Reformer, as we have seen, for example, in Luther's presentation of the marks of the Church. It was there already at the beginning. For Luther, the cause of theology and the salvation of the brethren were inseparably united.[23] Consequently his discovery of the true meaning of God's righteousness at the same time provided him with a hermeneutical key to the understanding of the Bible and the consolation of troubled consciences. Luther's biblical and pastoral work resulted also in hymns with the Gospel as their key signature. Therefore, the study of his hymn-writing provides us with a good

[22] Nathan Söderblom: *Herdabref till prästerskapet och församlingarna i Uppsala ärkestift* (Uppsala, 1914), 26.

[23] Leif Grane: *Martinus Noster. Luther in the German Reform Movement 1518–1521* (Mayence, 1994), 19.

approach to his theology. The hymns enable us to explore a theology which in its very essence is pastoral.

Carl Axel Aurelius is Deputy Secretary General of the Church of Sweden. Aurelius has earned his reputation as a Luther scholar from his dissertation on Luther's ecclesiology, *Verborgene Kirche. Luthers Kirchenverständnis in Streitschriften und Exegese 1519–1521*, (1983) a commentary on the Augsburg Confession, *Hjärtpunkten. Evangeliets bruk som nyckel till Augsburska bekännelsen* (1995), a history of the Luther reception in Sweden, *Luther i Sverige. Den svenska Lutherbilden under tre sekler.* (1994), and translations of Luther texts into Swedish. Dr. Aurelius is a member of the Continuation Committee of the International Congress for Luther Research.

Lutheran Tradition and the Medieval Latin Mass

Nils Holger Petersen

In the following I will explore fundamental attitudes in Luther's writings concerning his formulation of a German Mass and the transformations of the Latin mass traditions involved in this. I will further contextualize these attitudes in a modern perspective through comments on a contemporary musical mass composition which – in a sense – reverses certain of Luther's ideas.

Luther's Deutsche Messe *(1525/26)*
A famous and decisive transformation of the medieval liturgical heritage occurred when Martin Luther after a long (and admitted) hesitation held his first German Mass on 29 October 1525. His German mass order was subsequently published at the turn of the following year as *Deutsche Messe und Ordnung Gottesdiensts* (1526).

I will not go into the details of Luther's construction of his German Mass.[1] Rather, I want to stress the general attitude found in Luther's order for the Mass, an attitude which may in itself constitute the most important break with liturgical history from what is usually termed the later Middle Ages. This is brought out from the very first words of Luther's written text, in his introduction to the printed edition of the *Deutsche Messe*:

> Vor allen dingen wil ich gar freundlich gebeten haben, auch umb Gottis willen, alle die ienigen, so diese unser ordnunge ym Gottis dienst sehen odder nach folgen wollen, das sie ja keyn nöttig gesetz draus machen noch yemands gewissen damit verstricken odder fahen, sondern der Christlichen freyheyt nach yhres gefallens brauchen, wie, wu, wenn und wie lange es die sachen schicken und foddern. Denn wyr auch solchs nicht der meynunge lassen aufgehen, das wyr yemand darynnen meystern oder mit gesetzen regiern wolten, sondern die weyl allenthalben gedrungen wird auff deutsche Messen

[1] *D. Martin Luthers Werke. Kritische Gesamtausgabe* vol. 19 (Weimar, 1897), 72-113, introduction, ibid., 44-71. *D. Martin Luthers Werke. Kritische Gesamtausgabe* henceforth referred to as WA. I have discussed Luther's order for a German Mass in Nils Holger Petersen: *Kristendom i musikken*, (Copenhagen, 1987), 64-80.

> und Gottis dienst und gros klagen und ergernis gehet uber die mancherley weyse der newen Messen, das eyn iglicher eyn eygens macht, etliche aus guter meynunge, ettliche auch aus furwitz, das sie auch was newes auffbringen und unter andern auch scheynen und nicht schlechte meyster seyen; wie denn der Christlichen freyheyt alle wegen geschicht, das wenig der selbigen anders gebrauchen denn zu eygener lust odder nutz und nicht zu Gottis ehre und des nehisten besserung.[2]

> In the first place, I would kindly and for God's sake request all those who see this order of service or desire to follow it: Do not make it a rigid law to bind or entangle anyone's conscience, but use it in Christian liberty as long, when, where, and how you find it to be practical and useful. For this is being published not as though we meant to lord it over anyone else, or to legislate for him, but because of the widespread demand for German masses and services and the general dissatisfaction and offense that has been caused by the great variety of new masses, for everyone makes his own order of service. Some have the best intentions, but others have no more than an itch to produce something novel so that they might shine before men as leading lights, rather than being ordinary teachers – as is always the case with Christian liberty: very few use it for the glory of God and the good of the neighbour; most use it for their own advantage and pleasure.

The main theme of this text is to some extent counterbalanced by Luther's reference to St Paul (1 Corinthians 1: 10) exhorting the Corinthian congregation to unity of mind and speech.[3] Even so, Luther never makes an outright demand for a specific restraint on freedom, but only formulates a desire that some kind of unity within limited areas for all the various German mass orders should be found. He makes it very clear that those who already have "good mass orders" ("gute ordnunge") or who can arrive at such through God's grace may disregard his proposal. He continues:

> Denn es nicht meyne meynunge ist, das gantze deutsche land so eben müste unser Wittembergische ordnung an nemen. Ists doch auch bis her nie geschehen, das die stiffte, klöster und pfarhen ynn allen stucken gleych weren gewesen.[4]

[2] WA vol. 19 (Weimar, 1897), 72. English translation by Augustus Steimle in: *Luther's Works* vol. 53, (ed. Ulrich S. Leupold), (Philadelphia, 1965), 61. *Luther's Works* henceforth referred to as LW.

[3] WA vol. 19 (Weimar, 1897), 72.

[4] WA vol. 19 (Weimar, 1897), 73. English translation by Augustus Steimle in: LW vol.

> For I do not propose that all of Germany should uniformly follow our Wittenberg order. Even heretofore the chapters, monasteries, and parishes were not alike in every rite.

Luther here seems to refer to an experience of the lack of liturgical unity in the (late) Middle Ages. This has been corroborated by modern liturgiological scholarship.[5] What is new in Luther's attitude is not so much that he allows a variety of practices, but the basic idea of freedom in his statements. Conversely, the Catholic Church, in the aftermath of the Council of Trent made liturgical unity an issue through the emulation of the Missale Romanum (1570) and the Breviarium Romanum (1568).[6] It has recently been demonstrated, however, that even the post-Tridentine mass stipulations did not lead to complete musical uniformity.[7] A statement by Pope Gregory XIII (written in 1577) in a letter to two composers in Rome, the famous Giovanni Pierluigi da Palestrina and Annibale Zoilo, where they were given the task of revising the music for the Roman Mass and Office liturgy in the wake of the decisions of the Council of Trent (and the afore-mentioned liturgical books) does, in any case, throw light on the attitude towards liturgical authority and uniformity in the Catholic Church. Gregory writes among other things (here quoted in English translation):

> And thus we charge you with the business of revising and (so far as shall seem expedient to you) of purging, correcting, and reforming these Antiphoners, Graduals, and Psalters, together with such other chants as are used in our churches according to the rite of Holy Roman Church, whether at the Canonical Hours or at Mass or at other divine services, and over all of these things we entrust you for the present with full and unrestricted jurisdiction and power by virtue of our apostolic authority, and in order that you may pursue the aforesaid more quickly and diligently you have our permission to admit other skilled musicians as assistants if you so desire.[8]

53 (ed. Ulrich S. Leupold), (Philadelphia, 1965), 62.

[5] See for instance Cyrille Vogel: *Medieval Liturgy. An Introduction to the Sources* translated and revised by William G. Storey and Niels Krogh Rasmussen (Washington DC., 1986), 4.

[6] Joseph A. Jungmann: *Missarum Sollemnia* vol. I (Wien, 1952), 182-83, A.G. Martimort: *L'Église en prière* (Paris, 1965), 43-46 and 871-72.

[7] Research to this purpose was presented in a preliminary form at the conference of the International Musicological Society in Budapest, 23 – 31 August 2000 ("The Past in the Present") independently by Janka Szendrei (Budapest) and Theodore Karp (Chicago).

[8] "Itaque vobis Antiphonaria, Gradualia, psalteria et alios quoscumque cantus quorum in

The tone is clearly rather different from Luther's. The difference in attitude becomes even more obvious when Luther at the end of his mass order returns to the ideas of freedom and the lack of authority not only of his own mass order, but of any service order:

> Summa, diser und aller ordnunge ist also zu gebrauchen, das wo eyn misbrauch draus wird, das man sie flux abthu und eyne andere mache, gleych wie der künig Ezechias die eherne schlange, die doch gott selbs befolhen hatte zu machen, darumb zubrach und abthet, das die kinder Israel derselbigen misbrauchten; denn die ordnung sollen zu fodderung des glaubens und der liebe dienen und nicht zu nachteyl des glaubens. Wenn sie nu das nicht mehr thun, so sind sie schon thot und abe und gelten nichts mehr, gleych als wenn eyn gute muntze verfelscht, umb des misbrauchs willen auffgehaben und geendert wird, oder als wenn die newen schuch alt werden und drucken, nicht mehr getragen, sondern weg geworffen und ander gekaufft werden. Ordnung ist eyn eusserlich ding, sie sey wie gut sie will, so kan sie ynn misbrauch geratten. Denn aber ists nicht mehr eyn ordnung, sondern eyn unordnung; darumb stehet und gilt keyne ordnung von yhr selbs etwas, wie bis her die Bepstliche ordnunge geachtet sind gewesen, sondern aller ordnunge leben, wirde, krafft und tugent ist der rechte brauch, sonst gilt sie und taug gar nichts. Gotts geist und gnade sey mit uns allen. Amen.[9]

> In short, this or any other order shall be so used that whenever it becomes an abuse, it shall be straightway abolished and replaced by another, even as King Hezekiah put away and destroyed the brazen serpent, though God himself had commanded it be made, because the children of Israel made an abuse of it. For the orders must serve for the promotion of faith and love and not be to the detriment of faith. As soon as they fail to do this, they are invalid, dead and gone; just as a good coin, when counterfeited, is cancelled and changed because of the abuse, or as new shoes when they become old and uncomfortable are no longer worn, but thrown away, and new ones bought. An order is an

ecclesiis est usus, iuxta ritum Scae Romanae ecclesiae tam in horis canonicis quam Missis et aliis diuinis celebrandis reuidendi et prout uobis expedire uisum fuerit, purgandi, corrigendi et reformandi negocium damus atque super his omnibus plenam et liberam auctoritate Apostolica tenore praesentium facultatem tribuimus et potestatem, et quo celerius ac diligentius praemissa exequi ualeatis, uobis ut aliquot alios Musicae peritos adiutores arbitrio uestro asciscere possitis, concedimus."
See Raphael Molitor: *Die nach-Tridentinische Choral-Reform zu Rom* (Leipzig, 1901-2), 2 vols, I, 297-98. The English translation given above is quoted from Gary Tomlinson (ed.): "The Renaissance" in: Oliver Strunk (ed.): *Source Readings in Music History*, revised edition, edited by Leo Treitler (New York, 1998), 281-510, (375).

[9] WA vol. 19 (Weimar, 1897) 113. English translation by Augustus Steimle in: LW vol. 53 (ed. Ulrich S. Leupold), (Philadelphia, 1965), 90.

external thing. No matter how good it is, it can be abused. Then it is no longer an order, but a disorder. No order is, therefore, valid in itself – as the popish orders were held to be until now. But the validity, value, power, and virtue of any order is in its proper use. Otherwise it is utterly worthless and good for nothing. God's Spirit and grace be with us all. Amen.

The radically different approach of Luther, where a so-called abuse of a liturgical order is demanded to lead to the abandonment of the order altogether and the formulation of a new one, goes beyond the idea of the imperfection of concrete liturgical orders. Imperfections may be remedied, and thus a certain kind of freedom concerning the reception of liturgical orders already follows from such an idea. In the quoted passage, however, Luther expresses as a much more fundamental idea that no external order in principle can have absolute authority. An external order may only be appreciated through its usefulness, a concept highly emphasized in Luther's text by the use of metaphors like worn-out shoes and counterfeit coins. Luther seems not to try to approach any ideal of a mass order, but simply to establish a temporary framework in which the assembled congregation will be able to participate in a service where the Gospel is preached and where it is possible to receive the sacraments.

This should not be misunderstood as a modern type of relativism. As will become apparent below, Luther's main concern was that God would recognize the chosen framework. Precisely the combination of absolute postulates about the fundamental prerequisites of the mass order and the lack of any authority in itself of this mass order, may make it rather difficult for a modern reader to understand Luther's position. Furthermore, Luther was not at all indifferent about the way to proceed when introducing a German Mass. His general criticism of many such orders – especially for not thinking about the relationship between words and music – is well known. He enunciated such thoughts in his *Wider die himmlischen Propheten, von den Bildern und Sakrament* earlier in 1525. According to this text, the continuing indiscriminate use of the familiar mass chants (from the Latin Mass) adapted to words translated into German seemed to him to be an act of mimicry rather than a real effort to create a German Mass:

Ich wolt heute gerne eyne deutsche Messe haben, Ich gehe auch damit umbe, Aber ich wolt ja gerne, das sie eyne rechte deutsche art hette, Denn das man den latinischen text verdolmetscht und latinischen don odder noten behellt,

las ich geschehen, Aber es laut nicht ertig noch rechtschaffen. Es mus beyde text und notten, accent, weyse und geperde aus rechter mutter sprach und stymme komen, sonst ists alles eyn nachomen, wie die affen thun, Nu aber der schwermer geyst drauff dringet, Es musse seyn, und wil aber die gewissen mit gesetz, werck und sunde beladen, wil ich myr der weyle nemen und weniger dazu eylen denn vorhyn nür zu trotze den sunden meystern und seel mordern, die uns zu wercken nottigen als von Gott gepotten, die er nicht gepeut.[10]

I would gladly have a German Mass today. I am also occupied with it. But I would very much like it to have a true German character. For to translate the Latin text and retain the Latin tone or notes has my sanction, though it doesn't sound polished or well done. Both the text and notes, accent, melody, and manner of rendering ought to grow out of the true mother tongue and its inflection, otherwise all of it becomes an imitation, in the manner of the apes. Now since the enthusiast spirit presses that it must be, and will again burden the conscience with law, works, and sins, I will take my time and hurry less in this direction than before, only to spite the sin-master and soul-murderer, who presses upon us works as if they were commanded by God, though they are not.

It seems that some kind of aesthetic judgement has entered into Luther's otherwise theologically informed statements at this point.[11] In addition, his theological criticism of those who made the establishing of a German Mass a theological demand, and thus – in the eyes of Luther – made themselves guilty of a kind of justification by deeds, is used as a (somewhat awkward) argument not to hurry with his work on a German mass order. In this way what first appears as (possibly) an aesthetic criterion concerning how to formulate such an order in terms of words, music, and gesture, a criterion which seems to be used as a warning against a too rash formulation of a German Mass, is supplemented by a theologically informed polemical (and idiosyncratic) reaction.

To complicate matters, the following quotation, which stems from what Luther apparently said at the end of his sermon on 29 October 1525, i.e. the very first time his German mass order was used, discusses the new

[10] The full text of this document is found in WA vol. 18 (Weimar, 1908), 62-125 (first part), and 134-214 (second part). Introductions ibid., 37-61 and 126-33. The quoted passage is found on p. 123. English translation by Bernhard Erling in: LW vol. 40 (ed. Conrad Bergendorff), (Philadelphia, 1958), 141-42.

[11] See also the discussion of Luther's possible combination of theological and aesthetic ideas in Eyolf Østrem's article in this volume.

practice in yet another way, seemingly more in terms of a validation of the liturgical order through the experience of God's acceptance of the order, and through the intercession for this by the congregation. Thus, arguments pertaining to the realm of religious experience seem to be added to the theological and – to some extent – aesthetic criteria. When Luther's first German Mass was celebrated in October 1525, it had experimental status but it subsequently received full acceptance as the (official) liturgical form of the German Mass in Wittenberg from Christmas Day 1525 onwards.[12]

> Wyr haben angefangen zuversuchen eyn deutsche Mess anzurichten. Ihr wist, das die Messe ist das furnemest eusserlich ampt, das do verordnet ist zu trost den rechten Christen, Darumb bitt ich euch Christen, yhr wolt Gott bitten und anruffen, das er yhm das las wolgefallen, Ihr habt offt gehort, das man nicht leren solle, man wis denn, das es Gottis wort sey, also soll man nicht ordnen und anheben, man wis denn, das es Got gefalle, man soll auch nicht mit der vernunfft dareyn fallen, denn so es nicht selber ansehet, so wird nichts daraus, Darumb hab ich mich auch so lang gewert mit der deutsche Messe, das ich nicht ursach gebe den rotten geystern, die hyneyn plumpen unbesunnen, achten nicht ob es Gott haben wolle. Nu aber so mich so viel bitten aus allen landen mit geschrifft und brieffen, und mich der weltlich gewalt darzu dringet, kunden wyr uns nicht wol entschuldigen und ausreden, sonder mussen darfur achten und halten, es sey der will Gottis, wa nu da etwas gehet, das unser ist, das soll untergehen und stincken, wenn es gleich eyn schon und gros ansehen hat, Ist es aber aus Gott, so mus es fort gehen, ob es sich gleich nerrisch let ansehen, Also alle ding, die Gott thut, wens gleich nymant gefelt, mus es fort, Darumb bitt ich euch, das yhr den Herren bittet, wenn es eyn rechtschaffne Mes sey, das sie yhm zu lob und ehren fort gehe.[13]

We have started our efforts to hold a German Mass. You know that the Mass is the foremost outward office which has been ordained for the comfort of the true Christians. Therefore, I ask you Christians that you will pray to God and implore him that he will deign to be pleased with it. You have often heard that one should not teach unless one is sure that what is taught is God's Word. Thus, one should not ordain or commence something unless one is certain that it pleases God. Neither should one only judge it by common sense, for if God does not see to it, nothing will come out of it. Also for this reason I have resisted to make an effort concerning the German Mass for so long, so that I

[12] WA vol. 19 (Weimar, 1897) 51.

[13] WA vol. 17 (*Erste Abteilung*), (Weimar, 1907), 459. The "do" in the second line of the quotation must be a writing error. My translation.

did not become a cause for the gangs of spirits who put their foot in it thoughtlessly; they do not pay attention to whether God wants it so. But since so many people from all countries now have asked me in writing and letters and the worldly power impels me, we could no longer make excuses or talk ourselves out of it, but must think and accept that it is God's will. If there is something in it which is ours, it should perish and rot even if it should be considered, at the same time, fine and of great reputation. If it is from God, it must continue even if – at the same time – it seems foolish. Thus, every thing which God does must go on, even if it doesn't please anyone. Therefore, I ask you to beseech the Lord, that if this is a proper Mass it will be to his praise and glory.

All in all, Luther's criteria for the validity of his German Mass may seem obscure. To a certain extent it seems to be a matter of religious experience, and Luther insists on the necessity of praying for God's acceptance. On the other hand, criteria of an aesthetico-theological nature (although these are never specified) also seem to be of some importance. On top of it all, the external frame is denied authority. What can we make of this?

First of all, it must be emphasized that the texts drawn on here are not academically conceived texts in a modern sense. They are written for particular situations, and may – at least to some extent – be the outcome of more impulsive and polemical reactions. Altogether, they seem to reflect Luther's position as a receiver of a complex medieval Latin (and Roman) liturgical and theological tradition. The authoritarian Catholic outlook on this tradition was obviously on Luther's mind at this time. His transformation of the medieval Latin mass heritage, as I see it, is primarily concerned with lack of (priestly) pretense, and with a high demand for honesty or an emphasis on the spiritual purity of the intentions and the use of the liturgical practice. What seems to matter is that one tries to carry out the service to the glory of God – and that one does not compromise in this respect, neither in terms of what in a modern perspective seems to be the aesthetic formulation of the order, nor in terms of its theological content. In addition, Luther's attitude seems to bring out the admission that purely human efforts are being used to try to frame divine acts. It is clearly essential to Luther that divine action should not be confused with human acts.

In this respect, Luther's liturgical view exposed by these short readings points to the secularization of a sacred space and of a sacred liturgy as well as to the internalization of the sacredness. Such a secularization was certainly to come in the course of the centuries. What may be termed the intimacy of religion seems to be a marked feature of all protestant history – and to a certain degree (as pointed out above), this is already a characteristic feature of Luther's liturgical attitude.[14] Notably, during the late seventeenth and early eighteenth centuries such an intimacy of religion made itself strongly felt in the North European protestant civilization through the so-called pietistic movements as also in the revivals of the nineteenth and twentieth centuries.

Before I discuss my second example, I would like to point out briefly some few important characteristics for a cultural historical interpretation of Luther's German Mass.

Luther, in a long discussion in his introduction, emphasizes the didactic function of the Mass. The service is not necessary for the Christians, he says, they have all they need spiritually. The service is, according to Luther, necessary for "us" who need to become Christians.[15]

In general, it can be stated that the order of Luther's German Mass seems to keep quite closely to the general structure of the medieval Roman Mass, as close as it would be possible in view of the most important criterion, which must have guided Luther: the theological purification of the traditional liturgical formulae (especially concerning the canon of the Mass, and the idea of the Eucharist as an offering to God and a beneficial act), all according to his reformed theology. The order as such is not at all polemically turned against the traditional Roman mass order. The very important means that Luther used, and for which he is far more renowned than for any of the other liturgical work in his German Mass, is his use of the German song as a fundamental tool for his formulation of the form. With the exception of the *Kyrie eleison* item, which he only abbreviated (in terms of fewer repetitions), all the choral items of the so-called Ordinary of the Mass, i.e. the *Gloria*, the *Credo*, the *Sanctus* with *Benedictus*, and the *Agnus dei*, were either left out or replaced by German

[14] Compare H.G. Koenigsberger: "Music and Religion in Modern European History", in: J.H. Elliott and H.G. Koenigsberger (eds.): *The Diversity of History: Essays in Honour of Sir Herbert Butterfield* (London, 1970), 35-78.

[15] WA vol. 19 (Weimar, 1897), 73: [...] umb unser willen, die noch nicht Christen sind, das sie uns zu Christen machen [...].

hymns paraphrasing the original Latin texts (to which Luther had no objections).[16]

The dichotomy between an Ordinary and a Proper of the Mass in medieval liturgical practices is in a certain sense reversed by Luther, although hardly as a conscious decision, since there is no specific mention of this aspect in Luther's text. But the reality of his proposal makes it clear. The items of the Ordinary were, as mentioned, generally replaced by hymns which no longer had completely fixed authoritative verbal (or musical) texts.[17] Even though there was a long way to the Lutheran pastors' more individual, "free" choice of hymns from hymn books (a practice which seems to have begun in the eighteenth century[18]) – Luther primarily points to hymns paraphrasing the original Ordinary items – the suggested hymns are proposed precisely as possible solutions, they do not constitute a new Ordinary of the Mass. What remains stable in the order is rather the structure, and the biblical readings which after all are still taken from an authoritative book, the Bible (even though Luther also suggests the use of a paraphrase of the Lord's prayer[19] and a paraphrase of Salvation History as an introduction to the Eucharist[20]) and the sermon. In other words, what earlier constituted the Proper – the exchangeable – becomes the center of stability in Luther's German Mass. In a long-term cultural historical view the tendencies pointed out here in Luther's reform seem to recur – on a different scale – in the loosely structured composition of various hymns which became the characteristic modern Lutheran mass celebration, tied together by (changing) biblical readings, the (individually constructed) sermon, and a fixed mass structure, but not by verbal items of any great number or solidity during the Mass.

The aforementioned pedagogical aspect of Luther's German mass order, which must be thought of as just one aspect (especially if compared with what Luther said to his congregation on 29 October), is borne out very clearly in his German paraphrase of the Latin *Sanctus* from the Mass.

[16] WA vol. 19 (Weimar, 1897), 86, 95, 100-102.

[17] Cf. Luther's remarks about the hymn singing, see WA vol. 19 (1897), 80, 90, 95, and 99.

[18] Walter Blankenburg: "Der gottesdienstliche Liedgesang der Gemeinde", in: Karl Ferdinand Müller and Walter Blankenburg (eds.): *Leiturgia. Handbuch des Evangelischen Gottesdienstes* vol. IV (Kassel, 1961), 559-660 (642).

[19] WA vol. 19 (Weimar, 1897), 95.

[20] WA vol. 19 (Weimar, 1897), 95-96.

Whereas the Roman Mass simply uses the biblical praise of the angels from Isaiah's vision of the divine throne in chapter 6 of the Book of Isaiah, Luther's hymn paraphrase of the *Sanctus* clearly emphasizes the point of explaining the biblical context at the expense of preserving the traditional situation. In the Latin mass *Sanctus* the congregation may be said to join the angelic praise at the throne of God.[21] In the German Mass – instead – they seem to sing about the angelic praise: "Jesaia dem propheten das geschach, das er ym geyst den herren sitzen sach [...]"[22]

This is a genuinely pedagogical measure, since it is very likely that many people at the time would not be aware of where the words came from.[23] At the same time, Luther's paraphrase shows a distinctive transformation from a medieval idea of a sacred space and time, where the Mass takes place at the divine throne and where the faithful – at least symbolically – join the angels and archangels in singing praises to God. In Luther's German Mass the congregation sings about how the angels were seen and heard singing their praises to the Lord. Accordingly, the hymn is worded in the past tense throughout.[24] One should be cautious not to overstate an interpretation based on a single textual element. However, the fundamental change in what seems to be the understanding of the situation of the Mass in this item may be symptomatic of the general process of secularization. Such a process seems to be characteristic for the history of the protestant cult (as touched upon above), even though Luther's German *Sanctus* did not become a stable part of Lutheran church services in general. In the Catholic Church, the Latin *Sanctus*, with its placement of the liturgy at the Divine throne, persisted for almost 450 years after the Lutheran Reformation.

Dieter Schnebel's Missa

As an epilogue which, I hope, provides perspective, I would like to introduce a completely different, and yet in a certain way parallel modern text by Dieter Schnebel, a contemporary German theologian and composer. According to his own statement, he belongs to the tradition which goes back to the so-called *Bekennende Kirche*, the group of German pro-

[21] Cf. Jungmann (1952), vol. II, 170.
[22] WA vol. 19 (1897), 100.
[23] Cf. WA vol. 19 (1897), 73, and 76.
[24] WA vol. 19 (1897), 100-102.

testant theologians that became famous for opposing the Nazi regime and were represented by such theologians as Dietrich Bonhoeffer (who was executed for his role in the attempted assassination of Hitler towards the end of the Second World War) and Martin Niemöller (who was also convicted but escaped death). Dieter Schnebel was born in 1930 and belongs musically to a modernist or, to some extent, postmodernist reaction against tradition.

The musico-verbal text I will introduce is also a mass, it is simply called *Missa* and must be seen or heard in the context of the history of the Mass. Its genesis is fairly complicated and does not concern me in this particular context. I will discuss certain aspects of the CD-version which was recorded in 1991 and released in 1993. The piece as such was given its premiere in the Jesus-Christus-Kirche in Berlin in 1988 – after a period of commission, writing, re-writing and practical performance problems. It is a mass, in the sense that it is a choral musical work based on the traditional Ordinary of the Mass combining the verbal texts of the Ordinary with fragments of translations into ancient Greek, Hebrew, and some modern languages and also with biblical quotations in those languages.[25]

As the work is presented on the CD – and thus as most potential listeners will be able to experience the work – it does not in the first place relate to the Roman Mass as a religious service including the Eucharist and the participation of a congregation. It relates to exactly the parts of the Roman Mass which were set in the "classical" mass compositions by for instance Josquin, Haydn, Mozart, Bruckner, Stravinsky, and many others, ("classical" as famous settings of the Latin Mass, but in other respects, of course, difficult to compare). In a modern concert hall and CD reception, these works appear detached from their roots in the religious mass celebrations into which most of them were actually written prior to the twentieth century. By constructing his work on the aforementioned mass items, Schnebel appears to relate more to the mass traditions of (later) musical history than to the history of the Latin mass celebration.

The musical style employed by Dieter Schnebel might be described by the notion of musical modernity. At the same time, the composition was also determined by a revaluation of the cultural or religious value of the

[25] Dieter Schnebel: *Missa*. The recording is issued as Wergo 286 218-2 (Mainz, 1993). The information given here is found in the textbook, 4-7 (in English, 26-30). The verbal text of the composition is found ibid., 14-24.

traditional (Catholic) Latin Mass. In the booklet of the CD edition, Dieter Schnebel states:

> [...ich meine], dass wir heute – im Unterschied zu vor zwanzig Jahren – eine veränderte Situation haben, in der es unter Umständen auch notwendig erscheint, traditionelle Formen zu retten und ihnen neue Inhalte zu geben, weil sie selber in Gefahr stehen. Damals konnte es noch legitim erscheinen, gegen erstarrte Gottesdienstformen, zu denen auch die Messe und der traditionelle Gottesdienst gehörten, zu opponieren und sie aufzubrechen. Heute sehe ich es auch als Aufgabe an, diese Formen in neue Zeiten hinüberzuführen, da die Kirchen selber ihr Ureigenstes zu zerstören beginnen. Ich bin zwar evangelischer Theologe, aber ich meine, es ist durchaus verhängnisvoll, dass die katholische Kirche das Latein als Universalsprache aufgegeben hat. Da verfällt man in einen lutherischen Fehler. Wo gibt es das sonst, dass in einer geistlichen Organisation überall auf der Welt eine Sprache als sakrale Sprache vorhanden ist? Ich finde es leichtfertig, dass man das einfach so aufgegeben hat.[26]

Here I will point to only a few features which at the same time seem to constitute a transformation of the religious and musical traditions of both the Latin medieval Mass and of the Lutheran congregational practices, and also through these transformations seem to preserve certain features of Luther's attitude discussed above.

Firstly, the idea of creating a CD (or formerly LP) version of a mass composition represents a transformation of the religious tradition which goes beyond the one already found in the transformation of musical mass compositions from being part of a religious practice to being elements in a cultural practice of concert performance. This is not so much because of the underlying technology, which obviously is an innovation of the twentieth century, but because the idea that a religious ceremony also can be appreciated separately for its aesthetic values has been even further individualized through the practice of LP or CD listening. The general transformation from religious practice to concert performance is ultimately a theme belonging both to music reception history and to the history of spirituality and of music practices in the society. The many recordings of classical mass compositions bear witness to this, and much more could be made of the various ways of appreciating such cultural items (for instance through an investigation of individual user practices).

In the case of Schnebel's *Missa*, however, we are not talking about the

[26] In the mentioned textbook (see n. 24) to the recording of Schnebel's *Missa* (1993), 6-7.

recording of a beloved and particularly famous and valued classical composition of the past, but of a recording of a piece which has been consciously located by the composer both inside and outside of the tradition of religious practice. It is presented as a work of art in the recording, something which is corroborated by the account of the history of its genesis in the accompanying booklet of the recording, which makes it clear that the work originated and was performed in the context of a church concert practice, not as part of a religious ritual.[27] At the same time it is endowed by its composer with a significance for the history of religious practice and understanding. Dieter Schnebel in his above quoted comment claims to see his work as a part of a more general effort to salvage historical religious ritual forms for the future. Thus his work is, in a sense, seen by its composer as a new type of ritual, a meta-service, not in the sense that it is meant to function directly as a religious, congregational Christian ritual, but as a historiographical – and spiritual – ritual through which the listener may become aware of the relevance of traditional ritual forms of the Western ritual heritage, although the exact way this may be supposed to happen is not made entirely clear, neither by the work itself, nor by the declarations in the booklet.

Secondly, through its very free relationship to the tradition of mass compositions to which it belongs, both in terms of its musical material and style, and the textual liberties, which after all also separates it from this tradition, Schnebel may bring to mind Luther's attitude to the external forms of worship. What matters seems to be the purity of intentions. And further, the idea that forms of worship, both aesthetically and religiously, and maybe in terms of historiographical significance, are subject to constant revaluations. Schnebel's thought-provoking remarks, quoted above, concerning the Latin mass tradition make it clear that the valuation of such religious practices is not considered as something that can be done in any authoritative way, detached from the historical moment. In this respect his view is completely in agreement with Luther's.

The difference is merely that Schnebel seems to have found an opposite type of perception to the one highlighted in Luther's metaphorical utterances. Whereas Luther's new understanding implies that forms of worship are not to be considered as timeless or true in themselves, Schnebel has come to the realization that just as one may sometimes

[27] Textbook (1993), 4-5 (English, 27-28).

happen to throw away shoes, which one might later regret losing, forms of worship may store cultural experiences which it is ultimately important in certain ways to carry over into new times. Thus a particular sensibility concerning cultural transitions is introduced into this area of the Western culture. Even though this recognition constitutes the opposite of Luther's experience, it presupposes Luther's way of thinking and in this way shows itself to be a true child of a Lutheran historical and in some ways relativistic approach to religious rituals and their aesthetic values.

Nils Holger Petersen (born 1946) has a Ph.D. in theology and is Associate Professor at the Centre for Christianity and the Arts (Department of Church History), University of Copenhagen. He has published on medieval liturgy and Latin music drama, on music and the history of Christianity, and on the concept of medievalism. Since 2002 he has been head of the Centre for the Study of the Cultural Heritage of Medieval Rituals (under the Danish National Research Foundation). He is also a composer. Address: Faculty of Theology, Købmagergade 44-46, DK-1150 Copenhagen K.

Luther, Josquin and *des fincken gesang*

Eyolf Østrem

That Martin Luther was fond of music, is well known. Likewise, that he particularly favoured the music of Josquin Des Prez (ca. 1450–1521). The most widely circulating quotation states that "Josquin […] ist der noten meister, die habens müssen machen, wie er wolt; die andern Sangmeister müssens machen, wie es die haben wöllen" ("Josquin is the master of notes, which must do as he wills; the other choirmasters must do as the notes will").[1] Although seemingly a telling aesthetic judgement from a period where such are scarce, the statement is too vague to support more specific interpretations about *what* Luther saw in Josquin's music that his contemporaries lacked.

There is, however, another quotation where Luther comments on Josquin in similar terms but at greater length, and in a way that connects a judgement which in modern terms might be called "aesthetic", with central theological dogmas. Luther says:

> *Lex et euangelium.* Was *lex* ist, gett nicht von stad; was *euangelium* ist, das gett von stadt. *Sic Deus predicavit euangelium etiam per musicam, ut videtur in Iosquin*, des alles composition frolich, willig, milde heraus fleust, ist nitt zwungen vnd gnedigt *per [regulas], sicut* des fincken gesang.[2]

> Law and Gospel. What is Law, is not done voluntarily; what is Gospel is done voluntarily. In this way God has preached the Gospel also in music, as can be seen in Josquin, from whom all composition flows gladly, willingly, mildly, not compelled and forced by rules, as *des fincken gesang*.

[1] Johannes Mathesisus: *Dr. Martin Luthers Leben* (St Louis and Dresden, 1883), 227–228. Mathesius' biography of Luther (in the form of seventeen sermons, held over several years) was first published in 1565, but this quotation refers back to 1540. See also Walter E. Burzin: "Luther on Music", in: *Musical Quarterly* 32 (1946), 80–97 where this and several other quotations from Luther about music in general are given. All English translations are mine.

[2] *D. Martin Luthers Werke. Kritische Gesamtausgabe. Tischreden* (Weimar, 1912–1921) 2:1258, 11f (before 14/12 1531). All quotations from the *Tischreden* are from the Weimar edition, and the references are henceforth referred to as WA *Tischreden* followed by the volume number, the page number, and the page number of the quation. "*[regulas]*" is an insertion made by the editors of the Weimar edition, where there is a lacuna in the original text, with reference to Aurifaber's translation (see next note).

Luther's friend and disciple Aurifaber rephrases the quotation more elaborately:

> Was Gesetz ist, das gehet nicht von Statt, noch freiwillig von der Hand, sondern sperret und wehret sich, man thuts ungern und mit Unlust; was aber Euangelium ist, das gehet von Statt mit Lust und allem Willen. Also hat Gott das Euangelium geprediget auch durch die Musicam; wie man ins Josquini Gesang siehet, daß alle Compositio sein fröhlich, willig, milde und lieblich heraus fleußt und gehet, ist nicht gezwungen, noch genöthiget und an die Regeln stracks und schnurgleich gebunden, wie des Fincken Gesang.[3]

> What is Law, does not come out successfully, nor does it go voluntarily from the hand, but resists and struggles, one does it reluctantly and without liking, but what is Gospel, that comes out successfully, delightfully and willingly. In this way, God has preached the Gospel also through music, as one sees in Josquin's music (Gesang), that all his composition gladly, willingly, mildly, and lovingly flows and goes forth, is not forced nor compelled and tightly and directly bound to the rules, as *des Fincken Gesang*.

This brings us a little closer to questions that are of interest to the contemporary understanding of a composer like Josquin (and hence, hopefully, to our own understanding of his music). But the statement is by no means clear. Several of the central points are ambiguous, almost to the point of being unintelligible. They need to be untangled, both as regards the actual meaning of the words themselves, and as regards what the quotation says, and about what – Luther and Lutheran theology? Luther's musical understanding? Josquin? His style as perceived by a listener, or his compositional technique? The last step in the interpretation of the quotations will be to combine whatever can be meaningfully drawn from them with the only thing the quotation is unambiguously about: Josquin's music.

[3] ibid. Since the nineteenth century, Aurifaber has generally been regarded as an unreliable source on Luther's actual words. In his article "Josquin und 'des Fincken Gesang'", in: *Deutsche Jahrbuch der Musikwissenschaft* 13 (1968), 72–79, Walter Wiora questions the editorial insertion of *regulas*, as a product of Aurifaber's desire to present a complete text – edited several years after the fact – rather than a reliable account of what Luther actually said, but he does not suggest an alternative to *regulas*. Later scholarship, however, "has come to a greater appreciation of the accuracy of Aurifaber's work" (William R. Russell: "Aurifaber, Johannes" in: *The Oxford Encyclopedia of the Reformation*, [New York, 1996], vol. 1, 101–102), and there seems to be no compelling reason to discard Aurifaber's version altogether. With this note of caution in mind, and for the lack of a better alternative, I take the reading with *regulas* as a point of departure.

"Des Fincken Gesang"
I shall begin with the end of the quotation: "*sicut* des fincken gesang". What *finck*? This passage has been interpreted in two different ways: either as a reference to the finch, or to the composer Heinrich Finck.

At first sight the bird interpretation seems far-fetched: why would Josquin be compared with a bird? There may be something to it, however. In his monograph about Finck, Hoffmann-Erbrecht refers to ornithological expertise which says that the finch sings in a manner that could fit Luther's description of *Lex* – that it "wegen seiner regelmäßigkeit als *'gezwungen'* und *'genötigt'* bezeichnet werden kann."[4] Walter Wiora has suggested that the quotation refers to a finch in a cage, "der singen muß, wie sein Besitzer es will, 'gezwungen und genötigt'," ("who must sing, in the way its owner wants, 'forced' and 'compelled'," as opposed to "der freien Selbstbestimmung und quellenden Produktivität Josquins" ("Josquin's freedom of choice and his welling productivity").[5] According to Wiora, keeping birds in cages was a common practice since before the sixteenth century, and would thus have been recognized as a metaphor for the unfree spirit. Hoffmann-Erbrecht supports this interpretation, and concludes that "mit dem Komponisten hat [der Ausspruch] also nicht das geringste zu tun" (p. 64).

I do not find the ornithological evidence as compelling as Hoffmann-Erbrecht does. The family of finches display a wide variety of sounds and ways of singing, and most of these are of a kind that does not primarily bring "regularity" to mind.[6] Besides, Luther doesn't say "finches in cages", but plainly "des Fincken Gesang". On the whole, it is difficult to assess what Luther might have meant, even if he had referred to finches. At best, the quotation is ambiguous – maybe intentionally so.[7] I will

[4] Lothar Hoffmann-Erbrecht: *Henricus Finck* (Köln, 1982), 63.

[5] Wiora (1968), p. 79.

[6] I'm grateful to the Swedish musicologist Kia Hedell, who has a great interest in and much knowledge about birdsong, for checking this for me. For what it's worth, I also find it difficult to relate and contrast the sound samples of finch song that I've heard myself to what I hear in Josquin's music.

[7] Rob Wegman comments upon the same phrase, and suggests that it may be a pun that refers to both the bird and the composer. Rob Wegman: "Who was Josquin?", in: Richard Sherr (ed.): *The Josquin Companion* (Oxford, 2000), 33. It should be noted that the English translation in Theodore G. Tappert: *Table Talk* (Philadelphia, 1967), vol. 54 of Helmut T. Lehmann (general editor): *Luther's Works* (Philadelphia, 1955–89) has "the song of the finch", and restructures the sentence to make it say that Josquin's music *is* like the song of the finch. Theoretically this is a possible translation, but one that seems to be

therefore leave ornithology aside, and instead concentrate on the other possibility: that it actually refers to the composer Heinrich Finck.

There are good arguments in favour of this interpretation. One is the parallelism (at least in Aurifaber's version) between the phrases "ins Josquini Gesang" and "des Fincken Gesang", each connected with a generalized stylistic description, which is then opposed to the other style. The whole phrase then becomes a mirrored construction: Josquin's music is like A, and not like B, as is Finck's music. The phrase "an die Regeln stracks und schnurgleich gebunden" also seems too specific to be applicable to birdsong – it seems to refer to someone who composes with one eye on the rulebook, rather than to the unfree bird in a cage.

The other main reason for assuming that Finck is the object of comparison comes from Luther's other Josquin quotation mentioned in the introduction: "Josquin is the master of notes, who must do as he wills; the other choirmasters must do as the notes will." Both in construction, with the obvious parallelism, and in content, the two quotations are so similar that it is not unlikely that they are two different realizations of the same idea – perhaps even of the same statement from Luther. In the second quotation, the comparison with other composers is explicit, and this strengthens the claim that that is the intention even in the first quotation.

Why Finck?
The second quotation mentions neither finches nor Finck, but compares Josquin with all other contemporary choirmasters. So why single out Finck in the first quotation? *If* Luther meant to compare Josquin with Finck specifically, what is the basis of that comparison?

First of all, it is noteworthy that Luther seems to have thought highly of Finck as a composer. On another occasion he praises him – in this case his memory – when he mentions Finck, as the only German composer, in the company of Josquin (d. 1521) and Pierre de la Rue (d. 1518), as some of those "feine" and "*excellentes*" *musici* who have died during the past 10 years or so.[8]

dictated more by a confusion over why Josquin is contrasted with a bird than by textual criteria.

[8] "Ach, wie feine *musici* sindt in 10 jharen gestorben! *Iosquin, Petrus Loroe, Finck et multi alii excellentes*. Die welt ist gelerter leuthe nimmer werth [...]" in WA *Tischreden* vol. 3 (Weimar, 1914), 371, no. 3516.

It is not an entirely simple task to evaluate Finck's music in a modern perspective. Whereas Josquin has been a central composer in today's slowly exploding early music market from the very beginning, recordings of Finck are virtually non-existent. A selection of his works has been edited by Lothar Hoffmann-Erbrecht, accompanied by a thorough "man-and-music" monograph,[9] but apart from that, there is not much written about Finck. Given this imbalance, the stylistic judgement will have to be tentative. Finck was born in 1445 and was active as a composer for 60 years, starting probably in Ockeghem's time and spanning Josquin's entire career — almost like a Renaissance Haydn in relation to Mozart. Most of his earliest works, written during his long sojourn in Poland (until 1505), are lost; a three-part mass is one of the few extant works in this group. This is a very skillful composition, but a composition in a late- (or post-) mediaeval style, loaded with rhythmical eccentricities, and with very difficult voice parts, verging on the unsingable — worlds apart from Josquin's simpler style. Judging from this composition only, it would be quite easy to make sense of Luther's comparison and to demonstrate the differences and the way they fit into the theological framework of Luther's statement.

But in his later works, written while he was active in different South-German cities, and thus closer to Luther both in time and place, he incorporated the fashionable Netherlandish style — to such a degree that, at times, it would be tempting to say that Finck is the least fitting German composer to take the position opposite Josquin in a comparison like Luther's. We do not know which works by Finck Luther would have known, of course, but Luther's statement was made in 1531, at a time when both Finck and Josquin had been dead for a few years (Finck died in 1527, Josquin in 1521). There is nothing he categorically *couldn't* have heard, and of what he *could* have heard, his later works are the most likely.

This is not to say that there are no stylistic differences, even in the late style, that a "competent listener" at the time may have perceived along the lines drawn up by Luther — on the contrary. This may in fact be the main reason why Finck is chosen. It would have been a simple task to find a "Kleinmeister" who would immediately fall short when compared

[9] Heinrich Finck: *Ausgewählte Werke* vol. 1 (Frankfurt, 1962), edited by Lothar Hoffmann-Erbrecht. Das Erbe deutscher Musik vol 57; Heinrich Finck: *Ausgewählte Werke* vol. 2 (Frankfurt, 1981), edited by Lothar Hoffmann-Erbrecht and Helmut Lomnitzer. *Das Erbe deutscher Musik* vol. 70; Lothar Hoffmann-Erbrecht: *Henricus Finck* (Köln, 1982).

to the great Josquin. But by comparing Josquin with a *good* and highly valued composer like Finck, the most renowned composer from the German area, Luther would (implicitly) be pointing not to matters of compositional quality, but to matters of style, in a broad sense of the word. I will return to this more specifically in the analyses later on in the article.

Why Josquin?
Even though we can not be certain who or what Luther had in mind with "des Fincken Gesang", it is still possible to take his remark as a listener response primarily concerning Josquin, and widen the scope of the comparison at the other end to encompass the whole generation of composers before and contemporary with Josquin: not only Finck, but also Ludwig Senfl, Pierre de la Rue, Alexander Agricola, Jacob Obrecht, and even Johannes Ockeghem and Guillaume Dufay of the previous generations. If so, we avoid the problem of what exactly Luther was talking about, and we can instead rephrase the question as: what was so special about Josquin?

If so, we enter the most recent debate about the "Josquin generation", pursued especially by Rob Wegman. In his monograph *Born for the Muses* from 1994 about Jacob Obrecht (1457/8–1505), and more recently in his article "Who was Josquin?",[10] he argues that the image of Josquin which has dominated modern scholarship about music around 1500 was created at a relatively late stage, and that this has clouded our understanding of the musical development in this period. He claims that most of the technical features that Josquin has been credited with (first and foremost pervasive imitation and parody technique), were being established before Josquin burst on the scene around 1500. The recent discoveries concerning Josquin's biography – that the Josquin who is recorded as a singer at Milan Cathedral in 1459 was *not* the composer Josquin, and that his date of birth is not c. 1440 but rather c. 1450 or even later – support this.[11]

Wegman has been accused of going too far in his reappreciation of Obrecht and, hence, of Josquin. Peter Urquhart writes in a review of *Born for the Muses*:

[10] Wegman (2000).

[11] Richard Sherr: "Chronology of Josquin's Life and Career", in: Sherr (ed.): *The Josquin Companion* (Oxford, 2000).

This book was written largely without referring to Josquin. To some readers, this approach might seem comparable to writing a novel without using the letter 'e', but there is sense to Wegman's decision. [...] Wegman's chronology of the Masses is an attempt to chart the changes in Obrecht's style, and to trace the early stages of the transition from cantus firmus to parody, all without reference to Josquin.[12]

Urquhart sees this almost as a wish to reverse the roles and give Obrecht the position that Josquin has unjustly acquired. Wegman counters this implicit accusation: His aim is not a change of government, but of principles of understanding; the label "genius" has been attached to Josquin ever since shortly after his death, and it has been allowed to set the agenda for modern scholarship. But "'genius' is not an immanent quality, either in Josquin's personality or in his music".[13] The notion of the one genius rising above the level of "precursors" and "Kleinmeister", distorts our understanding, not only of *them* (they could not have been seen as precursors to anything in their own age), but also of Josquin, because it makes both them and him unhistorical characters, detached from their practical circumstances, their background and stylistic influences, and their personal ambitions.

The case is in many ways parallel to the "Bach syndrome", according to which Bach is the starting point of music history through his acceptance into the concert hall canon. Music prior to this hypothetical starting point will, then, mainly be of scholarly interest – to explain how music came to be "modern", understandable. During the twentieth century Josquin has achieved a similar position, perhaps thanks to the young student who in 1927 asked Friedrich Blume if they could sing Josquin's *Missa Pange lingua*, which the student had transcribed. They so did, Blume was captivated by what he heard, and the "early music" movement was born.[14]

[12] Peter Urquhart: "Obrecht's life and Masses", in: *Early Music* 23:4 (1995), 698.

[13] Wegman (2000), 41.

[14] At least that's how Blume presents it, in "Josquin des Prez: The Man and the Music", in: Edward E. Lowinsky (ed.): *Josquin des Prez: Proceedings of the International Josquin Festival-Conference held at the Juilliard School at Lincoln Center in New York City, 21–25 June 1971* (London, 1976), 18–27. The interest in early music was well on its way before that day, though, both in England and in the Netherlands, where, as Sherr points out (2000, 1), volumes of Smijer's complete Josquin edition were already beginning to appear in 1921.

Thus, if we are interested in a historical understanding, the rephrasing of the question: What did Luther mean? will have to take in a wider range of changes in the years around 1500, including "the emergence of a concern with musical authorship that was intimately connected with judgements of style[, and] the appointment of musicians as court composers, which suggests a professionalization of the craft of composition".[15] According to this line of thought, Luther seems to have singled out Josquin as the only representative of this change, but this does not mean that we are obliged to do so in our reading of his statement.

On the other hand, and despite Wegman's sound suspicion, it *was*, after all, Josquin who became the "genius", for whatever reasons, and his works were more widely disseminated and in more copies than was the case with any other composer of his time. And Luther does actually mention Josquin specifically, and he also gives some indications of why he mentions him. Which stylistic features, then, either in Josquin's music or in the more general musical development during his time, would have caught Luther's attention if we take him literally?

The Gospel According to Josquin
Luther's statement involves three different, albeit interrelated, observations about Josquin's music: First, that God preaches his Gospel through it, i.e. that it conforms with certain principles that Luther associates with the Gospel; second, that it "flows and goes freely, voluntarily, mildly and lovely" (which is what prompts Luther's association with the Gospel, but which is also a statement about the music in its own right); and, third, that it is not "forced and compelled and strictly bound by rules", unlike "des Fincken Gesang" and other composers' music, who "must do as the notes decree".[16]

Luther's first point, that God preaches the Gospel through Josquin, is not just a poetic way of saying that Josquin's music is particularly divine. Luther uses Josquin's music in a simile about Gospel and Law. This was the central theological problematic to Luther, and a metaphorical topos to which he returned on several occasions and from different angles. It should be kept in mind that his primary aim is probably not to say something about music and Josquin, but to find ways of encircling the

[15] Wegman (2000), 48.

[16] See notes 1–2.

central difficult distinction between the Law and the Gospel. In another *Tischrede*, Luther says that although he has diligently studied this problem for twenty years as a Doctor in the Holy Scripture, he still doesn't grasp it – and no one ever will: Not even Jesus was certain; even he had to be consoled and taught about the Gospel in the garden of Gethsemane.[17] He approaches this through various general images that each in their own way can illustrate this difficult relation metaphorically (see below). Thus, even though the framework in which the quotations appear is certainly loaded with theological import and belongs to the core of Luther's theology, these quotations aren't necessarily a "theology of Josquin". A corollary of this is that we should not expect these metaphors to be logically consistent on all points – they are associations, bright ideas, that for all we know may have come into his mind as he was speaking.

What makes Josquin's music represent the Gospel is that his music demonstrates principles that Luther associates with the Gospel: the free flow or progression and the freedom from the limitations of rules. Unfortunately, his initial image is rather unclear: what does "geht/geht nicht von Statten" mean? In the various translations and transcriptions of this passage, both in English and in German, it is interpreted in a variety of ways: "geht nich von Statten" as something that "gelingt schlecht",[18] or "doesn't make progress",[19] or as something that is "not done voluntarily",[20] and opposed to the artful freedom from the Law.[21] That the voluntariness is part of what is intended, appears from another *Tischrede*-quotation:

[17] "Das Gesetz vom Euangelio recht zu unterscheiden ist so schwer, daß auch ich, der ich ein Doctor in der heiligen Schrift bin (und nu länger denn etliche zwänzig Jahre mit Fleiß drinnen studirt, gelehrt, gelesen und geprediget habe und wol geübet), doch mich noch nicht recht drein richten kann. Ja, es ist kein Mensch, der es könnte rech unterscheiden. Und das ist nicht Wunder, weil es auch Christus im Garten nicht gewußt noch gekonnt hat, da er vom Engel das Euangelium gelehrt und getröstet mußte werden." in: WA *Tischreden* vol. 1 (Weimar, 1912), 550, 1098.

[18] Wiora (1968), 72.

[19] Tappert (1967), 129.

[20] Wegman (2000), 33.

[21] Christoph Krummacher: *Musik als praxis pietatis. Zum Selbstverständnis evangelischer Kirchenmusik* (Göttingen, 1994), 25: "In dieser artifiziellen Freiheit vom Gesetz ('Was lex ist gett nicht von stadt') […] entdeckt Luther die Parallelität zum Evangelium".

> Werk des Gesetzes geschehen mit Unwillen. Doctor Martino bracht man sein Töchterlin Magdalenichen, das sollt ihrem Vetter N. singen: "''Der Papst ruft Kaiser und König an'''" etc., aber sie wollts nicht thun, ob sie wol die Mutter sehr dazu trieb. Da sprach der Doctor: "Aus den Werken des Gesetzes geschieht doch nichts Guts, wenn nicht die Gnad dazu kömmet; was man gezwungen thun muß, da gehet doch nichts von Herzen, ist auch nicht angenehm; denn unter Mose murret man allein und will ihn allwege steinigen; man ist ihm doch nicht hold."[22]

> Deeds of the Law are done unwillingly. Doctor Martin's little daughter Magdalene was brought to him to sing "Der Papst ruft Kaiser und König an" for his cousin N., but she didn't want to do it, even though her mother urged her strongly. Then the Doctor said: "Nothing good comes from the work of the Law, if it isn't done with Grace; that which one is forced to do, does not come from the heart, and is not pleasing either; for under Moses one just grumbles and wants to stone him; one doesn't love him."

Similarly about the organist Görg Planck:

> Das *lex iram operatur*, siht man an dem wol, daß Görg Planck [...] als besser schlecht, was er von sich selbs schlecht, den was er andern zu gefallen schlagen mus, vnd das kumpt *ex lege*. [...] Wo *lex* ist, da ist vnlust; wo *gratia* ist, da ist Lust.[23]

> That the law causes anger, one can see from the fact that Görg Planck [...] plays everything which he plays at his own choice better than what he has to play to please others, and that comes from the Law. [...] Where the Law is there is disliking, where the grace is there is liking.

In both these cases it is fairly easy to draw the parallel to the Josquin quotation: his music is unhindered, free-flowing.[24] Luther uses the lex-evangelium simile in at least two other *Tischreden*, where the point is less obvious.

[22] WA *Tischreden* vol. 6 (Weimar, 1921), 123, no. 6707.

[23] WA *Tischreden* vol. 5 (Weimar, 1919), 122, no. 5391.

[24] Wegman (2000, 33) assumes that Luther has had the compositional process in mind and contrasts this with what Glareanus says about Josquin – that he worked slowly, revised and corrected his works and only presented them to the public after keeping them to himself for several years. The observation is good, but it can be objected that Luther's primary concern would have been a listener's response to the music as he heard it, and not the hardships of composition.

Quomodo differunt Punctus {physicus/mathematicus} {des physici kan niemand feilen,/ den mathematicum kan niemand treffen, quia ille habet latitudinem et circumferentiam arbitrariam pro loco et persona, iste est sine latitudine et arbitrio, sed certa lex. [...] Lex est punctus mathematicus, euangelium punctus physicus. [...] Et in telorum ludo non solum ille vincit, qui attingit clavum aut signum, sed: Es gilt, welcher der nehest ist [...].[25]

How do the physical and the mathematical points differ? No one can miss the physical point, no one can hit the mathematical point, because the former has an extension and an arbitrary outer limit, concerning place and person[al judgement], the latter has no extension and is beyond judgement, but has a certain law. The Law is the mathematical point, the Gospel is the physical point. [...] and in the archer's contest, it is not simply the one hitting the target who wins, but what counts is who is closest [i.e., even if no one hits].

And the following, which even takes its subject matter from music:

B molle[26] in musica est euangelium, moderatur in tota musica, ceterae claves sunt lex, et ut lex obtemperat euangelio, ita B molle regit ceteras claves.[27] Et ut euangelium est doctrina suavissima, ita mi fa[28] est omnium vocum suavissima. Ideo infirmus peccator est secundus tonus, qui in h fa b mi tam mi quam fa canere permittit.[29]

B molle [or: *B fa b mi*] is like the Gospel in music, since all of music is governed by it. The other degrees are the Law, and just as the Law is ruled by the Gospel, so the *b fa b mi* rules the other degrees [and *mi* is the Law, *fa* is the Gospel]. And just as the Gospel is the sweetest doctrine, so the mi and the fa are the sweetest of tones. The second tone is a poor sinner, who in *b fa b mi* permits both *mi* and *fa* to be sung.

This is a confusing quotation, and the many variant readings indicate that Luther's audience have thought so too. The mediaeval scale theory is based on hexachords, series of six tones, *ut, re, mi, fa, sol* and *la*, with a

[25] WA *Tischreden* vol.1 (Weimar, 1912), 255, no. 558.

[26] Other versions have *"b fah mi"* and "B fa b mi".

[27] The German version of *Tischreden* 816 has: "Gleich wie das Gesetz dem Euangelio gehorchet, also sind auch die andern Claves dem B fa b mi gehorsam." *Tischreden* 2996 adds: *"et mi est lex, fa euangelium."*

[28] Other versions have *"das Mi und Fa"*, *"mi fa mi"* (*Tischreden* 816), and *"bfa b mi"* (TR 2996).

[29] The text is the longest Latin version of the quotation from WA *Tischreden* vol. 1 (Weimar, 1912), 396, no. 816. The quotation is also found in: WA *Tischreden* vol. 3 (Weimar, 1914), 136, no. 2996.

semitone between *mi* and *fa* and whole tones between the other steps. In the classical system, developed by Guido de Arezzo around 1000, the series can begin on *c*, *g* or *f*. These series were called the *hexachordum naturale, durum* and *molle*, respectively.

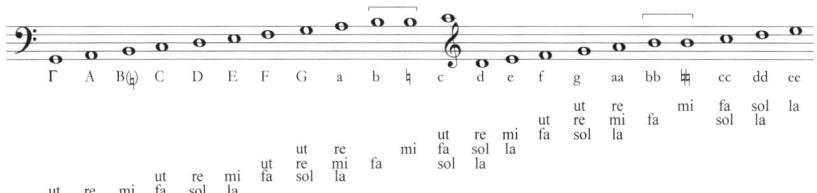

EXAMPLE 1: The mediaeval *gamut*

Each degree in this scale was denoted by the tone name plus all the hexachordal syllables for the degree in question (middle *c* would be called *c sol fa ut*, and would thus be distinguishable from the low *C fa ut* and the high *cc sol fa*), and the scale itself was called the *gamut*, after the first note, *gamma ut*.

What separates *b fa b mi* (or more precisely ♭ *fa* ♮ *mi*) from the other degrees in the gamut is that whereas *they* are fixed to a specific pitch regardless of which hexachord they belong to, the pitch of *b fa b mi* will depend of the hexachord: in the *hexachordum durum* (from *g*) it will be sung high (*mi* or *b*), in the *hexachordum molle* (from *f*) it will be low (*fa* or *b* flat). Hence, it is not fixed to a specific pitch level: *b fa b mi* comprises two separate pitches that count as the same step.[30] Furthermore, when the hexachord theory was applied to polyphonic music, an alteration of any note through accidentals (roughly what was called *musica ficta*) was interpreted as if that tone temporarily enters a *mi-fa* relation and thus becomes *mi* or *fa* for a while. Thus, the "freedom" that characterizes *b fa b mi* overrules the "law-boundedness" of the other degrees. This may be what is intended in the latter part of the quotation, viz. if we take "the second tone" to mean whatever other tone above or below a *mi* or *fa*

[30] This is why the full form *b fa b mi* is usually preferred to the simpler form *b fa mi*, which would have been in analogy with the names of the other degrees (but note that one of the versions of Luther's quotation uses *b fa mi*). For a fuller account of the hexachordal system, see e.g. Margaret Bent: "Diatonic Ficta", in: *Early Music History* vol. 4 (1984), 1–48, especially pp. 7–12.

which will have to be changed according to the rules of *musica ficta*: the *e* a fourth above a *b fa* (i.e. *b* flat) will become a *fa* too (*e* flat). It is a "poor sinner" which, if sung according to the Law (its fixed-pitch scale degree), will be false, but will be brought into harmony with the rest of the parts under the moderation of the Gospel. But Luther doesn't only speak about scale degrees. In the comparison with the Gospel as the "doctrina suavissima", he no longer refers to a scale degree (*clavis*), but to separate tones (*voces*; Stimmen: the scale degrees *mi* and *fa*) as the sweetest of tones; even with hints at a melodic outline in one source (*mi fa mi*, which can only be understood as tone names). I will not pursue this further here, only point out that a substantial number of Josquin's most famous works are written in the phrygian mode, where the melodic movement *mi fa mi* (*e-f-e*) is definitorical. This predilection of Josquin would have to be studied more in detail and in relation to other composers, but my impression is that Josquin used the phrygian mode(s) more consistently than his contemporaries, and in slightly different ways.

The point in both of the last two quotations is that the law is presented as unyielding, by logic or by definition, but at the same time not decisively so: The archer may aim for a theoretical "punctus mathematicus" somewhere in the middle of the target, but he can never hit it; he can only hit a punctus physicus, whose extension is relative, so that if no one hits the target, there will still be a winner: the one who came closest. Thus, the law may be precise, as a *punctus mathematicus*, but its practical relevance comes through its mediation (and mitigation) by the Gospel, not as a dichotomous opposition of good and bad, but as a hierarchical relation where the Gospel has the upper hand because it refers itself to the practical human life and conditions.[31]

To sum up, the two main angles from which Luther approaches the Law/Gospel problem are the character of the freedom of the Gospel, and how to relate to the absoluteness of the Law. With this in mind, we can return to Josquin. I will use the last part of this paper to suggest some

[31] This can also be related to the development of a practially based music theory as opposed to the *ars musica* of the *artes liberales* – another equivalent to the *punctus matematicus*. The main character in this development is Ramos de Pareja, who broke both with the traditional hexachord theory and with the pythagorean tuning. See Frieder Rempp: "Elementar- und Satzlehre con Tinctoris bis Zarlino", in: Frieder Zaminer and Alberto Gallo (eds.): *Geschichte der Musiktheorie* vol. 7 (Darmstadt, 1989), 57–64. See also Nils H. Petersen's remarks about Luther's practical view on music in the Introduction to this volume.

ways in which these general and theologically motivated statements can be put directly in relation to features of Josquin's music.

Von statten zu gehen

Of which rules is Josquin free in his music? The rules of counterpoint can hardly be what is meant. They were codified in Josquin's age, as never before, by theorists like Johannes Tinctoris and Franchino Gaffurio, and Josquin is a meticulous composer who rarely makes mistakes: That particular rule-book is followed more rigorously by Josquin than by most others.

Another reasonable guess might be that it has to do with *cantus firmus* techniques. Josquin is regarded as a central character in the development of pervasive imitation where compositions free themselves from the strict regime of the pre-existing *cantus firmus* and treat these freely, or leave them out completely. But even this doesn't seem conclusive: Josquin too wrote strict *cantus firmus*-based counterpoint, and the free *cantus firmus* techniques were used both before his time and by his contemporaries, among them Finck.

I would instead suggest two other possibilities. In addition to the more technical rules of counterpoint and *cantus firmus*, theoreticians had formulated another "rule" of a more aesthetic character: *varietas*. Rob Wegman gives a good description of this principle in his liner-notes to a recording of Dufay's *Missa L'homme armé*:

> That aesthetic principle [of *varietas*] may be hard for us to appreciate today, since the *Missa L'homme armé* moves entirely within the musical horizon of the 15th century, whereas the modern ear is conditioned mostly by what lay beyond that horizon. Given the astonishing range of musical styles to which we are exposed every day, Dufay's setting may strike us initially as homogeneous rather than varied, and perhaps as undistinguishable from any other 15th-century mass. It would take considerable effort to imagine the sensitive and discerning ear that would have been shaped by a lifetime spent singing, composing, and listening within the same horizon. Given the relative homogeneity of the musical idiom, variety would have been detectable in the smallest detail – the very level on which Dufay sought to impress his contemporary audience most.
>
> Beyond that, we are heirs to a musical tradition that values unity (whether cyclic or motivic) more than variety. [...] In the *Missa L'homme armé* Dufay seems to have been concerned to create a fundamentally irreducible variety of

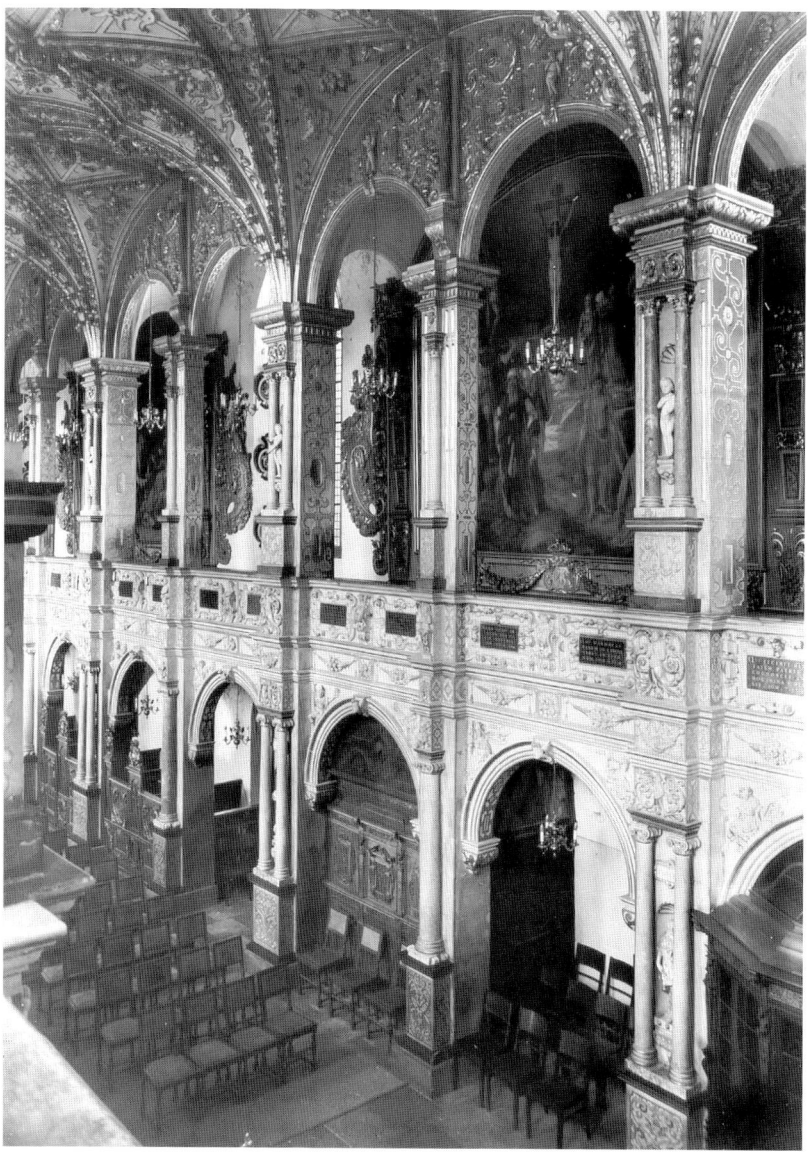

Fig. 1. Christian IV's chapel (1608–17) at the castle of Frederiksborg: Eastern long-side of the gallery. Photo: Author 1971.

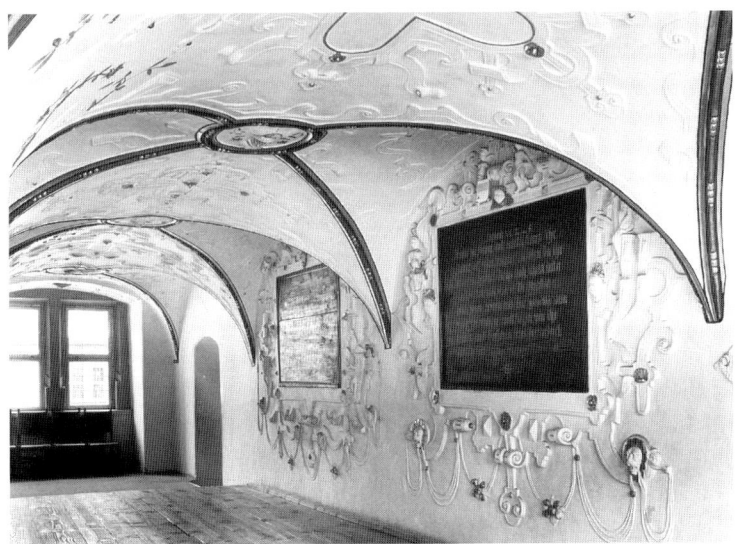

Fig. 2. Christian IV's chapel (1608–17) at the castle of Frederiksborg: Marble tablets from the southern short-end of the gallery with texts from 1. Tim. 4:8–10, etched by Villads Pedersen Trellund. The sandstone cartouches with putti, holding the instruments of Christ's Passion, were carved by the court-sculptor, Hans Brockman. Photo: Author 1975.

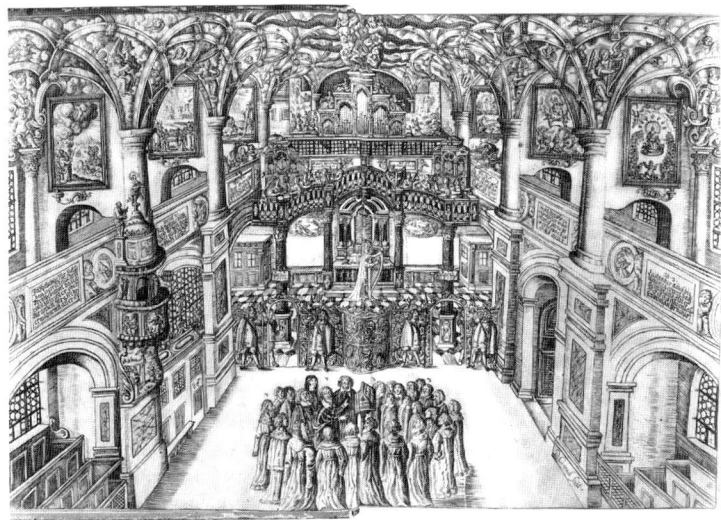

Fig. 3. The demolished chapel (1549–55) at the castle of Dresden (Saxonia): Interior towards the altar, showing Heinrich Schütz amidst his choir. Engraving by David Conrad 1676 used as frontispiece in Christoph Bernhard: *Geistreiches Gesang-Buch* … (Dresden, 1676). Photo: Landesarchiv, Dresden.

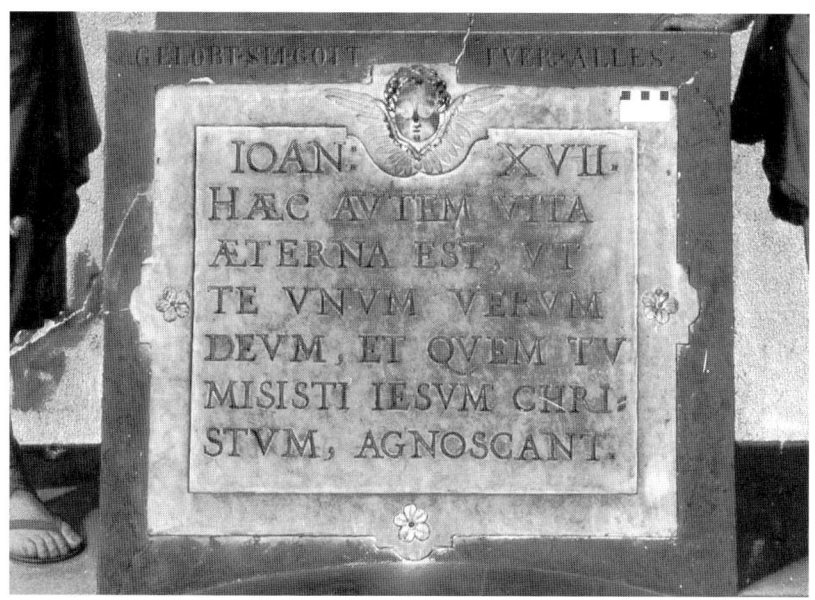

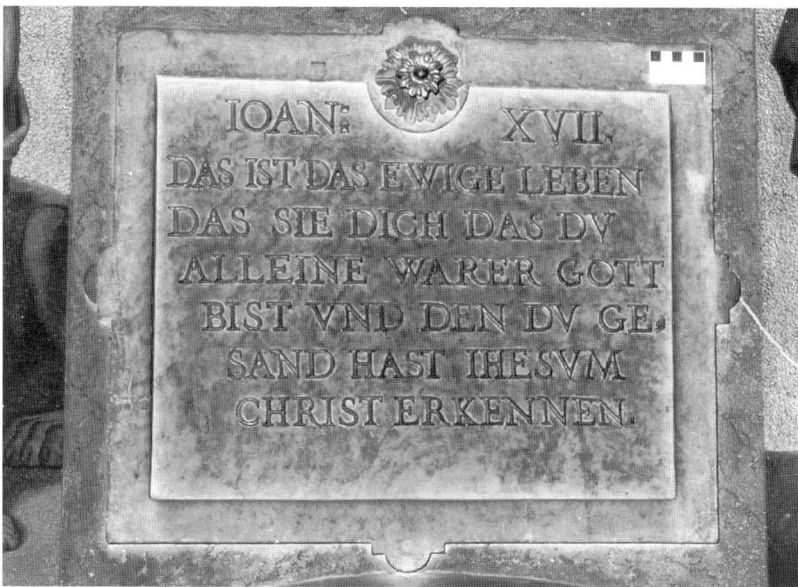

Fig. 4. The chapel (1560–63) at the castle of Schwerin (Mecklenburg): Alabaster tablets with parallel texts in Latin and German from Jn. 17:3. Photo: Author 2002.

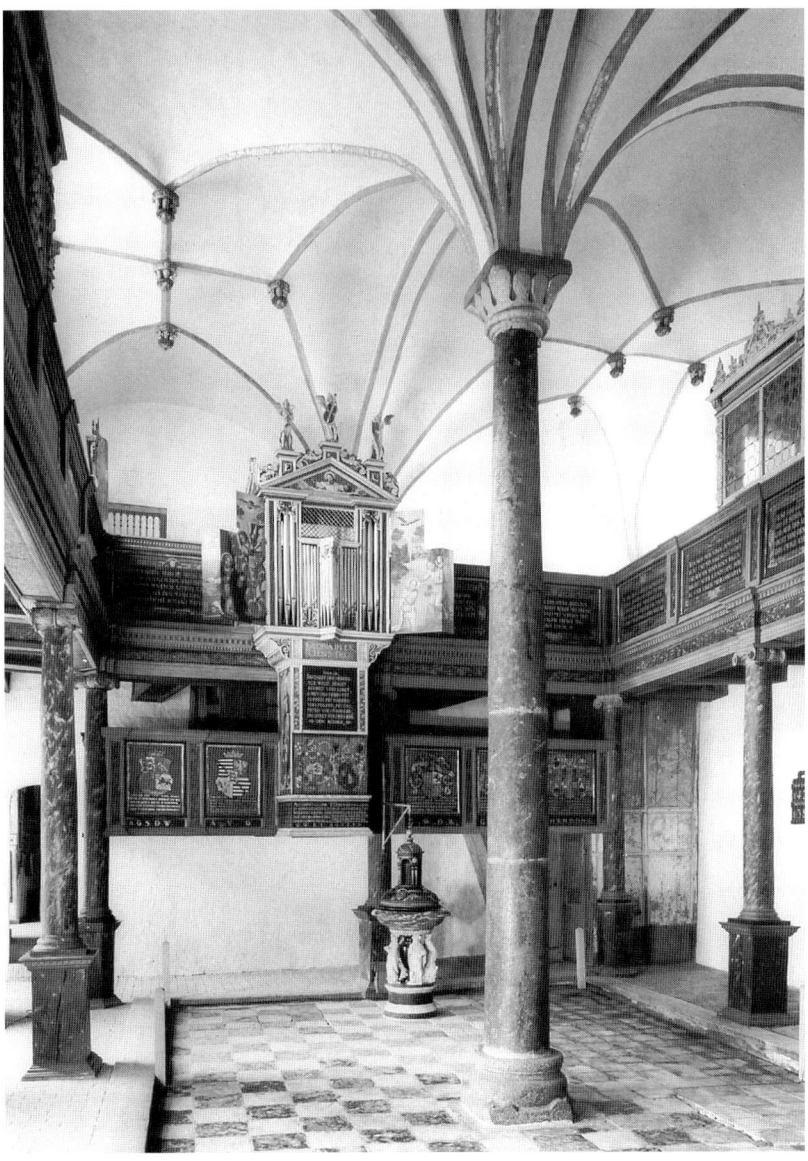

Fig. 5. Queen Dorothea's chapel (1568–70) at Sønderborg Castle, seen towards the west. On the parapet of the wooden gallery are panels with painted biblical texts, cf. fig. 10. Photo: Lennart Larsen 1960 (The National Museum, Copenhagen).

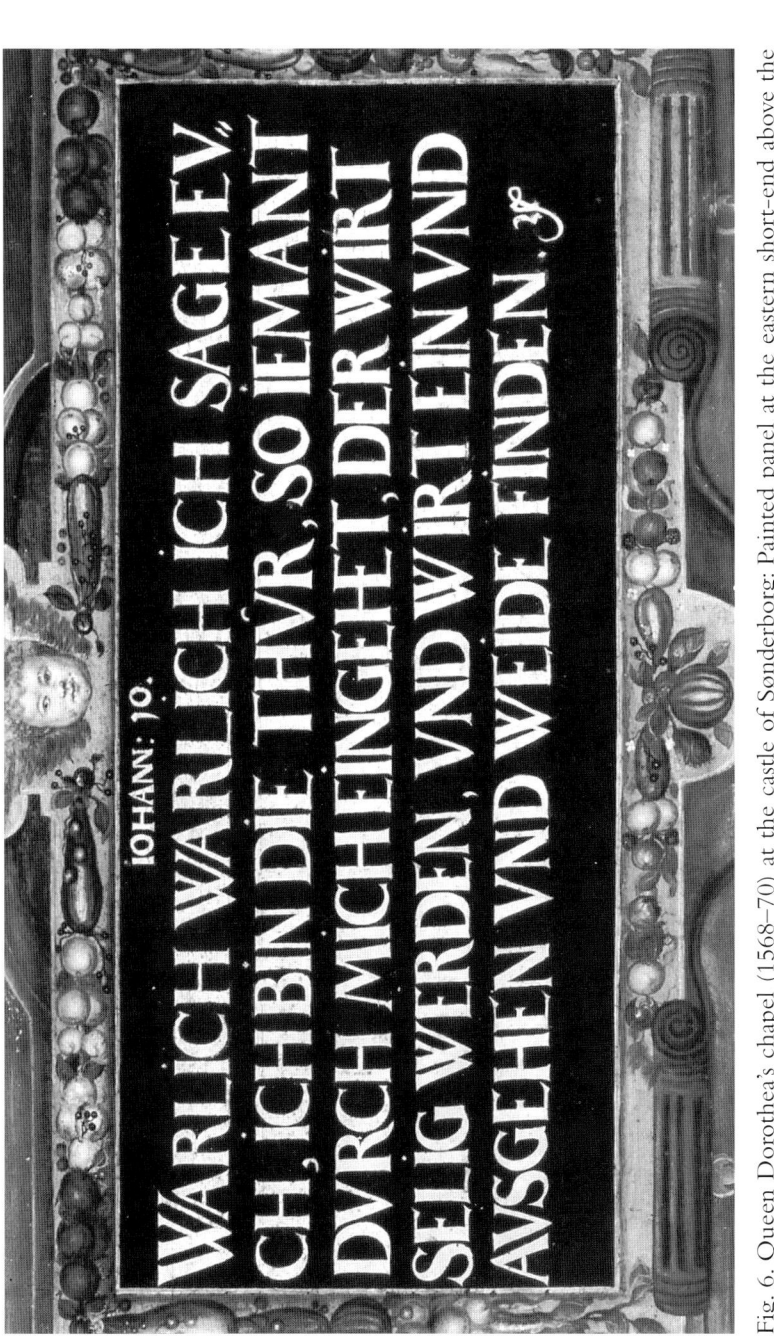

Fig. 6. Queen Dorothea's chapel (1568–70) at the castle of Sonderborg: Painted panel at the eastern short-end above the altar, citing Jn. 1:9. Photo: Mogens Larsen 1956 (The National Museum, Copenhagen).

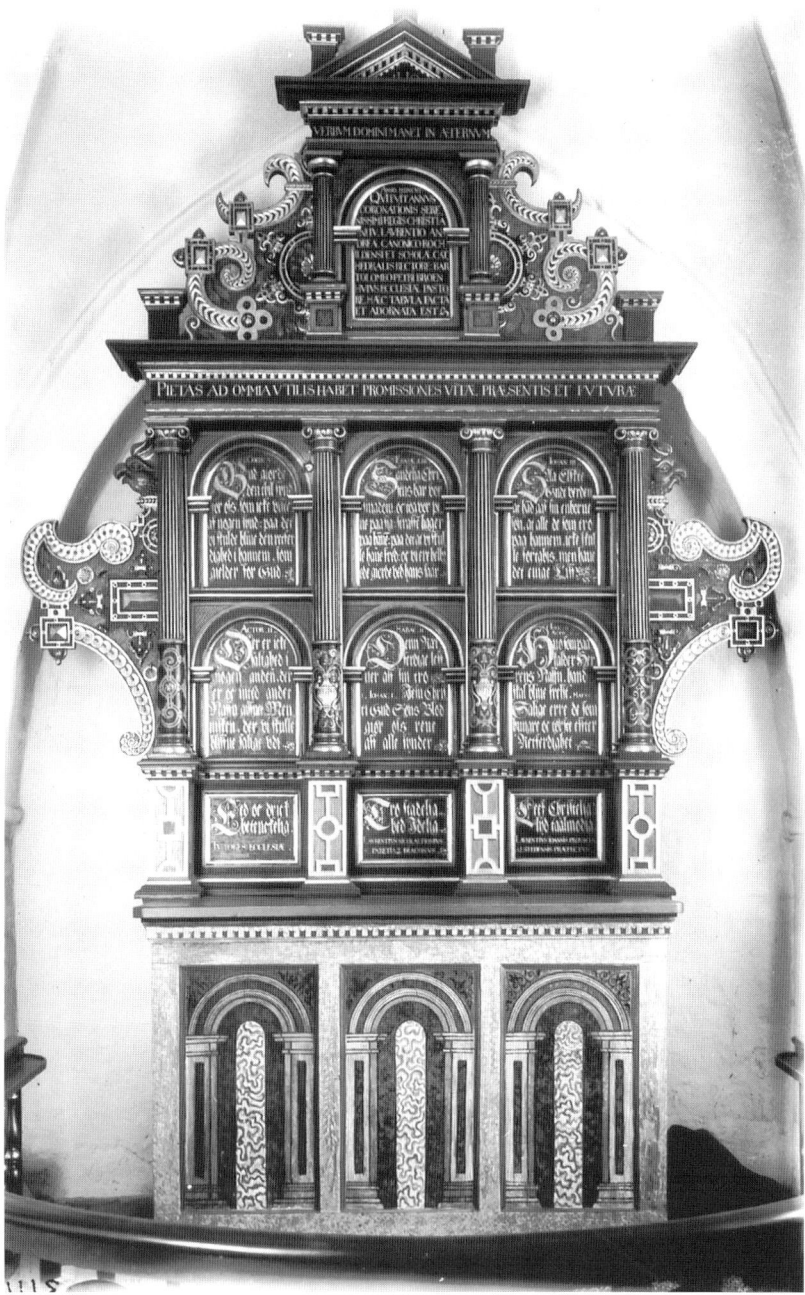

Fig. 7. So-called catechism-altar (1596) at Sigersted Church in Zealand. Photo: Harald Munk 1933 (The National Museum, Copenhagen).

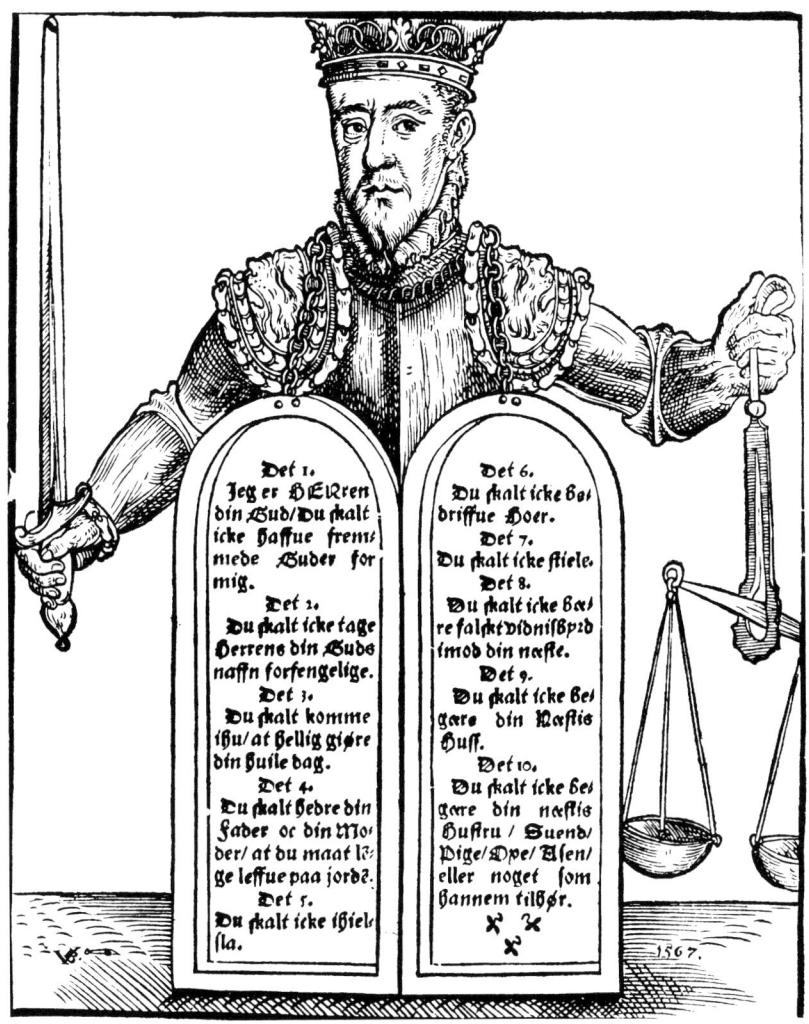

Fig. 8. Frederick II as judge, acting in accordance with the Law of Moses, cf. fig. 9. Woodcut by Lorentz Benedicht, printed as frontespiece in Niels Nielsen Colding: *De besynderligste Historier i Den hellige Skrift om Øvrighed* (Copenhagen, 1567). Photo: The Royal Library, Copenhagen.

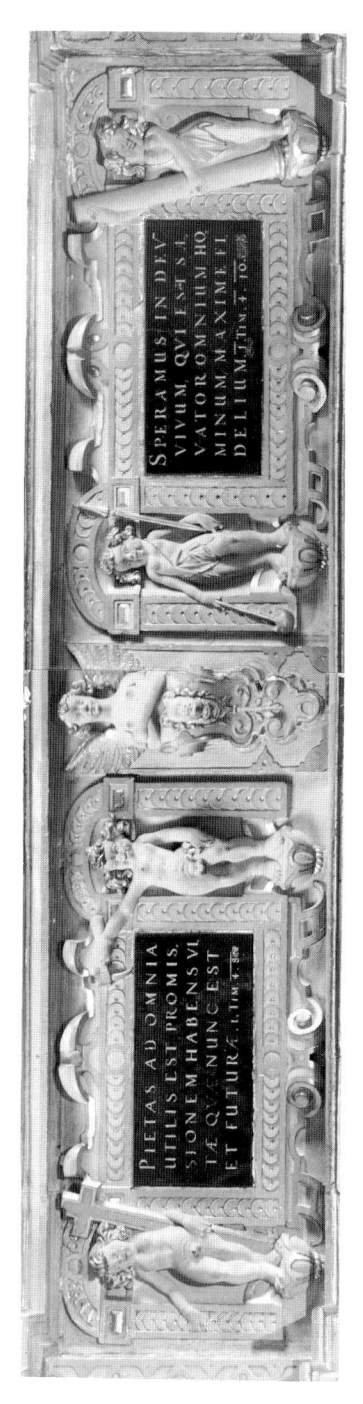

Fig. 9. The chapel (1588–90) at Wilhelmsburg in Schmalkalden (Thuringia): The pew of Duke Wilhelm with wooden tablets, painted with biblical texts. Photo: Author 2000.

kaleidoscopic detail in which moments are to be relished rather than eliminated in search of some deeper structure.[32]

This is the only point on which Josquin's music flagrantly violates a general "rule",[33] and consistently so. Examples can be found in his entire oeuvre, but nowhere more clearly than in his motet *Miserere mei deus*:

EXAMPLE 2: Josquin: *Miserere mei Deus*, mm. 24–34, (*superius* and *altus*)

EXAMPLE 3: Josquin: *Miserere mei Deus*, mm. 117–135 (*superius*, *altus* and *tenor primus*)

[32] Rob Wegman: [liner notes to the recording of Dufay's *Missa L'homme armé* by Oxford Camerata (Naxos 8.553087)] (1995), 3.

[33] In the third book of his *Liber de arte contrapuncti* from 1477 (ed. by Edmond de Coussemaker in: *Scriptorum de musica medii aevi nova series a Gerbertina altera* 4 vols., [Paris, 1864–76; reprint: Hildesheim, 1963], 4:147–53), Johannes Tinctoris formulated this as an explicit rule, and not just a more general principle: "Octava si quidem et ultima regula haec est quod in omni contrapuncto varietas accuratissime exquirenda est [...]" (152).

The entire motet is a rumination on melodic and harmonic cells like these ones. Not generally as persistent as in this example, but still, the variety, so highly valued in the fifteenth century, has been sacrificed (on what altar will become clear in the following).

The other boundary that Josquin stretches, is that of the modes. In his *Dodekachordeon* from 1547, Glareanus gives many examples of *commixtio modorum* in polyphonic pieces, and Josquin is amply represented. Glareanus particularly praises the way Josquin manages to combine the dorian and phrygian modes in *De profundis* "without offending the ears". But although he is impressed, he continues:

> But he did this in other songs too, although not only, I would say, out of love for novelty, and because he too much wanted to win a little honour for such a rare accomplishment, a vice towards which the brightest professors of the disciplines strive. And however rare this is among composers: if many did it, it would be a common vice.[34]

It appears from this and similar quotations that Josquin worked with harmony in ways that were considered novel and striking, maybe even daring. And it *is* one of the striking features of Josquin's style. More than any composer before him, he seems to have thought of harmonic progressions first, and individual voice parts second. This can be seen on several levels, both in the actual harmonies and in the melodic style of the separate parts.

A general tendency in the period of Josquin is the increasing use of chord relations by fourth or fifth. According to counterpoint theory, melodic fourths and fifths in the bass are to be seen as non-essential additions to the two-part framework (typically between superius and tenor) that is the actual foundation of the counterpoint. It would be an anachronism to equate these with dominant relations in modern tonal harmony.[35] However, one may argue that the way in which such and similar

[34] "Verum in alijs quoque cantibus id fecit, nec solus tamen, immo dico nouitatis scilicet amore, et nimio gloriolae captandae ob raritatem studio, quo uitio ferme ingeniosiores disciplinarum professores usque laborant, ut quamuis Symphonetarum hoc sit peculiare, cum multis tamen id habeant, commune uitium." Henricus Glareanus: *Dodekachordeon* (Basel, 1547), vol. 3, 364 (quoted from facsimile ed., New York, 1967).

[35] See Carl Dahlhaus: *Untersuchungen über die Entstehung der Harmonischen Tonalität* (Kassel, 1968), especially 82, and Margaret Bent: "The Grammar of Early Music: Preconditions for Analysis", in: Cristle Collins Judd (ed.): *Tonal Structures in Early Music* (New York and London 1998), 15–60.

progressions are employed as fixed patterns, such as moving along the circle of fifths and stacking thirds on top of one another (as in the introduction to and end of his motet *Memor esto*),[36] in fact introduces an understanding of harmony that departs from that of his predecessors, in the direction of tonality.

Josquin also shows great care in handling the passage between different harmonies. He takes his time to establish each single harmony, often slowing down the harmonic rhythm to one sonority per *tactus*, and the progression from one such harmonic "block" to the next is in general well prepared. This is particularly prominent in the cadences, frequently with long cadential passages, where the goal, when reached, seems planned well ahead. Syncopations which might blur the line between one harmony and the next, are generally avoided, and one will very rarely find syncopations in several voices at the same time, without a (usually) lower part that marks the progression. Thus, syncopation predominantly becomes a means of accentuating cadences.

This emphasis on harmony influences Josquin's melodic style too. He devises melodic cells that are both self-contained and open, in one or more of several ways. They often stay within one triadic sonority, or within strong fifth- or fourth-relations, or imply a rise by a third.[37] His melodic phrases are often not in themselves conclusive, but can easily be extended or given a cadential turn. This can be seen in most of the verses of *Miserere mei Deus*, or in the introduction to his chanson *Mille regretz* (Ex. 4). Measures 4–17 are an elaboration of one single descending motive. In its first presentation (mm. 5–6) it is cut short at the third *c''-b'-a'*, before the cadence to *a* in the next measure is reached. The next presentation (mm. 7–9) takes the descent one step further down, this time ending with a syncopated cadential gesture, but again the phrase is cut off without reaching a goal. In the third attempt (mm. 10–13) the cadential gesture finally comes to a conclusion, but it turns out to be a weak cadence: the *c* in the bass precludes the otherwise expected hightening of the *g* in the superius, the cadence itself goes, not to *a* but to an *f* sonority (m. 13), and the melody in the superius flows without a break into the

[36] See Timothy H. Steele: "Tonal Coherence and the Cycle of Thirds in Josquin's *Memor esto verbi tui*", in: Judd (1998), 155–182.

[37] See exx. 2–3. This melodic style may be seen as the outcome of the expertise, gained from the *cantus firmus* techniques of composers like Obrecht in the previous decades, in handling long pedal-points in a way that gives (or preserves) a sense of motion.

next descending fourth, this time *a'–e'* (mm. 13–14). This is, in turn, repeated in the lower parts, ending on the first cadence to *e* in the song. And so on; the rest of the chanson is a continuous succession of similar short motives spanning a fourth.

EXAMPLE 4: Josquin: *Mille regretz*, mm. 1–17

Another particularity of Josquin's style is the use of melodic cells that are well fitted for contrapuntal, canonic treatment, either in pairs or in a fuller texture. In two-part writing, scalar passages in parallel thirds or sixths are frequent, as in this excerpt from *Miserere mei Deus* (ex. 5). Each of the duet pairs follows a simple scale figure which alternates between intervals of thirds and sixths.

EXAMPLE 5: Josquin: *Miserere mei Deus*, mm. 372–380 (*superius, altus, tenor primus* and *bassus*)

In a fuller texture, various combinations of thirds and fourths are particularly frequent. This can be seen in the excerpt from *Mille regretz* above, where the bass figure *c'-g-a-e* is a very standardized way of harmonizing a chain of thirds in the upper parts. The same motive in a more elaborate form is found in this passage from the last *Agnus dei* of his *Missa L'homme armé super voces musicales*:

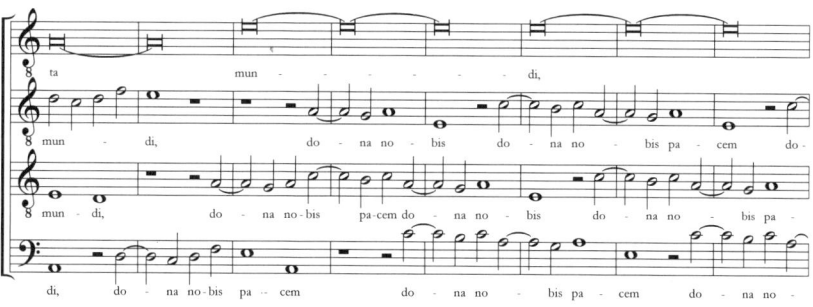

EXAMPLE 6: Josquin: *Missa L'homme armé super voces musicales, Agnus Dei III*, mm. 163–170)

Another version of the third–fourth outline is found in the *Credo* of the same mass (Ex. 7), and numerous different realizations of this pattern can be found throughout his oeuvre.

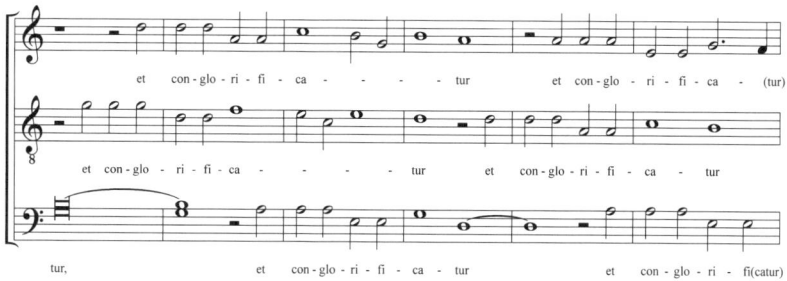

EXAMPLE 7: Josquin: *Missa L'homme armé super voces musicales, Credo*, mm. 187–192)

In all these cases, this device is used almost as a fixed scheme, which, when filled in according to certain principles, will almost automatically

produce a sonorous canon or quasi-canon with a root movement of fourths or fifths. Furthermore, these figures are frequently employed as short, unconcluded statements, building blocks for a larger musical structure, where such cells are either tossed between the parts in a fragmented canon (as in the last three examples above), or lead to a cadence through emphasized progressions and motivic elaboration or transformation (as in the first two examples). Common to both these cases is that melody seems subordinate to harmony, and that the harmonic level seems, to some extent, to be moulded according to an overall design.[38]

Even in the rhythmical area, harmony has gained a dominant position. It would be exaggerated to call Josquin's rhythmical style sparse, but the emphasis on harmony still reduces the role of the rhythmic element in the melodies, in favour of a more ornamental use of rhythmical cells, within the prevailing harmony. The general pulse also seems planned in accordance with the same principles: a mass movement or a motet is a passage through well-defined stages.[39]

All in all this gives a sense of a carefully planned harmonic progression, underlined by melody and rhythm. Glareanus points to this trait in Josquin's music in another comparison, this time with Virgil:

> For just as Maro [i.e. Virgil], with his natural facility, was accustomed to adapt his poem to his subject so as to set weighty matters before the eyes of his readers with close-packed spondees, fleeting ones with unmixed dactyls, to use words suited to his every subject, in short, to undertake nothing inappropriately, as Flaccus [i.e. Horace] says of Homer; so our Josquin, where his matter requires it, now advances with impetuous and precipitate notes, now intones his subject in long-drawn tones.[40]

[38] Features like harmonic plans and motivic unity in Josquin's works have been pointed out by several authors, most recently Steele (1998), and Patrick Macey: "Josquin and Musical Rhetoric: *Miserere mei, Deus* and Other Motets", in: Sherr (2000), 485–5. A word of caution is still merited: What may appear as motivic development if that's what one is looking for, may just as well be the result of a style based on melodic writing of a formulaic kind within a system of modes, where variety of the kind described by Wegman above was valued, and where the connection with the plainchant repertory, with its large stock of such figures, although attenuated, was still considerable.

[39] A good example is the first Kyrie in the *Missa Pange lingua*, where the plainchant melody has been reshaped so as to allow a bipartite form of the whole section, with a first part starting e-e-f-e and a second echoing this with c'-c'-d'-c', with a corresponding distribution of cadential degrees.

[40] "Vt enim Maro naturae felicitate carmen rebus aequare est solitus, quemadmodum res graueis coaceruatis spondeis ante oculos ponere, uelocitatem meris dactylis exprimere, suae

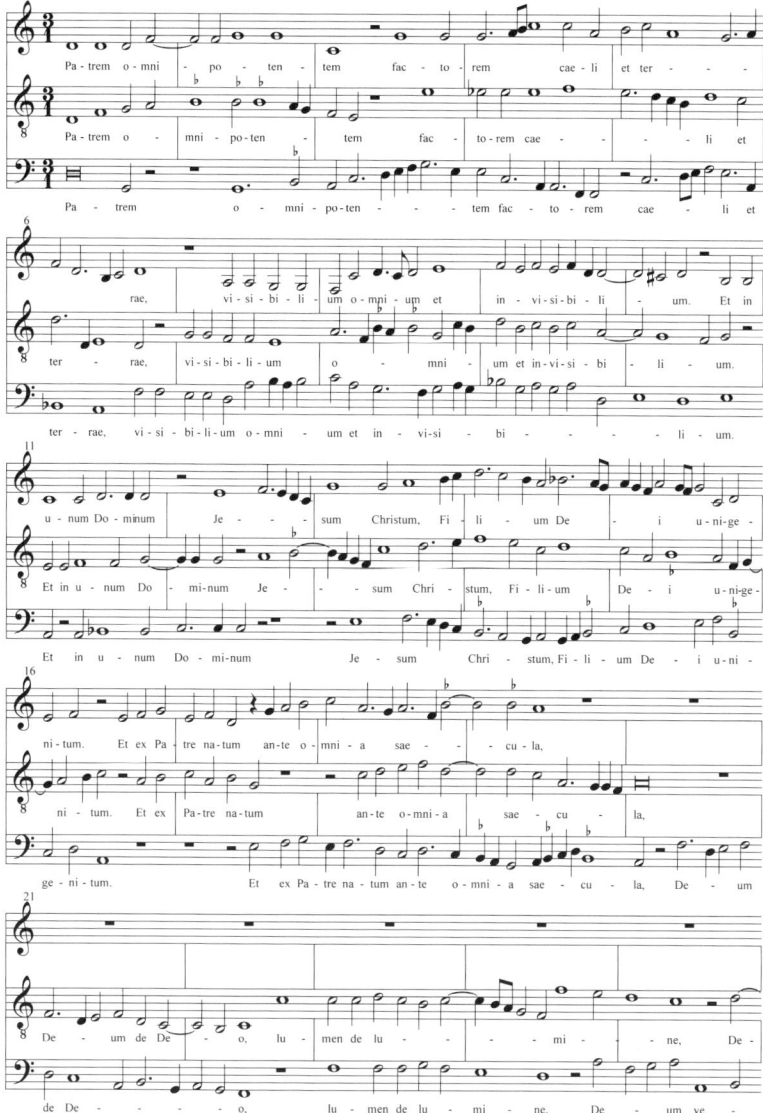

EXAMPLE 8: Finck: *Missa a 3*, Credo, mm. 1–20

cuique materiae apta ponere uerba, denique nihil inepte moliri, ut de Homero dixit Flaccus. Ita hic noster Iodocus aliquando accelerantibus ac praepetibus, ubi res postulat, notulis incedit, aliquando tardantibus rem phthongis intonat [...]". Glareanus: *Dodekachordeon*, vol. 3, 362.

As argued above, we have nowhere near the same opportunity to judge Finck's music, neither in terms of studies nor recordings. Nor may it be entirely relevant to go into a very detailed comparative analysis, given the uncertainty about what Luther actually meant. Still, some of the traits highlighted in the description of Josquin's style can be contrasted with Finck's music, especially concerning harmonic progression and rhythm. The first example is from the beginning of the Credo of Finck's three-part mass (see example 8).

Already the first measure contains a passage that it would be difficult to find in Josquin. The bass drops down a fifth from d to G on the third semibreve, but then it suddenly disappears; it is left quickly because of the unpermitted dissonance with the sustained f in the superius, which – together with the b flat in the tenor – is where the phrase is heading. The bass G has no influence on this goal, its function is vertical, not horizontal. The passage could be seen in the light of the strongly tenor-based style of composition in Germany. Assuming that the tenor was written first, and that the plan for the superius was to imitate the d-f opening of the tenor, the bass would have to go to g to avoid dissonances with the other parts,[41] but also to leave it immediately. Had tenor and bass been the only parts, the G could have been sustained until it was picked up again in the next measure. As it now stands, however, it appears that the guiding principle is harmonization of the tenor outline, and not fitting the tenor into a planned harmonic progression.

The f in the superius forces a *b flat* in the second measure to avoid a diminished fifth. In measure three, this creates a problem of decision: whether to allow a melodic tritone in the tenor between the *b flat* and the e, which is sustained for a whole measure, or to enter a chain of alterations that in the end creates more problems than it solves.[42] Either way, mm. 3–5 would have presented a problem if the harmonic considerations found in Josquin were to be given priority: either move away from the mode of the piece already at the outset, or emphasise a tone (e) that is in

[41] This also includes the fourth that would result between bass and tenor had the bass stayed on d. A fourth against the lowest part was considered a dissonance.

[42] Karol Berger has argued that in cases like this, the theoretical sources are in favour of the first option, i.e. to allow a melodic dissonance to avoid chain reactions of musica ficta. See Karol Berger: *Musica Ficta: Theories of Accidental Inflections in Vocal Polyphony from Marchetto da Padova to Gioseffo Zarlino* (Cambridge, 1987), 88–92.

contrast with the overall dorian mode, even before this mode has been established.[43]

The descent by thirds in the bass (mm. 3–4) resembles figures that we find in Josquin's music, but the outcome sounds quite differently. Josquin typically uses the chain of thirds as a way of gradually expanding or shifting the harmonic area, e.g. in his chanson *Plaine de dueil* (ex. 9). The three middle parts enter on *a* with a motive consisting of an ascending minor third *a-c'*, gradually building the full triad *a-c'-e'* when the superius echoes this motive on *e'*. The *a* is abandoned and *a-c-e* becomes *c-e-g*; the *g* is retained and the sonority shifts to *g-b flat-d*, and so forth, in a seamless sequence of triads.

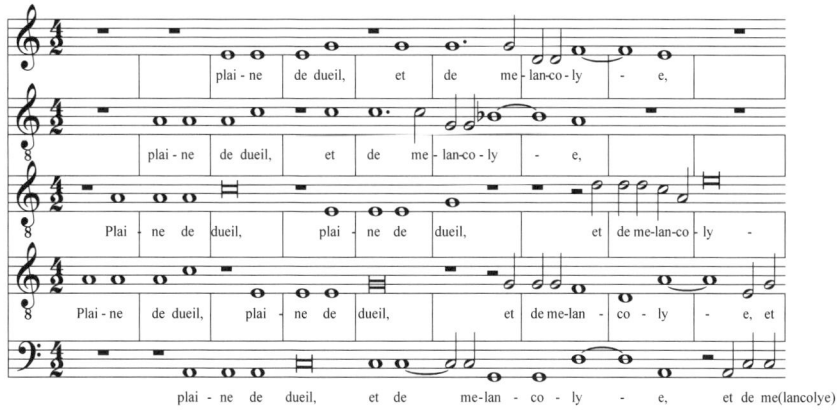

EXAMPLE 9: Josquin: *Plaine de dueil*, mm. 1–9

Finck, on the other hand, does not share Josquin's concern for full triads or chordal progression. In the course of one measure in the transcription, he moves through triads on *c* and *f*, only to return to *c* again, as if nothing had happened – and, indeed, harmonically nothing has. The descending figure makes more sense if regarded as a harmonization of the tenor's sustained *e'-f'-e'*. The passage is dominated by simple intervals (thirds, fifths or sixths), and once again the bass tone (*F*) is left hanging in the air, fol-

[43] The octave leap from *e* to *e'*, which gives this tone an even more prominent position, is most likely dictated by the text: *factorem caeli et terrae*.

lowed abruptly by a strongly contrasting interval (*e'–b'*) in the upper parts.[44]

More or less the same observations can be made about the following phrase (mm. 6–9): from the *d* at ter*rae* to the *d'* at omni*um*, the tenor ascends through combinations of rising fourths and falling thirds, but, again, not as a way of creating harmonic progression of Josquin's kind, but rather as a melodic embellishment, the effect of which is largely limited to the part in question.

This is not to say that Josquin is the more competent composer, only that Finck's composition is more oriented towards a varied accompaniment of a central voice: *varietas* and the tenor principle against Josquin's harmonic predilection.

Also in another area – dissonance treatment – one might pass an unjustified judgement on Finck if viewed from Josquin's perspective. Carl Dahlhaus has pointed out that Josquin's dissonance treatment differs from the "classical" Palestrina style only in minor details.[45] Not so with Finck: his writing abounds in dissonances left or entered by leap, and with more or less concealed parallel fifths.[46] Together with the abrupt transitions between intervals mentioned earlier, this might have been taken as evidence of Finck's negligence or incompetence, but it is probably wiser to see it instead as evidence about *Josquin* and his new orientation towards a more careful planning of the transition from one note to the next, owing to the increasing awareness of the interrelatedness of harmony and melody. In the older system the horizontal level (melody) governs vertical relations, whereas in Josquin it goes both ways: Vertical relations have a strong impact on the horizontal level.

The three-part mass is an early work, belonging to a style that differs from Josquin to begin with. The last example is from Finck's late-style *Magnificat*.

[44] A similar descent by thirds appears in the superius in mm. 5–6.

[45] Carl Dahlhaus: "Zur Dissonanzbehandlung um 1500", in: *Kirchenmusikalisches Jahrbuch* vol. LV (1971), 21–24.

[46] See e.g. example 8, m. 8f and mm. 12–13. See also mm. 21 where, twice in a row, a fourth is followed by a second and vice versa.

EXAMPLE 10: Finck: *Magnificat octavi toni*, mm. 82–102

The change in style in a direction towards Josquin, is evident: The rhythmic complexities and the break-neck harmonic changes are gone, and the dissonance treatment is more modern.[47] But incorporating these changes does not turn the writing into a "Josquin style". The quoted passage begins with figures (on *implevit*) over a pedal point, written in a way that, more than anything, brings to mind Dufay's and Dunstaple's harmonious elaborations of long *cantus firmus* tones. This is followed (mm. 85–90) by a passage with repeated figures that more resemble Josquin, but where the overall impression still is that the purpose of the figurations is to fill in the tones given by the *cantus firmus*, and not, as with Josquin, to shroud the *cantus firmus* in a progression in the other parts that seemingly moves on its own impetus, independently of the given tones.

[47] Compare the figure in ex. 8, mm. 12–13, with the quite similar passage in ex. 10, mm. 85–89, where the existing dissonances are *Durchgangsdissonanzen*, which may be harsh, such as the parallel seconds in m. 88, but permissible even in later styles.

The remainder of the example (mm. 91–102) gives the most striking illustration of the difference between the new tendencies taken as stylistic surface-traits or as elements of a new stylistic approach altogether. The beginning could have been taken from a Josquin composition: a rhythmically pregnant motive, with note repetition in a full C triad, which is shifted a third lower in a way that recalls the beginning of *Plaine de dueil* (ex. 9). But again, when the *cantus firmus* enters in m. 95, we are back to C and the Dufay-type of prolongation figures, which simply remain on triads over *c*, the upper tone alternating between *g* and *a*. What promised to be the beginning of a progression, turned out to be "just" a contrapuntal device, following the cantus firmus wherever it takes one.[48]

★ ★ ★

The foregoing analysis is not a comprehensive discussion of Josquin's and Finck's styles, but an attempt to point out some of the features that may have prompted Luther's remark, based upon a close reading of a few chosen passages. My intention has been to show that what Luther may have had in mind when he referred to Josquin's freedom from rules (if that is what he actually said or meant) is his way of handling harmony, which to a contemporary listener may well have been perceived as a new approach to the established rules of composition. Both the method of analysis and the conclusions bring up a wider range of questions, concerning stylistic development and judgements about it – contemporary and retrospective – and ultimately about historical understanding. For the remainder of the article, I will concentrate on these questions in the light of the foregoing discussions.

It has been said that the counterpoint rules of the Renaissance are so well formulated that anyone who follows them will be able to produce a piece of music that sounds good – but not necessarily more than that. Nikolaus Apel's *Mensuralcodex*, a collection of German, mainly liturgical

[48] The motive that is repeated here is quite similar to the motive in ex. 5 above from Josquin's *Missa L'homme armé*. The main difference is that there the section is an element in a longer buildup towards the end of the mass section (and of the entire mass), where the very length of the standstill is an essential part of this. This does not seem to be the case in Finck's example.

music from c. 1500,⁴⁹ is a possible illustration of that. In general, one can say that any of the anonymous hymn and responsory settings in the collection would have made a more fitting object of comparison in Luther's statement than Finck: They follow the rules of counterpoint and the *cantus firmus*, and it all sounds pleasant (and in the cases where things do sound odd, it can usually be brought back to contrapuntal errors), but slightly dull and meaningless, without a sense of direction – at least if compared with Josquin. With this collection as the background, Luther's statement makes perfect sense; it becomes clear that Josquin follows compositional principles that may have the contrapuntal rules and practices at their core, but which do not stop there. The handling of the contrapuntal web is governed by the insight that it is *not* enough to follow the rules, they have to be brought, as one element among several, to a higher level, where other considerations decide whether the rules will apply, or whether it is more appropriate with a broken rule to the benefit of expression, declamation, wit, progression, or any other outer circumstance.⁵⁰ This is the point in the other "*Lex et evangelium*" similes too: The mathematical point is of no practical importance for the archer, and the notes in the gamut, no matter how strictly they can be defined, will nevertheless have to yield to *b fa b mi* if circumstances demand it.

The problem, both in these technical matters, and concerning Josquin's musical superiority over others, and ultimately with the mystery of Law and Gospel, is that the circumstances defy definition. Thus, Luther's 20-year's struggle with this problem and his conclusion that it cannot be resolved, can in effect be read as a statement about aesthetic judgement: It is ultimately as impossible to define why Josquin is better than Finck, as it is to make a clear distinction between Law and Gospel.

So, we may ask: why do we – in Luther's footsteps as well as in Blume's – with such relative ease take Josquin to our hearts? Is it just a matter of quality, or are there other reasons? I would argue that one reason is that his music sounds familiar, and can with ease be related to our modern, musical background, since he seems to follow a number of

⁴⁹ Rudolf Gerber (ed.): *Der Mensuralkodex des Nikolaus Apel (Ms. 1494 der Universitätsbibliothek Leipzig)*; *Erbe deutscher Musik* vol. 32–34, Abteilung Mittelalter, vol. 4–6 (Kassel, 1956–75).

⁵⁰ Ideas like these were to become prominent in seventeenth-century aesthetics, as a reaction to attempts to formulate exact rules for art production. See e.g. Monroe C. Beardsley: *Aesthetics from Classical Greece to the Present* (New York, 1966), 166.

principles that have been central to the development of Western music since at least the eighteenth century. Josquin's harmonic patterns lie close to those we recognize in tonal harmony, whereas the rhythmical and melodic finesses and extravaganzas of composers like Ockeghem and Obrecht – and for that matter Finck – have no direct parallels in post-baroque music. If we instead looked at Josquin historically, it would be possible to construe an opposite – and negative – Josquin image, of a Josquin who explores and exploits a few harmonic tricks, patterns, and schemes, but at the cost of having to sacrifice a lot of the musical techniques available to him, such as melodic variety and rhythmical vitality. Accordingly, our judgement will have to do with *our* perspective, and not necessarily with Josquin's music – no matter how profound the insights, style knowledge, and interpretations we build on we cannot escape our modern vantage point. And no matter how comfortable we may feel in our confidence in the humanity of history when we are greeted by a fellow human being from across the centuries, it is of course we who construct the similarity and the connection.

This leads to the intriguing question: What, then, is the use of these profound insights? The history of the cracking of the "hieroglyph code" is an interesting parallel.[51] During the sixteenth century several textbooks on the subject appeared, based on the assumption that hieroglyphs were ideographs and that each sign represented a whole word. These were combined with biblical and medieval symbols into a system which was "more frequently the product of artistic and poetic imagination than diligent, scholarly research".[52] The culmination came with Athanasius Kircher, who was able to translate long texts according to the ideographic principle – and not a word of it was correct, since, as was discovered later by Jean-François Champollion, the hieroglyphs in fact have phonetic values. Only a historical understanding can disclose the (historical) meaning of the signs. We can of course read the other interpretations as well – as the Renaissance interpreters did – and they may for that matter even be more interesting (read, e.g., as surrealistic poetic texts), but if what we are after is an understanding of the hieroglyphs – or a piece of music – as part of the continuum of human actions, the interpretation that

[51] See Simon Singh: *The Code Book* (London, 1999), ch. 5, for a captivating presentation of this.

[52] Wladyslaw Tatarkiewicz: *History of Aesthetics* vol. III: Modern Aesthetics (The Hague, Paris, and Warszawa, 1974), 225.

is based upon the historical understanding will have to be privileged.

Thus, there are at least three levels involved in the understanding of Luther's quotation, apart from the theological matters: Josquin's music itself, the principles and standards of quality by which the music was once composed and evaluated, and the principles by which we judge it today. The two sets of principles may coincide, but that is no guarantee that they are connected: we may appreciate Josquin for completely different reasons than Luther did.

I am grateful to The Nordic Academy for Advanced Study (NorFA) for a one-year grant which has enabled me to carry out the research for this article. I am also grateful to Nils Holger Petersen for having drawn my attention to the quotation about "des Fincken Gesang", and for valuable comments to the article.

Eyolf Østrem (1967), Ph.D. in musicology from Uppsala University with the dissertation *The Office of St Olav. A Study in Chant Transmission* (2001), is presently employed at the Theological Department, University of Copenhagen, on grants from The Nordic Academy for Advanced Study, and The Danish National Research Foundation: Center for the Study of the Cultural Heritage of Medieval Rituals. He has written about medieval music and history, aesthetical questions, and popular music (Bob Dylan).

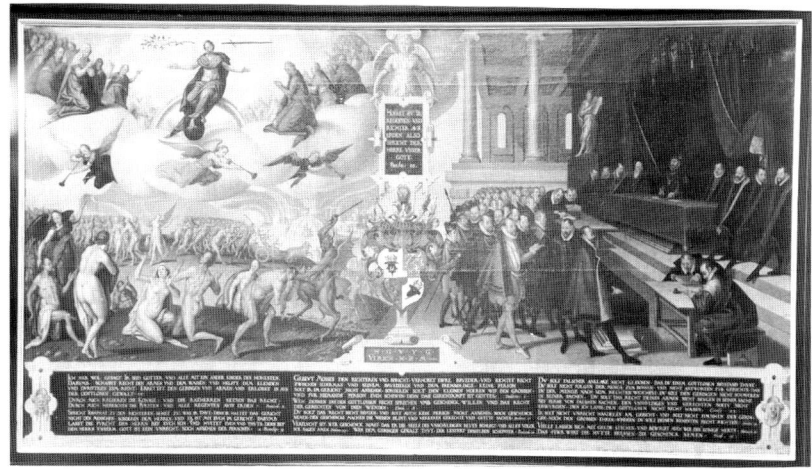

Fig. 10. The Last Judgment and the Law Court of Duke Ulrich. Oil-painting by Hans Metzger 1584, donated to the City Hall of Güstrow. Photo: City Museum of Güstrow.

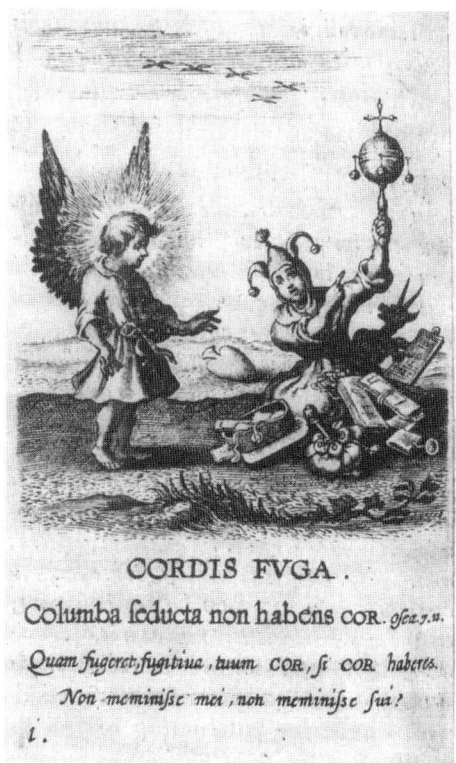

Fig. 11: "Cordis fuga". *Schola Cordis*, emblem 1; *School of the Heart*, emblem 4.

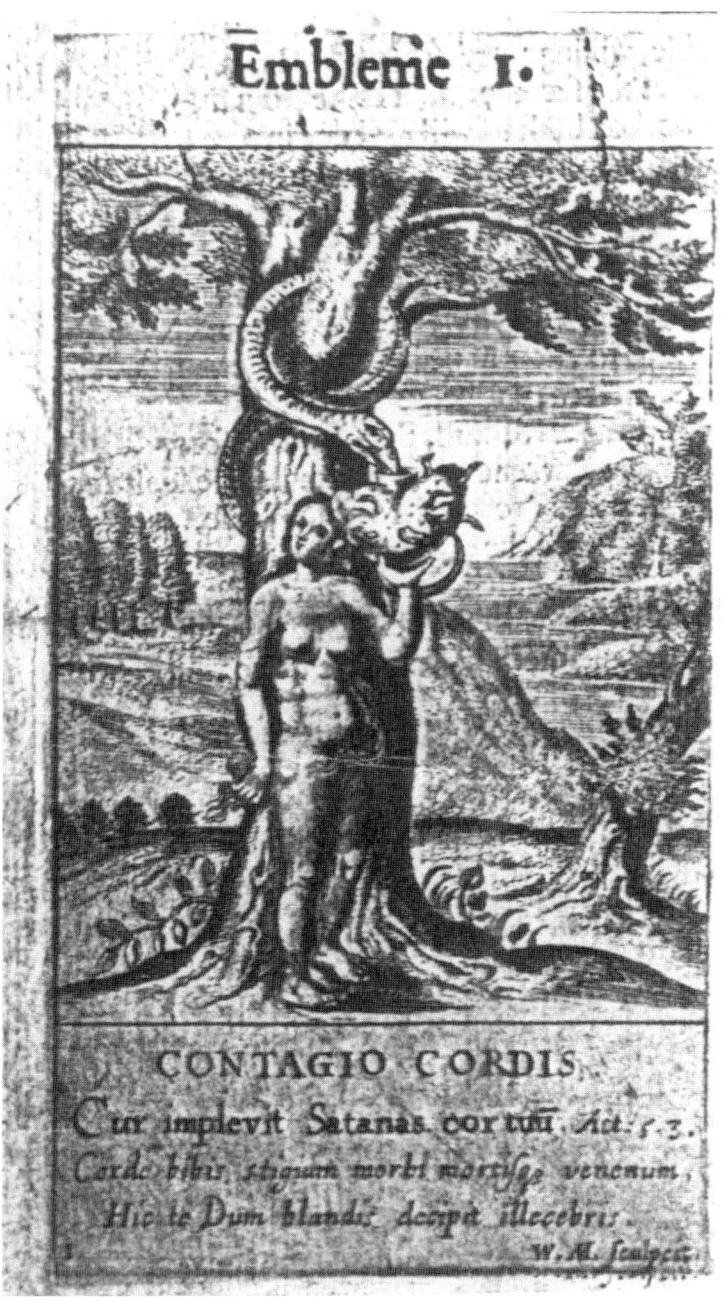

Fig. 12: "Contagio Cordis". *School of the Heart*, emblem 1.

Fig. 15: "Aratio Cordis". *Schola Cordis*, emblem 24; *School of the Heart*, emblem 27.

Fig. 16: "Cordis in cruce expansio". Schola Cordis, emblem 48.

Fig. 17: "Evertit, sed aptat". Roemer Visscher, *Sinnepoppen*, I, 3.

DECAS I. 17

EMBLEMA I.
Nunquid non verba mea, sunt quasi malleus conterens petram?
Ierem. 23. 29.
Ist mein Wort nicht wie ein Hammer der Felsen zerschmeist?

Cor mihi saxosum est, mollit me malleus, ictus
Sustineo: quid tum, dummodo sim meli...

Fig. 18: "Mollesco". *Emblemata Sacra*, emblem I, 1.

DECAS IV. 169

EMBLEMA XXXIX.

Cupio diſſolvi, & eſſe cum CHRISTO.
Philipp.1.23.

Ich habe luſt abzuſcheyden/vnd bey Chriſto zu ſeyn.

Vita hæc eſt carcer, pœna eſt ſententia mortis,
Imo penu, & funus fœnus, & horror honor.

L 5 SIC

Fig. 19: "Mors lucrum". *Emblemata Sacra,* emblem I, 39.

DECAS V. 201

EMBLEMA XLVII.

Quoniam sagittæ tuæ infixæ sunt mihi, & confirmâsti super me manum tuam.

Psal. 38. 3.

Denn deine Pfeil stecken in mir / vnd deine Handt drücket mich.

*Non ferit, ut terat, at reficit, cùm interficit : ergo
Sim scopus ipse DEI, ut sit scopus ille meus.*

Fig. 20: "Vulneror". *Emblemata Sacra*, emblem I, 47.

EMBLEMA XLV.

Convertam de profundo maris.

Psal. 68. 23.

Aus der Tieffe des Meers wil ich etliche holen.

Mergor, at emergo; & licet in vasto æquore verser,
Ut tamen elucter tu facis alma manus.

Fig. 21: "Emergo". *Emblemata Sacra*, emblem I, 45.

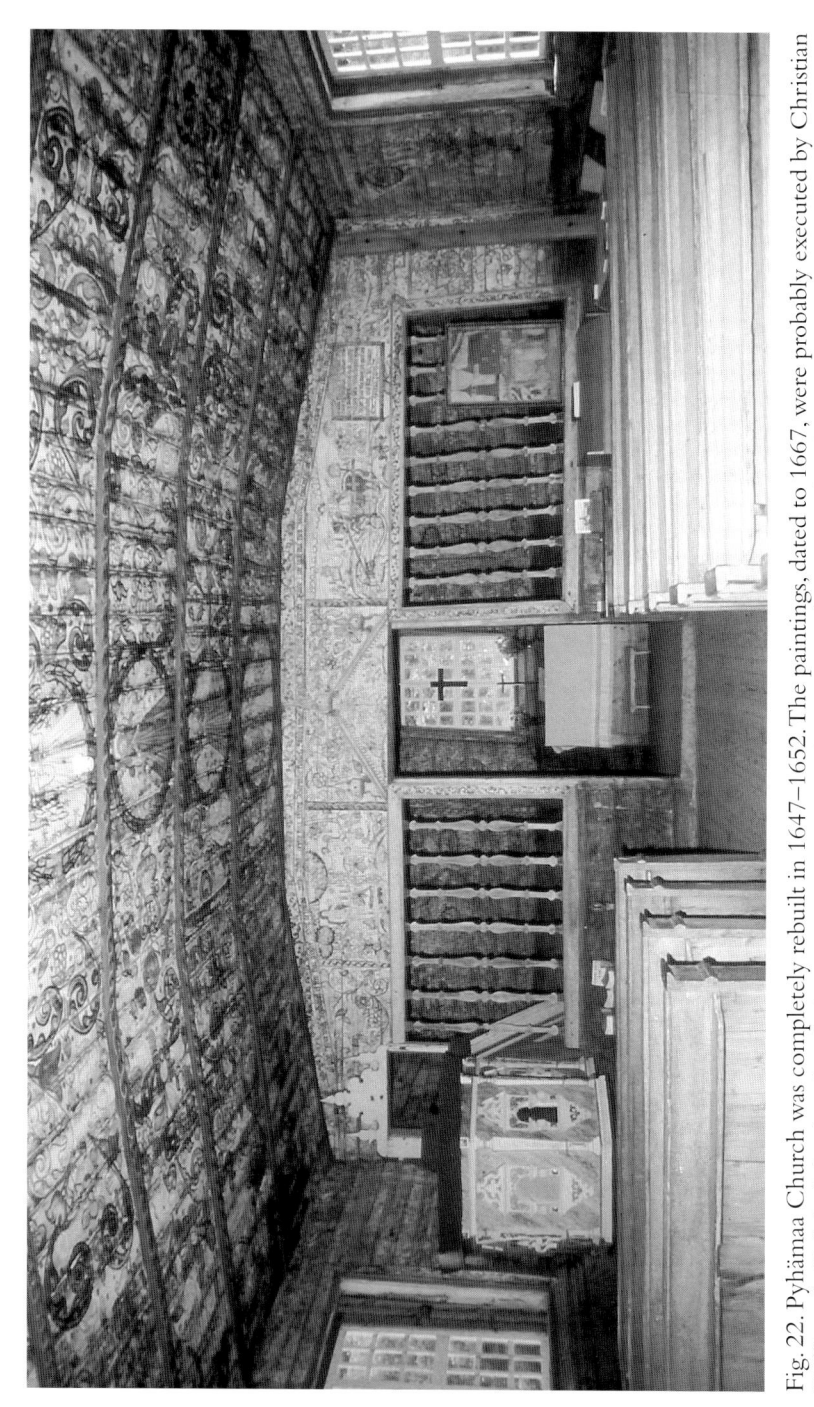

Fig. 22. Pyhämaa Church was completely rebuilt in 1647–1652. The paintings, dated to 1667, were probably executed by Christian Willbrandt. Pulpits joined to the choir screen were common in seventeenth-century churches. Photograph by Heikki Hanka.

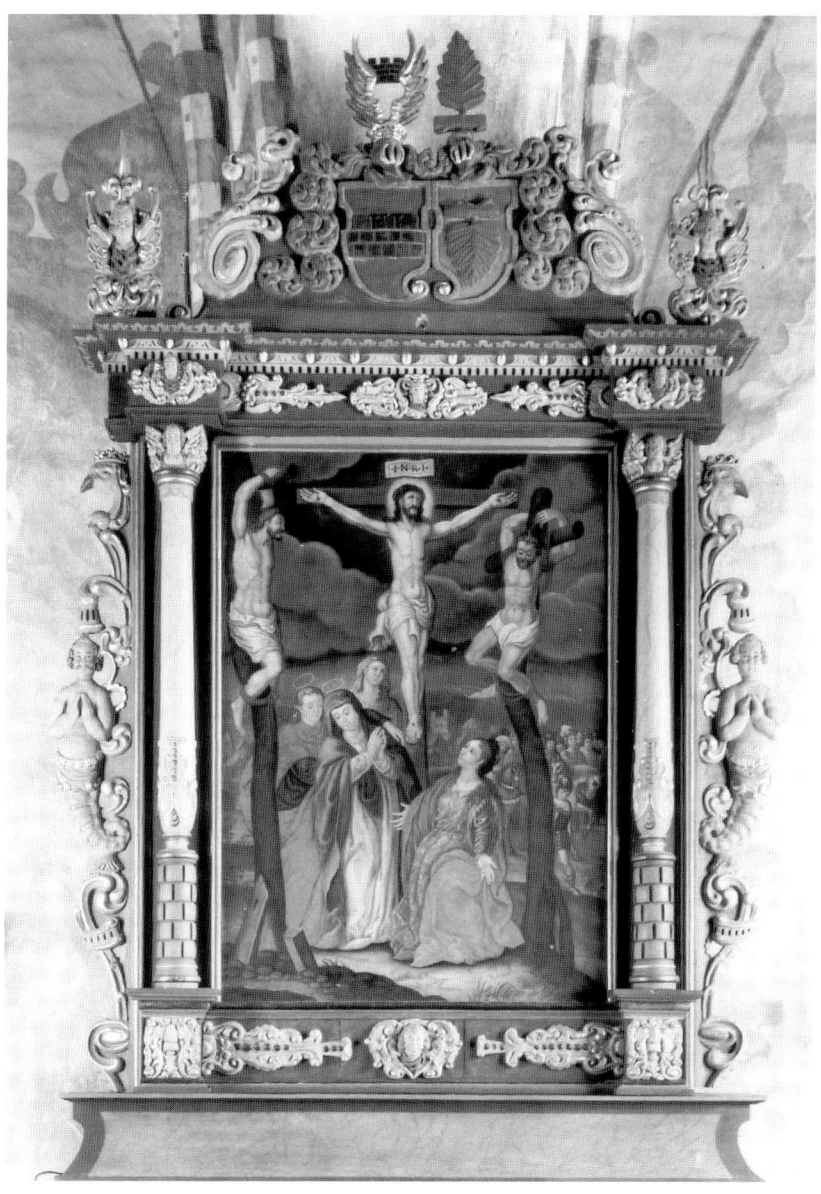

Fig. 23. The altarpiece of the medieval Hollola parish church was donated by Colonel Claes Johan Wrangel in the 1660s. It is topped by the armorial bearings of the donor's parents. The frame was carved by Mathias Reiman, a master craftsman from Turku. The painting, imported from Germany, is based on an engraving after a painting by Christoph Schwartz. Photograph by P. O. Welin/National Board of Antiquities.

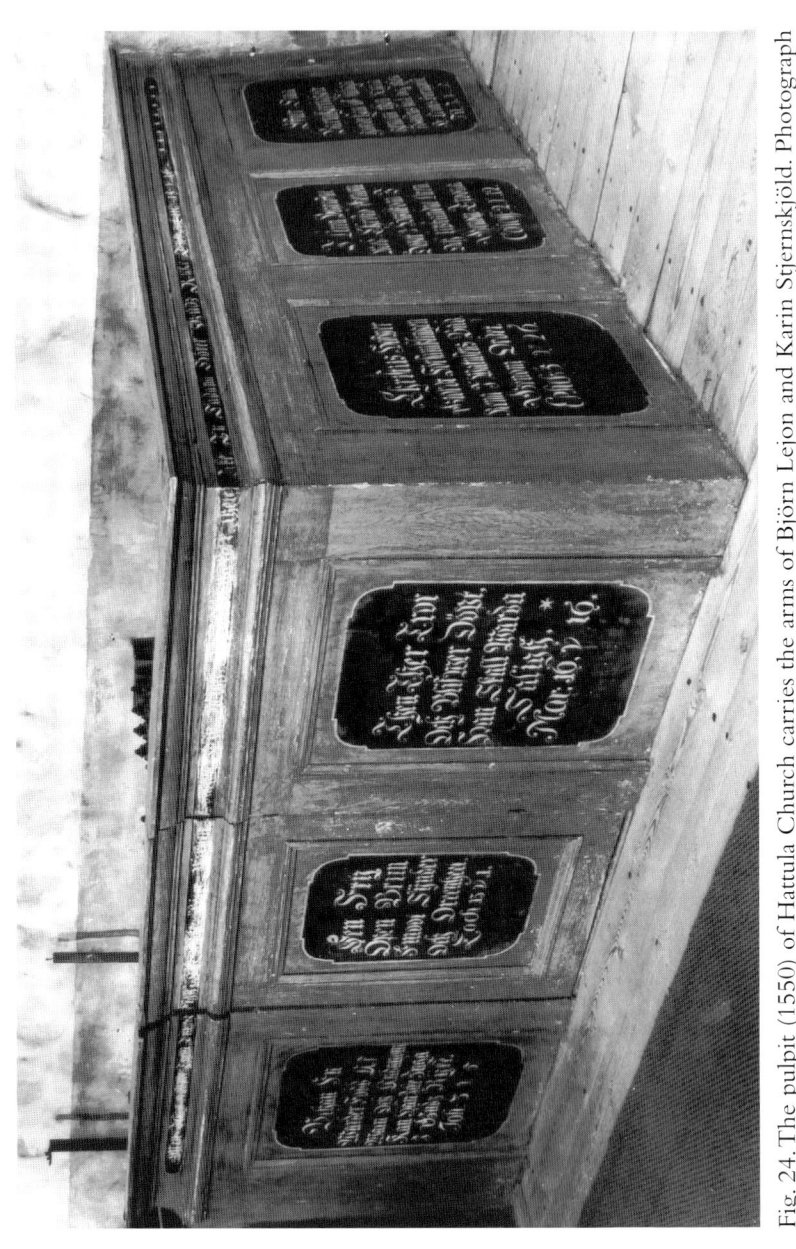

Fig. 24. The pulpit (1550) of Hattula Church carries the arms of Björn Lejon and Karin Stjernskjöld. Photograph by Hanna Pirinen.

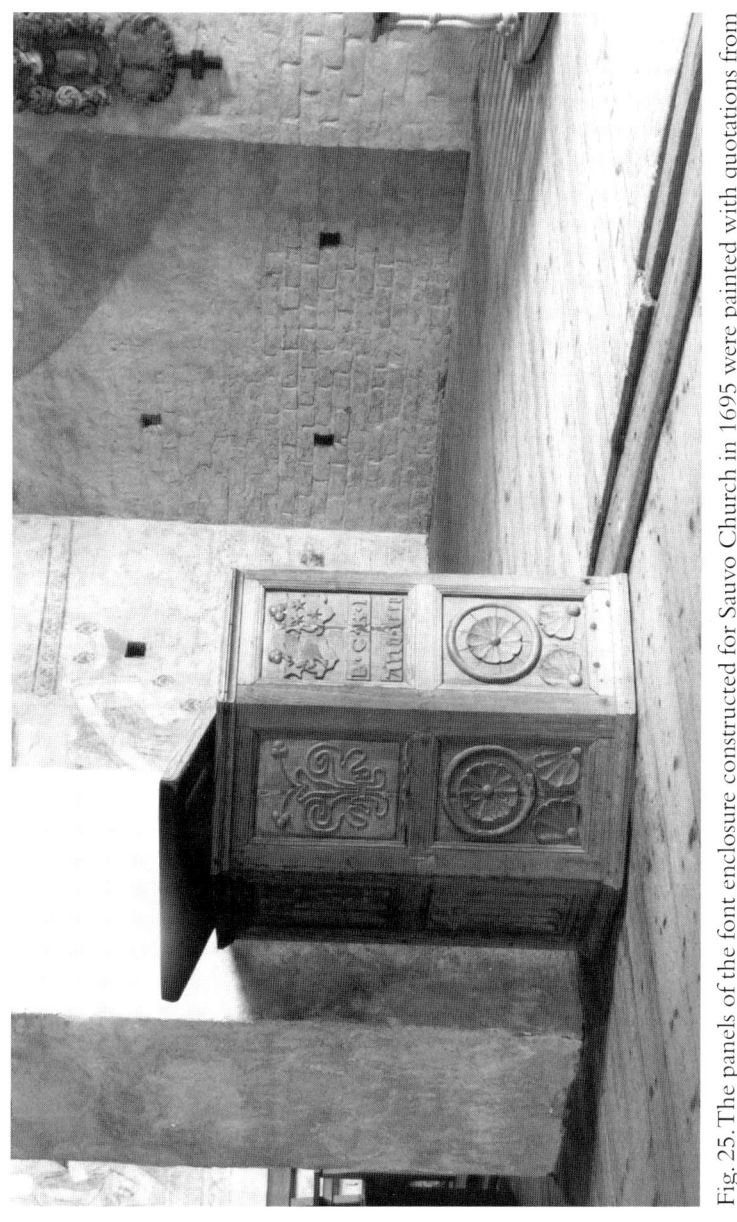

Fig. 25. The panels of the font enclosure constructed for Sauvo Church in 1695 were painted with quotations from the Bible. The arrangement was modelled on the Puritan tablets that Bishop Gezelius had seen on the walls of English churches and also on the fonts and their railings reinstalled in many churches after the Restoration. Photograph by P. O. Welin/National Board of Antiquities.

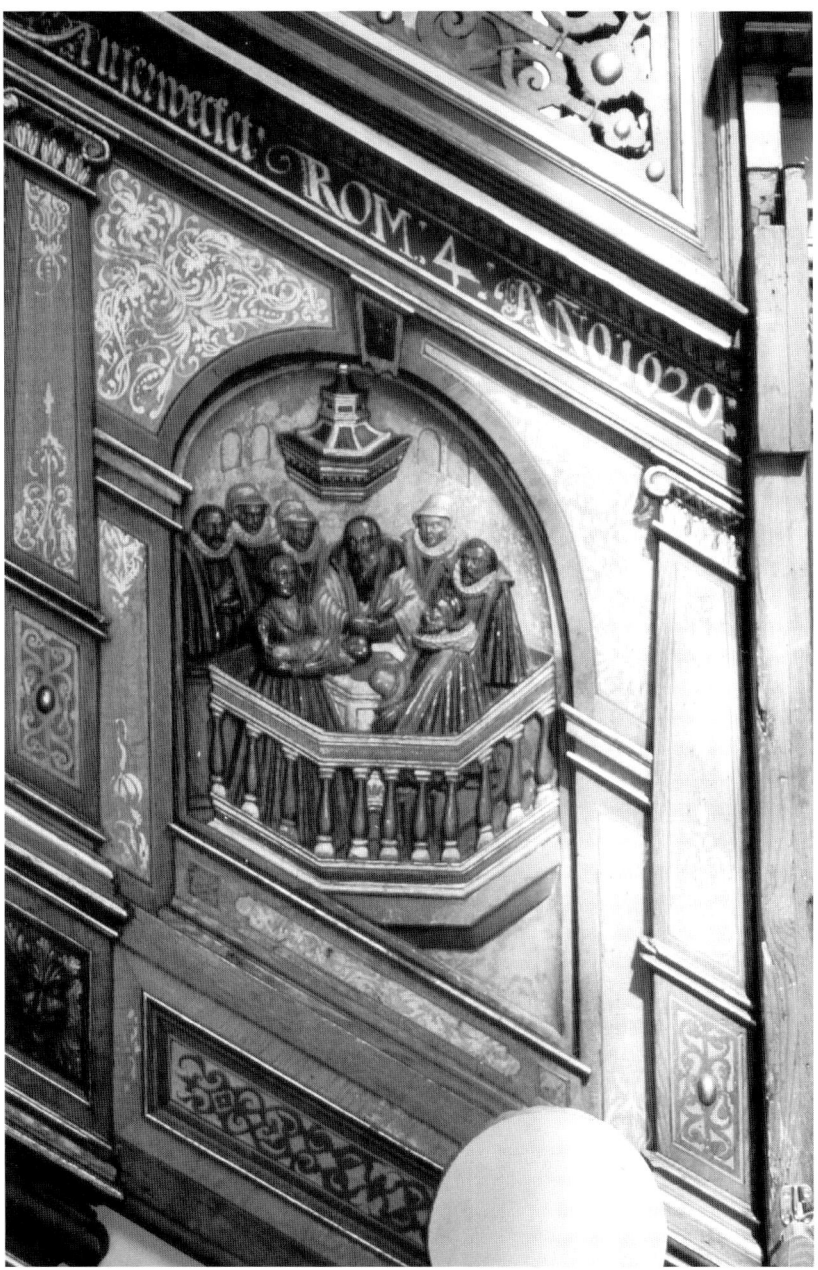

Fig. 26. A font cover with a balustraded enclosure. A relief in the pulpit of Goslar church in Germany.
Photograph by Hanna Pirinen.

The Writ on the Wall

Theological and Political Aspects of Biblical Text-Cycles in Evangelical Palace Chapels of the Renaissance

Hugo Johannsen

During the years 1601–23 Christian IV (1588–1648) erected the magnificent Castle of Frederiksborg in Northern Zealand as his favourite residence and the supreme symbol of his political power during the early part of his reign. The palace chapel, which was installed from 1608 to 1617 in the western wing of the main castle, miraculously survived the catastrophic fire of 1859, when the greater part of the interiors were destroyed. In spite of later alterations, the deplorable loss of the King's oratory in 1859 and necessary restorations after the fire, the chapel is almost intact and the most well-preserved interior of the Renaissance castle.[1] Architecturally the chapel belongs to a family of palace chapels built by evangelical princes in Germany and Scandinavia of which the prototype was that of Schloss Hartenfels in Torgau (Saxony), inaugurated by Martin Luther in 1544 as a paradigm, adapted to the changed Lutheran liturgy.[2] The chapel of Christian IV, however, exceeds all its pre-

[1] The basic monograph on the castle is still Francis Beckett: *Frederiksborg II. Slottets Historie* (Copenhagen, 1914) (French and German summary); see also Jan Steenberg: *Christian IVs Frederiksborg* (Hillerød, 1950). An updated monograph, however, that takes recent research into account is still a *desideratum*.

[2] The standard description of the Frederiksborg-chapel is by Hugo Johannsen, Marie-Louise Jørgensen and Elna Møller, in: *Danmarks Kirker. Frederiksborg amt* 3 (Copenhagen, 1970 [1973]), 1673–1926 (German summary). Interpretations of the decoration of the chapel and of the king's prayer-room are Hugo Johannsen: "Regnat Firmat Pietas. Eine Deutung der Baudekoration der Schloßkirche Christians IV zu Frederiksborg", in: *Hafnia. Copenhagen Papers in the History of Art 1974* (1976), 67–140; Hugo Johannsen: "Den ydmyge konge. Omkring et tabt maleri fra Christian IV.s bedekammer i Frederiksborg slotskirke", in: Hugo Johannsen (ed.): *Kirkens bygning og brug. Studier tilegnet Elna Møller* (Copenhagen, 1983), 127–54 (English summary). The architectural genesis is briefly outlined by Beckett (1914), 145; Walter Ohle: *Die protestantischen Schlosskapellen der Renaissance in Deutschland*. Dissertation (Stettin, 1936), 61; Steenberg (1950), 39f. and *Danmarks Kirker* (1973) 1762–66. See also: Hugo Johannsen: "The Protestant Palace Chapel. Monument to Evangelical Religion and Sacred Rulership", in: Nils Holger Petersen, Claus Clüver and Nicolas Bell (eds.): *Signs of change. Transformations of Christian Traditions and their Representation in the Arts, 1000–2000* (forthcoming). A more detailed interpretation will be presented in a forthcoming monograph on the palace chapel by this

decessors both in size and sumptuousness, and to the beholder it presents itself more like a gold-shimmering *aula regia,* embellished with precious materials (gold, silver, marble, alabaster, and rare sorts of wood) than a private, evangelical prayer-room (fig. 1).

Amidst all the lavishness one element strikes a more stern tone, namely the 56 tablets of polished black Belgian marble with etched and gilded quotations from the Bible, adorning the parapets of the gallery (fig. 2).[3] These tablets were ordered by the king in 1609 to be made by the schoolmaster and calligrapher Peder Trellund Riber, whose son, Villads Pedersen Trellund, at the death of Trellund senior in 1612 took over the unfinished enterprise and received his last payment in 1617. The Latin texts are taken from the Lutheran edition of the *Vulgata* (Tübingen 1573–86) and comprise 29 quotations from the Old Testament and 27 from the New. Most of the books of the Old Testament are represented, whereas the texts from the New Testament are concentrated in the Four Gospels with only one other quotation and that is from the Epistles of St Paul. Some texts are quoted verbatim, others are excerpts and two paraphrased. The arrangement of the texts respects the biblical order with Old Testament quotations on the western half of the gallery, beginning above the two western arcades behind the altar. The texts from the New Testament continue along the eastern side of the gallery, ending above the two eastern arcades behind the altar. Two of the texts on this southern short-end of the gallery were interchanged during the restoration 1860–64 for purely aesthetic reasons, because the architect Ferdinand Meldahl wanted to establish symmetry between the carved sandstone cartouches, which frame the marble tablets (fig. 2).[4]

author. Research for this and the present article was supported by a grant from the Carlsberg Foundation 1999–2000.

[3] The inscriptions and their textual basis are published by H. D. Schepelern in: *Danmarks Kirker* (1973), 1742–50.

[4] The western half comprises: Ge. 49:10, Ex. 15:11, Lev. 26:12, Nu. 6:24, Nu. 6:25, Nu. 6:26, Nu. 6:27, Deu. 32:36, Judg. 5:31, Ru. 1:16, 1 Sa. 2:6, 2 Sa. 22:50, 1 Ki. 8:57, 2 Ki. 5:15, 1 Chr. 16:11, Ezr. 8:22, Job 1:21, Ps. 1:6, Ps. 2:10, Ps. 2:11–12, Ps. 2:12, Ps. 100:1–2, Ps. 120:1, Ps. 150:4, Ps. 150:6, Pro. 1:7, Ec. 3:1, Song. 4:16. The eastern half: Tob. 12:7, Mt. 6:33, Mt. 7:7, Mt. 7:8, Mt. 7:12, Mt. 10:28, Mt. 10:40, Mt. 11:24, Mt. 15:13, Mt. 18:20, Mt. 23:12, Mk. 8:34, Mk. 11:17, Mk. 11:24, Lu. 11:23, Lu. 17:10, Lu. 18:27, Jn. 3:5, Jn. 3:6, Jn. 3:35, Jn. 6:44, Jn. 6:58, Jn. 7:17, Jn. 12:46, Jn. 17:3, 1 Tim. 4:8, 1 Tim. 4:8, 1 Tim. 4:10.

Considering the paramount importance of Holy Scripture for the Lutheran Reformation, it may not be suprising to find this array of biblical texts ostentatiously displayed in the model chapel of the King, being, as he was, head of the national church. Nevertheless, the marble tablets in the palace church of Frederiksborg deserve closer investigation as to the origin of using self-contained sequences of biblical quotations in a church, its relation to similar contemporary uses of Holy Writ in church furniture, and most important: the meaning of the texts as metaphors, referring to the king's role and religious status.

As indicated above, Christian IV's chapel at Frederiksborg represents the culmination and consummation of half a century of experiments in designs for evangelical palace chapels since that of Torgau.[5] The Frederiksborg chapel draws in many ways on the tradition of Saxon chapels (Torgau, Dresden, and Augustusburg) – a choice, that was certainly ideologically and politically grounded: *Ideologically* because Saxony was the birth-place of Lutheranism and origin of the Danish Lutheran Reformation. *Politically* through a strengthening of the family bonds between the Danish and Saxon dynasties.[6]

Thus, to Saxony we must turn in order to trace the formal genesis of the textual cycle of the Frederiksborg parapet. It is still absent in Torgau, but a few years later it figures prominently in the lost chapel (1549-55/56) of the castle in Dresden, begun by the new Elector, Moritz of Saxony (†1553), as a somewhat smaller copy of Torgau, thus stressing that leadership among evangelical princes had, following the Battle of Mühlberg, passed to the Albertine branch of the Saxon dukes.[7] The inscription tablets

[5] A brief survey of the Saxon chapels besides Ohle (1936) is Hans-Joachim Krause: *Sächsische Schlosskapellen der Renaissance. Das christliche Denkmal* (Berlin, 1970); Krause also made one of the few attempts at a more iconological approach to these chapels and their decoration: "Zur Ikonographie der protestantischen Schlosskapellen des 16. Jahrhunderts", in: Ernst Ullmann (ed.): *Von der Macht der Bilder. Beiträge des C.I.H.A.-Kolloquiums "Kunst und Reformation"* (Leipzig, 1983), 395–412.

[6] In 1478 King John was married to Christine, daughter of the Elector of Saxony, Ernst, and sister of Frederick the Wise. In 1548 Princess Anna, daughter of Christian III was married to August, the later Elector and Duke of Albertine Saxony. In 1602 these ties were renewed through the marriage of Hedvig, sister of Christian IV, to the reigning Saxon duke, Christian II.

[7] Cornelius Gurlitt in: *Beschreibende Darstellung der älteren Bau- und Kunstdenkmäler des Königreichs Sachsen* 21–23 (Dresden, 1903), 143–67; Ohle (1936), 31–34; Krause (1970), 15–20; Krause (1983), 397ff.; Heinrich Magirius, in: *Das Dresdner Schloss. Monument sächsischer Geschichte und Kultur* (Dresden, 1992), 78–84.

have long since disappeared and are now only partially known through a print from 1676 by David Conrad showing the interior (fig. 3). The stone tablets with biblical quotations in German were held by angels and flanked by medallions with apostles or prophets. Six of the tablets – the total number being at least eight, perhaps ten – are to be seen on the print that allows identification of the texts. Of these three are from the Old Testament, three from the New (Epistles of St Paul) seemingly placed more or less at random.[8]

However, the lost inscription tablets of Dresden are probably not the earliest example of a sequence of self-contained biblical quotations without reference to pictorial representations used for the edification of a Lutheran community. Contemporary or slightly older than the tablets of the palace chapel is a sequence of 24 biblical texts in German, carved with Roman capitals beneath the parapet of the surrounding gallery of the Marktkirche in Halle (Saxony).[9]

A slightly later, still extant palace chapel exhibiting biblical inscription tablets was erected 1560–63 by Duke Johann Albrecht I of Mecklenburg in his castle in Schwerin.[10] The chapel was radically altered from 1851 to 1855 as part of a general renovation of the castle, but enough remains to reconstruct the original interior, designed as a "copy" of the Saxon paradigms in Torgau and Dresden – an intention that was furthermore stressed by commissioning the entrance portal, the altar, and the pulpit from Saxon artists, who had worked in the above-mentioned chapels.[11]

[8] On the southern long-side, from the altar towards the duke's pew on the western short-end: Mi. 6:8, Ro. 3:28 and Titus 3:14. Correspondingly on the northern long-side: Ps. 141:5, Deu. 30:19 and 2 Tim. 4:1. The earliest identification of the quotations seems to be by Eberhard Schmidt: *Der Gottesdienst am Kurfürstlichen Hofe zu Dresden* (Göttingen, 1961), 155.

[9] Hans-Joachim Krause, Leipzig, has kindly drawn my attention to this early example of biblical quotations in a Lutheran church interior, see: Hans-Joachim Krause: "Die Marktkirche zu Halle", in: Hartmut Boockmann, Ludger Grenzmann, Bernd Moeller, Martin Stachelin (eds.): *Literatur, Musik und Kunst im Übergang vom Mittelalter zur Neuzeit. Bericht über Kolloquien der Kommission zur Erforschung der Kultur des Spätmittelalters 1989 bis 1992* (Göttingen, 1995), 391–458, especially 410–12 with a complete transcription on pp. 422–29.

[10] G. C. F. Lisch: "Geschichte der fürstlichen Residenzschlösser zu Wismar, Schwerin und Gadebusch", in: *Jahrbücher des Vereins für mecklenburgische Geschichte und Alterthumskunde* V (1840), 51–55; Friedrich Schlie, in: *Die Kunst- und Geschichtsdenkmäler des Grossherzogthums Mecklenburg-Schwerin* 2 (Schwerin, 1899), 584–94; Ohle (1936), 46–48; Krause (1983), 399–400; Susanne Klett: *Schloßkirche Schwerin* (Berlin, s.a.).

[11] The pulpit of Simon Schröter (1562) repeats in both form and iconography his famous

The inscription tablets, of alabaster with Roman capitals in high relief (fig. 4), however, are not placed on the facades of the gallery parapets, but above the gallery passages in the internal buttresses – a constructional device, also inspired by the Saxon examples. The fourteen tablets, one of which, at least, has been replaced during restoration, only comprise eight different quotations from the Bible, as six of them are presented in both German and Latin versions, the remaining two in German only.[12] The texts of the German quotations are taken from Luther's Bible, whereas the Latin counterparts mainly reflect a translation of the Bible, ordered by the duke in 1557 to be made by his trusted advisor and friend, Andreas Mylius. The duke expressly recommended Mylius to use Luther's German translation "being closest to the Hebrew style and the truth" ("Besonders aber empfehle ich ihm die deutsche Uebersetzung Martin Luther's, als der hebräischen Ausdrucksweise und der Wahrheit am nächsten stehend").[13]

The earliest known, still extant Danish example is to be found in the wonderfully preserved little chapel in the Castle of Sønderborg (fig. 5).[14] As stated on an inscription tablet, the chapel was built in 1568–70 by Dorothea, Queen Dowager of Christian III and a frequent visitor to the ducal courts of Saxony (Torgau, Dresden), from 1548 residences of her

pulpit in Torgau, from which Luther inaugurated the chapel. The altar (1562) was carved by his son, Georg, and the portal (1561), a reduced version of the one in Dresden (1555), was personally commissioned by the duke in Pirna from Hans Walther, who had taken part in the execution of the Dresden portal. See also Walter Hentschel: *Dresdner Bildhauer des 16. und 17. Jahrhunderts* (Weimar, 1966), 43f, 46; Jeffrey Chipps Smith: *German Sculpture of the Later Renaissance c. 1520–1580* (Princeton, 1994), 96f.

[12] On the northern long-side, from the altar in the east: Mt. 11:28 (German), Jn. 17:3 (Latin), same (German), Jn. 3:16 (Latin), same (German), 1 Jn. 1:7 (German). The seventh tablet on this side, Mt. 11:28 (Latin) has been replaced and is now to be found in the lower church, to the left of the entrance. Correspondingly on the southern long-side: 1 Tim. 1:15 (Latin), Jn. 16:23 (German), same (Latin), Isa. 53:4 (German), Jn. 11:25 (Latin; on the tablet wrongly indicated as Jn. 14), Isa. 53:5 (German), 1 Tim. 1:15 (German).

[13] The duke's commission is in Latin and is printed, with a German translation, in: G. C. F. Lisch: "Andreas Mylius und der Herzog Johann Albrecht I. von Mecklenburg, in ihrer Wirksamkeit und in ihrem Verhältniss zu einander", in: *Jahrbücher des Vereins für mecklenburgische Geschichte und Alterthumskunde* XVIII (1853), 73. It is the merit of Hans-Joachim Krause to have investigated this textual background of the Schwerin tablets, cf. Krause (1983), 400.

[14] Otto Norn: "Dronning Dorotheas kapel paa Sønderborg slot", in: *Historisk Samfund for Als og Sundeved* XXXVII (1958), 29–72; and: *Danmarks Kirker. Sønderborg Amt* (Copenhagen, 1961), 2129–60, for the inscriptions esp. 2140f.; Cathrin Haufschild: "Schlosskapellen in Schleswig-Holstein um 1600", in: *Nordelbingen* 65 (1996), 13–39.

daughter, Anna. The surrounding gallery is a very elegant wooden construction, whose parapet is adorned with 21 inscription tablets. To suit the material, the tablets are painted: golden capitals on a black background, framed by strap-work cartouches (fig. 6). The texts are in German and copied from Luther's Bible, although in a number of cases quoted as paraphrases. The number of New Testament quotations is nearly twice the number of texts from the Old Testament (fourteen to eight) with particular emphasis on the Gospel according to St John.[15]

The use of tablets with biblical quotations in Evangelical palace chapels has presumably been more widespread than appears from the extant examples. In Denmark, however, it is unknown whether this element was included in the first generation of Lutheran palace chapels, erected by Christian III in the castles of Copenhagen and Koldinghus in the 1550s.[16] Neither do we know anything definitive as to the palace chapel of the king's brother, Duke Hans, built in his castle Hansborg at Haderslev and inaugurated in 1566.[17] But at any rate, the still extant chapel of Kronborg, built in 1578–82/88 by Frederick II has preserved (in copies from the nineteenth century) the original painted decoration of self-contained biblical inscriptions, although not on tablets, but placed frieze-like along the gallery as in Halle's Marktkirche.[18] Lastly it remains an open question as to whether the galleries of the lost chapels at Nykøbing castle, built for the Queen Dowager, Sophia, in 1588–94,[19] or the second one at

[15] Above the altar (on the eastern side), from north to south: Jn. 5:24, Jn. 10:9, Jn. 6:24 and 53, Isa. 55:1. On the southern side, from east to west: Mt. 6:33, Ps. 112:1–3, Ps. 23:1–2, Isa. 57:13f. and Ps. 50:15, Jn. 3:36, Jn. 8:51, Rev. 1:5–6. On the western side, from south to north: Eph. 2:8–9, Isa. 33:11, Lu. 21:34. On the northern side, from west to east: Isa. 43:24–25, 2. Chr. 7:14, 3. Jn. 16:1. Co. 15:21, Jn. 14:6, Ac. 10:43, Mt. 11:28.

[16] The medieval chapel of Copenhagen Castle was converted in response to the demands of the new, Lutheran liturgy by Christian III in 1552–58, but we know very little of the different pews that were installed here. A cross-section from 1707 show a pew with compartments that may have contained biblical inscriptions, as pointed out by Birgitte Bøggild Johannsen, see *Danmarks Kirker. København By* 5 (Copenhagen, 1983), 30–50 with fig. 15; the kings' contemporary, but newly built chapel in Koldinghus seems to have anticipated the Sønderborg chapel in its layout, cf. Mogens Vedsø: "Christian III's Koldinghus. Sydfløjen og dens indretning", in: *Bygningsarkæologiske studier* 1993, 49–54.

[17] *Danmarks Kirker. Haderslev Amt* (Copenhagen, 1954), 237–39; Otto Norn: *To grænseslotte. Frederik I's Gottorp og Christian IV's Koldinghus* (Aabenraa, 1986), 66–70.

[18] *Danmarks Kirker. Frederiksborg Amt* 1 (Copenhagen, 1964), 562–636, for the inscriptions: 618f., 624.

[19] *Danmarks Kirker. Maribo Amt* 1 (Copenhagen, 1948), 251–55.

Koldinghus, built by Christian IV in 1601–04, had tablets on the parapets.[20]

Turning to the royal palace chapels of Sweden, the ones built by Johan III in the castles of Uppsala (c. 1583–91) and Stockholm (1588–92) were also enriched with biblical inscriptions, of which, however, only two Latin texts in stucco are still discernible (Ps. 33,18 and 145,18) in the remains of Uppsala castle.[21] The king's chapel in Kalmar castle, built in 1577–85 for his Catholic, Polish queen, is preserved with stucco-framed tablets on the walls and in the window niches, which, however, in their present shape seem to have been added at a later date, c. 1620–40 during the reconstruction that followed the Danish capture of the castle in 1612. Of the 33 painted inscriptions tablets, 20 are in Swedish, painted in golden black letter and taken from the New Testament, the remaining partly in Latin with golden capitals and all of them quotations from the psalms.[22]

In general terms the purpose of these biblical inscription-cycles in evangelical palace chapels, which were widespread, although not ubiquitous, naturally reflects the crucial importance of the word of God for the reformers – a fact that was destined to have a deep influence on the question of both liturgical disposition and decoration of the "true church". This attitude was strikingly summed up in a lost tablet mounted in the palace chapel in Torgau, where it accompanied a painting, representing the strife between Elijah and the priests of Baal (1 Ki.18, 20–40) – a story of "true" and "false" worship. Thus the text, stressing the importance of "the new house, built in honour of Jesus Christ", ended with praise for the pious Elector and Luther, who inaugurated it – "not with ointment, banners, incense, candles and holy water – but with the only necessities: the word of God, prayer, and the community of believers" ("Kein cresam, fahnen noch weihrauch / Kein kertz noch weihwasser er braucht. / Das gottlich wordt vnd sein gebet / Sampt der gleubigen dartzu thet").[23]

[20] Norn (1986), 83–91.

[21] Martin Olsson: "Det gamla slottet", in: *Stockholm Slotts Historia* I (Stockholm, 1940), 192; Torbjörn Fulton: *Stuckarbeten i svenska byggnadsmiljöer från äldre Vasatid* (Uppsala, 1994), 202 (English summary).

[22] Martin Olsson: "Kalmar slotts kyrkor", in: *Sveriges Kyrkor. Småland* 117 (Stockholm, 1968), 39–55.

[23] The full text of the tablet is included in *D. Martin Luthers Werke. Kritische Gesamtausgabe.*

Consequently, the focal points of the Lutheran church – pulpit and altar – are very often provided with biblical texts, interpreting their pictorial representation – "signs" for the illiterate: in the case of the pulpit, referring to its function as a platform for preaching the Gospel,[24] and for the altar, reflecting its status as a communion table. According to Luther, the subject of the Last Supper, being the most appropriate picture for an altar, should be accompanied by a textual explanation, written in golden letters.[25]

Apart from the widespread use of pictures explained by biblical texts (or *vice versa*) – an exuberant example among the palace chapels being the uniquely well-preserved one in the castle of Celle (c. 1565–76) with more than one hundred paintings and reliefs[26] – further examples of pure textual embellishment apart from the cycles of biblical quotations treated here could be numbered.[27] A telling phenomenon is the great number of altarpieces, so-called catechism-altars, preserved or known in Danish and Norwegian churches from around 1600 (fig. 7).[28] In half of these, the texts are combined with paintings, the Scripture, however, still remaining the dominant element. As to the content of the texts that are both in Latin and Danish, a minority part repeats all parts of Luther's Smaller Catechism (The Ten Commandments, the Confession of Faith, the Lord's Prayer, the Sacraments of Baptism and of Communion), more frequent

Tischreden vol. 5 (Weimar, 1919), 640. no. 6396.

[24] Peter Poscharsky: *Die Kanzel. Erscheinungsform im Protestantismus bis zum Ende des Barocks* (Gütersloh, 1963), 141–45.

[25] This often cited passage is from his interpretation of hymn 111 (1530), see WA 31, 415.

[26] Armin Zweite: *Marten de Vos als Maler* (Berlin, 1980), 85–146; Armin Zweite: *Die Schlosskapelle Celle*. Schnell Kunstführer Nr. 1439 (München, 1983, second ed. 1991); Burghard Bock: "'In diesen letzten bösen Zeiten'. Lutherische Ausstattung des 16. Jahrhunderts in der Celler Schlosskapelle", in: *Jahrbuch der Gesellschaft für Niedersächsische Kirchengeschichte* 95 (1997), 155–268.

[27] For the now evidently restricted number, see Reinhard Lieske: *Protestantische Frömmigkeit im Spiegel der kirchlichen Kunst des Herzogtums Württemberg* (Berlin and München, 1973), 71–74; Elisabeth Anton: *Studien zur Wand- und Deckenmalerei des 16. und 17. Jahrhunderts in protestantischen Kirchen Norddeutschlands* (München, 1977), 159–61; in the Swedish church of Bettna, tablets are preserved with remnants of a textual decoration from c. 1600 on the vault, where the biblical quotations are painted as tablets in strapwork cartouches, see Mereth Lindgren: *Att lära och att pryda. Om efterreformatoriska kyrkmålingar i Sverige ca. 1530–1630* (Stockholm, 1983), 100–102, 279.

[28] Ragne Bugge: "Teksttavlerne i Danmark-Norge omkring 1600", in: Ingmar Brohed (ed.): *Reformationens konsolidering i de nordiska länderna 1540–1610* (Oslo, 1990), 306–26.

are excerpts and combinations with different selections of biblical texts.[29]

Returning to the Frederiksborg-tablets and their predecessors, the meaning of such pure textual programmes has hitherto only partly been analyzed, especially as part of the author's interpretation of the pictorial and textual programmes of Christian IV's great palace chapel.[30] In this context, interpretation will be restricted to a more general evaluation, not only due to the sheer number of quotations, but also in recognition of the need for a more detailed, theological investigation.[31]

As to the confessional aspects of the texts, it seems reasonable to presuppose that they would have been chosen at least partly to demonstrate how fundamental Lutheran doctrines – the fear and praise of God, the salvation of sinful man only through God's grace and the self-sacrifice of his son, Jesus Christ, restriction of the number of sacraments, the necessity of prayer and sermon – were all grounded in and proved by God's own Scripture. These tenets were also emphazised in the so-called Confession of Augsburg (*Confessio Augustana*, henceforth CA) from 1530, that became the foundation for the teachings of the evangelical churches, e.g. in Denmark-Norway.

The fundamental Lutheran conception of man's salvation and remission of sins, not through own merits and deeds, but by the grace of God, through belief in Christ alone, was proclaimed through quotation from Ro. 3:28 on one of the tablets in Dresden, conspicuously placed above the entrance door (fig. 3): "So halten wir es nun dafür, dass der mensch gerecht werde ohne das Gesetz" (cf. CA, article 4). The same dogma is also upheld in Sønderborg, now by another quotation from the letters of St Paul (Eph. 2:8–9): "Aus Gnaden seid Ihr selig worden, durch den Glauben […]" (cf. CA, article 20). Christ's role as God's intermediary, the

[29] A telling example of such combination was the altar-piece donated in 1582 by counsellor Niels Kaas for the cathedral in Odense as part of its adaptation to the new Lutheran liturgy, see *Danmarks Kirker. Odense amt* 2 (Herning, 1995), 547f. An interesting proposal for an altar with biblical texts, drawn c. 1578 by the historian Anders Sørensen Vedel, is published by Otto Norn: "Ripensiske patriciere. Epitafieportrætter fra renaissancetiden", in: Svend Ellehøj, Svend Gissel and Knud Vohn (eds.): *Festskrift til Astrid Friis* (Copenhagen, 1963), 177 (pl. 3).

[30] Johannsen (1976), 107–110 with notes 95–121.

[31] This is to be expected in connection with the texts from the pew gallery in Halle's Marktkirche, see Krause (1995), 411, note 103. Hans-Joachim Krause has kindly informed me (letter of 17 June 2002), that a theological interpretation by Dr. Friedrich de Boor, Halle, is forthcoming.

Redeemer granting us eternal life through his death on the cross, is also frequently repeated. In Schwerin this is the central theme, taught through the preference for quotations from the Gospel According to St John. This is also the case in Sønderborg, e.g. from Jn. 14:6: "Ich bin der Weg, die Wahrheit und das Leben [...]" (cf. CA, article 20), whereas in Frederiksborg we read from Jn. 17:3: "Vita æterna est cognoscere Deum et Christum."

The belief in Christ, however, cannot exist or operate in man without help from God's word or the sacraments. As to the sermon we read in Dresden from 2 Tim. 4:1f.: "Ich bezeuge für Gott und dem Herrn Jesu Christi, predike das Wort [...]." As fruits of belief in Christ, the words of God will and shall produce good deeds as also stated in Dresden by quoting Titus 3:14. The good deeds that man learns from the Bible (cf. in Frederiksborg from Mt. 7:12, "Omnia ergo quæcunquæ vultis ut faciant vobis homines et vos faciate illis") are fruits of this obedience, not personal tools of salvation, as stated further on in Frederiksborg by quoting Lu. 17:10: "Cum feceritis omnia quæ precepta sunt vobis, dicite, servi inutiles sumus" (cf. CA, article 6). The Sacrament of Baptism is referred to in Frederiksborg by quotations from Jn. 3:5–6, and the Holy Communion through Jn. 6:15.

More could be said about the theological significance of the biblical texts in the palace chapels, e.g. on the necessity of prayer and of the praise of the Lord, not the least through hymn-singing and music. Instead we will turn to another aspect: the meaning and use of the texts to further an ideology of royalty as a God-given order for society, being vehicles to bolster up theocratic government through the church.

In the first instance, by giving the word of God such emphasis in his own, personal chapel, the ruler demonstrates that he not only holds the scripture in the highest esteem but recognizes its fundamental importance in the Lutheran reform. In short motto-like form – VDMIAE (*Verbum Domini Manet In Aeternum*) – this motto of the Lutheran Reformation and of the Saxon dukes who succeeded Frederick the Wise was proclaimed at the entrances to the chapels in Dresden, Freiberg and elsewhere.[32] An-

[32] The motto is still to be seen on the wooden door from the Dresden chapel, cf. Gurlitt (1903), 149, and verbatim above the entrance to the chapel in Schloss Freudenstein in Freiberg, inaugurated in 1576, cf. R. Steche, in: *Beschreibende Darstellung der älteren Bau- und Kunstdenkmäler des Königreichs Sachsen* (Dresden, 1884), 76. It figures also prominently in the biblical texts in Halle, cf. Krause (1995), 412, 425, and on one of the columns of

other even more telling manifestation of the same idea, illustrating the prince's responsibility as head of the National church, is the endeavour to have new translations of the Bible printed – the publications promoted by the Danish kings Christian III (1550), Frederik II (1589) and Christian IV (1607 and 1633) being prominent examples.

Returning to the biblical inscriptions of the palace chapels, the mosaic-like character of the selection of quotations is an obvious parallel to similar collections of texts, printed in the name of rulers in order to demonstrate their piety and reverence towards the word of God. Thus, in 1583 a small book was printed in Copenhagen, containing texts from The Book of Proverbs and from Jesus the son of Sirach (*Etzliche auserlesene vnd vorneme Sprüche vnd Sententzen aus den Sprüchen Salomonis vnd Jhesus Syrach: zusammengebracht Durch ... Herrn Friderich der ander*), by the personal choice of Frederich II as fruits of his intense Bible-reading. It was followed in 1586 by a collection of hymns (*Etzliche auserlesene Psalmen und Sprüche...*), likewise selected by the king and explained in detail by his court-preacher, Christopher Knoff.[33] In fact these collections were used as sources for the greater number of biblical texts, painted in the king's own chapel in Kronborg Castle.[34] It seems thus reasonable to assume that such was also the case in other palace chapels. An obvious example would be the chapel in Schwerin, whose builder, Duke Johann Albrecht I, as formerly mentioned, took great interest in humanistic studies, guided by his advisor, Andreas Mylius. An early example (1557) of Mylius' Latin translation of the Bible is the Gospel according to St John.[35] The preference for St John – used exclusively on the altar-piece – and the de-

the altar in the palace chapel of Schwerin, cf. Lisch (1840), 53. The examples on altar-pieces (cf. fig. 6) and pulpits are numerous, of course. For the political use of the motto by early Reformation princes, see F. J. Stopp: "Verbum Domini manet in Aeternum. The dissemination of a Reformation slogan, 1522–1904", in: Siegbert S. Prawer, R. Hinton Thomas & Leonard Forster (eds.): *Essays in German Language, Culture and Society* (London, 1969), 123–35.

[33] The king's selection from the Books of Psalms and Wisdom was originally printed in 1585 as a private edition, now only preserved in one copy (Wolfenbüttel, Library of Duke August), enriched by autograph mottos of the royal family, see Erik Dal: "Die Wolfenbütteler Danica", in: Paul Raabe (ed.): *Wolfenbütteler Beiträge* 8 (1988), 57. In a copy of "Etzliche auserlesene Psalmen und Sprüche" (Copenhagen, The Royal Library) the Queen Dowager, Sophia, and her children have likewise written their names and mottos on 17th July 1588.

[34] *Danmarks Kirker. Frederiksborg amt* 1 (Copenhagen, 1964), 606, 618, 624.

[35] Cf. Lisch (1853), 69.

monstrative juxtaposition of tablets containing the same quotations in both German and Latin points to the duke as originator of the programme.[36] The Evangelist being the namesake of the duke hints in the same direction.[37] To sum up: By using series of quotations from the Bible in their chapels, the princes demonstrate what is reiterated time and again by clergymen in speech and writing, namely their will to defend and spread the word of God, following the paradigm of every God-pleasing, Christian king. During the coronation ceremony of Christian IV in 1596, the ordaining bishop, Peder Vinstrup, thus urged the young king to follow the example of his grandfather and father, who "daily had recited, read themselves and contemplated The Holy Bible, God's pure word and doctrine".[38]

Seen from a political perspective the texts can be interpreted as parallels to the widespread Mirror of Princes literature, following in the wake of Erasmus of Rotterdam's *Education of a Christian Prince* (1516) – although significantly extracted from the oldest and richest book of wisdom and education. A contemporary example of such "biblical" Mirror of Princes was published in 1567 by Niels Nielsen Colding, court-preacher of Frederick II, and translated into German in 1572 (*Die vornemsten Historien und Sprüche, so in der Heiligen Schrifft, von der Obrigkeit Beruff, Ampt und Regiment gefunden werden*). Both editions contain a foreword by the eminent theologian, Niels Hemmingsen and a wood-cut (fig. 8), showing the king as judge and defender of God's law. In Hemmingsen's introduction as well as in the pictorial representation, the two-fold meaning of the texts is made quite clear. On one side they should serve those in authority to give them wisdom and prudence as rulers; on the other side they were also addressed to the subjects of the king in order to show them how to honour, obey and pray for their king, because he is bound to rule in his capacity as God's earthly representative. His duty was to protect Gods' Holy Word and Church, to keep peace within the realm and punish evil-doers, while rewarding the righteous, being a foster father to the fatherless and the widows. On the Day of Judgment however, he himself shall answer to God alone and will consequently be judged.

[36] Cf. also Krause (1983), 400.

[37] In Frederiksborg, the guiding principle of the pictorial and textual programme is seemingly based on Christ and Christian IV being almost namesakes – a play with names common for much princely panegyric, cf. Johannsen (1976), 92ff.

[38] Johannsen (1976), 108.

Similar theocratic basis for the selection of the biblical texts seems to prevail in the later palace chapels, e.g. in Kronborg and Wilhelmsburg in Schmalkalden (Thuringia). The latter built 1586–90 for Count Wilhelm IV of Hesse, is outstanding in more than one respect and famous for the concentration of altar (with baptismal font), pulpit and organ in one short-end of the surrounding gallery – anticipating the so-called pulpit-altar in Evangelical churches of the seventeenth and eighteenth centuries.[39] Another remarkable element of Count Wilhelm's chapel bordering on our subject, was the paintings on the *Passional Christi und Antichristi* that originally was placed on the parapets, accompanied by verses, written by the count's son, Moritz (then only fifteen years old and called "the Learned").[40] This pictorial and textual programme, of which only the Latin inscriptions in the gallery-friezes survive, was harking back to Lucas Cranach's famous woodcut series of 1521 with texts by Melancthon and Schwertfeger contrasting the "true" and "false" Church – a return to the polemics of the early Reformation, that seem a reaction to the growing success of the Counter-Reformation in neighbouring areas such as the dioceses of Würzburg and Fulda.[41] More in the ethical spirit of the Mirror of Princes literature, explaining the obligations of the duke as head of society, are the biblical texts (Job 29:12–16; The Book of Wisdom 6:2–5 and 1 Cor. 1:26–29), written in golden black letter on a wooden tablet mounted on the wall in the duke's pew (fig. 9).

The biblical texts of Frederiksborg represent a climax in this respect.[42] Fear of God and the necessity of piety for the king being God's vicar, is the fundamental message repeated over and over again, e.g. Pro. 1:7: "Timor Domini principium sapientiæ […]," 1 Chr. 16:11: "Qværite Dominum et vitutum eius, Qværite faciem eius semper," or Ps. 2: 10–12: "Nunc reges intelligite, erudimini iudices, osculamini filium, ne irascatur dominus."[43] The pious king, being *summus episcopus* in his realm protects

[39] Friedrich Laske and Otto Gerland: *Schloss Wilhelmsburg bei Schmalkalden* (Berlin, 1895); Paul Weber, in: *Die Bau- und Kunstdenkmäler im Regierungsbezitz Cassel* V: Kreis Herrschaft Schmalkalden (Marburg, 1913), 237–43; Peter Handy: *Schloss Wilhelmsburg Schmalkalden* (Schmalkalden, 1977); Dieter Eckhardt a.o.: *Schloss Wilhelmsburg in Schmalkalden* (München and Berlin, 1999).

[40] Otto Gerland: "Die Antithesis Christi et Papae in der Schlosskirche zu Schmalkalden", in: *Zeitschrift des Vereins für hessische Geschichte und Landeskunde* N.F. 10 (1891), 189–201.

[41] Krause (1983), 401.

[42] For a fuller presentation, see Johannsen (1976), 107–110.

[43] The same quotation from the Book of Psalms is also used as motto for the biblical

the true church of Christ against every sign of heresy, as: "Omnis plantatio qvam non plantavit pater meus eradicabitur" (Mt. 15:13). As a judge, having the power of life and death, he acts on behalf of God: "Dominus mortificat et viuificat, deducit ad ima et reducit" (1 Sa. 2:6) or: "Nouit Dominus viam iustorum et impiorum peribit" (Ps. 1:6). Ruling in accordance with the laws of God, the king and his subjects shall live in peace and prosperity: "Qværite ergo primum regnum Dei et iusticium eius, et hæc omnia adiicientur" (Mt. 6,33). Only then – following the example of his pious predecessors – can he rely on God's help: "Ad Dominum cum tribulare clamavi: et exaudivit me" (Ps. 120:1) and: "Sit Deus nobiscum, sicut fuit cum patribus nostris, non derelinquens nos" (1 Ki. 8:57). In return for all these blessings the grateful king and his people thank the Lord daily in their prayers: "Laudate Dominum in tympano, in chordis et organo" (Ps. 150:4).

The elaborate programme of biblical texts in Frederiksborg contains much more than what is briefly outlined above, focusing on fundamental politico-religious dogmas. The long sequence of texts opens with Jacob's prophecy of the Messiah: "Non auferetur sceptrum de Iuda, nec dux de foemore eius donec veniat Siloh" (Ge. 49:10) stating that power will remain in the hands of this royal lineage until the end of time, because they are pious vicars of Christ, to whom they shall answer on The Day of Judgment. The concluding quotations from 1 Tim. 4:8–10 (cf. fig. 2): "Pietas ad omnia utilis est promissionem habens vitæ qvæ nunc est et futuræ," once more underline the necessity for obedience and piety for the prosperous continuation of the reign of Christian IV, revealing the biblical origin of the king's personal motto RFP, that is, "Regna Firmat Pietas".

The Latin texts in Frederiksborg and the contemporary Evangelical palace chapels were primarily directed towards the restricted elite, whom the church was originally meant to serve; the prince and his family, servants of the castle and, not least, the noble, often foreign, guests that the king wanted to impress. However, the idea of a christian state, held together by piety and obedience to the word of God as well as to his secular representative, the prince, is fundamental to the concept of human society in Post-Reformation Denmark-Norway before as well as after the reign of Christian IV. The Lutheran church had become an instrument

Mirror of Princes by Niels Nielsen Colding (1567/1572).

– severe and intolerant in many ways – meant to secure, through religious education, not only salvation of the individual soul, but, even more, the stability and peace of the realm.

Seen in this light, the concepts permeating the selection of texts in the Frederiksborg gallery – although in many ways of a personal character – are echoed in contemporary fittings of many churches. Telling examples are the numerous text-altars mentioned above, of which the greater part were put up during the later years of Frederick II and the early reign of Christian IV, often crowned by the initials and mottos of the King and Queen. Thus, the texts in Danish and Latin on the altar from Sigersted in Zealand (fig. 7) reveal that it was erected in 1596 "qui fuit annus coronationis serenissimi Regis Christiani IV".[44] The motto of the King is paraphrased in the inscription of the architrave: "Pietas ad omnia utilis, habet promissiones vitæ præsentis et futuræ," anticipating the same quotation in Frederiksborg (cf. fig. 2). On the pediment is the well-known "Verbum Domini manet in æternum", referring to the biblical texts of the pedestal and the central panel, who tell (in Danish) of Christ the Saviour. The purpose, then, of the texts is also two-fold here. On one hand they promise Salvation and Eternal Life, on the other hand, they constitute rules and guiding examples, especially for the pious king, who is to be honoured and obeyed by his subjects in return.[45]

The use of biblical texts as an important element of the new Lutheran iconography have here been illustrated through a particular example: the series of tablets in palace chapels. The widespread religious use of texts should not, however, be interpreted merely as a symptom of a crypto-calvinistic hostility to pictures. They signify first of all the crucial importance of the Word of God for the Lutheran Reformation.[46] Another aspect of this attitude was a heightened artistic cultivation of the letter itself, be it painted on wood (figs. 6 and 7), carved or etched in imperishable materials (figs. 2 and 4). Thus, in his handwritten manuscript on the art of writing – *Scriffuer Konst* – dedicated to the young Christian IV in 1590, the calligrapher Peder Trellund Riber even maintained that writing

[44] *Danmarks Kirker. Sorø Amt* 1 (København, 1936), 435f.

[45] Bugge (1990), 317.

[46] On the theological disputes over the use of pictures in the Early Lutheran church, see Anita Hansen & Birgitte Bøggild Johannsen: "IMO LICET. Omkring Niels Hemmingsens billedsyn", in: *Kirkearkeologi og kirkekunst. Studier tilegnet Sigrid og Håkon Christie* (Øvre Ervik, 1993), 181–198.

had to be reckoned among the liberal arts, being God's gift to mankind in order to strengthen and preserve knowledge and memory of all things.[47]

The wide-spread use of biblical quotations during the Reformation century were far from being restricted to the ecclesiastical sphere. Several examples can be found in secular contexts as well, ranging from the palaces of the prince and the dwellings of the nobility or ordinary citizens to the buildings of the city magistrates.[48] A telling example of this last-mentioned use is Hans Metzger's monumental canvas (fig. 10) from 1584, donated by Duke Ulrich of Mecklenburg to the City Hall of Güstrow, city of residence.[49] The painting juxtaposes the Last Judgment with the duke's court of justice, the latter being a reflection of the former, and thus illustrates the crucial notion of how the regent is bound to rule and pass judgment in accordance with God's law. The visual argument is supported by a number of quotations from the Old Testament, just as the duke is being flanked by a statue of Moses with the tablets of the law (cf. fig. 8). The message of the duke's donation is thus a pedagogical presentation to the city magistrates of the dogma of theocratic rule as God's order. It is more than tempting to assume that the young prince Christian (IV), a frequent visitor to his grandfather, Duke Ulrich in Güstrow, actually had the opportunity to contemplate Hans Metzger's painting and its biblical texts, "Ich hab wol gesagt, Ir seid Götter [...]" (Ps. 82:6) and "Durch mich regieren die Könige [...]" (Pro. 8:15–16), later to repeat this wisdom in his own "catechism of good government" inscribed in the marble tablets of his palace church at Frederiksborg.[50]

[47] This aspect has been discussed by Otto Norn: "Ord og Billede", in: *Nordiske Studier. Festskrift til Chr. Westergård-Nielsen* (Copenhagen, 1975), 195–208. As to the use of biblical quotations in the buildings of noblemen and private citizens, cf. Chr. Axel Jensen: "Lutherdom og Kirkekunst", in: *Fortid og Nutid* XI (1935–36), 143.

[48] In his funeral sermon for the Royal Chancellor Johan Friis, the historian Anders Sørensen Vedel referred to similar rhymed quotations put up in a number of manor houses belonging to the deceased; see Norn (1975), 207 (note 36).

[49] Johannes Erichsen (ed.): *1000 Jahre Mecklenburg. Geschichte und Kunst einer europäischen Region. Landesausstellung Mecklenburg-Vorpommern* (Rostock, 1995), 272.

[50] For this apt expression, used to characterize the paintings by Hans Vredeman de Vries for the Town Hall of Gdansk, cf. Susan Tipton: *Res publica bene ordinata. Regentenspiegel und Bilder vom guten Regiment. Rathausdekorationen in der frühen Neuzeit* (Hildesheim, Zürich, New York, 1996), 263.

Hugo Johannsen (b. 1942), MA in History of Art from the University of Århus. Since 1970 co-editor (1979–86 and 1995–98 director) of *Danmarks Kirker* (Denmark's Churches), a topographical inventory of Danish churches, published by the National Museum, Copenhagen. He is co-author of the inventories of churches in Northern and Western Zealand, Funen (Odense) and Eastern Jutland, most importantly the church of Our Lady, Kalundborg and St Canute's Church in Odense, the Cathedral of Funen. He has also written books and articles on Medieval and Renaissance architecture, especially from the reign of Christian IV. Together with his wife and colleague, Birgitte Bøggild Johannsen he is author of *Kongens Kunst* (Copenhagen, 1993) a volume on the Renaissance and the Baroque, published in a recent corpus on Danish art (ed. Fogtdals Forlag).

Religious Meditations on the Heart: Three Seventeenth Century Variants

Bernhard F. Scholz

> Ne cherchez plus mon coeur; les bêtes l'ont mangé.
> Charles Baudelaire (1821–67)

Introductory Remarks
Despite the fact that the seventeenth century was by and large a century of institutional differentiation and consolidation in matters religious during which controversialist rather than irenic attitudes characterized the theological enterprise, the religious literature of the period – below the level of official and institutionalized theology, so to speak – displays an at times surprising degree of homogeneity across denominational borders. Books of religious meditation could be made to suit the spiritual needs of the faithful of a denomination or a church other than that to which their original authors belonged, by occasionally rather minor adjustments in word and image. Add to this the fact that the religious literature below the level of controversialist theology produced by all churches and denominations could not help but exploit the riches of a shared *mundus significans*,[1] of a vast storehouse of genres, concepts and images handed down through the ages, and it will not come as a surprise that one is likely to encounter in that literature of religious meditation rather more similarities than differences. Comparisons of books of religious meditation from the seventeenth century will, I believe, yield more than just contingent insights into contingent differences and similarities with little significance beyond the fact that they are just that, similarities and differences. Instead they will offer us a view of a complex mosaic in which those seemingly heterogeneous books drawn from at times mutually tolerant, at times mutually antagonistic religious groupings, are likely to appear like pieces which will fit in more than one place.

[1] On the use of the concept of *mundus significans* as an analytical tool see Thomas M. Greene: *The Light in Troy. Imitation and Discovery in Renaissance Poetry* (New Haven and London 1982), 20.

In what follows I would like to make a modest contribution to the reconstruction of that mosaic by taking a closer look at three seventeenth century treatments of the heart as object, image and concept in the context of religious meditation: first an illustrated Roman Catholic book of meditation, Benedictus van Haeften's *Schola Cordis* (Antwerp, 1629), then a Protestant adaptation and translation into English of Van Haeften's Latin text, Christopher Harvey's *School of the Heart* (London, 1647/1664), and, finally, Daniel Cramer's *Emblemata Sacra* (Frankfurt/M., 1624), a Lutheran book of religious emblems. Studying Benedictus van Haeften's *Schola Cordis* in conjunction with Christopher Harvey's *School of the Heart* will need little justification. As an adaptation of Van Haeften's book, Harvey's *School* derives a good deal of its textual and pictorial material and its overall meaning from its predecessor. Contrasting it with Van Haeften's *Schola*, and focussing on the departures from the original which Harvey thought were necessary in order to make his book acceptable in a Protestant environment may therefore yield a number of insights into the different ways in which the piety of the laity was viewed and encouraged in both the Catholic and the Protestant camps. Daniel Cramer's *Emblemata Sacra*, by contrast, is not related to the other two books in terms of influence. But it does draw from the same storehouse of concepts and images, the same *mundus significans* as the other two, and it offers, we shall see, a genre-specific use of the same conceptual and iconographical materials also to be found in Benedictus van Haeften's and in Christopher Harvey's texts. All three texts are books of religious meditation, and that fact alone would suffice as a plausible *tertium comparationis*. Add to this that all three are *illustrated* books of religious meditation which employ the image of the heart as the principal iconographical element of the pictorial representations accompanying the verbal texts, and we will indeed find ourselves working in an area of the mosaic just mentioned, in which we may expect both a number of significant similarities as well as a number of significant confessional differences in the manner in which the concept and the image of the heart were being used in the seventeenth century for the purpose of stimulating and guiding religious meditation.

Obviously I can make no claim that the three religious-meditative descriptions of the heart on which I am going to focus exhaust the whole range of representations of the heart which the authors of seventeenth century books of religious meditation had at their disposal. My purpose

in studying these three texts is the rather more modest one of offering a contextual analysis of some uses of the heart – possibly exemplary ones – in seventeenth century religious texts, and to suggest that there existed during that period a range of conceptions of the heart which cuts across denominational lines, and which therefore should be viewed as forming part of the continuum of a theology of piety (*Frömmigkeitstheologie*[2]) which, as such, was not necessarily congruent with the institutionalized controversialist theologies taught in the seminaries and universities during that period.

That the three texts are not presented here in chronological order is due to the fact that Protestant books of religious meditation more often than not make a selective use of elements from an older and shared Christian *mundus significans* of literary and pictorial genres, concepts and images. Undoubtedly they also add new elements, especially elements capable of representing the inner, rather than the outer world of man. But in order to be able to appreciate the nature of both the selections and the additions, it is advisable to study the culturally "older", and that means the Catholic book of religious meditation, first.

Benedictus van Haeften's Schola Cordis:
the Heart as the Centre of Creation
Let us begin, then, with a brief analysis of some of the salient characteristics of Benedictus van Haeften's *Schola Cordis*.[3] The very first sentence of the *Schola Cordis* suggests that what Van Haeften had in mind was not

[2] I am using the term in the sense proposed by the Lutheran church historian Berndt Hamm who introduced it with an eye to having at his disposal a means to discuss the manner in which theological concepts find expression in texts other than those produced by academic theologians. See his "Frömmigkeit als Gegenstand theologiegeschichtlicher Forschung", in: *Zeitschrift für Theologie und Kirche* 74 (1977), 464–497.

[3] Benedictus van Haeften's numerous works of religious meditation are still waiting to be rediscovered. A considerable number of his allegorical sermons have not yet been published. For an overview see H. Verleyen OSB: "Dom Benedictus van Haeften, Proost van Affligem. Bijdrage tot de studie van het kloosterleven in de Zuidelijke Nederlanden", in: *Verhandelingen van de Koniklijke Academie voor Wetenschappen, Letteren en Schone Kunsten. Klasse der Letteren*, vol. 45, nr. 106 (1983), 196–205; H. V.: "Benedictus van Haeften († 1648) als Geestelijk Schrijver", in: *Ons Geestelijk Erf. Orgaan van het Ruusbroecgenootschap* 60 (1986), 204–253, 349–392 and 61 (1987), 219–263; For a more detailed discussion of Van Haeften's use of the heart than can be given here see my "Het hart als *Res Significans* en als *Res Pica*", in: *Spiegel der Letteren* 33 (1986), 115–147. When offering quotations in the body of the text I shall use "*SC*" for Benedictus van Haeften's *Schola Cordis*, "*SH*" for Christopher Harvey's *School of the Heart*, and "*ES*" for Daniel Cramer's *Emblemata Sacra*.

a theological treatise on the human heart which would have satisfied the norms of definition and presentation which were prevailing at the time for such treatises. Instead, his aim was to write a book in which the intended reader's own affairs would be dealt with in such a way that he or she would recognize that this was so:

> CORDI tuo, Lector CORDATE, Gymnasium CORDIS aperimus; in quo de CORDE tuo, ad COR tuum loquimur. (SC, 1)

> For the benefit of your heart, dear reader, we are going to open this School of the Heart, in which we shall speak to your heart about your heart.

The heart is to be instructed with the aid of answers to the questions how it should be led to God, how it should enter God's presence, and, finally, how it should be united with God ("… quomodo ad Deum dirigi, illi aptari, eidemque vniri debeat ….", SC, 1).

The human heart is thus both the subject and the recipient of the teaching offered by the *Schola Cordis*. We are therefore looking at a book in which *doctrina* and *applicatio*, doctrine and application, have not yet parted company,[4] as they were to do in the texts of the New Science of the seventeenth century.

Yet what is being said about the heart is nevertheless offered as *scientia* and not merely as *opinio*.[5] In keeping with tradition, Van Haeften, in presenting his doctrine of the heart, relies heavily on what had previously been said on this subject by the *auctores*: the prefatory pages of his book contain an "Auctorum qui in his Libris citantur syllabus", a lengthy list of authorities cited. The message clearly is that what he has to say derives both its authority and the conviction it will impart from those *auctores*. Van Haeften himself, the actual author of *Schola Cordis*, wishes to disappear, as it were, behind a cloud of quotations:

> Cum enim vix quidquam dici possit, quin dictum iam illud sit prius; placuit ipsos Auctores suis verbis loquentes potius audire, quam rudi nostro stylo eorum conceptus Lectoribus repraesentare. Habent enim SS. Patres, veteresque Scriptores plurimum roboris, auctoritatis, atque elegantiae, quibus animus hominis efficacissime conuincitur. (SC, 6)

[4] On the role of *applicatio* in medieval hermeneutics see Hennig Brinkmann: *Mittelalterliche Hermeneutik* (Darmstadt, 1980).

[5] On the significance of this distinction during the seventeenth century see Ian Hacking: *The Emergence of Probability* (Cambridge, 1986), 18–38.

Since hardly anything can be said that has not been said before, we have ourselves preferred to listen to the words of the *auctores* themselves, rather than conveying their ideas to our readers in our own rough style. For the most saintly Fathers and the old Writers possess the greatest strength, authority and elegance, by which the human mind is won over most successfully.

Note that the choice is not between either conveying one's own ideas or those of the *auctores*; it is between conveying their ideas either in their own words or in one's own inferior ones.

An additional reason for quoting the *auctores* literally rather than just paraphrasing them is of particular interest in view of what Harvey will eventually do with Van Haeften's text. Explaining why he chose the term "lectio" rather than "meditatio" he points out that not only does "lectio" better agree with the notion of "schola" in the title of his book, but the very concept of "meditatio", he believes, would represent an obstacle to giving the *auctores* their due:

> [...] placuit tamen Lectionum potius, quam Meditationum nomine insignire: cum quod Scholae nomine id magis congruere videretur: tum vt varii Auctores, (qui passim in hoc Opusculo citantur, interque illos subinde etiam Poëtae, Ethnicique Scriptores) melius sua phrasi loquerentur: quod Meditationum forma non ita comode forsitan admisisset. (SC, 7)

> [...] nevertheless we decided to call them (i.e. the considerations offered in the *Schola Cordis*) lessons rather than meditations, on the one hand because that name agreed better with that of a School, on the other because the various *auctores* (who are being quoted *passim* in this work, and among whom there are also poets and pagan writers) should better speak with their own words, something perhaps not so easily permitted by the form of meditations.

The very form of a meditation, in Van Haeften's view, would not have permitted quoting the *auctores verbatim*. Van Haeften does not tell us why that should be so, but the reason can only be that the kind of book of meditation he has in mind would have to involve in the subject position a meditating self uttering his own thoughts and feelings, and that is precisely the stance which he himself does not wish to adopt in his text.

Not surprisingly, then, Van Haeften's text turns out to contain, for clearly programmatic reasons, numerous quotations from specific *auctores*, but also assertions regarding the heart identified as deriving from the arts of the *trivium* and the *quadrivium*, that is from Grammar, Dialectics,

Rhetoric, Music, Arithmetic, Geometry and Astronomy. In addition it offers insights about the heart culled from the *scientiae superiores*, as he calls them, that is from physics, jurisprudence, ethics, medicine and theology.

All of these disciplines Van Haeften treats as *exegetic* rather than *analytical* or *empirical* disciplines. Their explicit task in his view is to contribute, each from a specific disciplinary point of view, to *the deciphering of the text of the human heart written by the hand of God*. That idea of a text of the human heart waiting to be deciphered, it hardly needs pointing out, is in perfect accord with the traditional view of the sciences as contributors to the deciphering of the *liber naturae*, the book of nature, which had been the dominant view until the advent of the New Sciences in the seventeenth century.[6]

That this *exegetic approach to nature* with the aid of the texts of the *auctores* was no longer unchallenged by the end of the first third of the seventeenth century becomes apparent if we cast a brief glance at what René Descartes had to say on the subject of the *auctores* at around the same time. In his *Regulae ad directionem ingenii* of 1628, his *Rules for the Guidance of Reason*, Descartes insists on beginning with elementary truths, and then moving on to the analysis and explanation of complex phenomena on the basis of what one has already found out about their elementary components. What certainly must be avoided, he points out, is spending much time on studying and interpreting what others have already said about the topic. What we must do instead, he suggests in rule III, is to concentrate on perceiving those elementary truths with our own eyes, and, subsequently, on deduction:

> [...] non quid alii senserint, vel quid ipsi suspicemur, sed quid clare et evidenter possimus intueri vel certo deducere quaerendum est; non aliter enim scientia acquiritur.[7]

[6] On the *topos* of *liber naturae* see Ernst Robert Curtius: *Europäische Literatur und Lateinisches Mittelalter* (Bern, 1948), 306–352 (tr. by Willard R. Trask under the title *European Literature and the Latin Middle Ages* [New York, 1953], 302–347); Erich Rothacker: *Das "Buch der Natur". Materialien und Grundsätzliches zur Metapherngeschichte*, Ed. W. Perpeet (Bonn, 1979). On the cognitive significance of this metaphor see Hans Blumenberg: *Die Lesbarkeit der Welt* (Frankfurt/M, 1981). On the "book of nature" as an *apriori* of representation see my article "Marginalien bij het Boek der Natuur", in: *Feit en Fictie. Tijdschrift voor de geschiedenis van de representatie* I, 2 (1993), 51–74.

[7] René Descartes: *Regulae ad directionem ingenii. Regeln zur Ausrichtung der Erkenntniskraft*, Ed. H. Springmeyer et al. (Hamburg, 1973), 14.

We must not inquire into what others have thought or what we ourselves suspect, but what we can see with a clear and evident intuition, and what we can reliably deduce. That alone is how one acquires knowledge.

If we were to concentrate instead on what the *auctores* have said on a particular subject we would end up with historical rather than with scientific knowledge: "[...] ita enim non scientias videremus didicisse, sed historias."[8]

In Descartes' *Regulae ad directionem ingenii*, then, published one year before Van Haeften's *Schola Cordis*, we encounter a complete rejection of the traditional role of the *auctores* in favour of an exclusive reliance on one's own senses and one's own reason, and an explicit denial of the label "scientia" to the products of those *auctores*.[9] In the case of Van Haeften's *Schola Cordis*, by contrast, we encounter an equally complete reliance on the wisdom and knowledge of the auctores.[10] Christopher Harvey, we shall see, will likewise turn away from the *auctores*; but in his case the alternative is not a reliance on one's own senses and one's own reason. Instead it consists in an abdication of both, and complete surrender to the will of God.

A brief passage from the *Schola Cordis* will serve to illustrate the effect on the structure of the text of that reliance on the *auctores*. Van Haeften here tries to locate the heart, as it were, by means of an open series of analogies derived from various sciences:

> Quare quod in caelestibus illis orbibus est primum mobile; quod in vniuerso hoc, Sol; quod in plantis, radix; quod in circulo, centrum; quod in Paradiso fuit fons ille qui irrigabat vniuersam faciem terrae, hoc in homine est COR, a quo omnis lux, omnis calor, omnis motus, omniumque operationum principium in reliqua membra deriuatur. (*SC*, 3)

> What the *primum mobile* is to the heavenly spheres, the sun to the world, the root to the plant, the centre to the circle, what that well was in Paradise which moistened the whole earth, that for man is the heart from which derive all the

[8] Ibid. 16.

[9] For a discussion of the role of the *auctores* in the context of medieval argumentation, a role which is as yet unchallenged in Van Haeften's text, see e.g. L. M. de Rijk: *Middeleeuwse wijsbegeerte. Traditie en vernieuwing* (Assen, 1981), esp. 115–24 and 129–34.

[10] If one wishes, one may see this as a foreshadowing of the "two cultures" that became the hallmark of Western culture during the nineteenth and the twentieth centuries.

light, all the warmth, all movement, and all impetus toward action in the other parts of the body.

The principle underlying Van Haeften's idea of knowledge is that of resemblance: his text unfolds like an elaborate net of similarities which is cast over the world. The heart, one might put it, becomes a central node or intersecting point in that net, and it is linked through relations of resemblance and analogy to all other nodes.[11]

All of this gathering and serial ordering of the knowledge and the wisdom of the *auctores* takes place in the first part of Van Haeften's *Schola Cordis*. Not inappropriately, he calls that first part the "Praevia ad Doctrinam Cordis introductio", the "Prefatory Introduction to the Doctrine of the Heart". There is, thus, for Van Haeften a mass of received doctrine concerning the heart, gathered together by the *auctores* in many fields of knowledge. The intended reader of the *Schola Cordis* needs to have been made familiar with that doctrine if he is to benefit from the actual lessons which follow a few pages later. The Praevia ad "Doctrinam Cordis introductio", one might put it, delineates the proper frame of reference, derived from and sanctioned by the *auctores*, in the context of which the instruction of the heart will be able to take place. Putting it perhaps just a little too pointedly, one might say: prior *instruction about the heart* on the basis of the knowledge gleaned from the *auctores* serves as a *conditio sine qua non* of the *instruction of the heart*.

The actual "School" where the instructing of the heart takes place comprises a total of fifty-five lessons. These are subdivided into three books and seven classes. The ordering of the lessons within the three books is dogmatically motivated, beginning with *Cordis Aversio*, the turning away of the heart, and ending with *Cordis cum Cruce et Crucifixo confirmatio*, with the heart's confirmation by means of cross and crucifix. It is, one might say, a narrative ordering which traces the road of the heart from sin to salvation, marking the stations on that road with passages from the Bible, and with homilies based on those passages. We shall return to the structure of these lessons when we take a closer look at the word-image relations in the three texts.

[11] In the terminology of Foucault's *Les Mots et les Choses* Van Haeften's text would clearly be one informed by the "episteme of resemblance".

Christopher Harvey's School of the Heart: *the Road to Inwardness*

Christopher Harvey's *School of the Heart* can be considered an adaptation of Benedictus van Haeften's *Schola Cordis*. It offers a perfect example of how, in the course of the seventeenth century, a considerable amount of religious poetry, especially religious poetry written by Protestant authors, turned inward. That development could easily be linked with certain tenets of Protestant theology, both Lutheran and Calvinist. However, being interested more in religious discourse than religious dogma at the moment, I shall refrain from pursuing this line of investigation. I shall concentrate instead on the question of how that inward turn – if that is what we wish to call it – manifested itself in the verbal parts of Harvey's *School of the Heart*, and in the new role which those emblems that were taken over from Van Haeften's *Schola Cordis* came to play in Harvey's text.[12]

Harvey reduced the number of lessons from fifty-five to forty-seven. When an "emblem" or a lesson accompanying it looked or sounded too Roman-Catholic to him, he either left out the lesson in question altogether, or he saw to it that the *pictura* was altered or replaced so as to conform with Protestant doctrine. The most striking example of this practice is the replacement of Van Haeften's introductory emblem entitled "Cordis fuga" (fig. 11), the "Flight of the Heart from God", by one entitled "The Infection of the Heart", (fig. 12) depicting Eve and the Serpent. The Thomist idea of evil as a *defectus boni*, a diminishing of the good, one might put it, has given way to an image recalling the Calvinist idea of total depravity as a consequence of original sin.

Less obvious, but perhaps more interesting for our topic are the facts that while Van Haeften's *Schola Cordis*, with the exception of the distichs accompanying the emblems, is all in prose, not a single line of prose is to be found in the text of Harvey's *School of the Heart*; that the speaking voice of the *School of the Heart* is no longer that of the teacher addressing and instructing another person but that of the confessing soul itself, inviting the reader to follow its example; and, finally, that the material of Van Haeften's introductory book on the doctrine of the heart, and with it every single reference to the *auctores* and to the knowledge about the human heart which could be gathered from the texts of the *trivium*, the

[12] I shall assume that an investigation of the word-image relations realized in both texts should go beyond studying only those pages which contain the emblems. Otherwise, their function will remain obscure.

quadrivium, and the *superiores scientiae*, has been omitted in Harvey's *School of the Heart*.

These changes are radical indeed, and it stands to reason that the "emblems" of Harvey's *School of the Heart*, taken over from Van Haeften's *Schola Cordis*, and again occupying a whole page at the beginning of every lesson, will also have a rather different role to play from the one they played in the *Schola Cordis*. Let us briefly consider each of these points of difference.

Van Haeften, as we have seen earlier on, was at pains to stress the role of the *auctores* for his work. Not only did he want to make use of their ideas; their very own words, too, were to be used. The use of prose throughout the *Schola Cordis*, it would seem, is well suited for establishing the desired (inter)textual continuity between Van Haeften's own texts and those of the *auctores* whose wisdom and knowledge he, in an attitude of authorial modesty, wished to convey to his readers in their own rather than in his words. Continuity with tradition is a central issue for Van Haeften, and prose, since it permits quotations from various origins without superimposing the contours of a single speaking voice, is therefore the appropriate medium for safeguarding that continuity. Prose recommends itself also in the actual lessons addressed to the reader of the *Schola Cordis*. Van Haeften's is clearly an *argumentative text*, a text intended to persuade its reader by means of argument, and one frequently encounters paragraphs beginning with "Considera ergo Primo", "Considera Secundo", "Considera Tertio", "Considera Quarto", passages raising rhetorical questions and passages pleading with the reader. The *reader*, in short, is constituted by Van Haeften's text as the *rational Other* who can be brought to change his ways by means of argument. The *speaker*, on the other hand, is constituted as the *self-effacing teacher* addressing the reader in his capacity as a spokesman for and a mouthpiece of received knowledge, but also as a teacher who knows that he is only a feeble stand-in for the only real teacher, namely the "caelestis doctor" (*SC*, 30) who created man. And the *heart*, finally, which is to receive instruction through Van Haeften's text, is a *rational heart*, if I may put it that way, a heart to be persuaded by argument and insight, not swayed by emotions.

Harvey's text by contrast, as I have already pointed out, is all in verse. In the place of Van Haeften's lessons in prose addressed to a reader

waiting to be instructed, Harvey has "odes".[13] Harvey's odes vary considerably in length and in form. What they all have in common, though, is that in each the soul speaks about itself, and in so doing reveals its present stage on the path towards salvation. In a few cases this takes the form of dialogue: in Ode I the soul speaks with the Serpent; in Ode IV it speaks with Christ. But the presence of dialogue in a number of odes is subsidiary to the essentially *confessional* nature of the *School of the Heart* as a whole. Harvey's dialogues are not meant to confront the reader with both sides of an argument, or to lead him to reject one side of an argument and accept the other. Instead, they show the confessing soul engaged in activities which will bring it closer to salvation, and the thrust of those odes, too, is the encouragement of the reader to follow the confessing soul's example, rather than an invitation to reasoning.

Here are the introductory stanzas of the first ode in which the soul, in dialogue with the Serpent, gains an understanding of the contagion by which it is affected:

> *The Soul.*
> Profit, and pleasure, comfort, and content,
> Wisedom, and honour, and when these are spent
> A fresh supply of more! Oh heav'nly words!
> Are these the dainty fruits, that this fair Tree affords?
>
> *The Serpent.*
> Yes these, and many more, if more may be,
> All, that the world contains, in this one Tree
> Contracted is. Take but a tast, and try,
> Thou maist believe thy self, experience can not lye. (*SH*, 3)

The soul is presented as questioning, trying to understand the meaning of the Tree in this first lesson of the *School of the Heart*, and as struggling against what its "voyce-enveigled ear" (*SH*, 3) allows it to hear. Note also the negative connotations attached to experience brought about by making the Serpent its champion. The denigration of the senses and of the kind of experience they are able to offer to the soul, we shall see, is

[13] Why Harvey should have called his poems "odes" is not quite clear; perhaps that genre term was suggested to him by the flurry of odes which appeared in England in the middle of the seventeenth century in the wake of the publication of Abraham Cowley's *Pindaric Odes*.

an important aspect of the didactic programme of Harvey's *School of the Heart*.

The *voice of the teacher* which had characterized Van Haeften's text, and the *arguments* addressed by that teacher to the reader have thus completely disappeared from Harvey's text. In their place we find the *voice of the confessing self on the path toward self-knowledge and salvation*. The omnipresent Other of Van Haeften's *Schola Cordis*, the reader to be instructed, makes only one very brief appearance in Harvey's text: having stated in the introductory poem that the goal of the *School of the Heart* is self-knowledge, the speaking self, in the last two lines, considers the possible use of this book to others:

> Lord, if thou wilt, thou canst impart this skill: [i.e. the skill of self-knowledge]
> And for other learning take't who will. (*SH*, Introduction, 3)

Confession in the place of argument, facilitating repetition and re-enactment in the place of offering instruction, that is how one might sum up this shift from Van Haeften's *Schola Cordis* to Harvey's *School of the Heart*. And in this context it seems relevant that the *voice-neutral* or *non-voiced prose* of Van Haeften has given way to the *voice-marked poetry* of Harvey. For at issue is not the wisdom of the teacher which has been inherited from tradition and is waiting to be passed on, but the experience of the self as self. And while, as we have seen, the reader in Van Haeften's text is constituted as the Other at whom an argument is directed, he (or she) is constituted in Harvey's text as another self who, in reading and singing the odes which now make up the lessons, becomes himself or herself the confessing "I" by adopting, as it were, the personal pronoun "I" of the *persona* of those odes.

The silencing of the voice of the teacher goes hand in hand with a muting of what one might call external as opposed to internal knowledge. I have already mentioned that Harvey omits all of the materials of Van Haeften's introductory book on the doctrine of the heart. Not only does he leave them out; if one reads Van Haeften's *Schola* next to Harvey's *School* that omission takes on the appearance of a programmatic rejection. Here are the first few lines from Harvey's introductory poem entitled "The Introduction":

> *Turn in, my mind, wander not abroad,*
> Here's work enough at home, *lay by that load*
> *Of scattered thoughts*, that clogs and cumbers thee:
> Resume thy long neglected liberty
> Of *self-examination: bend thine eye,*
> *Inward, consider where thy heart doth lye,*
> How 'tis affected, how 'tis busi'd: look
> *What thou hast Writ thyself in thine own Book,*
> *Thy Conscience*: here set thou thy Self to School.
> Self-knowledge 'twixt a Wise man and a Fool
> Doth make the difference. […] (SH, Introduction, 1)[14]

And, a little later, there is a reference to what self-knowledge stands in opposition to:

> Find'st thou such sweetness in *those sugar'd lyes*?
> Have *Forain objects* so *ingrost thine eyes*?
> Canst thou not hold them off? Hast thou an ear
> To listen, but not what thou should'st not hear?
> *Are thou incapable of every thing,*
> *But what thy senses to thy fancy bring*? (SH, Introduction, 1)[15]

All through the *School of the Heart* one comes across similarly disparaging remarks about knowledge granted by and obtained through the senses. The self is presented as drowning itself in "sensual delight" (lesson 2), it is called by Christ "Poor, silly, simple, sense-besotted soul" (lesson 4), and accused by him in these words: "Thy sense-led fancy barters good for reason". Is this, one wonders, a reaction to the extolling of sense experience as the only reliable source of knowledge by representatives of the empiricist strand of the New Sciences of the seventeenth century? And is the inward movement of Harvey's discourse on the heart – as that of many other religious writers on the heart – perhaps due, at least in part, to the fact that with the outer world having been claimed and, as it were, carried away by the New Sciences, the representational model exemplified by Van Haeften's *Schola Cordis* could no longer be used for matters of the heart?[16]

[14] Italics mine.

[15] Italics mine.

[16] True, the idea of turning away from the senses as a reliable source of knowledge is traditional in the Middle Ages, and so Van Haeften could be understood to be continuing

While the argument of Van Haeften's *Schola Cordis* was addressed to the understanding of the reader in the hope of convincing him to give up his *Fuga Cordis*, the "Flight of his Heart", Harvey's *School of the Heart* starts out from the conviction that getting to know one's heart on one's own is quite impossible:

> *Thou know'st I do not, cannot, have no mind*
> *To know mine heart*: I am not only blind,
> But lame, and listless: *thou alone canst make*
> *Mee able, willing: and the pains I take,*
> *As well as the successe, must come from thee,*
> *Who workest both to will and do in me.* (SH, Introduction, 2)[17]

That impossibility, it would seem, refers both to knowledge afforded by the senses – and to knowledge inherited by tradition. Hence there is, if you wish, no role left to play in Harvey's *School* for the teacher as a gatherer and mediator of traditional knowledge, nor for the sense experience of the New Sciences. The soul is still the scholar – in the sense of "pupil" – but in the *School of the Heart* it is presented as going through God's own school and giving – lyrical – voice to that experience so that others might repeat it.

I mentioned earlier on that in Harvey's *School of the Heart* the *auctores* of Van Haeften's *Schola Cordis* have been eliminated together with their authoritative wisdom, as have the references to the *artes* and the *scientiae* which had played such a prominent role in Van Haeften's programme of instruction. The last part of that claim I now need to modify slightly in order to do full justice to Harvey. It is true that since he does not allow for the possibility of causing the soul to change its ways through argument, Harvey has no use for the knowledge gathered through learning. Yet, in the concluding section of his *School of the Heart*, he offers, under the general title of "The Learning of the Heart", first a brief "Grammar of the Heart", then a "Rhetorick of the Heart", and, finally, a "Logick of the Heart". But now those three *artes*, in contrast to the role

this line of thought. But it is one thing to denounce the senses in a cultural context which is broadly united in doing so, and finds support for this attitude in the *auctores*, and quite another thing to do so in a cultural context with an increasingly vocal and influential sector which denounces the *auctores* as unreliable, and extols sense experience as the most prominent if not the only valid source of knowledge.

[17] Italics mine.

they had been assigned to play in Van Haeften's text, are no longer viewed as the disciplines which gather *knowledge about the heart*. Instead, they are now presented as the *artes* – in the sense of skills – which should govern the very speaking of the heart:

> My *Grammar*, I define to be *an Art,*
> *Which teacheth me to write and speak mine heart.*
> By which I learn that smooth tongu'd flatt'ries are
> False Language, and in love irregular.
> *Among'st my Letters, Vow-wells [sic!] I admit,*
> *Of none but Consonant to sacred Writ.*
> [...]
> My Grammar hath no moads [sic!] nor conjugations:
> Tenses, nor Persons, nor Declensions,
> Cases, nor genders, nor comparisons
> [...]
> *Concord is all my Syntax and agreement*:
> Is in my Grammar perfect regiment. (SH, 192)[18]

Rhetoric and logic both receive similar treatment. But in all three cases the *ars* in question is not considered a repository of rules for making grammatically coherent, rhetorically effective or logically sound texts. Van Haeften, we may be sure, would have considered those arts in this manner. Instead, they are employed by Harvey as suppliers of extended metaphors which he can put to use in describing the qualities of his writing:

> My *Logick* is the *faculty of Faith,*
> Where all things are resolv'd into he saith;
> And Ergoes drawn from trust and confidence,
> Twist and tie Truths with stronger consequence
> Than either sense or reason: for *the heart*
> *And not the head is fountain of this Art.* (SH, 195)[19]

[18] Italics mine.

[19] Italics mine. One is reminded of the Jansenist idea of a *logique du coeur* in Pascal's *Pensées* which dates from the same decade as Harvey's *School of the Heart*: perhaps one has to cast one's net more broadly in order to understand the precise nature of Christopher Harvey's Englishing and Reforming of Benedictus van Haeften's *Schola Cordis*.

Daniel Cramer's Emblemata Sacra: *the Heart Speaking*

In contrast to Benedictus van Haeften's *Schola Cordis* and Christopher Harvey's *School of the Heart*, both of which defy generic categorization beyond the broad claim that these are books of religious meditation which contain, among other types of texts, a number of emblematic word-image combinations strongly reminiscent of emblems, Daniel Cramer's *Emblemata Sacra* is easily identified as an emblem book.[20] It is, indeed a book of emblems which can easily be assigned a place within the range of variants which the emblem genre had developed in the just under one hundred years since its first appearance on the literary scene in 1531 in the form of Andrea Alciato's *Emblematum liber*.[21]

Emblemata Sacra comprises two groups of fifty self-contained word-image texts, each occupying two facing pages, and each made up of an emblem proper consisting of motto, *pictura* and subscription, to which are added a quotation from the Old or the New Testament on the right-hand page, and, on the left-hand page, four poems in Latin, German, French and Italian which offer variations on the motto and/or the biblical quotation.

The preface to the "günstige Leser", the benevolent reader, by Daniel Cramer's Frankfurt printer and publisher, Lucas Jennis, offers the reasons for this innovative combination of emblems with biblical quotations. The ancient Egyptians, Jennis points out, used "to reveal to each other their deep wisdom and the thoughts of their hearts through characteristic images of animals or other familiar and natural objects" ("ihre hohe Weißheit / und Hertzens Gedancken / einander mit sonderlichen Bildern der Thier / oder anderer bekandten und natürlichen Dingen pflegten zu offenbahren") (*ES*, A iiii). In later ages, Jennis suggests, the example set by the ancient Egyptians of speaking and teaching ("ermeldte Ahrt des Redens und Lehrens") prompted poets to produce

[20] On Daniel Cramer as a writer of emblem books see Sabine Mödersheim: *'Domini Doctrina Coronat': Die geistliche Emblematik Daniel Cramers (1568–1637)* (Frankfurt/M, 1994); S. M.: "Biblische Metaphorik in Daniel Cramers '80 Emblemata moralia nova'", in: B. F. Scholz et al. (eds.): *The European Emblem* (Leiden, 1990), 107–116; S. M.: "Herzemblematik bei Daniel Cramer", in: A. Adams et al. (eds.): *The Emblem in Renaissance and Baroque Europe. Tradition and Variety* (Leiden, 1992), 90–103.

[21] For an overview of the development of emblematics during the sixteenth and the seventeenthy centuries see my "Emblematik: Entstehung und Erscheinungsweisen", in: U. Weisstein (ed.): *Literatur und bildende Kunst. Ein Handbuch zur Theorie und Praxis eines komparatistischen Grenzgebietes* (Berlin, 1992), 113–137.

Vielfältige *Inventiones* ... / so zum theyl ganz erdichtet / zum theyl auch mit wahrhafften Historien vermenget ... / damit sie nicht nur die Ohren / als mit Mehrlein und Fabeln erfüllen / sondern vielmehr die Gemüther unterrichten wollen / wie sie nemlich allerhandt Laster ... sollen meiden / und dargegen sich der Tugend (welche ein geruhig und glückselig Leben verursachet) befleissen (*ES*, A iiii, A5 v).

many different kinds of inventions ... which were sometimes totally fictitious, sometimes mixed with true stories ... and all with the aim of not only filling their readers' ears with tales and fables, but rather to teach their minds how to avoid all kinds of vices ..., and how to practice the (one) virtue (which is the source of a quiet and happy life).

The art of Egyptian hieroglyphical writing – as (mis)understood during the seventeenth century[22] – thus serves as a model for moral instruction. What Cramer, according to Jennis, wished to take over from that writing by means of images was its (assumed) ability to "reveal" wisdom and innermost thoughts ("Hertzens Gedancken") by means of the depiction of familiar objects taken from the natural world. But according to Jennis there was the danger in proceeding in the manner of the ancient Egyptians that these images would fill the mind with tales and fables only ("Mehrlein und Fabeln"), with fictions, that is: hence the decision by some poets to add true stories ("wahrhaffte Historien"), and thus to ensure the proper – in the sense of well founded – avoidance of vice and the striving after virtue. But if we follow Jennis' capsule history of writing in pictures up to Cramer's *Emblemata Sacra*, that was still not enough. The virtues presented there, now taught properly by means of true stories – Jennis is undoubtedly thinking of the teaching of right action through historical *exempla* – might indeed be the ones needed for conducting the kind of quiet and happy life the ancients had envisaged. They were, however, not yet the ones which a Christian needed to be taught in order to be able to attain the salvation of his soul:

In diesen unsern Zeiten aber ist man hierinnen so weit gekommen / daß man die Poetische Fabeln etlicher massen verlassen / und damit solche Erinnerungen desto mehr durchdringen / und auch diese Ubung zur mehrern *Perfection* gebracht würde / die Heilige Schrifft dazu gebrauchet / und

[22] For a brief overview see my article "Hieroglyphik", in: *Reallexikon der Deutschen Literaturwissenschaft*, Vol 2 (Berlin, 2000), 46–49.

Emblemata sacra gemacht / dardurch dann nicht nur eusserliche Tugendten / sondern auch zugleich wahre Gottseligkeit vorgestellet werden (*ES*, A5 v).

In these times we have reached the point were we have left poetic fables far behind, and in order that this recollection (i.e. of the Egyptian practice of conveying wisdom) would become all the more pervasive and also that this practice would reach a higher level of perfection, we have made use of the Holy Bible and made the *Emblemata sacra* in such a way that now not only the outward virtues but also and at the same time true beatitude in God can be represented.

Daniel Cramer's *Emblemata sacra* are thus presented by his printer/publisher as taking up and continuing an ancient tradition which could be traced all the way back to the hieroglyphs of the ancient Egyptians. In addition, Cramer is credited with having provided that tradition with both a new and different focus and a new and different content, leaving only its signifying practices intact, one might add. In the place of the older Pagan "eusserliche Tugendten", which did indeed enable one to live "ein geruhig und glückselig Leben", a quiet and a happy life, Cramer is said to have wished to put forward a Christian virtue which promises "wahre Gottseligkeit". Hence, undoubtedly, the decision to cull as much as possible of the conceptual as well as the pictorial material of *Emblemata sacra* from the Old and the New Testament.

It is worth noting in passing how the term "eusserlich" is used here by Jennis in such a way that an openly contrary opposition of ancient (pagan) and Christian virtue is avoided. Placing "eusserliche Tugendten" and "wahre Gottseligkeit" in opposition to each other *de facto* amounts to labelling – albeit implicitly – the former as "false" and the latter as "inward". The point, however, is precisely that this contrary labelling occurs by implication only. The formulations actually chosen by Jennis avoid qualifying ancient virtue in an altogether negative manner, while at the same time leaving no doubt in the reader's mind as to which of the two virtues is the one required for the conduct of a Christian life, and therefore the one to be preferred. The opposition between the two kinds of virtue thus emerges as one which is not really mutually exclusive. It allows for a form of coexistence side by side, a reading which is supported by the fact that Jennis makes use of a syntactical construction which does indeed come close to stressing their necessary coexistence: the relation of outward virtues and beatitude in God, we are given to understand, is not only a case of "not only … but also" but, stronger still, also one of "at the

same time": "nicht nur eusserliche Tugendten sondern auch zugleich wahre Gottseligkeit". Jennis thus manages to stay clear of the simplistic and potentially dangerous opposition of "outward virtues" and "true beatitude in God", and to leave room for the view that even the concentration on "wahre Gottseligkeit" expected of a believer must also involve some attention given to "eusserliche Tugendten". I think one would not be stretching matters too much if one were to suggest that this carefully crafted rhetorical balance between inward and outward virtue is in keeping with both the Lutheran understanding of Matthew 22:21 as an advice to give both realms, the Emperor's and God's, their due, and of John 17 with its not mutually exclusive opposition of "in the world" and "of the world".[23]

Since the emblems of *Emblemata Sacra* will indeed focus exclusively on "wahre Gottseligkeit" we are possibly meant to read this preface not only as a brief reminder of the genre conventions which Cramer will be following – presenting "hohe Weißheit und Hertzens Gedancken" by means of pictures in the fashion of the hieroglyphs of the ancient Egyptians – but also as a hint that the chosen focus of the book, the presentation of true beatitude in God, should not be read as a suggestion to flee the world altogether. Daniel Cramer died in 1637, and the term "pietism" is indeed not attested earlier than in the last third of the seventeenth century. So we would undoubtedly be going too far if we were to think of this as an implicit position-taking in a pietist debate regarding the proper conduct of life, and the place therein of "the world". That debate was still a while off in the future. But it seems to me that in the run-up of that debate, in the decades, that is, during which this debate was gradually taking shape, Cramer's printer and editor Jennis may indeed have wished to suggest, by means of his preface, that the recommendation of a complete withdrawal from the world was not to be derived from *Emblemata Sacra*, despite the volume's explicit focus on true beatitude in God.[24]

[23] Needless to add that with this recognition of an opposition resp. non-opposition of "wahre Gottseligkeit" and "eusserliche Tugendten" we are right in the center of the Reformation struggle about the proper understanding of virtue. Thus Luther in his *Disputatio contra scholasticam theologiam* of 1517 insists that "nulla est virtus moralis sine vel superbia vel tristicia, id est peccato" (No. 38), see *D. Martin Luthers Werke. Kritische Gesamtausgabe*. Vol. 1 (Weimar, 1883), 226. But even with such a qualification – not to say indictment – of *virtus moralis* we would probably go too far if we were to read it as an outright dismissal of moral virtue.

[24] But in the absence of documents pertinent to the reception of the *Emblemata Sacra* we

Emblemata Sacra does indeed contain no reference to "the world" as creation, as Benedict van Haeften's *Schola Cordis* does repeatedly. The ontological dimension of the *Schola Cordis*, that is to say, which accounted for the *situs* of the heart in the totality of things, now remains unspecified. Nor does *Emblemata Sacra* explicitly present us with the theme of an inward movement, of a withdrawal from the world as does Christopher Harvey's *School of the Heart*. Instead, the *world*, in the relatively few cases when it is mentioned in one of its worldly aspects by means of a line or two first from the Vulgate and then from Luther's translation of the Bible, appears as the implacable *opponent* against which the heart of man should be on guard: "Fället Euch Reichtumb zu / so hänget das Hertz nicht daran" (Ps. 62, emblem I, 16); "Wohl dem der für bösem Maul bewahret ist" (Eccles. 28:23, emblem I, 27; "Weder zur Rechten / noch zur Linken" (Num. 20:17, emblem I, 34); "Wo ewer Schatz ist / da ist ewer Hertz" (Matt. 6:21, emblem I, 32); "Wir haben hier keine bleibende statt / sondern die zukünftige suchen wir" (Hebr. 13:14, emblem I, 37); "Wo ein Aaß ist / da samblen sich die Adler" (Matt. 24:28, emblem I, 11; "Daß wir durch viel Trübsal müssen in das Reich Gottes gehen" (Acts 12:22, emblem I, 43). In biblical quotations such as these the world never figures as the place where one has to live one's life and to prove oneself; rather, it is presented simply as the "other" place, so to speak. The vast majority of Cramer's emblems, however, make no mention of the world at all. They focus instead, once again by means of brief quotations from the Old and the New Testament on events in the inner life of the heart which will bring closer *wahre Gottseligkeit*: "Ist mein Wort nicht wie ein Hammer der Felsen zerschmeist?" (Jer. 23:29, emblem I, 1); "Die sinds die das Wort hören vnnd behalten in einem feinen guten Hertzen / und bringen Frucht in Gedult" (Luke 8:15, emblem I, 2); "Webe durch

have no way of knowing whether its readers did or did not establish a link between Jennis' preface and Cramer's emblems. (I am grateful to Petra Seegets, Erlangen University, for having prevented me from rashly associating Daniel Cramer with early pietism). – In the Latin version of the Preface the opposition of "only outward virtues" and "true beatitude" is replaced by that of "a moral virtue only" ("virtus moralis tantum") and "true piety, and all truly Christian virtues" ("vera pietas, omnesque virtutes Christianae"); the French version contrasts "une vertu morelle & exterieure seulement" with "une pietè vrayement Chrestienne", and the Italian version opposes "la virtù morale sola" to "la vera pietà e altre virtù Christiane". It is tempting indeed to imagine that the German and the French versions reflect the Lutheran and Calvinist traditions established in these languages and familiar to the (Protestant) native speakers of those languages while the Latin and Italian versions reflect the usage of countries which were predominantly Catholic.

meinen Garten / daß seine Würtze trieffen" (Song of Sol. 4:16, emblem I, 4); "In deinem Liecht sehen wir das Liecht" (Ps. 36:10, emblem I, 6); "Kompt her zu mir alle die ihr mühselig vnd beladen seyd / Ich wil euch erquicken" (Matt. 11:28, emblem I, 38); "Laß deine Brüste seyn wie Trauben am Weinstock / vnnd deiner Nasen Ruch wie Epffel" (Song of Sol. 7:8, emblem I, 41); "Erhalte meinen Gang auff deinen Fußsteygen / daß meine Tritt nicht gleitten" (Ps. 17:5, emblem I, 49).

Assuming that the term "Hertzens-Gedancken" used by Jennis with respect to the messages conveyed by the ancient Egyptians by means of their hieroglyphs was meant to apply *a fortiori* to the messages conveyed by Cramer's emblems, we can discern a rhetorical situation which in some respects is similar to that of the *Schola Cordis*: here, too, the heart is both the topic and the addressee of the discourse. In the *Emblemata sacra*, however, it is not possible to identify a speaker's role as we were able to do in both the *Schola Cordis* and the *School of the Heart*: neither is there a *persona* like Van Haeften's teacher addressing and instructing the heart nor one like Harvey's speaking and singing voice which we identified as that of the confessing self appearing before his or her God. In *Emblemata Sacra* we have in fact before us a book of religious meditation which is not held together and organized into a whole by an instance which could be identified by asking the question "who is speaking?" Indeed, it is, in the absence of a unifying voice of this sort, rather difficult to determine whether Cramer's two series of fifty emblems are meant to be read as just a random collection of emblems, held together only by the fact that each emblematic *pictura* contains the image of the heart as its central element, or whether there is an underlying organizing principle at work which, once identified, might assign to each emblem a specific place in the sequence.

Each book of fifty emblems is prefaced by an index which lists the emblems in the order of their appearance, together with their mottoes and the references of the biblical quotations which serve as their point of departure. The indices are called "Elenchus emblematum" which can be translated both as "the register of the emblems" and as "the pearl of the emblems". On the first reading, the indices are just that, indices, listings, registers of the content of the book. On the second, the – metaphorical – reading, Cramer can be thought to have chosen a formulation which suggests the existence of an outer shell and an inner core or center, and which thus allows the reader to identify the two focal points of each

emblem, namely the biblical verses which it presents both verbally and pictorially, and the transformation of the passage from the Bible into a motto which the believer can make his or her own.[25] The *elenchus* of the first book begins with "Mollesco", "I am becoming soft", continues via "Cresco", "I grow", "Alta peto", "I reach for the heights", "Amo", "I love", "Lateo", "I hide", "Illuminor", "I am being enlightened", "Sum constans", "I am constant", "Vivo", "I live", and "Nil sum", "I am nothing", and a whole range of other mottoes, most of them in the first person singular, and closes – via "Emergo", "I rise from the depth", "Vulneror", "I am being injured", "Affligor", "I am being frightened", "Circumspecte", "Circumspect" – with "Memento mori", "Consider the end". Halfway between the first and last emblems, "Mollesco" and "Memento mori", we find emblem XXIII, "Praedestinor", "I am elected". One might be tempted to construe this as marking the beginning, middle, and end of an ordered series. The recognition of being elect, more strongly stressed in Calvinism than in Lutheranism, but certainly not absent in the latter, might in that case be understood as the turning point in man's life. But it would probably be a mistake to construe this textual series as referring to a sequence of events involving an element of time, for it is hardly plausible from a theological point of view to place the act of election so far from the beginning marked by "Mollesco".[26] However, if we were to opt for an ordering in terms of relative weight but free of temporal implications, the positions of beginning, middle, and end would emerge as the three most weighty ones, with the middle position marked by "Praedestinor" occupying the most prominent place. But then the question would arise why, in terms of emphasis, "Praedestinor" should be preceded by "Non laedor", "It does not damage me", by "Absolvor", "I am being absolved", and by "Superaedificor", "I am being built/edified"; and why should it be followed, again in terms of emphasis, by "Probor", "I am tried", "Refrigor", "I am cooled", and "Protegor", "I am protected"? Very

[25] We shall return to this point in the next section in conjunction with the discussion of Cramer's reasons for adopting the emblem form.

[26] There are other religious emblem books which are indeed organized in accordance with the church year and with the pericopes prescribed for each Sunday, e.g. Johann Mannich's *Sacra Emblemata LXXVI. Das ist Sechsvndsibentzig Geistliche Figürlein in welchen eines ieden Evangelij Summa Kürtzlichen wird abgebildet* (Nürnberg, 1625) or Johann Michael Dilherr's *Heilige Sonn- und Festtagsarbeit. Das ist: Deutliche Erklärung der jährlichen Sonn- und Festtäglichen Evangelien* (Nürnberg, 1660).

likely there is no *raison de la série* either in terms of time or of emphasis for the sequence over and beyond the weighted positions of the emblems occupying the beginning, the middle, and the end of the book.[27]

The structure of Daniel Cramer's *Emblemata Sacra*, it has been argued a few years ago,[28] can be viewed as the result of a transfer of the method of Philipp Melanchthon's *Loci theologici* from the realm of church dogmatics to that of the literature of religious meditation. Accordingly, each emblem, together with its quotation from the Bible, its emblematic motto, *pictura*, and epigrams in three languages should be viewed as an exemplary elaboration of one of the *loci* of Lutheran dogma. If correct,[29] this analysis would indeed explain the comparatively self-contained nature of each emblem: unlike the lessons of Benedictus van Haeften's *Schola Cordis*, these emblems do not form a *gradus ad salutatem* which one has to follow under the guidance of a teacher, nor do they present the series of steps taken by a self coming to an awareness of itself of Christopher Harvey's *School of the Heart*. Instead they seem to amount to so many word-image sermons, each on a biblical verse, the selection of which verses may or may not have been prompted by the model of Melanchthon's *Loci theologici*. But while this explanation would indeed tell us something about the selection of those verses and about their relation to Lutheran dogma, and thus about the thrust of the book as a whole, it would still tell us nothing about a possible reason for using these two groups of fifty elaborations of as many biblical verses. Accepting therefore the claim about the influence of Melanchthon's work on selecting and assembling the elements of the *signifié* of Cramer's *Emblemata Sacra*, we still need to find a plausible explanation for Cramer's choice of *signifiant* for the purpose of communicating that *signifié*.

Cramer's *Emblemata Sacra*, it would appear, were meant to be opened

[27] The *elenchus* of book II begins with "Radificabor", "I am being rooted" and ends with "Morieris", "You will die" and "Ne peream, pereant", 'May they (i.e. the things of the world) perish so that I shall not perish.' Once again the weighty middle position is occupied by an emblem with a particularly significant motto: "Te sequar", "You I shall follow".

[28] See Sabine Mödersheim: *'Domini Doctrina Coronat': Die geistliche Emblematik Daniel Cramers (1568–1637)*, (as in note 20), 95–101.

[29] Since no attempt was made by the proponent of that suggestion to identify which of Melanchthon's *loci* were actually taken over, and thus to show the degree of congruence between Melanchthon's work and Cramer's, it is impossible to assess the validity of this interesting suggestion.

at any page, if not at random then at least according to the presently felt need of the reader. The *Elenchus Emblematum* at the beginning of each group of fifty emblems would then acquire a more important function than that of simply listing the content of the two books. The reader could determine on its basis which of the mottoes, most of them, as already mentioned, in the first person singular, was applicable to his or her present situation, and he or she could then turn to the word-image sermon which could serve to elaborate on that motto.

As we shall presently see when we turn our attention to the characteristics of the word-image combinations in the three books, an understanding of the structure of each emblematic double page along these lines will offer a plausible explanation why Daniel Cramer may have opted for the emblem form.

The Word-Image Combinations in Benedictus van Haeften's Schola Cordis, *Christopher Harvey's* School of the Heart *and Daniel Cramer's* Emblemata Sacra

In our discussion of what we called the "inward" turn of Harvey's text we concentrated on the shift from the subject position of Van Haeften's text which was that of the teacher to Harvey's confessing self, and we have so far considered only the verbal components of both Van Haeften's *Schola Cordis* and Harvey's *School of the Heart*. In our discussion of Daniel Cramer's *Emblemata Sacra*, too, our focus so far has been on a possible explanation for the organization of the book, and on the manner in which, due to the absence of an explicit subject position, it differed substantially from the other two books. We must now turn to the pictorial components of all three texts, and, in the case of Cramer's *Emblemata Sacra*, to the question left open previously concerning the significance of the choice of bi-medial emblems for the purpose of elaborating on the biblical verses.

With regard to Van Haeften's *Schola Cordis* and Harvey's *School of the Heart* we must inquire into the relation of word and image, and we must raise the question how the "same" emblems function in so vastly different textual wholes. With regard to Daniel Cramer's *Emblemata Sacra*, the question which needs to be raised is likewise how word and image together contribute to conveying a particular kind of knowledge about the heart to the reader.

At first glance, and paying attention only to outward appearances, the emblems of Benedictus van Haeften's *Schola Cordis* and of Christopher Harvey's *School of the Heart* are indeed, with a few exceptions, motivated by dogmatic considerations, nearly identical. At the beginning of each lesson there is, in both books, an emblem occupying one whole type page (plates 13 to 16). In the case of both Van Haeften's *Schola Cordis* and Harvey's *School of the Heart* each emblem consists, in vertical arrangement, of an engraving, a brief text in Latin identifying the theme of the engraving and of the lesson which follows, then a quotation from the Old or the New Testament, and, finally, a Latin distich by Van Haeften himself. In Harvey's *School of the Heart*, in keeping with the practice of seventeenth-century emblem writers, the word "embleme" and a sequential number are placed above each of the *picturae*, while the remainder of Van Haeften's emblem pages, including the Latin of his texts, is retained. The "Englishing" and "reforming" only begin on the pages following each emblem where motto, biblical verse, and epigram are repeated in English, and they serve as a point of departure for Harvey's own contributions to the *School of the Heart*, his odes.[30] Four-line epigrams by Harvey now take the place of Van Haeften's distichs, and the quotations from the Old and the New Testament are now from the King James Bible. In contrast to the remainder of the book, the emblem pages of the *School of the Heart* can thus be considered replicas of the originals in Van Haeften's *Schola Cordis*. The major change consists in the shift from Latin to English throughout the actual lessons. Undoubtedly this made Harvey's *School of the Heart* accessible to a much larger readership than Van Haeften's Latin *Schola Cordis*.[31]

[30] Harvey, however, did not follow this practice consistently. In a number of cases he takes over Van Haeften's emblem page in its entirety, yet follows it up, perhaps once again for dogmatic reasons, with a motto, a verse, and an epigram on an, at times slightly, at times considerably different theme. Thus the emblem page of Harvey's "Embleme 7" offers a facsimile of Van Haeften's emblem with the motto "CORDIS AVARITIA", while the lesson immediately following deals with the topic of 'The Covetousness of the Heart'. Apart from suggesting a certain carelessness on Harvey's part, this also suggests a rather tenuous link between the emblem pages and the texts of Harvey's *School of the Heart*.

[31] A German translation by Carl Stengel of Van Haeften's *Schola Cordis* was published in Augsburg in 1664 under the title of *Hertzen Schuel. Oder des von Gott abgefüerten Herzens, widerbringung zu Gott, und unterweisung* (Glasgow University Library, SMadd15). It leaves the Latin of Van Haeften's emblem pages untouched, rendering only the introduction and the lessons into German.

The emblems of the *Schola Cordis*, as I have suggested elsewhere,[32] deviate from "normal" emblems in that they do not depict objects *ex natura vel ex historia* which are then, in the epigram, submitted to an exegesis which involves the discovery or the invention of a *sensus spiritualis* which is thought to inhere in the *res picta* either due to divine *fiat* or due to human wit. Instead they offer literal pictorial renderings of, in most cases, metaphorical passages from the Old and New Testament. The *res pictae* presented in these emblems are thus not presented as elements from the world of nature and history which are *turned into* vehicles of metaphors as a result of the exegesis offered by the epigram. Rather, what is rendered pictorially in each instance is the metaphor as such. We are not shown, as our familiarity with the rules of emblematic signification would lead us to expect, a plough in a field (fig. 17)[33] which is subsequently treated as the vehicle of a proportional metaphor of the form "plough : field = word of God : human heart".[34] Instead we are shown in both the *Schola Cordis* and the *School of the Heart* a plough breaking the surface not of a field but of a heart (fig. 15). As the formulations "cordia agrum" and "crucis aratrum" of the accompanying distich suggest, a proportional metaphor like the one operating in Roemer Visscher's *Sinnepoppen* is once again at the root of the *pictura*: "aratrum : ager = crux : cor". But now the *pictura* offers a combination of the pictorial representations of an element of the total vehicle (plough) and the total tenor of the proportional metaphor (heart), rather than the whole of the vehicle. In contrast to "normal" emblematic practice, the identification of the tenor is not left to exegesis by means of the *subscriptio*. With this shift in the selection of the elements of the proportional metaphor which are to

[32] See my article "Het Hart als *res significans* en als *res picta*. Benedictus van Haeftens *Schola Cordis* (Antwerpen, 1629)", in: *Spiegel der Letteren* 33, 3 (1991), 115–147.

[33] From Roemer Visscher: *Sinnepoppen* (Amsterdam, 1614), II, 3. For a detailed analysis of the structure of Roemer Visscher's emblems see my article "Overwegingen bij de tekstsoort 'embleem' en bij het genre van Roemer Visschers *Sinnepoppen*", in: *Vorm en Functie in Tekst en Taal* (Leiden, 1984), 73–106.

[34] In the case of Roemer Visscher's use of this familiar pictura the comparison, as the accompanying *subscriptio* in prose suggests, is actually somewhat more complicated: "Although the plough brings what is undermost to the surface it yet makes the field suitable for sowing and growing good fruit. This means that a good, upright and virtuous man, no matter how well he acts, won't act well according to the common judgement of the fickle members of society. And yet he brings things to a good and profitable end. And then people say: 'Who would have thought so!' ". Roemer Visscher: *Sinnepoppen*, II, 3, (my translation).

be depicted, the verbal components of Van Haeften's and Harvey's emblems are bound to acquire a different communicative function from the one they had when only the vehicle of the proportional metaphor was depicted, and the *subscriptio* served to identify the allegorical import of that vehicle.

Semantically speaking, the combination of "plough" and "heart" offered by the *pictura* is the "same" as the one which is offered by the accompanying motto: "Aratio Cordis". The motto itself can be understood as a transformation of the passage from Ezekiel (36:9) which follows immediately underneath: "Convertar ad vos, et arabimini et accipietis sementem" ("For behold, I am for you, and I will turn to you, and you shall be tilled and sown"). In this as in many other instances in the *Schola Cordis* the transformation of the biblical verse into the motto consists in combining a noun which sums up the action or suffering of the heart referred to in the passage quoted with the term "cor": "Cordis fuga" (fig. 11), "Cordis mundatio" (fig. 13), "Cordis vigilia" (fig. 14), "Aratio Cordis" (fig. 15), "Cordis in Cruce expansio" (fig. 16).

The distich placed below the passage from the Bible, finally, offers what one might call an elaboration on or paraphrase *ad usum lectoris* of the biblical passage which also provides the key pictorial elements, suggests the motto, and is quoted literally as part of the *subscriptio*. But whereas the motto aimed at reducing the biblical verse to one single concept, the distich expands on the passage and, in many cases, relates it directly to the reader. In the example discussed ("Aratio Cordis", fig. 15) the elaboration *ad usum lectoris* consists in an unfolding of the proportional metaphor on which the biblical verse is based, and from which all other texts are derived. Although the didacticism is not quite as explicit in other distichs, the didactic function is clearly present more strongly in the distichs than in the other parts of the emblem.

There is thus an extraordinary degree of redundancy in the texts accompanying the *picturae* of the *Schola Cordis* and the *School of the Heart*: in every instance picture, motto, biblical quotation and distich all repeat the same message which is thought to mark a stage in the "ad Deum dirigi, illi aptari, eidemque uniri" (*SC*, 1; see above), which, we have seen, is the overall purpose of Van Haeften's book. This redundancy in itself underlines the didactic import of the emblem pages.

A reading of Van Haeften's apology for writing his *Schola Cordis* which is contained in the paragraphs entitled "Instituti nostri ratio" (*SC*, 5)

suggests that he had, indeed, a didactic goal in mind with his emblems. The most important part of every *lectio*, we are told, is not the emblem but the prose text immediately following. Contrary to what one may have expected from reading other emblem books with prose commentaries added to the emblems, the lessons in prose which follow each emblem page are not meant to be understood as further elucidations of certain elements of the *picturae*, with perceptual primacy belonging to the *picturae*. Judging from his *Instituti nostri ratio*, things are rather the other way round in Van Haeften's case. Van Haeften reminds his readers of three main arguments of the contemporary debate about the structure and function of texts: he mentions considerations regarding the manner in which we remember things, which were being discussed in the context of *ars memoriae*, he refers to ideas regarding the role of the eye discussed in the context of the contemporary debate about *ut pictura poesis,* and he finally calls upon the authority of Horace in order to justify the didactic function of literature. The distichs have been placed at the beginning of every lesson, he suggests,

> vt ita rei summam breuissime, & non sine aliqua voluptate exhiberemus. Ipse enim carminum flexus & numerus, vt animum allicit, sic memoriae firmius haeret, variaque iucunditate mentem permulcens, facit ne pene vmquam ea, quae recte percepit, obliuiscatur. (*SC*, 7)

> in order to be able to introduce the topic (of every lesson) as briefly as possible but not without providing enjoyment. For as the turn of the phrases and the rhythm of the poems will attract the soul, they will also be held more firmly by memory, they will win over the mind by a varied agreeableness, and they will make sure that nothing will be forgotten which has been well understood.

The decision to add a picture to each distich, Van Haeften explains, was taken in view of the fact that there is a *societas* between poetry and painting such that

> ut quod illa verbis, tropis, alijsque dictionum luminibus praetat; haec coloribus, lineamentis, atque vmbris repraesentare conetur: vtraque item, quidquid in quouis genere praestantissimum reperit, id e multis in vnum, quod sibi proposuerit, transferat (*SC*, 7)

> what the one knows how to realize by means of words, tropes and other ornaments of language, the other aims to represent by means of colours, lines

and shadows; and both apply the best of the many possibilities they have at their disposal to the single topic they have set themselves.

Distichs, *picturae* and *lectiones*, Van Haeften concludes his apology, thus have a single goal in common:

> Scopus mihi in hoc Opere non alius fuit; quam Imaginibus, oculos; versibus, aures; ipsis denique Lectionibus, animum & COR oblectare, instruere, & permouere. (SC, 8f.)
>
> My purpose with this work was none other than to please, instruct and move the eye by means of pictures, the ear through verse and the mind and the heart through lessons.

Thus, attempting to account for the word-image relations which are realized in the emblem pages of Van Haeften's *Schola Cordis* and between the emblem pages and the remainder of the book in cognitive terms would not take us very far. Van Haeften's emblems simply do not possess such a cognitive function, nor are the word-image relations in *Schola Cordis* as a whole meant to carry such a function. Their primary function is to ensure, by means of appealing to the eye, the ear, the mind, and the heart, that the reader will not forget the lessons which follow, and that in addition he will experience those lessons as pleasant. In view of this mnemotechnic function which Van Haeften assigns to his emblems, it may be justifiable to consider the stereotypically recurring heart in each and every *pictura* as a *locus* ("memory place") from the *ars memoriae*, i.e. as a conventional sign which has as its sole function to pin down the knowledge of the heart as *res significans* as it was presented in the introductory first book of the *Schola Cordis*.[35]

In Harvey's *School of the Heart*, as we have seen, there are no arguments of the sort offered by Van Haeften, and there is no implicit reader of the kind constituted by Van Haeften's text, to whom those arguments are addressed. Here, the lessons in the form of odes, we have claimed, are meant to allow the reader to re-enact, to repeat the confessional stance adopted by the speaking self. Thus they no longer offer arguments with the expectation that the intended reader will take them to heart and act

[35] For the older discussion of the art of memory see Frances A. Yates: *The Art of Memory* (Chicago, 1966). A very valuable more recent study is Mary Carruthers: *The Book of Memory. A Study of Memory in Medieval Culture* (Cambridge, 1990).

upon them. Nor do the emblems play a reenforcing role any longer in the context of a didactic programme. They could not possibly do so, for the *School of the Heart* as a whole has no such didactic programme.

The emblem pages themselves are closely modelled on those of the *Schola Cordis*; the layout is identical, the only difference, as has been pointed out above, is that all the Latin texts have been translated into English, and that Van Haeften's distichs have been replaced by four-line epigrams.

What, then, is the relation between these emblems and the remainder of Harvey's text which, as we have seen, is radically different in structure and function from Van Haeften's?

The emblems taken over from Van Haeften, one could argue, still function as memory places of sorts, but not as memory places for recalling arguments. In Harvey's *School of the Heart*, the speaking self is meant to respond directly to what it sees in the emblems, and it responds in a language addressed to the ear rather than the eye. Here, looking at the emblematic *picturae* is like looking into a mirror, to be followed by the "turning inward" described in the introductory poem. The odes in which the self reflects on its salvational state can then be said to be taking their point of departure from what appears in that mirror. Thus the ode responding to the emblem with the title "Cordis Vigilia", and depicting *anima* asleep while its heart is awake begins – *in medias res*, so to speak – with the words

> It must be so: that God that gave
> Me senses, and a mind, would have
> Me use them both, but in their several kinds ... (*SH*, 13)[36]

And the ode following the emblem entitled *Cordis Humiliatio*, which depicts the heart being flattened in a bookbinder's press, begins with

> *So let it be,*
> Lord, I am well content,
> And thou shalt see
> The time is not misspent. (*SH*, 59)[37]

[36] Italics mine.
[37] Italics mine.

In cases like these the speaking self responds directly to what it has seen. The antecedent of the "it" in "It must be so" and in "So let it be" is in both instances the scene depicted in the *pictura*; take the preceding emblem away, and the particle "so" of "So let it be" would have no antecedent to which it could refer. Emblems and odes of the *School of the Heart*, that is to say, are frequently held together by anaphorical or deictic expressions, with the *res pictae* of the *picturae* serving as antecedents. In the *Schola Cordis*, by contrast, it would not have mattered, as far as the development of the argument is concerned, whether the emblems had been placed at the end of each lesson, except that perhaps the function of the emblems of winning over the reader would have been lost. The effect of looking at the pictures and reading the quotations from the Bible, the distichs and the argumentative lessons in prose was meant to be cumulative, systematically enlisting all of the senses in order to achieve the didactic goal of each lesson. Now, in the *School of the Heart*, there is a parallelism between the sequential arrangement of emblem and ode on the one hand, and the development of the attitude of the speaking self on the other; leave out the starting point of the sequence, i.e. the emblem page, and the speaking self has nothing to respond to.

There is in fact no explicit *exegetic* relation between the *res pictae* of Harvey's emblems and the texts of the lessons following. That is what we would expect from emblems functioning in accordance with the rules of the genre. In Harvey's case the point of the emblems need not be brought home by means of an exegesis. The emblems pictorially and metaphorically represent elements of self-knowledge, points of attack of conscience, and the self recognizes only too well what it sees. With a phrase borrowed from George Herbert, the poet Christopher Harvey wished to emulate,[38] one might say: the emblems show "something understood". They offer metaphorical mirror images to the self, metaphorical self-images if you wish, and the self, in turn, responds to those images, and in so doing, finds the topics and the tropes of a language which will enable

[38] Christopher Harvey was also the author of *The Synagogue*, a series of devotional poems appended anonymously to the 1640 edition of George Herbert's *The Temple*. The poems of *The Synagogue* were reprinted with most of the later editions of *The Temple*. The third edition of the *School of the Heart*, published in London in 1676, does not reveal Christopher Harvey's proper name either. Instead it offers a description linking the anonymous author of *The School of the Heart* to George Herbert: "By the *Author* of the SYNAGOGUE Annexed to *HERBERT'S POEMS*."

it to articulate its knowledge about its current state of salvation. This responsive character of the odes following the emblems can be derived from the manner in which both are textually linked. Thus, in the case of "Cordis Divisio", the "Division of the Heart" the accompanying epigram reads:

> Vain trifling Virgin, I myself have given
> Wholly to thee: and shall I now be driven
> To rest contented with a petty part,
> That have deserved more than a whole heart? (*SH*, 35)

And the ode continues this reproach addressed to the heart that does not wish to give itself up whole:

> More mischief yet? was't not enough before
> To rob me wholly of thine heart,
> Which I alone
> Should call mine own,
> But thou must mock me with a part?
> Crown injury with scorn to make it more? (*SH*, 35)

The speaker here, clearly, is not Van Haeften's teacher expounding the text of the heart to the heart. It is, if you wish, the internalized teacher, God himself, speaking through conscience – the divided heart addressing itself. Even the fact that these emblems are to be understood as visualizations of verses from the Old and the New Testament now takes on a special significance. Rather than being offered by the teacher, as in the case of Van Haeften's text, as memory places for the benefit of the pupil, they signal the soul's complete dependence on God:

> Thou know'st I do not, cannot, have no mind
> To know mine heart: I am not only blind,
> But lame, and listless: thou alone canst make
> Me able, willing: and the pains I take,
> As well as the successe, must come from thee,
> Who workest both to will and do in me:
> Having made mee now willing to be taught,
> Make me as willing to learn what I ought. (*SH*, Introduction, 2–3)

This is clearly not a self capable of enthusiastically exclaiming with Walt Whitman about an element of this world, "Thee for my recitative!"[39] Instead it is a self which, having left the world of the senses, and having turned inward, cannot but stand and wait for the teacher to come there, too.

The characteristic manner, then, in which the *picturae* of Van Haeften's *Schola Cordis* and of Harvey's *School of the Heart* pictorially render proportional metaphors by combining elements of the vehicle with elements of the tenor of the metaphor, is in both cases motivated by the diverging roles those *picturae* are meant to play in each text. In Van Haeften's case, a pictorial rendering of an as yet uninterpreted metaphorical vehicle could have served as a memory place meant to anchor each lesson in the mind of the reader. For that purpose only a pictorial rendering of the vehicle *as interpreted* would be suitable. In Harvey's case, on the other hand, a pictorial rendering of just the vehicle, followed by a verbal interpretation of that vehicle, would not. Here, only the understood image could serve as a point of departure for the soul's odes.

If the illustrations accompanying Benedictus van Haeften's *Schola Cordis*, as we saw, in a sense do not qualify yet as emblems proper, and if those accompanying Christopher Harvey's *School of the Heart* do so no longer,[40] what about the illustrations of Daniel Cramer's *Emblemata Sacra*? Daniel Cramer's book of religious meditation is, after all, the only one of the three which, through its very title, presents itself as a book of emblems, and so we may expect to find here a pictorial presentation of a description of the heart which conforms to the "rules" of the emblem genre.

In the first book of the *Emblemata Sacra* all but five of the fifty emblematic *picturae* contain the image of the heart. In the second book there are slightly more *picturae* without that image, namely eighteen out of fifty, but that fact does not diminish the importance of the heart image as the central iconographical element of both books. In most cases when the heart image is used, it occupies centre stage (fig. 18, "Mollesco"); only in a few cases does it occupy a less prominent place in the margin (fig. 19,

[39] The opening line of "To a Locomotive in Winter", from Walt Whitman's *Leaves of Grass* (1855).

[40] This observation is obviously only meant to characterize Van Haeften's and Harvey's use of the emblem genre in relation to rules of that genre; it is not meant to imply a value judgment.

"Mors lucrum"). If we take as our point of departure the biblical verses elaborated by one emblem each, we recognize that the heart is explicitly mentioned in only five out of fifty biblical quotations in Book I and in only six out of fifty in Book II. The frequent use of the image of the heart in Cramer's *Emblemata Sacra* therefore cannot be understood as having been prompted by the desire to offer a pictorial rendering of the verbal references to the heart in the passages quoted from the Bible.[41] Instead it has to be seen as a strategy of encoding the action (and the result of that action) of a self applying a given biblical verse to himself or herself by means of a conventional pictorial image, namely that of the heart. The image of the heart, in other words, functions in Cramer's *Emblemata Sacra* as a pictorial device through which the *tua res agitur* of a sermon is transformed into the *mea res agitur* acknowledged by the believer, and this is true both of the verses which already use the first person personal or possessive pronoun, and of those verses without an explicit reference to a speaking self. Thus in Emblem I, 47 with the motto "Vulneror", "I am injured" (fig. 20), the speaking self of the quotation is pictorially represented by the heart image, while the second person possessive pronoun of "deine Pfeil" and "deine Handt" is represented by yet another conventional image, namely that of the hand stretching from the cloud.[42] The case of an *applicatio* by a speaking self when the verse neither contains an explicit reference to the heart nor to the (human) speaking self is exemplified by Emblem I, 1 with the motto "Mollesco", "I soften" (fig. 18), where, for the sake of making the *applicatio* possible, the human heart must be imagined to be made of stone. Corresponding to this applicative use of the heart image is the already mentioned fact that virtually all mottoes involve a verb in the first person singular: Just as the heart image serves as a sign for the self engaged in the act of *applicatio*, the motto of each emblem articulates that act verbally. Now, however, instead of rendering that act uniformly by means of one and the same pictorial image, each motto is phrased in such a way that the specific action

[41] If Cramer had wished to produce heart emblems as *illustrations* to heart references in the Bible he could undoubtedly have found enough suitable passages among the c. 180 heart references. This number is based on the entry "Herz" in the *Wortkonkordanz zur Stuttgarter Konkordanz-Bibel* (Stuttgart, 1953).

[42] On the emblematic pictorial motif of the arm and hand stretching from the cloud, see my article "'Ownerless Legs or Arms Stretching from the Sky': Notes on an Emblematic Motif", in: P. M. Daly (ed.): *Andrea Alciato and the Emblem Tradition: Essays in Honor of Virginia Woods Callahan* (New York, 1989), 249–283.

referred to by the verse is presented either as being carried out or undergone by the speaking self, or that the results of that specific action are born by the self. Thus the divine question of the verse of Emblem I, 1 "Ist mein Wort nicht wie ein Hammer der Felsen zerschmeist?" from Jer. 23:29 is transformed into "Mollesco", "I soften", and the verse "Aus der Tieffe des Meers wil ich etliche holen" (Ps. 68:23) of Emblem I, 45 yields the motto "Emergo", "I rise" (i.e. from the depth, fig. 21).

With this insight into Cramer's double strategy of using the pictorial image of the heart as the sign for the speaking self in the act of *applicatio*, and of phrasing the mottoes of his emblems in such a way that the actions (or the results of those actions) referred to by the verses are made to appear as carried out or undergone by the speaking self, we are in a position to elucidate why the bi-medial art form of the emblem very likely[43] recommended itself as a suitable form for articulating these exemplifications of the *loci theologici* of Lutheran dogma.

The term "emblem" in Early Modern usage could cover variants in which the application was general, in the sense that the moral lesson conveyed was meant to be applicable to "all", as well as variants which continued the somewhat older tradition of the device or impresa.[44] The latter was conceived of as a way of articulating a person's "inner" mind by means of a visibly worn "outer" form. They were, in the words of a sixteenth century English theorist of the impresa, Samuel Daniel, "conceiptes, by an externall forme representing an inward purpose," and hence it was understood that the meaning communicated by that external form was "the Authors meaning", which in this case meant the bearer's meaning.[45] A typical occasion to wear such devices was a tournament. Here the coat of arms worn by the participants served to identify one's family affiliation while the device was meant to reveal one's personal

[43] Since we have no explicit statements by Cramer that would allow us to determine why he adopted this form, the following attempt at an explanation remains no more than a hypothesis.

[44] See my articles "Emblem" and "Imprese", in: Klaus Weimar (ed.): *Reallexikon der deutschen Literaturwissenschaft. Neubearbeitung des Reallexikons der deutschen Literaturgeschichte* (Berlin and New York, 1997–2002), vol. 1, 435–438 and vol. 2, 135–137 respectively.

[45] Samuel Daniel: *The worthy tract of Paulus Iovius, contayning a Discourse of rare inuentions, both Militarie and Amorous called Imprese* [...] (London, 1585), Preface, n. p. I am using the facsimile reprint edited by N. K. Farmer, Jr: *Paolo Giovio. The Worthy Tract of Paulus Giovius (1585), translated by Samuel Daniel, together with Giovio's Dialogo dell'Imprese Militari et Amorose* (Delmar, New York, 1976).

identity, one's mind. If we recall what Jennis had to say about the use of hieroglyphics among the ancient Egyptians – their purpose was "ihre hohe Weißheit / und Hertzens Gedancken / einander mit sonderlichen Bildern der Thier / oder anderer bekandten und natürlichen Dingen pflegten zu offenbahren" – are we going too far if we imagine that it was the idea of life as a "fray" which made it possible for Cramer to adopt the form of the emblem or impresa for the purpose of religious meditation?

Remembering Cramer's double strategy which, as we saw above, enabled a reader of *Emblema Sacra* to apply each and every emblem to himself or herself, it would not appear far-fetched to claim that these emblems were meant to be viewed as *religious devices* or *impresas* through which one could reveal one's "inward purpose" with regard to the point one had reached on the road to *Gottseligkeit*. Daniel Cramer in producing his *Emblemata Sacra* undoubtedly used a then fashionable secular art form for his own religious ends. But he did so in a very skilful manner, since by turning the heart into a pictorial sign of the self, and by casting the mottoes of his emblems in the first person singular, he found a way to present Lutheran church dogma – as laid down e.g. in Melanchthon's *loci theologici* – as applicable to the inner life of the believer. This clearly could not have been achieved with the aid of Benedictus van Haeften's heart emblems in which the mottoes were formulated as descriptive phrases of the type "Cordis fuga", "Cordis vigilia", "Aratio Cordis", "Cordis in Cruce expansio". Cramer, one imagines, in keeping with his strategy of adapting the heart imagery to his readers' spiritual needs, transformed this into "I am fleeing", "I am keeping watch", "I am riven apart", and "I am stretched on the cross". And one wonders whether Christopher Harvey, if he had been familiar with Cramer's book of sacred emblems, would not himself have followed the latter's example rather than simply changed Van Haeften's mottoes and translated them into English. For the focus of Cramer's emblems on the self articulating stages on the road to beatitude in God would undoubtedly have been consistent with the inward direction of Harvey's *School of the Heart*.

Concluding Remarks

Our study of three seventeenth century books of religious meditation, Benedictus van Haeften's *Schola Cordis*, Christopher Harvey's *School of the Heart*, and Daniel Cramer's *Emblemata Sacra* has taken us into a still largely uncharted area of Early Modern *Frömmigkeitstheologie*. Further research

based on a substantially larger corpus of texts will undoubtedly be required before it will be possible to give a reliable answer to the question how art and theology interacted in the literature of religious meditation of that period, and whether and how that interaction played a role in the development of a popular *Frömmigkeitstheologie* which, though it was undoubtedly differentiated along denominational lines, nevertheless would appear to have displayed considerably more cross-denominational similarities than did the "high" – and mighty – theology which was officially taught in the schools and the universities.

Wishing nevertheless to generalize on the basis of the three books of religious meditation studied, we might tentatively claim that their differences are primarily to be found in the manner in which they constitute the roles of the speaker and the reader by means of the textual strategies which they adopt, rather than in their propositional content.

Bernhard Scholz is a Professor of Comparative literature at Groningen University, the Netherlands.

Changes in the Furnishings of the Finnish Parish Church from the Reformation to the End of the Caroline Period (1527–1718)

Hanna Pirinen

The interior of the Lutheran parish church took shape through a process that extended over a considerable period of time and combined several strata. The material effects of the Reformation were felt in Finnish church architecture only after a long delay. The aim of this study is to examine the continuities and innovations uncovered by analyses of the interiors of Finnish churches.[1]

Administrative sources, such as the documents of diets and synods, show when the changes started. When the decrees and legislation directives of the central government are put into their historical contexts, other persons, groups and institutions also influential in the background stand out. An examination of the political levels and theological trends making up the historical situation reveal the individuals or interest groups behind ideas and attitudes.

In the hierarchy of church administration, the diocese serves as an important link between the upper levels of the hierarchy on the one hand and the local parishes on the other. The bishop visited his parishes at intervals of 3–5 years. In the intervening years the parishes were inspected by the local dean. Records of the bishop's and the dean's visitations, inventories, donation books and account books preserved in the archives of local parishes are central source material for studies of church interiors. In the parishes of South West Finland, such sources generally go back to the first half of the seventeenth century.

In this study the interior decoration of the parish church has been examined using a method derived from function analysis, which provides

[1] The article is based on the writer's doctoral dissertation in Finnish, published in 1996. Hanna Pirinen: *Luterilaisen kirkkointeriöörin muotoutuminen Suomessa. Pitäjänkirkon sisustuksen muutokset reformaatiosta karoliinisen ajan loppuun (1572–1718)*, Suomen Muinaismuistoyhdistyksen Aikakauskirja – Finska Fornminnesföreningens tidskrift 103 (Vammala, 1996).

us with a procedure for an art historical investigation of the material dimension of the Lutheran liturgical space. Its furnishings are studied empirically within the framework of the general features displayed by the development of the Lutheran liturgy. The liturgy and the requirements of the church services have determined the furnishing of the sacral space (fig. 22).

New Demands for the Sacral Space
Changes in the divine service became possible in the Swedish Church at the end of the 1540s. The Edict of Örebro, issued in 1540, ordered a thorough purification of both the doctrine and the ritual. Gustav Vasa's address to the Diet of Västerås in 1544 ennunciated very clearly the principles of the new church policy. The decrees of the diet contain detailed instructions about liturgical reform. They address the status of the saints, pilgrimages and sacramental piety as well as liturgical requisites. At the same time the diet prohibited Catholic consecration ceremonies, now considered a malpractice, and central forms of Catholic devotional practices. Religious guilds must cease their activities and the adoration of the saints, requiems and other private masses must be discontinued.[2]

In the diocese of Turku the innovations of the Reformation were introduced discreetly. Michael Agricola, who followed Martinus Skytte as the head of the diocese (1554–1557), drew on the moderate opinions of Luther, and stressed on several occasions that the reforms should be put into effect in a judicious manner so as to avoid confusing the common parishioners by too rapid changes. This attitude reflects Agricola's concern for the preservation of public order.[3]

To supply the needs of Finnish services the authorities published in 1549 a manual of church ceremonies (*Manuale*) and a manual of divine

[2] *Svenska riksdagsakter jämte andra handlingar som höra till statsförfattningens historia. Under tidehvarfvet 1521–1718*, I:1 (Stockholm, 1887), 390–391; Sven Kjöllerström: "Guds och Sveriges lag under reformationstiden", in: *Bibliotheca theologiae practicae* 6 (1957), 22–23; Sven Kjöllerström: "Laurentius Petris Kyrkoordning 1751–1971. Tillkomst och användning", in: Sven Kjöllerström (ed.): *Den svenska kyrkoordningen 1571 jämte studier kring tillkomst, innehåll och användning* (Lund, 1971), 206; Kauko Pirinen: "Bibelhumanism och reformationen. En forskningsöversikt", in: Carl-Gustaf Andrén (ed.): *Reformationen i Norden. Kontinuitet och förnyelse*, in: Skrifter utgivna av Nordisk Intitut för kyrkohistorisk forskning 3 (Lund, 1973), 57.

[3] Kauko Pirinen: *Turun tuomiokapituli uskonpuhdistuksen murroksessa*, Suomen kirkkohistoriallisen seuran toimituksia – Finska kyrkohistoriska samfundets handlingar 62 (1962).

service (*Missale*). Reformed handbooks in the vernacular slowly replaced medieval liturgical books, a process largely accomplished by the end of the sixteenth century. It was only at the beginning of the seventeenth century that the Lutheran liturgical reform was brought to its completion in Finland.[4]

The Swedish Church Ordinance of 1571 included a separate chapter on churches and their interiors, where the author of the document, Archbishop Laurentius Petri, formulated his standpoint on church vestments, paraments, pictorial representations and means of lighting. In his opinion, the furniture of the church was, as such, in accordance with Luther's adiaphorist views, a neutral, external issue. As with Luther, Laurentius Petri's criticism of the use of images was an aspect of his criticism of forms of piety that had prevailed in popular religion.

Like Luther, Archbishop Petri emphasised instruction as a means of putting an end to erroneous uses of images. The section on images in his ecclesiastical rules also incorporates a critique of false iconoclasm. The criticism articulated in Laurentius Petri's ecclesiastical rules is directed at specific features of Catholic devotional practices: denounced are miraculous images and pilgrimages, votive offerings, the ceremonial consecration of liturgical implements and church buildings, and older uses of images during Lent and Easter plays.[5]

During the Swedish Reformation, debates on the justification of the liturgical use of images and on the form of church ceremonies surfaced several times as an issue of ecclesiastical and state policy in connection with changes of rulers. The debate on the status of images was bound up with European doctrinal conflicts.[6]

[4] Jyrki Knuutila: "Liturgisen yhdenmukaistamisen toteutuminen Suomessa reformaatiokaudella 1537–1614", in: *Suomen kirkkohistoriallisen seuran vuosikirja – Finska kyrkohistoriska samfundets årsskrift* 80–81 (Jyväskylä, 1991), 34–38.

[5] Sven Kjöllerström (ed.): *Den svenska kyrkoordningen 1571 jämte studier kring tillkomst, innehåll och användning* (Lund, 1971), 110–114; Lindgren (1983), 18; Bengt Ingmar Kilström: "Synen på kyrkoprydnader i Laurentius Petris kyrkoordning 1571 och konsekvensen av denna", in: Martin Blindheim, Erla Hohler and Louise Lillie (eds.): *Tro og bilde i Norden i reformasjonens århundre* (Oslo, 1991), 193–195.

[6] Sergiusz Michalski: *The Reformation and the Visual Arts: The Protestant image question in Western and Eastern Europe* (London, 1993); Bengt Arvidsson: "Bildstrid Bildbruk Bildlära. En idéhistorisk undersökning av bildfrågan inom den begynnande lutherska traditionen under 1500-talet", in: *Studia Theologica Lundensia* 41 (Lund, 1987); Sven Kjöllerstöm: *Striden kring kalvinismen i Sverige under Erik XIV. En kyrkohistorisk studie* (Lund, 1935), 78–81; Roland Persson: "Johan III och Nova Ordinantia", in: *Bibliotheca theologiae practicae*

Church policy documents of the reign of Erik XIV include highly iconoclastic statements. The Meeting of Arboga in 1561 decreed that henceforth, only a crucifix and an altarpiece would be allowed as altar decorations. Duke Charles' aim was to purge Lutheran liturgical usages of their last vestiges of catholicism. However, despite strong views being expressed, discussions on the liturgical status of the image remained rather abstract. A partial explanation for the unchanged furnishings of churches was the conservatism of the clergy, which on various occasions obstructed the implementation of government decrees.[7]

In Finland, the 1590s were a period marked by heated political and religious controversies. The Finnish high nobility, who criticised the reforms, found themselves a leader in Klaus Fleming, High Constable (d. 1616), whose opinions the opposition movement adopted. Some of the hearsay reports that the liturgical controversy gave rise to reached the court of Sigismund.[8] The impression that Sigismund gained by a sharp turn to Calvinism in the development of Finnish Lutheranism finds its explanation in doctrinal changes brought about, at the end of the sixteenth century, in certain of the regions dominated by moderate Lutheranism. There were profound changes in liturgical practice when the Lutheran ecclesiastical system was replaced by the Calvinist or Zwinglian Reformed Doctrine, as happened in, for example, the German duchy of Anhalt. Finland, however, saw no changes of this kind. There were only unfounded rumours that images had been destroyed in Turku Cathedral.

The Finnish manual published in 1614 marked the end of the liturgical

30 (Lund 1973), 49–50; Hans Cnattingius: *Uppsala möte. Konturer av en kyrkokris* (Uppsala, 1943), 109–110; Ingun Montgomery: "Värjostånd och lärostånd. Religion och politik i meningsutbytet mellan kungamakt och prästerskap i Sverige 1593–1608", in: *Acta Universitatis Upsaliensis. Studia Historico-Ecclesiastica Upsaliensia* 22 (1971); 313, 338–339; Mereth Lindgren: *Att lära och att pryda. Om efterreformatoriska kalkmålningarna i Sverige cirka 1530–1630*, Kungl. Vitterhets Historie och Antikvitetsakademien (Stockholm, 1983), 21–26; Hanna Pirinen: "Reformation jälkeinen kirkkotila – jatkuvuutta ja muutosvaatimuksia", in: Nina Lempa (ed.): *Kirkko kulttuurin kantajana* (Vammala, 2000).

[7] *Svenska riksdagsakter* II:2 (Stockholm, 1899), 6–7, 61; Kjöllerström 1935, 81–83, 126.

[8] Eric Anthoni: *Till avvecklingen av konflikten mellan hertig Carl och Finland. Konfliktens uppkomst och hertigens seger* (Helsingfors, 1935), 79; Eric Anthoni: "Clas Eriksson Flemings motskrift till Ericis Erici och Gregorius Martini Teit av den 28. Aug. 1595", in: *Suomen kirkkohistoriallisen seuran vuosikirja – Finska kyrkohistoriska samfundets årsskrift* 25 (1936), 166–165; Olle Hellström: "Några synpunkter på prästerskapets ställning från Uppsala möte till Arboga riksdag", in: *Kyrkohistorisk Årsskrift* (1943), 107.

development that had taken place during the Reformation. Ecclesiastical affairs entered a new phase. However, despite the reforms, even during the period of Lutheran orthodoxy, many customs rooted in the Middle Ages were preserved in the outward form of church services. The new manual, which covered the forms of both the mass and church ceremonies, was a Finnish translation of a manual published in the same year in Sweden. This parallelism reflects the goal of liturgical uniformity adopted by the Swedish Church.

The many levels of the Lutheran theology of the church building are bound up with the functions of the sacral space. In the documents of the Reformation the church was very much a room for public assembly. Lutheran theological discussion steered clear of defining the concept of sanctity in concrete material terms. The significance that its use indirectly lent to its material form required that the churchroom should be fitted out in a manner appropriate to the activities that took place there. As Luther saw it, showing respect for the divine service meant giving the pulpit, the altar and the choir an appropriately dignified form.

According to a theological interpretation, space and objects acquired their value from the actions with which they were associated. Such interpretations linked sanctity with the content of the divine service and of the rituals of the church.[9]

The Age of Greatness – Towards Uniform Usages
At the beginning of the seventeenth century the central authorities wanted to bring Finnish development more closely into line with the practices observed in the mother country. Swedish Isaac Rothovius, appointed the head of the diocese of Turku in 1627, proved a highly influential administrator, and many of the aims of the Swedish policy of uniformity were achieved during his episcopate office (1627–52). The models for the repairs that Bishop Rothovius and Pehr Brahe, Governor-General of Finland, demanded in Finnish churches may be found in reforms started in Sweden. Under the vigorous leadership of Bishop John Rudbeckius, the diocese of Västerås became a leader in church reno-

[9] See the Swedish discussion on this point: Jan Arvid Hellström: "Heligt rum och allmänneligt hus. Synen på kyrkans rum och byggnad under svensk reformations- och stormaktstid", in: Lars Eckerdal (ed.): *Kyrka och universitet. Festskrift till Carl-Gustaf Andrén* (Stockholm, 1987); Anders Jarlert: "Genom heligt bruk avskilt till allmännelighet. Det reformerade kyrkorummet enligt Kyrkoordningen 1571", in: *Kyrkohistorisk Årsskrift* (1995).

vation. Rudbeckius, a man of many interests, emerged at the end of the seventeenth century as the figurehead of the reformist Lutheranism of the period. As Bishop of Västerås (1618–46) Rudbeckius showed a very active concern for the churches under his care.[10]

Due to the poor finances of the parishes, churches had fallen into decay after the Reformation. Pehr Brahe, who served as a Governor-General in Finland, mentions in his report in 1639 the dilapidated state of old churches. Brahe had in mind above all the medieval greystone churches of Southern and South-West Finland, by this time in sore need of renovation. His report reflects the fact that there was pressure from above on the parishes to repair their churches and to obtain up-to-date furnishings. Brahe required the parishes to also acquire works of visual art.[11]

Donors and Benefactors

In the early stages it was largely the wealthy donors who were saddled with the expense of church repairs. Following the theocratic social ideology that characterised Sweden's Age of Greatness, Bishop Rothovius assigned the role of social benefactor particularly to the clergy and the nobility.

The variety of the objects donated to beautify the Lutheran sacral space reflects particularly the prevailing economic conditions of society.[12] From the middle of the seventeenth century until the end of the 1680s, the artefacts presented to adorn the church mirror the political and social ascendancy of the nobility. An indication of the wealth of the feudal nobility in the middle of the seventeenth century are pulpits and elaborate altarpieces lavishly embellished with polychromatic sculptural decoration (fig. 23).

Materially furnishing the church gave persons of rank the opportunity

[10] Gerda Boëtius: "Konsthistoriska riktlinjer inom Västerås stift under 1600-talet", in: *Från Johannes Rudbeckius' stift. En festgåva till Rudbeckius-jubileet* (Stockholm, 1923), 54–56.

[11] Nils Ahnlund (ed.): *Rikskansleren Axel Oxenstiernas skrifter och brefvexling*, 1923 Kungl. Vitterhets historie och antikvitets akademien. Senare avdelning vol. 12: Brev från andlige och lärde (Stockholm, 1930), 249.

[12] See the studies of various local phemenomena: Per-Gustaf Hamberg: *Norrländska kyrkoinredningar. Från reformation till ortodoxi: Idehistoria, kulturförbindelser, mästare* (Stockholm, 1974); Ingrid Telhammer: *Predikstolmakare predikstolkonst före 1777 i norra Hälsingland, Medelpad och Ångermanland*, Kungl. Skytteanska Samfundets Handlingar 20 (Umeå, 1978); Ingrid Telhammer: *Svenskt eller danskt. Kyrklig inredningskonst i Jämtland 1520–1720* (Östersund, 1992).

to display not only their social status but also their intellectual authority: An academic education enabled its possessors to elaborate the theological substance of religion in a personal manner. The gentry did indeed make use of their theological knowledge on politically and socially motivated occasions. By contributing visual art the donor assumed the role of a public benefactor, acquiring religious merit from the paintings and objects given to make the church beautiful and to spiritually edify the congregation.

In a community marked by the social and political pretensions of the feudal nobility, the church became the burial place and family museum of noble houses contending for social authority. Liturgical objects were donated by an ascendant nobility. At the end of the Age of Greatness the nobles had ceased to contribute works of visual art.

Rich donations came to an end as the nobility lost some of its political power when the crown, in 1680, began to revoke feudal fiefs through what was known as the Grand Reduction. At the end of the seventeenth century the nobility concentrated on more private symbols such as coats of arms to decorate their graves and tombs. The studies of parish historians indicate a simultaneous sociohistorical change. A look at sociopolitical local history reveals that the 1690s were a turning point. Instead of individual donors it was now the congregation that commissioned acquisitions, calling, after matters had been decided in the church assembly, the craftsmen of the neighbourhood to execute the improvements agreed on. The enterprises were financed out of the parish coffers. The available funds determined the type of objects thus acquired. Instead of polychromatic sculptural decoration, the reredoses and pulpits produced at the end of the seventeenth century were adorned with modest figure paintings.[13]

The Medieval Heritage
Finnish churches retained much of their medieval sculpture and murals. The images decorating their walls, ceilings and altars were relics, in the Lutheran sacral space, of earlier religious practices, something that the emerging Lutheran Church had to address. The moderation shown in the way in which medieval pictorial works were accepted shows that Lutheranism had little need to focus its attention, in discussions on images, on the content of the pictorial motifs. The pictures painted on church

[13] Pirinen (1996), 115–118, 121–126, 132.

walls and ceilings during the Catholic period were allowed to remain visible irrespective of the subject depicted and the doctrinal content of the image represented.

In many parish churches the walls were painted over considerably earlier than the vault cells. As a rule, when whitewashing began, the pictures painted on the walls were covered first. The reasons were mainly practical. The soot from candlelight and the dust rising from the earthen floor stained the walls quickly. Technically, it was considerably more difficult to whitewash the vaults than the walls. In many churches the vaults were whitewashed as late as at the end of the eigthteenth century or even in the 1860s and 1870s as happened in Parainen (1873), Laitila (1860) and Perniö (1865). In some churches the medieval vault paintings were never painted over, as was the case in the churches of Lohja, Kumlinge, Rauma, Sauvo, Rymättylä and Taivassalo.

Churches retained some of their medieval furnishings, too.[14] In medieval churches rood lofts, rood screens and chancel screens were usually placed at the boundary between the nave and the choir, extending across the whole of the nave. A screenwork separating the choir and the nave has been rather common in Finnish medieval churches. All known fragments are dated to a period of some fifty years from the 1460s to the 1510s (Hollola, Korppoo, Sauvo, Kalanti, Mynämäki, Taivassalo).[15]

In the Middle Ages, the pulpit was closely linked with the rood loft. Nordic galleries incorporating a pulpit-like projection illustrate this transformation of form and structure. Material from Denmark and Norway makes possible an examination of variants of the typological development of medieval rood lofts and post-Reformation gallery pulpits.[16]

The gallery pulpits common in Danish churches are unknown in Finland. The oldest Finnish pulpit, constructed in 1550, is in Hattula

[14] See the German perspective: Johann Michael Fritz (ed.): *Die bewahrende Kraft des Luthertums. Mittelalterliche Kunstwerke in evangelischen Kirchen* (Regensburg, 1997).

[15] Hanna Pirinen: "Valta, voima ja sakramentti. Corpus Christi -kultti keskiajan kuvataiteeseen ja kirkkointeriööriin vaikuttaneena tekijänä", in: Tuukka Talvio (ed.): *Suomen Museo* 1999 (Vammala, 2000), 21–22, 26–27.

[16] Marie-Louise Jørgensen: "Lektorieprædikestole i Østdanmark", in: Hugo Jørgensen (ed.): *Kirkens bygning og brug. Studier tilegnet Elna Møller* (København, 1983); Ebbe Nyborg: "Lektorieprædikestole og katekismusaltertavler", in: Martin Blindheim , Erla Hohler and Louise Lillie (eds.): *Tro og bilde i Norden i Reformasjonens århundre* (Oslo, 1991); Håkon Christie: "Kinsarvik kirke og dens restaurering", in: *Foreningen til norske fortidsminnesmerkers bevaring. Årbok* (Oslo,1960).

Church. Its form parallels closely the medieval lectern. However, a detailed structural analysis shows that it was never part of the gallery[17] (fig. 24).

The choir screen continued to serve as the boundary between the choir and the nave. Swedish researcher Anna Nilsén has dated the earliest choir screens constructed after the Reformation to the second half of the sixteenth century. Historically this is consistent with the prevalent opinion among researchers that the church interior remained unchanged up until the 1550s, when the alterations that shaped the Lutheran sacral space started.[18]

According to Finnish sources, the construction of choir screens culminated here a little later than in Sweden. Sources from the period between the 1650s and the 1690s preserved in church archives include frequent mention of the erection of choir screens. They ceased to be constructed at the turn of the nineteenth century under the influence of an ideology of church building marked by the ideas of the Enlightenment. Some churches had their choir screens removed as early as in the eighteenth century, but according to the sources, choir screens were still a common feature of churches at the beginning of the nineteenth century.[19]

After the Reformation, the font was moved from its position by the church door. Initially it was, i.e. during the seventeenth century, placed close to the door of the choir screen. The instructions issued in 1604 by the diet of Norrköping prohibited baptising children in the porch. Instead, the baptism must henceforth be performed in the church proper.[20]

The altar rail, surrounding the altar on three sides, was a post-Reformation innovation in the Finnish parish church. In 1673 Johannes

[17] Marie-Louise Jørgensen and Markus Hiekkanen: A Record of an Examination of the Pulpit of Hattula Church 8.9.1992. National Board of Antiquities, Helsinki.

[18] Anna Nilsén: *Kyrkorummets brännpunkt. Gränsen mellan kor och långhus i den svenska landskyrkan. Från romantik til nygotik,* Kungl. Vitterhets Historie och Antikvitets Akademien (Stockholm, 1991), 52, 84–88, 216–217.

[19] Pirinen (1996), 84–90.

[20] Boëtius (1923), 54; Pentti Lempiäinen: "Kastekäytäntö Suomen kirkossa uskonpuhdistuksesta 1600-luvun loppuun", in: *Suomen kirkkohistoriallisen seuran toimituksia – Finska kyrkohistoriska samfundets handlingar* 69 (Forssa, 1965), 48–49, 134–138; Isaacus Rothovius: *Constitutiones Pastoribus in Dioecesi Aboënsi* [s.a]; Martti Parvio: "Isaacus Rothovius. Turun piispa", in: *Suomen kirkkohistoriallisen seuran toimituksia – Finska kyrkohistoriska samfundets handlingar* 60 (Forssa, 1959), 334; Olof Wallqvist: *Ecclesiastique Samlingar.* Femte Flocken (Stockholm, 1791), 164–165.

Gezelius the Elder, Bishop of Turku, gave instructions concerning the construction of such rails, specifying that the altar must be enclosed on three sides. During Communion the rail must be covered with a clean linen cloth.[21] Altar rails are linked with the reorganization of the choir that took place at the end of the seventeenth century. The order in which such changes were made varied in different parishes. Sometimes it was the acquisition of an altarpiece that occasioned a reordering of the choir; in some churches the alterations began with changes made to the altar, followed by the erection of a communion rail. It was usual after the middle of the seventeenth century to dismantle the medieval main altar in the choir and build the new altar against the eastern gable wall of the church[22] (fig. 25 and 26).

Since the end of the sixteenth century, paintings on canvas had been gaining increasing importance as a genre of European visual art. Around the middle of the seventeenth century novelties such as the altarpiece were becoming common in the prosperous heartlands of Southern and South-West Finland. In the Caroline period, an oil painting on panel or canvas set up over the altar became an innovation whose spread was quickened by the recommendations of the administrative hierarchy of the Church. The Baroque altarpiece with a polychromatic frame inherited the form of its predecessor, the medieval polyptych, as a work of art linked with the altar.

In Swedish culture the Age of Greatness was a highly international period. Both the wars waged by Sweden as a great power in Europe and the range of international commercial links, as well as cultural contacts, strengthened the ties connecting the regions lying north of the Baltic Sea with the coastal towns of the Southern Baltic and the thriving cultural centres of Central Europe. The various international contacts enjoyed by nobles active in Finland linked them with the core areas of European culture. The Dutch and the North Germans in particular transmitted styles and models from the centres of trade and culture.[23]

[21] Johannes Gezelius: *Perbreves commonitiones eller korta påminnelser* (Åbo, 1673), Cap. II Om Kyrkian och hwadh ther widh fordras; Carl-Martin Edsman: Offer och mässoffer eller "Det offer som på handklädet faller", in: *Svensk Teologisk Kvartalskrift* (1950), 196–198.

[22] Pirinen (1996), 90–91.

[23] Sigrid Christie: *Den lutherske ikonografi i Norge intill 1800* I (Oslo, 1973); Herman Oertel: "Das protestantische Abendmahlsbild im niederdeutschen Raum und seine Vorbilder", in: *Niederdeutsche Beiträge zur Kunstgeschichte* 13 (München, 1974); Louise Lillie: "Luthersk ikonografi og lutherske billedprogrammer. En vurdering af disse begrebers indhold set i

In the creative processes of the visual arts, the sociohistorical and economic changes that took place between the 1680s and the 1720s meant that one type of donor was superseded by another. In church art this was seen in a reduction in donations from the nobility. In a new situation, parishes became increasingly active commissioners of altarpieces. In terms of their function, the altarpieces commissioned by parishes represented a new type of artwork. The plainly framed altarpiece acquired a didactic function. The Communion altar was placed in the choir. Naturally enough, the parish adorned the altar with a pictorial representation that was directly linked with the sacrament for which the altar was used. One explanation for the frequency with which the Last Supper appeared as the subject of altarpieces acquired by parish funds are the medieval triumphal crucifixes preserved in many churches; at the same time, choosing the Last Supper as the subject of the altarpiece reflected the functions of the churchroom.

Galleries began to be built around the middle of the seventeenth century when an increase in parish populations made it necessary to provide churches with more pews.[24] Galleries accommodated household servants and the young people of the parish. It was common to decorate the wood panels of the balustrade with a series of paintings of the Evangelists and the Apostles occasionally also with extensive pictorial cycles representing the prophets and kings of the Old Testament.

The Caroline Period as a Synthesis of the Process of Change
It was in the Caroline period (1654–1718) that Finnish churches were furnished in a characteristically Lutheran style. The causes of this late triumph of Lutheran features on the level of actual interior decoration are economic, social and political. The delay was due to the fact that after the Reformation, the parishes were financially embarrassed because the funds had been seized by the crown and valuable property expropriated. A systematic remodelling of church furnishings began during the first half of

relation til 1600-tallets kirkelige kunst i Danmark", in: Taidehistoriallisia tutkimuksia – Konsthistoriska studier 8: *Bild och bruk. Föredrag vid det 8. nordiska symposiet för ikonografiska studier, Pålsböle, 22–26 augusti 1982* (Helsinki, 1985); Inga Lena Ångström: *Altartavlor i Sverige under renässans och barock. Studier i deras ikonografi och stil 1527–1686*, in: Acta Universitatis Stockholmiensis, Stockholm Studies in History of Art 36 (Nyköping, 1992).

[24] See: Reinhold Wex: *Ordnung und Unfriede. Raumprobleme des protestantischen Kirchenbaus im 17. und 18. Jahrhundert in Deutschland* (Marburg, 1984).

the seventeenth century on the initiative of active pioneers holding key positions in the Swedish Church. Johannes Rudbeckius, Bishop of Västerås, was the most enthusiastic champion of renovating churches to bring them up to date. These were the models adopted when refurbishment also began in Finland.

Johannes Terserus was the first Caroline bishop of Turku to have studied extensively abroad. He had been educated at Västerås Grammar School, and later served as a notary during Johannes Rudbeckius' tour of inspection in Ingermanland and Estonia in 1627. His international influences accumulated during a long study tour in Europe in 1633–37. He studied in Germany but also visited universities in France, England and the Netherlands.

Johannes Gezelius the Elder's policies regarding the administration of the Church were shaped largely by the Västerås circle. Gezelius was a close friend of and collaborator with Olaus Laurelius, Rudbeckius' successor. Johannes Gezelius the Younger, who followed his father as Bishop of Turku, had, on his elevation, several years of study behind him on the continent. Between 1670 and 1674 he had, as a stipendiary of the Swedish state, studied in Germany, the Netherlands, England, France and Switzerland.

The bishops' personal preferences and ideals concerning the furnishing of churches can be studied in committee minutes and inspection records. Johannes Terserus openly attacked the extreme manifestations of the self-assertive social hegemony of the nobility. In his eyes, the choir stalls of the nobles were such manifestations. The bishop's personal attitudes evoked a sympathetic response during a ministerial convention held in Turku in 1660, chaired by Terserus. The convention minutes record the assembled clergymen's disapproval of the nobles' choir stalls, perceived as being altogether too grandiose and as taking up far too much space.[25]

It is probable that Johannes Gezelius the Younger intended a fairly comprehensive reform of church furnishings, but that project was never carried out because a war known as the Great Wrath intervened. However, as an experiment of a kind he did carry through, in Sauvo Church, the church of his benefice parish, reforms that have parallels in England. Among other things he enclosed the font within a railing of a type set up

[25] K. G. Leinberg (ed.): *Handlingar rörande finska kyrkan och presterskapet* VI (Jyväskylä, 1907), 123, Nr 77.

in many churches in England in the 1660s.[26] Gezelius considered the interior of the church from a perspective that was above all practical. During an inspection tour in Perniö in 1699 the bishop's attention was drawn by the tall sculptured altarpiece in the church. In his eyes the altarpiece, donated by the family of a noble officer in 1667, was too large to be placed before the choir window. He exhorted the parish to make the altarpiece, now darkening the choir, lower so as to admit more light into the churchroom.[27]

★ ★ ★

By the end of the Caroline period the furnishings of the Lutheran parish church had matured into a rich synthesis combining the medieval heritage with influences from the Scandinavian and North European Lutheran cultural sphere. In addition, Netherlandish and English models were followed in certain details of the decor. The final features of the Finnish parish church represented an individual local adaptation, with pulpits and altarpieces of original design constructed by craftsmen making creative use of European models.

Hanna Pirinen (1965), Ph. D. Reader in Art History, University of Jyväskylä, Puistokatu 3 B 29, 40100 Jyväskylä, Finland.

[26] Paul Jeffery: *The City Churches of Sir Christopher Wren* (London, 1996), 158–162.
[27] Pirinen (1996), 66, 116.

Aspects of Musical Thought in the Seventeenth-Century Lutheran Theological Tradition

Sven Rune Havsteen

An important task in the study of the rich Lutheran musical culture in the seventeenth century in its relation to religion is to reconstruct the musico-theological thought that constituted the ideological framework for the musical practice. Some important work has already been done by various scholars,[1] but not only have many texts not yet been investigated thoroughly – on several points what has been done needs to be reconsidered. One ought, for instance, to examine more closely the theological context and premises by which musical thought of this period was influenced to a considerable extent. This is not an easy task, because the material is many-layered and quite vast.

In addition to this, the observation has to be made that the Lutheran musico-theological thought was never stated or summarized as a systematic-dogmatic doctrine in the proper sense of the word – and should not be presented as such – but is rather constituted by a number of considerations put forward in different contexts and at different occasions, and connected with various text genres. Thus the subject is treated not only, for instance, in monographs (treatises), but also in forewords to hymnals or music collections, in exegetical works (e.g. in interpretations of St Paul's letters to the Colossians and Ephesians, or of the Revelation), as well as in sermons. An interesting contribution is provided by the devotional literature – very important from the point of view of church history – where one now and then finds reflections that are relevant for the understanding of the religious status of music. What I have in mind is works like Johann Arnd's devotional book *Vier Bücher vom Wahren Christentum (Four Books on True Christianity)* and Johann

[1] See for instance: Irmgard Otto: *Deutsche Musikanschauung im 17. Jahrhundert* (Berlin, 1937); Christian Bunners: *Kirchenmusik und Seelenmusik. Studien zu Frömmigkeit und Musik im Luthertum des 17. Jahrhunderts* (Berlin, 1966); Rolf Damman: *Der Musikbegriff im deutschen Barock* (third impr., Laaber, 1995; first edition 1967); Joyce L. Irwin: *Neither Voice nor Heart Alone. German Lutheran Theology of Music in the Age of the Baroque* American University Studies, Series VII, Theology and religion vol. 132 (New York etc., 1993).

Gerhard's *Schola Pietatis (School of Piety)*, both monumental representatives of the Lutheran spiritual culture of the epoch. Here as well as in many other similar works one encounters meditative approaches to central parts of the Christian faith or life. Among other things, a theme like *the praise of God* appear, which has implications for the theological understanding of the musical practice in the Lutheran tradition.

★ ★ ★

The intention of this article is to present briefly some aspects of the musical thought in the Lutheran tradition of the seventeenth century mostly with reference to the theme of praise. The point of departure for the following presentation is two music monographs from the fourth decade of the seventeenth century. One was written by a theologian and pastor in Northern Germany, *Christopher Frick*, and published in 1631. The title is long, but quite telling:

> Music-Büchlein; Oder, Nützlicher Bericht Von dem Uhrsprunge/Gebrauche vnd Erhaltung Christlicher Music Vnd also Von dem Lobe Gottes/ Welches die Christen theils in dem niedern Chor dieses elenden betrübten Jammer-vnd Thränen-thals verrichten sollen; Theils aber (nach allhie aus-vnd abgesungenen Klagliedern/) dort in dem hohen helleuchtendem Engel-Chor des himlischen Frieden-vnd Frewden-Saals in vnaußsprechlicher Wonne vnd Herrligkeit verrichten werden […][2]

> A Little Book On Music; Or, A Useful Account of the Origin and the Usages of Christian Music and about How to Maintain It. Thus also about how to praise God, as Christians should do, both in the earthly choir of this wretched, miserable vale of tears, but also as they will do in the high and brightly illuminated angelic choir of the heavenly hall of peace and joy in ineffable bliss and glory (after the threnodies sung in this world).

The other monograph, printed in Copenhagen 1639, was written by *Laurentz Schröder*, an organist, probably of Northern German origin, who at that time was working in Copenhagen.[3] It has the following title:

[2] Reprint by Zentralantiquariat der deutschen Demokratischen Republik. Volksdruckerei Zwickau (Leipzig, 1976). [In the following: *Music-Büchlein*]. The monograph of Frick was preceded by an earlier one, *Musica Christiana*, from 1615. See the study by Joyce L. Irwin, referred to in n. 1, where the *Music-Büchlein* is briefly commented on.

[3] On L. Schröder, see short articles in: *Dansk Biografisk Leksikon* (2nd ed.: Povl Engelstoft,

Ein nützliches Tractätlein Vom Lobe Gottes / oder der Hertzerfrewenden *Musica*, Worinn kuerzlich vnd einfältig gezeiget wird/ wie die Musica sampt ihrer *Commodität* vnd Nutzbarkeit/einig vnd allein zur Ehre Gottes sol gerichtet seyn. Allen Christlichen Liebhabern der edlen Music-Kunst/zum besten/ vnd anreitzung/Gott dem HErrn durch dieselbe zu loben/verfertiget […][4]

A Useful Little Treatise About the Praise of God; Or, The Heart-Pleasing Musica, wherein it is briefly and simply shown how Musica with its appropriateness and utility must be directed solely for the honour of God: It must be written and performed for the benefit and incentive of all Christians who value the noble art of music, and in order to praise God the Lord through this same music.

Already these quite elaborate titles provide an idea of the perspective that characterizes the approach of these books to the topic of music. A closer examination of their content confirms this impression. In accordance with the titles, the question of the main purpose of any musical activity is put into focus. Again and again this purpose is pointed out to be *the praise of God*. It is a fundamentally important concern for these writers to emphasize this, as well as showing – from this perspective – the necessity of music, regarding music as a basic way of expressing man's relation to God. It is worth noticing that especially the *Nützliches Tractätlein* in its title relates the praise of God and the praise of the art of music in such a way that they are apparently put on the same footing.[5] Thereby, not only a close connection between divine reality and music is stressed, but at the same time the high status of music is pointed out, in a way which is in accordance with, and most probably dependent on, the view *Martin Luther* (1483–1546) as well as his musical adviser, the composer *Johann Walter* (1496–1570), promoted on various occasions.[6] For Luther the art

Copenhagen, 1941; third ed.: Sv. Cedergren Bech, Copenhagen, 1983); Friedrich Blume (ed.): *Musik in Geschichte und Gegenwart* (Kassel, 1949–); Stanley Sadie (ed.): *The New Grove Dictionary of Music and Musicians* (London, 1980). Short references in: Angul Hammerich: *Dansk Musikhistorie indtil 1700* (1921), 166; Nils Schiørring: *Musikkens Historie i Danmark vol. I: Fra Oldtiden til 1750* (Redaktion: Ole Kongsted og P.H. Traustedt) (1977), 216. On the tract of Schröder, see Kurt Gudewill: "Vom Lobe Gottes oder der Musica", in: Detlef Altenburg (ed.): *Ars Musica Musica Scientia. Festschrift Heinrich Hüschen* Beiträge zur Rheinischen Musikgeschichte, vol. 126, (1980), 190–197.

[4] Original in The Royal Library, Copenhagen. [In the following: *Vom Lobe Gottes*].

[5] An observation already made by Gudewill in the article mentioned in n. 3.

[6] An obvious reference in this context is Martin Luther's praise of music, the *Encomion musices*, i.e. his *Foreword* to the Wittenberg printer Georg Rhau's collection of motets, the

of music was a "donum divinum" (a divine gift),[7] for Walter "ein edle Gab" (a noble gift)[8] and a "heavenly",[9] "sacred, divine"[10] art that "God has created"[11] for the benefit of man. As such, it is to be praised by man, but at the same time to be used for the primary purpose of praising God.[12] In Frick and Schröder a similar idea is present. We learn for instance that:

> [...]*Musicam esse divinum quiddam, die Musica sey kein Menschlich inventum, oder Werck/ sondern komme/ als eine sonderbare Gabe/ vrsprünglich von Gott her* [...][13]

> [...]Music is something divine, music is not a human invention or work, but originates rather as a remarkable gift from God [...]

Or music is:

> [...] *durch Menschlichen fleis erdacht/ durch erleuchtung des heiligen Geistes erfunden/ vnd dem Menschlichen Geschlecht als eine Gabe Gottes mitgetheilet seyn* [...][14]

> [...] made out through human effort, invented through the enlightenment of the Holy Ghost, and imparted to the human genus as a gift from God [...]

Symphoniae iucundae (Delightful Symphonies) from 1538, in: *D. Martin Luthers Werke. Kritische Gesamtausgabe* vol. 50 (Weimar, 1914), 368–374. *D. Matin Luthers Werke. Kritische Gesamtausgabe* henceforth referred to as WA. See also Walter Blankenburg: "Überlieferung und Textgeschichte von Martin Luthers *'Encomion musices'*", in: *Luther-Jahrbuch* (1972), 80–104; this article contains the Latin text as well as a German version. Regarding Johann Walter, see his two laudatory poems on music: *Lob und Preis der löblichen Kunst Musica* (1538) and *Lob und Preis der himmlichen Kunst Musica* (1564), in: Johann Walter, *Sämtliche Werke* (ed. O. Schröder) [in the following: *SW*] VI, 153ff, 157ff. (Kassel, 1953–73). K. Gudewill (1980), see n. 3, also points to the dependence on the Lutheran–Walterian view on music.

[7] See for instance WA vol. 50 (Weimar, 1914), 368.
[8] Johann Walter: *SW*, VI, 157 (stanza 12).
[9] Johann Walter: *SW*, VI, 157 (stanza 10).
[10] Johann Walter: *SW*, VI, 156 (distichon 144).
[11] Johann Walter: *SW*,VI, 157 (stanza 7).
[12] See for instance WA vol. 50 (Weimar, 1914), 372. Johann Walter, *SW* VI, 154 (distichon 37f): "[...] Wie man die Music brauchen soll:/Aufs erst zu Gottes Lob und Ehr [...]."
[13] *Music-Büchlein,*165.
[14] *Vom Lobe Gottes,* 7.

The title of the *Music-Büchlein* also indicates the *eschatological* dimension of musical praise. A distinction is made between this life and the life to come, and the conditions of the latter give rise to a fulfillment of the praise of God through music, indicated by terms like the heavenly or angelic choir. This idea is of course not new, but it should be mentioned that it had its main representative in the early Lutheran tradition in Johann Walter.[15] Both of the monographs by Frick and Schröder give this theme exposition, making it an element of constitutive significance. As a consequence, musical practice is not only viewed as a preparation for and an anticipation, although incomplete, of transcendent music, it is also said to endure in eternity.[16]

Among the main issues, indicated by the titles and accounted for in the main texts, are furthermore the questions of *the origin of music* and, not the least, of *the use* and *the utility of music*. Under this heading, various approaches to the so-called *effects of music* are dealt with, which are of considerable interest for the understanding of the spiritual role of music in Christian life. Also in this respect, the authors are in accordance with Luther's and Walter's thinking.[17]

These topics recur again and again in contemporary theological texts on music, and the answers generally follow a common pattern. As far as the sources are concerned, a common stock forms the basis for the reflections: the Bible, Pagan authors of Antiquity (such as e.g. *Pliny the Elder, Plutarch,* and *Quintilian*), the Church Fathers (such as *St Justin Martyr, St Basil the Great, St Augustine*), the Ecclesiastical Histories of the Early Church, authors from the century of the Reformation, first and foremost Martin Luther, but also men like *Johann Mathesius* and *Cyriacus Spangenberg*. Among the contemporaries, *Johann Arnd* must be mentioned, especially in connection with Frick and Schröder.

★ ★ ★

In the following we shall dwell on some of the themes unfolded in the above-mentioned works, although the presentation will be based mainly on the Schröder text.

[15] In Walter's music poems (see n. 6) the idea of the eternal music performed by the elect in the heavenly choir is present. Johann Walter, *SW,* VI, 156 (distichon 145ff), 159 (stanza 48).
[16] See: *Vom Lobe Gottes,* 57f, 79f, 187ff. *Music-Büchlein,* 107ff, 297ff.
[17] So Gudewill (1980), see n. 3.

From a theological point of view, the question of what is called *the necessity of music* or *the obligation* to praise God also through music is fundamental. This necessity has interior as well as exterior reasons. The theological music monographs are not only to be read as examples of self-reflection by a member of a Christian community. They should probably also be perceived in that way, thus contributing to the understanding of the practice of faith within a certain community, though the monographs are also to some extent apologies or defences of the use of music in Christian worship. They are part of a debate in which the counterpart – such as, e.g., the reformed or Calvinist party – contested the validity of the positive Lutheran attitude towards music.[18]

The idea of necessity in connection with musical practice emphasizes that music is not an art which you cultivate as you please – on the contrary, it is an obligation for every Christian and every Christian society. This is so because music is linked – in accordance with Lutheran orthodox theology of the time – with the obligation to praise God, an obligation that is based on a divine command, a "mandatum", which is made manifest in biblical history.[19] The *mode* of praise is also based on a divine command. Praise has first and foremost to be advanced through hymns and spiritual songs, with reference to the example of King David. The obligation is of course universally valid, but Schröder mentions particular groups that are covered by the obligation. On the basis of some of the psalms of David,[20] he mentions kingdoms and kings, who are called upon to praise the Lord, and Schröder expresses the wish that the divine command be inscribed in the hearts of the kings. In other words: that the kings may have the praise of God very much at heart, in the sense that this matter may be recognized and experienced by the princes as fundamentally important for the community of faith. This is a matter which has to be dealt with on the personal level as well as on the institutional (liturgical) level. Princes of such piety will be praised like King David, who is regarded as an example to follow – paraphrasing Ecclesiasticus 47:9–12:[21]

[18] Thus Frick attacks the dismissive attitude of the Calvinists towards music. See *Music-Büchlein*, 28ff.

[19] *Vom Lobe Gottes,* 58ff. *Music-Büchlein,* 6ff.

[20] Ps 68:32: "You kingdoms of the Earth, sing to God, praise the Lord." And Ps 148:11, 13: "You kings of the Earth should praise the name of the Lord."

[21] *Vom Lobe Gottes,* 60.

(v. 9) Für ein jegliches Werck danckete Er dem Heiligen/ dem Höchsten mit einem schönen Liede/ v. 10. Er sang von gantzem Hertzen/ vnd liebete den/ der ihn gemacht hat/ v. 11. Er stifftet Sänger bey dem Altar/ vnd liess sie seine süsse Lieder singen/ v. 12. Vnd ordnet die Feyrtage herlich zu halten/ vnd daß man die Jahrfeste/ durchs gantze Jahr schön begehen solte/ mit loben dem Nahmen des Herrn/ vnd singen/ des Morgens/ im Heiligthumb.

8 In all his works he praised the Holy One most high with words of glory; with his whole heart he sung songs, and loved him that made him.
9 He set singers also before the altar, that by their voices they might make sweet melody, and daily sing praises in their songs.
10 He beautified their feasts, and set in order the solemn times until the end, that they might praise his holy name, and that the temple might sound from morning.[22]

The text is about King David, but in its actual historical application, it summarizes a number of important elements in a Lutheran view of the ideal Christian prince, who ensures that the praise of the Lord is enunciated and carried through in an ordered exterior form in accordance with certain criteria of value judgement, while at the same time being an expression of faith, i.e. a personal response to the acts of God towards man. Schröder's monograph was dedicated to the Danish king, Christian IV, thereby citing him as an example of a prince who lived up to this ideal.[23]

After this, a more general appeal – on the basis of quotations from a selection of the psalms of David – is presented, aiming at "the righteous and pious", or simply to "all flesh" that lives on Earth.[24] Schröder dwells on the word "all" in the quotations, and maintains that the reference concerns all who breathe. According to Schröder, it is only reasonable that man is requested to praise God in this way. He who receives the blessings of God has a natural obligation to thank God, just as he who recognizes the majesty and glory of God has a natural obligation to praise Him. But, since all humanity has received the blessings of God and is constituted in such a way as to know God through his word, the obligation is universal.

★ ★ ★

[22] The English Bible translation used here – and at other places – is the King James version, in the modern re-edition of Oxford University Press (Oxford, 1997). Note in this case that the numberings of verses differ between the German and the English Bible texts.

[23] See the *dedication letter* of Schröder, introducing the book.

[24] For this and the following, see *Vom Lobe Gottes*, 61ff.

Schröder further considers the limitations of the praise of God and the human condition. Reference is made to another text from *Ecclesiasticus* 43:28–36[25] that contains a reflection on the inconceivable greatness of God, in response to which man – with his limited existential abilities – inevitably will fail. The distance between God and man is such that man's praise of God will never be adequate. Even so, according to Schröder, despite the conditions of finiteness, man's doxological practice nevertheless prepares the way for some communication between man and God. A closer examination of the text at this place reveals its dependence on a passage in Johann Arnd's *Vier Bücher vom wahren Christentum*.[26] No direct reference to Arnd is given in the context, but a quotation later in the same chapter is explicitly attributed to him. The presence of Arnd is interesting for several reasons. One is of course the reception history of this important devotional book, but not least important is the joining together of the devotional-meditative tradition and music which takes place in this music monograph. The hidden Arnd quotation (beginning at "je höher [...]") is contained in the following passage:

> [...] Darumb wenn die Heiligen GOTTES den HERRN loben wollen/ so verwundern sie sich mehr/ als daß sie GOttes Lob erreichen solten: Sie haben wol den Willen vnd Vorsatz/ aber sie könnens nicht erreichen/ vnd zwar/ je höher einer im lobe GOttes ist/je tieffer er in Gedancken kömpt/ so in GOTT versenckt werden; Nicht dass einer aus fürwitz/ vnerforschliche dinge/ die ihm zu schwer sind/ gründen soll/ sondern dass GOtt offt den Reichthumb seiner Weißheit einen GOttlobenden vnd liebenden Menschen sehen lesset/ darüber er verstummet/ vnd es nicht außreden kann [...][27]

> [...] Thus, when God's holy ones want to praise the Lord, they wonder more than they are able to praise God. They certainly have this desire and intention, but it is not within their reach. Because the higher someone stands in his wish to praise God, the deeper he thinks about it and becomes absorbed in God. No one ought to ponder about inscrutable matters which are difficult for him in order to seem to know everything. Indeed, God often lets a pious and

[25] *Vom Lobe Gottes*, 67.

[26] Johann Arnd's (1555–1621) *Vier Bücher vom wahren Christentum*, was issued in the first decade of the seventeenth century, with several later reprints. A critical edition does not exist; the references are to: *Johann Arnd's Sechs Bücher vom wahren Christentum nebst dessen Paradies-Gärtlein* (Bielefeld, 1996) (In the following *WC*). In later editions of Arnd's work two further books were added, hence the title "Six Books etc".

[27] *Vom Lobe Gottes*, 67f. Arnd, *WC*, II, 43, 6.

devout person see the abundance of his wisdom, so that this person becomes silent and is unable to speak about it [...]

The text is taken from the Second book, chapter 43 of the *Vier Bücher vom wahren Christentum*, which together with the preceding two chapters focuses on the praise of God. The text refers to the basic existential situation of man in which he can never reach God. But on the other hand, out of the praise of God follows an absorption in God that one could call a doxological cognition of God. At the same time it is emphasized that this does not mean that man thereby is led astray and induced to occupy himself with divine matters which he is not entitled to do because they transcend the cognitive faculties of man. What it means, according to Arnd, Schröder's mouthpiece, is that God gives man – through his praise – access to himself in such a way that he gains an insight into the divine. It is, however, important to note that this divine reality is not communicated according to the ordinary human cognitive patterns, it is unspeakable – confronted with it, language falls short. In this Arndian perspective, the praise of God represents a specific theological communication and cognition that transcends the knowledge linked to language. It is at the same time existentially based because it stems from the experiences of living faith, a matter which is crucially important in Arndt's theological programme.

On the basis of this understanding, the further account is based upon a number of quotations from biblical texts that all consist of exhortations to praise God. From the New Testament one finds the classical texts on singing in St Paul's letter to the Ephesians (5:18-19)[28]:

> [...] Werdet voll Geistes vnd redet vntereinander von Psalmen vnd Lobgesängen/ vnd Geistlichen Liedern/ singet vnd spielet dem HERRN in ewern Hertzen [...]
>
> [...] Be filled with the Spirit; Speaking to yourselves in psalms and hymns and spiritual songs, singing and making melody in your heart to the Lord;

and letter to the Colossians (3:16):[29]

[28] *Vom Lobe Gottes*, 71f. The German biblical text is the one quoted by L. Schröder.
[29] *Vom Lobe Gottes*, 72.

> [...] Lehret vnd ermahnet euch selbst mit Psalmen/ vnd Lobgesängen/ vnd Geistlichen lieblichen Liedern/ vnd singet dem Herrn in ewern Hertzen [...]

> [...] Teaching and admonishing one another in psalms and hymns and spiritual songs, singing with grace in your hearts to the Lord.

These two important texts in the context of musico-theology show, according to Schröder, the right "place" for devotion. We have to think of the heart here, which is mentioned in both quotations. The heart is considered to be the point of departure for the praising of God; from there the praise has to be communicated. The exhortations are, it is underlined, not only meant to be appeals to other human beings, they are addressed to oneself as well. This may be understood in such a way that the basis of praise always has to be the existential involvement of faith. Against this background the passage is rounded off by an appeal to the Christian to implore the Holy Ghost to open eyes of understanding for him, so that he not only will praise God, but in addition experience an inner joy, praise and joy being complementary.[30]

The first part of these considerations focused on the praise of God through singing, i.e. of hymns and spiritual songs. The second part thematizes the instrumental praise, with reference to the command mentioned in 2 Chronicles 29:25 and Ps 33:2–3, where a number of instruments are involved in the praise of God.[31] The theme of instrumental music is used by Schröder as an occasion for some important theological reflections concerning what could be called the existential, or experientially oriented attitude, in which musical practice is considered to originate. In the context these reflections are immediately connected with instrumental music, but they are, in fact, related to a broader field of musical practice. Schröder has once again recourse to the aforementioned book by Johann Arnd. In accordance with Arnd, the Old Testament instruments are interpreted allegorically or typologically as the gifts of the Holy Ghost by which God is praised, and his deeds are made known. From the point of view of Salvation History, obviously present here, references in the Old Testament to instrumental use are replaced by ideas of a new practice where spiritual instruments are involved. The Old Testament points forward to a new spiritual practice where the praising of God so to speak

[30] *Vom Lobe Gottes*, 72.
[31] *Vom Lobe Gottes*, 73ff.

is redeemed. Undoubtedly the distinction between the Old and the New Era, where a spiritualized musical practice gains power is an important point for Johann Arnd, drawing on an old Christian idea. It is nonetheless important to note a certain ambiguity in Arnd's view on musical practice. It is as if his text displays a tendency towards a total spiritualization and interiorization of praising, which would imply a degradation of the music as actually performed, an attitude which can be found among some Lutheran devotional writers in the seventeenth century. But one thing is clear: Schröder is not using Arnd for such a purpose. He is aiming at a defence of music, performed from a spiritual basis. To be sure, Arnd himself is in agreement with this, if one reads him closely. He writes for instance as follows:

> [...]Diese unterschiedlichen Chöre und Instrumente, darauf im Alten Testament unterschiedliche Psalmen gespielet worden, weil's ein Stück vom äußerlichen zeremonialischen Gottesdienst gewesen, sind nun vergangen und ist nun unser Herz, Geist, Seele, Gemüt und Mund GOttes Posaune, Psalter, Harfe und Cymbel worden. Daher St Paulus spricht Kol. 3,16: Singet und spielet dem HErrn in eurem Herzen. Welches nicht also zu verstehen, als sollte man nun GOtt in der Versammlung oder daheim nicht mit lauter Stimme loben, oder mit anderen musikalischen Instrumenten. Nein; sondern St Paulus Meinung ist, daß es alles fein andächtig, geistlich und aus Grund des Herzens gehen solle, nicht daß es nur ein äußerlicher Schall oder Gepränge sein soll.[32]

> [...]These different choirs and instruments, on which different psalms were played in the Old Testament, have disappeared because they belonged to the exterior ceremonial worship, and have now become our heart, spirit, soul, mind and mouth and God's trumpet, psaltery, harp, and cymbal. For this reason St Paul says: "singing with grace in your hearts to the Lord" (Col 3,16). [An exhortation] which is not to be understood to the effect that God should not be praised in a loud voice or with other musical instruments, whether in the congregation or at home. No, it is the opinion of St Paul that everything should come from the depth of the heart in a pious and spiritual way and that it should not merely be an exterior sound or splendour.

The audible music is not turned down in favor of an inner spiritualized piety. But words like "Geist", "Seele", "gemüt" (spirit, soul, mind), "andächtig", "geistlich und auf Grund des Herzens" (in a pious, spiritual way and from one's heart) function as indicators of the demand that music

[32] *WC*, II, 41, 10.

practice should be based on religious-existential roots at the centre of the personality. Even so, music is still, it is emphasized, to be practiced as an audible phenomenon or reality.

★ ★ ★

On this background some further observations must be made. The idea of the inner rootedness of the praise of God as well as its ecstatic nature (i.e. its dependence on the work of the Holy Ghost) comes to the fore in the following quotation from Schröder which is partly based on Arnd:[33]

> [...]Denn gleich wie ein Musicalisch *Instru*ment des Menschen Werckzeug ist/ darauff er spielet: Also ist des Menschen Seele des Heiligen Geistes Werckzeug/ durch welches vnd in welchem er Gottes Lob wircket. Woraus wir mit hohem fleiß mercken sollen die hertzlustige Einigkeit des Heiligen Geistes vnd der Seelen eines GOttlobenden Menschen: Denn gleich wie ein Mensch nichts liebers vnd angenehmers in einem *Instrument* suchet/ als die liebligkeit/ vnter dem Wörtlein *Concordantia*, also suchet Gott der Heilige Geist an dem Menschen/der sein Instrument vnd Werckzeug ist/nichts angenehmers als die lieblichkeit vnter dem Wörtlein *Concordia*. Vnd wie die Syllabe *Cor* vnter den andern in der mitten stehet/ wie das Menschliche Hertz mitten im Leibe/ also suchet Gott diese *Syllabam Cor*, das ist dein Hertz vnd nichts anders auß der mitten herauß [...][34]

> [...] Just as a musical *instru*ment is a human tool on which a person plays, in the same way the soul of man is a tool for the Holy Ghost through which and in which he accomplishes the praise of God. Accordingly, we should assiduously note the unity of the Holy Ghost and the soul of someone praising God, a unity which gratifies the heart: For in the same way as a person finds nothing more lovable and attractive in an *instrument* than loveliness in terms of *concordantia*, so the Holy Ghost looks for nothing more attractive and lovable in a person, who is his *instrument* and tool, than the loveliness in terms of *concordia*. As the syllable *cor* is placed in the middle of the other syllables, just like the human heart similarly is found in the centre of the body, so God looks for this *syllable cor*, which is your heart, and for nothing else at the centre [...]

A metaphor depicting man as God's instrument is hardly an innovation, of course. It was used quite often in the seventeenth century, but can be

[33] *WC*, II, 43,4.
[34] *Vom Lobe Gottes*, 74.

traced back to Antiquity.³⁵ The text summarizes in fact an important line of thought not only in Schröder, but also in the *Music-Büchlein*. Compare the following quotation from Frick:

> Denn das Hertz des Menschen sol GOttes Wohnung seyn/ nicht weit vom Hertzen/ hat Gott die Lunge/ die *arteriam*, die Lufftröhre/ den Mund vnd die Zunge gesetzt/ welche die Stimm vnd den Gesang machen/ auff daß der Mensch wenn er sich selber anschawet/ sich erinnerte er solte seiner Gliedmaß vmb das Hertz also gebrauchen/ daß Gott/ der in dem Tempel vnsers Hertzens wohnen wil/ gelobet vnd aus warer Danckbarkeit angesungen werde.
>
> Ja wenn der Mensch sich recht beschawet/ so wird er ein herrliches Orgelwerck/ mit einer schönen Concordantz aller Gliedmassen an sich befinden.³⁶

> For the heart of man should be the abode of God. God has placed the lung, the artery, the windpipe, the mouth and the tongue, which produce the voice and the singing, near the heart, so that man when he observes himself will remember to use these body parts around the heart in such a way that God – who wants to dwell in the temple of our heart – will be praised with singing in an attitude of true gratitude.
>
> Yes, when man observes himself in the right way, he will find a magnificent organ with a beautiful concordance of all bodily parts.

These texts are examples of a theological approach that emphasizes the religious and spiritual foundation of music. In this perspective a close link is established between the experience of the divine presence in the personal as well as bodily centre of man – in the language of the seventeenth century: the heart – on the one hand, and the unfolding of man's musical activities on the other. The divine presence in the heart indicates in itself a concordance – i.e. some sort of harmony between God and man. One may ask to what this concordance more specifically refers. The

³⁵ For this topos see Rolf Damman: *Der Musikbegriff im deutschen Barock* (Laaber, 1995), 420f. Damman traces the metaphor back to pagan Antiquity, where it was used by theologians of the early Church (for instance Justin the Martyr, Clement of Alexandria, and Tertullian). In the Baroque era Damman quotes the German poet Angelus Silesius: *Cherubinischer Wandersmann* (1656):

"Das geistliche Orgelwerk: Gott ist ein Organist, wir sind das Orgelwerk/Sein Geist bläst jedem ein und gibt zum Ton die Stärk."

"The spiritual Organ: God is an organist, we are the organ. His spirit blows into everyone, and strengthens the tone."

³⁶ *Music-Büchlein*, 58.

musical concordance, manifested in and through the human body, mirrors, as it were, a concord, not only between God and man, but also, and closely connected with this, a concord among members of human society.[37] In the broader theological context, this theme was promoted and brought into the discussion in Lutheran theology of the Orthodoxy – often under the heading of *unio mystica*.[38] It was not only a concept within dogmatic theology, but was also stressed as an important reality in Christian life. As such it was considered to be a realizable goal within the spiritual life of faith – a fact heavily attested to by much devotional literature (Arnd's works are major examples of this, but many other writers could be mentioned, for instance Philipp Nicolai, and Johann Gerhard). The music monographs in question reflect this theological thinking and make music a vehicle for expressing man's response to the set of experiences connected to the idea of divine presence. In doing this, music comes very close to having a revelatory function – revelatory taken in the religious sense of the word.

★ ★ ★

From here there is a link to the question of the *effects of music* elaborated by both Schröder[39] and Frick.[40] Schröder draws the reader's attention to the fact that music not only drives away evil spirits, as it was (for instance) Luther's experience, but also attracts "holy and good spirits".[41] St Bernard is among others mentioned because of a statement, where he maintains that where men praise God, angels will be present.[42] A number of biblical quotations are also brought into the discussion in order to show how music attracts the Holy Ghost. For instance 1 Sam 10,[43] where the well known story is told about the newly anointed King Saul meeting the

[37] *Vom Lobe Gottes*, 75. *Music-Büchlein*, 272f.

[38] About the theme of *unio mystica*, see for instance: Matti Repo and Rainer Vinke (ed.) *Unio. Gott und Mensch in der nachreformatorischen Theologie. Referate des Symposiums der Finnischen Theologischen Literaturgesellschaft in Helsinki 15.-16. November 1994* Veröffentlichungen der Finnischen Theologischen Literaturgesellschaft 200, Jahrbuch 1995; Schriften der Luther-Agricola-Gesellschaft 35 (Helsinki, 1996).

[39] *Vom Lobe Gottes*, 134ff.

[40] *Music-Büchlein*, 75ff, 168ff.

[41] *Vom Lobe Gottes*, 143ff.

[42] From his 7th sermon on the Song of Songs.

[43] V. 5–6,10.

prophets, who, accompanied by music, were in an ecstatic state of mind. Saul, too, experienced the Spirit coming upon him. Two other biblical passages should be mentioned, 2 Chron 5:12–14 and Ps 22:3. The first describes how the Levite singers Asaph, Heman, Jeduthun together with a great company praised the Lord with songs and instrumental music at the consecration of the temple. They experience then, that the house was filled with a cloud. The glory of the Lord had filled the temple. The text runs:

> Die Leviten/ vnd alle/ die vnter Asaph/ Heman/ Jedithun/ vnd ihren Kindern vnd Brüdern waren/ sungen mit Cymbalen/ Psaltern vnd Harffen/ vnd stunden gegen Morgen des Altars/ vnd bey ihnen hundert vnd zwantzig Priester/ die mit Trometen bliesen. Vnd da die Stimm sich erhub von Trometen/ Cymbaln vnd andern Seitenspielen/ vnd von dem Loben des HErrn/ dass er gütig ist/ vnd seine Barmhertzigkeit ewig wäret/ da ward das Hauß des HErren erfüllet mit einem Nebel/ dz die Priester nicht stehen kunten zu dienen/ für dem Nebel/ denn die Herligkeit des HErrn erfüllet das Hauß Gottes.[44]

> [(12] Also the Levites *which were* the singers, all of them of Asaph, of Heman, of Jeduthun, with their sons and their brethren, being arrayed in white linen, having cymbals and psalteries and harps, stood at the east end of the altar, and with them an hundred and twenty priests sounding with trumpets:)
> 13 It came even to pass, as the trumpeters and singers were as one, to make one sound to be heard in praising and thanking the LORD; and when they lifted up their voice with the trumpets and cymbals and instruments of musick, and praised the LORD, saying, For he is good; for his mercy endureth for ever: that then the house was filled with a cloud, even the house of the LORD;
> 14 So that the priests could not stand to minister by reason of the cloud: for the glory of the LORD had filled the house of God.

And Ps 22:3

> Du Herr bist heilig/ der du wohnest unter dem Lob Israel.

> Thou art holy, O thou that inhabitest the praises of Israel.

The bringing together of these texts is also to be found both in the

[44] Quotation in *Vom Lobe Gottes,* 148.

aforementioned passage in Arnd's *Vier Bücher vom wahren Christentum* (in a somewhat hidden way),[45] and in Johann Gerhard's (1582–1637) *Schola Pietatis* (1622–23). From Gerhard's book the following quotation is taken:

> [...]*Gratiosa DEI inhabitatio*. Gottes gnädige Einwohnung/ 2. Paral. 5. v. 13 Als die Stimme vom Lobe deß HErrn gehöret wurde/ daß Er gütig ist/ und seine Barmhertzigkeit ewiglich währet/ da ward das Haus des HErrn erfuellet mit einem Nebel/ welcher Nebel ein Symbolum und Anzeigung war der sonderbaren gnädigen Gegenwart GOttes/ darum stehet Ps. 22. v. 4 GOtt wohne unter dem Lob Israel/ das ist/ im heiligen Tempel/ da man zusammen kömmt/ Ihn zu loben und zu preisen. Wie nun GOtt der HERR im Tempel zu Jerusalem mit seiner Gnadengegenwart gewohnet/ also will Er auch noch heutiges Tages wohnen in den Hertzen derer/ so Ihn loben und preisen [...][46]

> The gracious dwelling of God. 2 Chron 5:13. As the voice praising God was heard, because he is good and his mercy lasts forever the house of the Lord was filled with a fog; this fog was a symbol and a sign of the special and gracious presence of God. For this reason it is written in Psalm 22 v.4[47] that God "inhabitest the praises of Israel", that is in the holy temple where one gathers to worship and praise him. Just as God dwells in the temple of Jerusalem with his gracious presence, in the same way he will dwell even today in the hearts of those who worship and praise him.

We have here a strong indication of the connection between the presence of God in the heart of man and the practice of vocal as well as instrumental music, uttered by one of the principal theologians of Lutheran Orthodoxy. Gerhard, in his interpretation, focuses on the theme of the "gracious presence of God". And this is exactly also what Schröder does, using the aforementioned texts, as a tool for the understanding of the nature and effects of musical praise. In this respect, the theologian and the musician come very close to each other in their theological outlook.

★ ★ ★

[45] *WC*, II, 41.

[46] Quoted from Johann Gerhard: *Schola pietatis, das ist: Christliche und Heilsame Unterrichtung, was für Ursachen einen jeden wahren Christen zur Gottseligkeit bewegen sollen, auch welcher Gestalt er sich an derselben üben soll: Nunmehr zum siebendemal aufgelegt* (1691), (III, 23,4). Chapter 23: *Vom lob und Preis Gottes* [...], fourth paragraph *Multiplex commodum* (the manifold utility), 621.

[47] In the King James Version this is found in Psalm 22 verse 3.

ASPECTS OF MUSICAL THOUGHT 167

From the account given by the Frick and Schröder, we also learn, that music among its principal effects has the ability to evoke a *devotional feeling* in the heart of the religious.[48] Schröder writes for instance as follows:

> [...] wie herlich/ ja wie fest/ steiff vnd beständlich die wahre *Religion* durch Geistliche Hertzbewegende Gesänge/könne den Menschen beygebracht/ eingebildet/ eingepflantzet/ vnd folgends erhalten werden [...][49]

> [...] how wonderfully, yes, how firmly, definitely and constantly the true religion can be conveyed to, represented in, and implanted in a human person – and consequently preserved – through spiritual songs, which move the heart [...]

And Frick writes:

> Den die Gesänge haben die sonderbare Art vnd Eigenschafft/ daß sie dem Menschen ein Ding tief einbilden vnd anmutig machen. Dahero wenn von Hertzen gesungen wird/ es geschehen kan/ daß bey manchem mit einem Christlichen Gesange auch das/ welches bißweil wol mit einer Predigt nicht geschicht außgerichtet wird.[50]

> For the songs have the special nature and character that they can represent something deeply in a human person, in a graceful manner. For this reason, when one sings from the heart, it can happen that what has not hitherto been achieved through a sermon may be accomplished by a Christian song.

In both cases, these statements are followed by a reference to St Augustine's well-known account from the *Confessions Book 9, chapter 6,* where he describes his encounter with Church hymns during his stay in Milan. As he was deeply moved by the singing, this became an important event on his path to conversion. In the actual context, the devotional aspect of music, to which St Augustine is a principal witness, is connected with the ability of music to impress, so to speak, the truths of the Christian religion into the "heart" of the believer, while moving him. The expression "einbilden",[51] used in both texts to describe an important effect of music, is significant, because, in the view of these seventeenth-

[48] *Vom Lobe Gottes,* 149ff. *Music-Büchlein,* 75ff, 168f.
[49] *Vom Lobe Gottes,* 150.
[50] *Music-Büchlein,* 79.
[51] From the word "Bild" (image).

century writers, it underlines the power of music to vitalize the Christian proclamation in such a way that it gains access to the deeper layers of man's existence. In this perspective music performs a task which is central to Christianity itself.

★ ★ ★

This article has dealt with some aspects of musical thought in seventeenth-century Lutheran theological tradition. This presentation is of course not comprehensive in any way. The intention has been to focus on some important elements in musical thought in a Lutheran context from the theme of praise. But the question one may rightly ask at this point is: how Lutheran is this way of thinking about music? The general view advanced in both monographs about the high status of music attests to a concept that is very close to Luther's own, and seems in this respect to advocate a specific Lutheran attitude to music. In the Lutheran tradition, the arts, and especially music, are not banned. Music is, on the contrary, treated with great respect. The use of music for the purpose of praising God is of course not an exclusively Lutheran phenomenon. It is fundamentally the traditional practice of medieval liturgy, but it is – in the Lutheran tradition – more specifically connected to Luther's view that the praising of God – because of the good news of the gospel – is a principal motive for a musical expression of the evangelical joy.[52] It has to be noted, however, that Luther's view to a certain extent is coloured by a high degree of spontaneity, compared to the use of more legalistic terms in Lutheran Orthodoxy. The thematization of the divine presence in connection with musical praising, as it has been highlighted in various ways in this article, may perhaps be regarded as an area where Lutheran theological thinking has made a more specific imprint. Not only does the possession of faith, and the experience connected with it, form a basis for the use of music in a Christian context. It is also possible to see a link to the so-called *pro me* aspect of Lutheran theology that underlines the importance of making present – through the proclamation of the gospel – the salvation events in order that they become a matter of concern in the actual existence of man. This is an aspect related to what could be called the depth dimen-

[52] Expressed for instance in Martin Luther's preface to the Babst Hymnal (1545) in: WA vol. 35 (Weimar, 1923), 476f.

sion of the theological impact of the understanding of music in Lutheran tradition in the seventeenth century.

Sven Rune Havsteen, cand. theol., has been Assistant Professor and Head of the Department of Theology at Ilisimatusarfik – University of Greenland, Nuuk, since 2001. He has also been a research fellow at the Centre for Christianity and the Arts at the Department of Church History at the University of Copenhagen.

Contexts of Hindemith's *Frau Musica*

Magnar Breivik

Paul Hindemith (1895–1963) was one of the most prominent composers of his time. When he started his professional career in the early 1920s, he soon came into view as a versatile musician of almost unlimited capacity. As years went by, his musical approach developed in a decidedly contemplative direction. Hindemith's oeuvre contains an impressive output for literally every category of instrumental music, together with a variety of operatic works, *Lieder*, and other vocal music. Although Hindemith wrote the libretto to several of his own operas, his vocal works are generally based on texts of quite different categories and origins. In the years around 1920, Hindemith seems to have been especially attracted to early expressionist poets like Else Lasker-Schüler, August Stramm, and Georg Trakl. His song cycle *Das Marienleben* op. 27 (first version 1922–23), on texts by Rainer Maria Rilke, is often mentioned as an early indication of change in a more reflective direction. Hindemith's use of a Martin Luther text in his cantata *Frau Musica* six years later, may be regarded as a token of a still more decisive shift, now in the composer's basic attitudes towards his art and his vocation. The purpose of this article is to focus on contemporary views of the social function of music, the context in which Hindemith composed his *Frau Musica*.

Luther wrote *Frau Musica* as a rhymed *Vorrede* to "every good song book", originally to Johann Walter's extensive work on the art of music, *Lob und Preis der löblichen Kunst Musica,* 1538.[1] *Frau Musica* as a name for the art of music stems from a medieval tradition connecting female personifications to the disciplines of the *septem artes liberales*.[2] Luther's poem praises both the joys of music and its humanising powers. The modernised version Hindemith applied in his cantata, nearly 400 years later, runs as follows:

[1] See *D. Martin Luthers Werke* vol. 35 (Weimar, 1923), 483–84, and the introduction, 308.
[2] See, for instance, Tilman Seebass: "Lady Music and her Protegés: From Musical Allegory to Musicians' Portraits", in: *Musica Disciplina* 42 (1988), 23–62.

Frau Musica
Musik zum Singen und Spielen auf Instrumenten nach einem Text von Luther

Erstes Stück, Chor, *Mäßig schnell*:

Für allen Freuden auf Erden
kann niemand feiner werden,
denn die ich geb mit meim Singen
und mit manchem süßen Klingen.
Hie kann nicht sein ein böser Mut,
wo da singen Gesellen gut;
hie bleibt kein Zorn,
Zank, Haß noch Neid,
weichen muß alles Herzeleid;
Geiz, Sorg und was sonst hart anleit,
fährt hin mit aller Traurigkeit.

Zweites Stück, Eine Frauenstimme (Mezzo-Sopran solo) *Pastorale-Musette*:

Auch ist ein jeder des wohl frei,
daß solche Freud kein Sünde sei,
sondern auch Gott viel baß gefällt,
denn alle Freud der ganzen Welt:
dem Teufel sie sein Werk zerstört
und verhindert viel böser Mörd.

Drittes Stück, Männerstimme/Frauenstimme (Bariton/Mezzo-Sopran):

(M:) Das zeugt Davids, des Kön'ges, Tat,
der dem Saul oft gewehret hat
mit gutem süßen Harfenspiel,
daß er in große Mord nicht fiel.
(F:) Zum göttlichen Wort und Wahrheit
macht sie das Herz still und bereit.
Solchs hat Elisäus bekannt
da er den Geist durch Harfen fand.

Viertes Stück, Trio (instrumental), Männerstimme/Frauenstimme (duet), Chor:

Die beste Zeit im Jahr ist mein,
da singen alle Vögelein,
Himmel und Erde ist der voll,

> viel gut Gesang da läutet wohl.
> Voran die liebe Nachtigall
> macht alles fröhlich überall
> mit ihrem lieblichen Gesang,
> des muß sie haben immer Dank,
> viel mehr der liebe Herre Gott,
> der sie also geschaffen hat.
> Zu sein die rechte Sängerin,
> der Musica ein Meisterin.
> Dem singt und springt sie Tag und Nacht,
> seins Lobes sie nicht müde macht:
> Den ehrt und lobt auch mein Gesang
> und sagt ihm einen ewigen Dank.[3]

Hindemith's most significant works on music theory and thought are *Unterweisung im Tonsatz I*[4] and *A Composer's World: Horizons and Limitations*.[5] The first book is based on the author's arguments for an assumed universal status of tonality, while the other, as the title suggests, covers a substantially broader scope of the composer's universe. The latter even aims at investigating the philosophical foundations of music, focusing especially on medieval notions of music. The Luther *Frau Musica* text expresses basic ideas that would become apparent in Hindemith's writings, also in these two main books. The most important common trait is a firm belief in the universal status and importance of music, as an art in itself, an aid to individual moral growth, and as a means of human communication across any boundaries. Luther's direct reference to the story of Saul and David, a well-known biblical manifestation of the Orphic tradition, may be seen in connection with Hindemith's apparent affiliation with Pythagorean thought. In addition to the importance of the common sounding board, Hindemith's choice of text is typical for his increasing desire to establish a spiritual anchorage in conceptions of the past. The composition of the cantata *Frau Musica* is an example of how Hindemith tends to merge his own contemporary musical praxis with ancient thought and tradition. The use of text thus indicates the existence of several links between the views and attitudes of Luther the writer and Hindemith the

[3] Paul Hindemith: *Frau Musica. Musik zum Singen und Spielen auf Instrumenten nach einem Text von Luther Opus 45 Nr. 1* (Mainz, 1928).
[4] Paul Hindemith: *Unterweisung im Tonsatz I* (Mainz, 1940).
[5] Paul Hindemith: *A Composer's World: Horizons and Limitations* (Harvard, 1952).

composer. A closer look at the context in which Hindemith's piece was composed may throw some light upon this instance of cultural transformation from the sixteenth to the twentieth century.

In the history of music, the 1920s stand out as a most prolific decade. This was the time when Arnold Schoenberg launched his twelve-tone method and Edgar Varèse started making manifest efforts towards the liberation of sound. The emerging notion *new music* was heavily debated, as well as questions of tonality versus atonality – its supposed opposite. The decade was one of ardent musical experiments in an early, but still fast developing, media age. It was during these years that Hindemith started out as an eager and multifarious composer, soon to be counted among the elite of musical modernity.

As already suggested, before long, a change seemed to be taking place in Hindemith's musical approach. The unpleasant question that had started to haunt him was whether new music would survive, or if it was rather developing in the wrong direction, away from the public with whom it should communicate. An early example of Hindemith's severe concerns may be found in a letter to his publishers at Schott's, April 1925:

> *Mein Hauptbedenken ist aber dieses:* Ich bin der festen Überzeugung, daß in den nächsten Jahren ein schwerer Kampf um die neue Musik anheben wird, die Vorzeichen sind dazu da. Es wird sich erweisen müssen, ob unsere heutige Musik und darunter auch die meinige fähig ist, weiterzubestehen. Ich glaube natürlich sicher daran, weiß aber ebenso gut, daß die Vorwürfe, die man der Mehrzahl der sogenannten modernen Musik macht, nur allzu berechtigt sind.[6]

In this letter Hindemith, the confident advocate of musical expansion, admits that the opponents of new music may be right: a considerable amount of contemporary music has really developed in undesirable ways. The fate and future of music may thus be seriously at stake. In the years to come, this concern was to become decisive for literally any field of Hindemith's professional work. He continually pointed at the threatening dangers in a fast developing musical esotericism, a trend that, to him, was based on an unfortunate continuation of the Romantic *l'art pour l'art* doctrine, "the followers of which can only be emotional imps, monsters,

[6] Paul Hindemith: *Briefe. Herausgegeben von Diether Rexroth* (Frankfurt am Main, 1982), 120–121.

or snobs."[7] Hindemith's life's work as a composer, musician, teacher, theoretician, and even music administrator, may be seen as one huge effort to bridge the gap between music and people. A belief in music's fundamental importance to human beings, as also expressed in Luther's *Frau Musica*, was his vital driving force. One may say that Hindemith's mission became to bring music back to what he saw as its rightful public. In such a perspective, one might even suggest that the attitudes that Hindemith held towards art are the same as those held by Luther towards religion. They both see it as their vocation to return to people spiritual possessions that their trusted leaders in some way have taken from them. Hindemith became the chief advocate of the all-encompassing consequences of such views. This is apparent both in the universalist and ahistoric theories of tonality in *Unterweisung* and in the philosophical considerations of *A Composer's World*.

On applying the Luther perspective, one must not forget that Hindemith belonged to the generation of Ernst Krenek, Hanns Eisler, and Kurt Weill. These were all composers who made important contributions to a general renewal of German music life after the First World War – in different ways, but still starting from basically common ideals. Hindemith should thus not be regarded as a lonely reformer, but rather as the most prominent example of the emergence of a new type of composer in the Weimar Republic, for whom questions of music and society were of the utmost importance. This also means that the 1920s was far more than a time of musical experiments rooted in alleged esotericism. One may even say that other directions became of equal, if not greater, importance. The decade's attention to what Hermann Danuser calls *die mittlere Musik* – music situated in-between the traditional schism of high and low, art and function – challenged the traditional genre concept as new genres arose.[8] There was a particular focus on the utility potential of music, promoted by the ideal of *functionality*. An important basis for this ideal lay in an increasingly negative view of the traditional concert business. Leo Kestenberg, concert pianist and music education reformer, compared concerts with music retailing, and even with coffee and lumber merchandising.[9]

[7] Hindemith (1952), 75.

[8] Hermann Danuser: *Die Musik des 20. Jahrhunderts. Neues Handbuch der Musikwissenschaft* 7 (Laaber, 1996), 114.

[9] See Dorothea Kolland: *Die Jugendmusikbewegung. "Gemeinschaftsmusik" – Theorie und Praxis* (Stuttgart, 1979), 56, referring to Leo Kestenberg: *Musikerziehung und Musikpflege*

Commercialism had robbed the concert of its original status and spiritual contents. "Gradmesser der musikalischen Kultur ist nicht mehr das Konzertleben, dessen Hochblüte vorbei zu sein scheint und größtenteils einer rein kommerziellen Ausschlachtung von Musik gewichen ist,"[10] said Licco Amar, first violinist in the Amar Quartet. Views such as these were followed by critical voices describing the concert as really just being directed toward upper-class citizens, reflecting the contemporary decadent, capitalist bourgeois society. An important consequence of such attitudes was a shift in composers' orientation away from the centre of the concert arena toward its periphery, in the direction of musical activities to be found beyond traditional concert practices. On the one hand, this shift went in the direction of alternative communicative forms, through festivals and associations that attracted those with a special interest. On the other, there was the growing new market existing outside the concert hall, in the movie industry and broadcasting, in music theatre and amateur performance. The important point was to activate music's potential through purposeful communication and actual use. Within this field Hindemith would prove to make considerable contributions. *Gebrauchsmusik* became the genre term most frequently used.

The term was coined by the German musicologist Heinrich Besseler in the mid-twenties. The expression is in itself a token of the change in attitude towards the utility potential of music. The main idea in Besseler's *Habilitation* lecture, "Grundfragen des musikalischen Hörens",[11] was that the public concert system of modern times had failed: it had produced *passive* consumers instead of *active* listeners. The required *Gemeinschaft* between performer and listener had long been lost. According to Besseler's account, concert life had been commercialised through and through, both as regards trivial business matters, predilection for the virtuosity of professionals, and the institutional dependence on public music criticism. This regrettable situation had badly influenced the possibility of genuine musical appreciation, Besseler said. Since listening to music was regarded as a basically passive condition, the remedy must lie in active participation in musical performance. Although Besseler

(Leipzig, 1921), 8.

[10] Licco Amar: "Zur Frage der Gebrauchsmusik", in: *Die Musik* XXI/6 (1929), 401.

[11] Heinrich Besseler: "Grundfragen des musikalischen Hörens", in: *Jahrbuch der Musikbibliothek Peters* 32/1925 (Leipzig, 1926) 35–52.

highlighted dancing as an obvious example, amateur performance in general was appraised as an ideal way of participating. In the Weimar Republic, amateur music thus formed the core of contemporary *Gebrauchsmusik*, symptomatic of the general tendency to move music away from the traditional centre of professional musical life. The *Gebrauchsmusik* term was used in a highly comprehensive way and consequently not always easy to define. However, the decisive mark was that it was always rooted in some sort of active situation, in contrast to the passive listening conditions of public concerts and radio broadcasting.

Though Hindemith later in life came to disown the notion of *Gebrauchsmusik*, music history has continued to associate him quite closely with it. One reason for this may lie in the fact that Hindemith, throughout his entire professional career, was such an eager spokesman for musical activity. He had grown up in a home where the *Hausmusik* tradition was well preserved – a custom that had been of the highest importance to Martin Luther as well.[12] For all his fame as a composer, Hindemith was also considered one of his day's greatest viola players. As a student, he first laid the foundation for a career as a professional performer, but he saw no problem in keeping contact also with fellow amateur musicians. The focus in the 1920s on practical musical activity found instant response in Hindemith's identity and self-understanding. Still, the more obvious reason why the term *Gebrauchsmusik* remained attributed to him is probably that he produced such an extensive output of high-quality music for the amateur. *Frau Musica* is among the most important representatives of this part of Hindemith's oeuvre.

Hindemith's *Sing- und Spielmusik* began to appear in 1927, the year when his appointment as a professor at the Berlin Hochschule für Musik initiated his life-long career as a teacher. A still more decisive step had been made the year before, in October 1926, when he met with a huge amateur music branch of the *Jugendbewegung: Die Musikantengilde*. The occasion was an invitation to take part in the *1. Hochschulwoche der Musikantengilde*, also called the *Reichsführerwoche*, in Brieslang, in order to

[12] See, for instance, Martin Brecht: *Martin Luther* vol. 3, "Die Erhaltung der Kirche 1532–1546" (Stuttgart, 1987), 246: "In Luthers Haus wurde nach wie vor gerne mehrstimmig gesungen, so zum Beispiel an Neujahr 1537 nach dem Essen. Bei dieser Gelegenheit wurde Luther bewusst, wie viele gute Komponisten in den vergangenen Jahren gestorben waren: Iosquin de Prez, Pierre de la Rue und Heinrich Finck. Herzog Albrecht von Preussen tauschte mit Luther Lieder und Kompositionen aus."

study the musical activities and ideas of the movement at a close range.[13]

The immediate origin of the *Jugendbewegung* was the Berlin-Steglitz teacher Karl Fisher's *Wandervogelbewegung,* established at the turn of the century. This back-to-nature hiking movement was not just the result of romantic urges: it was also based in a reaction against what was regarded as negative contemporary tendencies. Through attitudes, clothing, and ways of living, the members objected to urban society, materialism, and human alienation. Already from the start, German folk song was a certain ingredient at the regular outings of the assemblies. From 1917, when the charismatic Fritz Jöde took over leadership, the organisation began to appear as the *Jugendmusikbewegung* with the immense *Musikantengilde* branch which Hindemith came to know. A popular character and a national foundation were to be maintained and further cultivated in this singing and playing *Gemeinschaft* (community).[14] According to the ideas of the movement, music had a particularly strong "gemeinschaftsbildende Macht". The contemporary music historian Hans Joachim Moser, closely connected to the views of the *Jugendmusikbewegung,* describes Martin Luther as a representative of a similar view, quoting a *Tischredenwort* reported by the Wittenberg student Georg Forster:

> Wie ich denn oft und dick von einem teuren Mann gehört, daß er unter allen Kurzweilen, damit man die Zeit zu vertreiben fürhätte, kein göttlicher, ehrlicher und schöner wüßt denn die edel Musik, Ursach daß kein andere Kurzweil als Spielen, Fechten, Springen (oder hießen wie sie wollen) dahin gerichtet, daß jeder vermeint dem anderen vor zu sein oder abzugewinnen, darum sich dann ein jeder befleißt, denen, damit er kurzweilet, zu bevorteilen, aus dem dann manch Unrat entstünd. Aber die Musik hat nichts anders Führhabens, denn daß sie mit allem Fleiß die Einigheit der Stimmen hilft erhalten und aller Mißhellung wehrt, wie denn ein jeglicher rechte Musicus bekennen wird.[15]

[13] It should be stressed that these movements are in no way identical with the notorious Hitlerjugend. When the National Socialists seized power, they first started inflicting the *Jugendbewegung* in different ways. After they had taken over and reworked some basic traits in the ideology of the movement, the *Jugendbewegung* in its initial form was forbidden.

[14] *Community* is the usual translation into English, also Hindemith's, though *Gemeinschaft* is a more complex concept than the translation necessarily suggests.

[15] Hans Joachim Moser: *Musikgeschichte in 100 Lebensbildern* (Stuttgart, 1958), 86–87. According to Moser, Georg Foster quotes these words from Luther in the *Vorrede* to the first of his two folksong volumes "Ein auszug frischer teutscher liedlein" (1539–40).

The *Gemeinschaft* designation, generally in vogue in the Weimar Republic, was rooted in Ferdinand Tönnies' antithesis *Gemeinschaft* and *Gesellschaft*, formulated in the late 1800s. To Tönnies, *Gemeinschaft* represented lasting human coexistence, comparable to a living organism, while *Gesellschaft* denoted the passing and inconstant mechanical institution.[16] The *Gemeinschaft* concept became vital also to Hindemith's engagement in the amateur field. To him, the establishing of a singing and playing community also appeared to be an immediate vehicle for the salvation of contemporary musical life. One important means to constitute a real musical *Gemeinschaft* was to make music more generally accessible. The public concert business was not regarded as capable of undertaking such a task, at least not alone. Hindemith thus shared the main views of the *Jugendmusikbewegung*, although he was sceptical about some of its sectarian traits.[17]

Genuine musical *Gemeinschaft* feeling was believed to emerge only by means of common musical activity through singing and playing. It should come as no surprise that Heinrich Besseler was also very much attracted to the general thoughts of contemporary amateur movements. The same applied to Leo Kestenberg, whose music education reforms were to a large extent inspired by ideas from the *Jugendmusikbewegung*. In 1926, when Hindemith encountered the organisation, the *Musikantengilde* branch numbered over one million members. Shortly after the Brieslang event Hindemith wrote to Fritz Jöde:

> Brieslang liegt ja nun schon einige Tage hinter uns. Haben sich bei Ihnen nachträglich irgendwelche Bedenken eingestellt? Oder sind Sie nachträglich erst recht begeistert über unseren gemeinsamen "Coup"? Ich das letztere. Ich bin so voller Hoffnung und Zuversicht wie noch sehr selten in meinem ganzen musikalischen Leben.[18]

In early January the following year, Hindemith developed his considerations in a letter to Otto Ernst Sutter, a possible co-operator on a potential music festival in Frankfurt:

[16] See Kolland (1979), 14.
[17] See, for instance, Paul Hindemith: "Forderungen an den Laien", in: *Aufsätze, Vorträge, Reden. Herausgegeben von Giselher Schubert* (Zürich/Mainz, 1994), 42–44.
[18] Hindemith (1982), 124.

> Die wichtigste Frage des heutigen Musiklebens, die Verbindung von Volk und
> Kunst, ist überhaupt nur durch rein persönliche Beziehungen zu lösen, Ich
> habe den Anstoß zu dieser Verbindung gegeben und habe Jöde und seinen
> ganzen Kreis herübergezogen.[19]

Obviously, Hindemith had now not only arrived at the conclusion that the salvation of modern music lay in bridging the gap between art and public: the immediate reason for his present enthusiasm was that he had started to conceive of amateur performance as the most promising means for reaching this goal. This is an important reason why Hindemith's devotion led to such an extensive musical output of works for the singing and playing amateur.

To *Die Musikantengilde,* Hindemith's cantata *Frau Musica. Musik zum Singen und Spielen auf Instrumenten nach einem Text von Luther* stood out as a model for successful new *Gebrauchsmusik.* Eduard Zuckmayer, one of the movement's leading figures, points to the brilliant musical combination of old and new compositional principles:

> Höchst eigenartige Verschmelzung zahlreicher Elemente antitonaler und
> atonaler Ausdrucksweise und ihrer Unterstellung unter die gesetzlichkeiten
> echter Polyphonie mit anderen Mitteln der "Kadenzflucht," die unbewußt der
> älteren Polyphonie, den Kirchentönen, der Pentatonik abgewonnen sind […][20]

In addition to the cultivation of the German folk song tradition, the *Jugendmusikbewegung* had been especially devoted to the performance of pre-romantic and pre-classical music. Apart from pieces from the baroque era, the repertoire often consisted of music by composers such as Heinrich Isaac, Josquin des Prez, and Praetorius. Even arrangements of chorales attributed to Martin Luther were quite frequently used. When Hindemith chose Luther's *Frau Musica*, he did not merely select a text with which he himself could identify: he also used material from a period with which the target group was already familiar. But Zuckmayer's main emphasis lies on what he sees as an ideal continuation of solid musical traditions in a contemporary piece of music perfectly suited to the amateur. Generally, the use of polyphony, a point that Zuckmayer stresses, was regarded as the

[19] *Ibid.* 130.
[20] Eduard Zuckmayer: "Warum werden wir diesem Sommer nicht zum 'Deutschen Kammermusikfeste' nach Baden-Baden gehen?" in: *Die Musikantengilde* 7 (1929), 84–85.

ideal way of blending individual and yet equal voices into an all-including, sounding whole. The fact that Hindemith's *Frau Musica* is constructed as a conventional cantata, with opening and concluding choral passages, vocal solos and duets, shows his interest in combining a new tonal language with traditional musical forms. As we shall see, this also permits a certain kind of flexibility in the amateur performance situation.

Seen in relation to Hindemith's musical development, the tonal language of *Frau Musica* is in a modernist vein quite typical of his style at the time, though considerably simplified in different ways. The composer's preface points to some technical adaptations:

> [...] von den Streichern wird nur das Beherrschen der ersten Lage verlangt, der Chor und die Solostimmen sind nach Möglichkeit mit leicht singbaren Linien bedacht.[21]

Despite obvious concessions to the amateur performer, Hindemith's ambitions to pave the way for particular challenges of new music are also quite evident:

> Trotzdem wird man von einer heute und für heutige Bedürfnisse geschriebene Musik nicht verlangen, daß sie von jedermann vom Blatt zu spielen ist. Dem Liebhaber werden hier einige Nüsse zu knacken gegeben.[22]

This shows a highly important point regarding Hindemith's attempts to build a bridge between music and people: it is not only the composer's duty to reach out to the performer and audience, it is also the obligation of the active amateur performer to reach out for the characteristics of new music.

The most significant statement in the *Frau Musica* preface is the introductory remark,

> Diese Musik ist weder für den Konzertsaal noch für Künstler geschrieben. Sie will Leuten, die zu ihrem eigenen Vergnügen singen und musizieren oder die einem kleinen Kreise Gleichgesinnter vormusizieren wollen, interessanter und neuzeitlicher Übungsstoff sein.

[21] Hindemith (1928), preface.
[22] *Loc. cit.*

Hindemith's attitude to the nature of amateur performance as not belonging in the concert hall should come as no surprise. By emphasising that the work was not written for *Künstler*, he does not mean that he believes it to be without artistic value. The creative artist lives by his profession: Hindemith might thus just as well have used the term *Berufsmusiker*. But then he would have missed another significant point. In certain circles, particularly in the first part of the 20th century, the concepts *art* and *artist* tended to be seen as negatively loaded. To a considerable degree they were regarded as representing the upholding of a subjective, far-from-reality and esoteric *l'art pour l'art* principle. It is hardly surprising that this view had gained a solid foothold in the *Jugendmusik* movement, where the noble amateur was considered the opposite of the professional artist. Nonetheless, in the preface to *Frau Musica*, Hindemith does not disregard the pleasure of the amateur in playing music for others. Yet, it is important to notice that it is the desire of the performing musician, not that of the listener, which ought to be favoured. In this context, Hindemith uses the expression *vormusizieren*, and not his more usual *vorspielen*.[23] *Vorspielen* can also denote performance in the sense of demonstrating how music should be performed, or how the intentions should objectively be realised. Precisely this kind of perfection was believed by the amateur movement to be dominant in the public concert practice, and it was what one really needed to escape. It is therefore characteristic that Hindemith stresses that any performance for others should take place in an intimate circle of equal minded people, i.e. in completely different circumstances from a traditional concert situation. The preface is directed toward the exclusive type of *Gemeinschaft* for which the *Jugendmusikbewegung* was known. On the other hand, *Frau Musica* is inclusive indeed, since literally everyone may participate in the performance. It is particularly this essential idea which is kept in mind in the work's construction. The opening and concluding choral movements are intended for *Allgemeiner Chor,* which means that everybody present is invited to join in:

> Den Eingangs- und Schlußchor mögen die gesamten Anwesenden, denen man vor Beginn der Aufführung mit Hilfe der auf einen Wandtafel geschriebenen Noten die betreffenden Stellen einstudiert hat, mitsingen.[24]

[23] See, for instance, Hindemith (1994), 42–44.

[24] Hindemith (1928), preface.

This performance model evokes Luther's *Deutsche Messe* (1526) in which the participation of an entire congregation within a comparatively fixed framework is a fundamental objective.[25] Luther's generally high evaluation of ensemble singing is also a characteristic that Hindemith shares in full. In *A Composer's World,* he even presents the amount of ensemble singing, as found in Luther's time and regrettably not in his own, as the yardstick, not only for a healthy musical culture, but also for a sound society:

> The quality of a society's art of ensemble singing and the value of the compositions written to satisfy the demands of the group singers is quite likely the best gauge of a period's musical culture. This art cannot grow except in a fertile ground of general human culture, of mutual understanding and a desire to share the joy and sorrows of one's neighbor; [...] Our own time, with its overweening estimation of instrumental music, possibly in its most obtrusive orchestral form, will perhaps, in a later evaluation of music history, count as a period of lowest artistic culture, compared to those epochs in which the art of ensemble activity with the emphasis of vocal participation flourished most noticeably. I refer to the period of Machaut, Dufay, and Josquin; the time of Isaac, Senfl, Finck, Hofhaimer, and many other contributors to the art of the German *Liederbücher* in the sixteenth century; the madrigalesque style of Marenzio, Monteverdi, and other Italians; the English madrigalists; and finally, the cantatas of Bach.[26]

There is also another aspect concerning the performance of *Frau Musica* that may be seen in relation to Luther's flexible approach to the construction of a German Mass in which everyone should participate actively. Extra instruments may be included at will by the performers:

> Sind Bläser vorhanden, können sie zur Verstärkung der Vokal- oder Instrumentalstimmen herangezogen werden. In der Partitur ist jeweils vermerkt wie ich mir die Verteilung dieser Verstärkungsstimmen denke.[27]

This type of consumer's accommodation typifies even more Hindemith's subsequent works for amateur performance. In the *Lehrstück* collaboration

[25] See the article on the *Deutsche Messe* in this volume.
[26] Hindemith (1952), 199.
[27] Hindemith (1928), preface, compare Luther's remark: "[...] und wo es hulfflich und fodderlich dazu were, wolt ich lassen mit allen glocken dazu leutten und mit allen orgeln pfeyffen und alles klingen lassen, was klingen kunde." in the *Deutsche Messe*, in *D. Martin Luthers Werke* vol. 19 (Weimar, 1897), 73.

with Bertolt Brecht (1929) and the children's opera *Wir bauen eine Stadt* (1930), for instance, not only the combinations of instrumental participation may be decided according to the user's preference: complete movements may even be substituted by other pieces. Hindemith's preface to *Lehrstück* is particularly illustrative in how far the composer was willing to go, at least in this experimental project:

> Da das Lehrstück nur den Zweck hat, alle Anwesenden an der Ausführung eines Werkes zu beteiligen und nicht als musikalische und dichterische Äußerung in erster Linie bestimmte Eindrücke hervorrufen will, ist die Form des Stückes dem jeweiligen Zwecke nach Möglichkeit anzupassen. Der in der Partitur angegebene Vorlauf ist demnach mehr Vorschlag als Vorschrift. Auslassungen, Zusätze und Umstellungen sind möglich. Ganze Musiknummern können wegbleiben, der Tanz kann ausfallen, die Clownszene kann gekürzt oder ausgelassen werden. Andere Musikstücke, Szenen, Tänze oder Vorlesungen können eingefügt werden, wenn es nötig ist und die eingefügten Stücke nicht den Stil des Ganzen stören. [...] Dem die Übung Leitenden und der Gemeinschaft der Ausführenden ist es überlassen, die für ihren Zweck passende Form zu finden.[28]

Hindemith's compositional efforts for the performing amateur culminated with the versatile *Plöner Musiktag* of 1932. Nevertheless, he also held true to the basics of his belief in the importance of all-embracing musical communication through the years to come. There is much to indicate that Hindemith brought his experiences from amateur music to his so-called concert music. One may sense an expression of a more balanced and clearer tonal organisation in his music from the beginning of the 1930s and beyond. Hindemith's concern with fundamental questions of tonality, as expressed in *Unterweisung,* led to the amendment of some of his earlier works. The most notable instance is the *Marienleben* revision, published in 1948. Another example is the new version of *Frau Musica* in 1943. In both revisions, Hindemith's main objective is to provide the music with a clearer tonal organisation.

Today Hindemith's symphony *Mathis der Maler* (1934), his ballet music *The Four Temperaments* (1940), and the orchestra piece *Symphonische Metamorphosen über Themen von Carl Maria von Weber* (1940–43) belong to the standard repertoire of the world's leading orchestras. His Luther

[28] Paul Hindemith: *Sämtliche Werke Band I [Bühnenwerke], 6, Szenische Versuche. Herausgegeben von Rudolf Stephan* (Mainz, 1982), 52.

cantata of 1928 is, however, only infrequently heard. Still, there are reasons to maintain that the wide implications of "Frau Musica", as this concept was recognised in a fundamental way and praised in Luther's text, always plays a leading part in Paul Hindemith's mature works.

Dr. art. Magnar Breivik (b. 1954) is Associate Professor at the Norwegian University of Science and Technology/NTNU, Trondheim. His work has been especially devoted to the music, arts, and aesthetics of late 19th and early 20th centuries. Breivik has published articles on composers like Gustav Mahler, Arnold Schoenberg, Alban Berg, Paul Hindemith, Ernst Krenek, and Kurt Weill.

Fear of Death in a Life Between God and Satan: Kari Tikka's Recent Opera *Luther*

Siglind Bruhn

Luther's life, theology, and music are the subject matter of an opera premiered in Helsinki, Finland, during the final weeks of the second millennium on 8 December 2000. Conceived and realized by the composer and Finnish National Opera conductor, Kari Tikka (born 1946), with a libretto written by the composer in collaboration with the director, Jussi Tapola,[1] the work represents in seven scenes essential stages in the development of the Reformer and father of the Finnish State Church.

Before I analyze the opera in its entirety, I wish to point to what I consider its most memorable feature, a "Dance of Death", whose scenic and musical materials dominate much of the first scene and recur throughout the work, and relate it to Luther's life and thinking. In the opening passage, the combined forces of choir and six-part ensemble sing, preceded by a mere two measures of harmonic and rhythmic preparation, a sentence that will recur to haunt the characters and their audience many more times: "Death reaps, Death reaps young and old, rich and poor – Death!" Meanwhile, Death the haughty avenger has already made his entry, in a black hooded cloak, almost immobile in the midst of four allegorical characters that slowly dance around him. These are Sin, Hell, Law, and another image of Death, the skeletal Grim Reaper. When the disdainful black-clad figure in the center begins to sing, summoning all humankind to his dance and calling on the collaboration of Sin whom he knows to work through the power of God's Law, and when he contemptuously lists the great men of spiritual history who have all become his victims ("Where now are Adam, Abraham and David, where is Solomon the Wise? Where now are Aristotle, Paul and Jerome, and a certain Augustine?"), one understands that this Death is an embodiment of Satan. And indeed, soon enough the black cloak will be exchanged for various garments identifying other impersonations of the Devil, while the

[1] For the score, see Kari Tikka: *Luther* (Helsinki, 2000).

choral refrain recurs to the words "Hell devours, Hell devours lords and fools, bishops and popes – Hell!"

What was the historical Luther's relation to death and the other concepts here materialized in allegorical form? Within a brief essay presentation, such a question cannot, of course, be dealt with in any depth, in a way that would do justice to the enormous corpus of Luther's own writings and the extant scholarship on Luther. However, in order to give a background for Tikka's opera – a work not written by a scholar but by a musician with a personal interest in his faith and its founder – I offer in what follows a few general observations as they can be obtained from modern general accounts of Luther's life.

As a student at Erfurt University and a young monk, Luther was assailed by what has become known as his *Anfechtungen*. In one of the most popular biographies of Luther in the English-speaking world,[2] Roland Bainton interprets these spiritual afflictions as Luther's doubts that God could save a sinner such as himself. Another scholar of Luther, Richard Marius, believes that this is too simplistic, that the doubts went far deeper, including "skepticism in human history, doubts that God exists at all and that he can or will raise the dead".[3] Whether or not Luther really wondered, as Marius believes, about God's power to raise the dead, there can be no question that death, as a threat not merely waiting at the end of life but lurking menacingly behind every corner, reigned supreme in the thoughts and fears of not only this young monk, but of his whole age. This fear was nourished and kept alive both on the practical and on the religious side. In daily life, there was the very real terror caused by the plague. In 1347, the year of its first great outbreak in Europe, this disease – popularly merely referred to as "the death" or "the pestilence" – had killed anywhere from a third to one half of the population of the continent. During the two subsequent centuries, the plague struck again and again; in fact, Luther lived through three outbreaks in Wittenberg, in the years 1527, 1535, and 1539, and lost siblings to the disease. On the spiritual side, death and its horrors were much used in medieval sermons to call Christians to repentance and atonement. As Ian Siggins has shown in great detail, the young Luther and his God-fearing contemporaries

[2] Roland H. Bainton: *Here I Stand* (New York, 1950).

[3] Richard Marius: *Martin Luther: The Christian Between God and Death* (Cambridge, MA, 1999), xiii.

would have been exposed to a never-abating series of gory descriptions of the particular horrors death inflicted on the less-than-perfectly pious from the pulpit.[4] The depictions of the Dance of Death, found as life-sized frescoes on many church walls and as etchings in countless books of popular edification (one is reminded of the famous woodcut series by Luther's contemporary, Hans Holbein, and of the naked women seized in the bony hands of leering, already rotting skeletons painted by another contemporary, Hans Baldung Grien), served both to console the future victims that death struck with no regard for worldly standing or wealth, and as a warning that God could do anything and allow anything if He so wished – that His power was as absolute as it was inscrutable.

Like many Luther scholars these days, Marius is convinced that an acute, ever-present, "devouring" fear of death may have been the most influential psychological impetus in the Reformer, who interpreted the often premature and brutal ending of human life and the concomitant threat of annihilation as the consequence of God's angry discontent with self-absorbed sinners. The fact that death, hell, the grave, and God's wrath appear as almost synonymous in Luther's rhetoric must be understood before this backdrop. At the same time, and further aggravating his mental agony, Luther seems to have taken the persistence of a person's fear of death as a sign indicating an imperfect love of God – in his own case, as a troubling indication that he did not accept God's will, and did not, perhaps, entirely believe in God.[5]

The biblical ground for this obsession with death rests in the epistles of St Paul, which exerted a strong influence on the young professor at Wittenberg and remained essential to Luther throughout his life. As Marius stresses, "Death for Paul was the mighty judgment of God against sinners. 'The wages of sin is death,' he wrote to Christians at Rome (Romans 6:23). [… Luther] would share Paul's attitude if he equated sin, death, and damnation so that […] separation from God was not torment in a blazing furnace but the absence of consciousness of God. […] As Luther struggled to believe in God's goodness, his grace, and his power,

[4] Ian Siggins: *Luther and His Mother* (Philadelphia, PA, 1981), 60–61.
[5] Marius (1999), 203–4. See also Werner Elert: *Morphologie des Luthertums* I (Munich, 1958), 16 and *passim*, who hears a "melody of death" resounding through Luther's life and thoughts, and Carl Stange, who opens his study, *Luthers Gedanken über die Todesfurcht* (Berlin, 1932), with the sentence, "In Luther's theology, his thoughts about the fear of death stand at the very center" (7).

the terror before death continued – a continuing sign to him of his unbelief."[6] Luther's focus on the justification by faith gains additional depth in this light: Death, along with Sin and Satan, is the enemy, but it can be conquered by faith in Christ and thus be denied its ultimate victory.

Contrary to St Paul, who did not think of Satan as an agent of Death or as a (Miltonian) sovereign of hell, his latter-day follower in Saxony was much concerned with what he perceived as other faces of the same foe. Sin, for Luther, was not primarily the sin of the flesh. Instead he identified it as regarding the fundamental attitude of Man toward God. Unbelief, self-love, and self-righteousness were essential elements in his concept of sin. Luther's unrelenting struggle against the Catholic understanding of the role of "good works" in salvation centered in the conviction that actions carried out in the context of such a theology would lead to hubris and self-satisfaction. The only way to redemption, he taught, is faith in the divine grace given despite the unworthiness of the recipient. Good works, which were likely to follow once a state of grace was achieved, might then be regarded as fruits of faith, done without spiritual pride and never to be invoked as spiritual assets.

Luther perceived Satan as looming large in life,[7] assailing God-fearing people in ever-new and ingenious impersonations. Bernhard Lohse, one of Germany's foremost Luther scholars at the turn of the twentieth century, qualifies the notion that Luther saw humans pulled between the two forces of the divine and the diabolical by explaining (paraphrasing Luther's *De servo arbitrio* of 1525):

> It is not that humans, as they may wishfully dream, are spectators at a wrestling match between God and the Devil. Rather, they themselves must fight in the arena, with either God or the Devil as their 'rider.' Humans thus stand in the very midst of the battle in which God and the powers hostile to God are the principal participants. Humans can therefore speak about the Devil only as individuals who are themselves intimately concerned, who experience ever anew their inability to conquer the inimical powers on the basis of their own strength.[8]

[6] Marius (1999), 66–67.

[7] One of the most influential studies of Luther's life and thinking, by Heiko A. Oberman, is entitled, *Luther: Mensch zwischen Gott und Teufel* (Berlin, 1982); English as *Luther: Man Between God and the Devil* (New Haven, 1989).

[8] Translated from B. Lohse: *Luthers Theologie in ihrer historischen Entwicklung und in ihrem*

To Tikka, Luther's Satan is involved in everything that runs counter to God's will. He brings misfortune and disease, causes the sins of the flesh as well as those of the spirit, and is thus the true origin of Death both corporeal and spiritual. He does not shy away from any guise. Far from fearing the pious fragrances of the Church, he appears with glee as a pope or bishop and even as a parody of Christ himself.

The final companion of Death in Luther's cosmos who is impersonated in the opera is Law. Pitted against the Gospel (as in his interpretation of Psalm 84, "the Law is the word of Moses to us, while the Gospel is God's Word within us"[9]), the Law, which fundamentally was good in Luther's eyes, because of the sin came to express God's wrath. Luther also deemed the laws of the world necessary and beneficial to guarantee some degree of order. In the hands of the Church, however, both the Law and ecclesiastical regulations had become instruments of alienation and terror suppressing the Gospel and leading to increased sinfulness. Church regulations had brought about what Luther despised: a catalogue of ritual practices intended to pile up merit even when performed mechanically, and thus favoring bigotry and leading away from God rather than nearer to Him.

Death as God's punishment; Hell as "the grave of the soul",[10] an unconsciousness akin to ultimate annihilation; Sin as the cause of both, which in turn is enhanced by Law; and Satan as the commander of them all: this is the guiding imagery on the pessimistic side of the Lutheran balance.

In Luther's life as in Tikka's opera, all these foes are overcome through an absolute faith in Christ. This faith is an attitude of unrestrained submission to God's will and of continuous repentance, rather than a system of doctrines and religious rituals. It allows humans to admit their helplessness and thereby to avoid the sin of self-righteousness, to trust in divine omnipotence and thereby to overcome the fear of death and hell, and to rely on God's Word and thereby to protect themselves from the deceitful ravages of the Law.

systematischen Zusammenhang (Göttingen, 1995), 270.

[9] In: *D. Martin Luthers Werke. Kritische Gesamtausgabe* vol. 4 (Weimar, 1886), 9: "Quia lex est verbum Mosi ad nos, Euangelium autem verbum dei in nos." See also Bernhard Lohse (1995), 285.

[10] Marius (1999), 62 referring to Luther's lecture on Ecclesiastes, in particular concerning 9:10.

The Many Guises of Satan

In the course of the operatic depiction of the main stations in Luther's life, Satan, aptly enacted by a voice so virtuosic as to appear diabolic rather than human, a coloratura tenor, takes on ever new roles. In five of the seven scenes, the seductive impersonator of the power of evil undergoes constant on-stage costume changes. These impersonations chart Luther's fears and enemies at least as intensely as the dramatic portrayals in the various scenes trace the events in his life.

In the center of scene 1, Satan materializes as a confessor. Cornering a pious but somewhat simple-minded and easily scared brother Sebastian, the thoughtful Elector of Saxony, Frederic the Wise, and Luther (a young monk at the time, disillusioned by his recent impressions of Rome but still primarily intent on being a good Augustinian), the diabolical priest gleefully works toward exacerbating the three God-fearing men's self-reproaches, suggesting sexual misbehavior, insufficient exercise of free will, and imperfect surrender to the will of God: trying with all means to lead people into existential despair. In contrast to the three men, two young convent girls, to whom the confessor turns next and whom he also attempts to terrorize with lewd suggestions, see through the guise and despise the man in the pious cloak ("Dear God, you won't really force us to make confession to that person, will you.")

Scene 3, which is divided between the disputation following the publication of Luther's theses against the sale of indulgences in Saxony itself and Luther's accusation at the Diet in Worms, presents four faces of the Devil. As the Duke George of Saxony, Satan gloats in the controversy set up between Luther and the theologian who defends the papal authority in matters of biblical interpretation; as the Pope, he pronounces Luther excommunicated (Tikka includes a translated quote from the Bull "*Exsurge Domine*"). In one of his brief undisguised appearances, showing himself as Satan, he looks forward to the fights he foresees ("OK, lads! All off to Worms!"); and as the clerical official presiding over the trial at the Diet, he declares Luther a heretic. In all these impersonations, the Devil is not so much a direct adversary of pious people but a facilitator of seduction and spiritual torment – which is how the historical Luther perceived him.

In Scene 4, which begins with Luther translating the Bible while in safe custody and then shows him back in Wittenberg during the years 1522–25, Satan is ever-present. He manifests first as the governor of the

Wartburg, later as Thomas Müntzer, the fanatic social reformer, advocate of adult baptism, and apocalyptically inspired leader of a contingent of the rebelling peasants, then as a deceitful suitor of Katharina von Bora, a "run-away nun" and Luther's wife-to-be ("Käthe"), and finally once again briefly as Death. In the three impersonations that concern the protagonist, the Devil now interacts directly, and in the most diabolical way, by quoting Luther's own words. The Wartburg governor, limiting himself to mocking and mimicking his famous charge, appears fairly innocuous. Müntzer, much more dangerously, uses Luther's thoughts out of their intended context to advance his own ends. In the historic controversy between the two men, the issues of contention centered in Müntzer's resolve to champion the use of arms with the aim of defeating the godless powers once and for all, and his interpretation of God's Word as only secondarily captured in the Bible but primarily embodied in the Holy Spirit. Against Luther's insistence on the Bible as the true and only foundation of the Christian faith, Müntzer believed that the Spirit continues to communicate, that its inspiration is therefore superior to that of Scripture, and that Christians could still be enlightened with new revelations – a view that for Luther could only come from the Devil.[11] At the end of the scene, Satan reverts to his favorite guise, that of Death. Heard laughing from the battlefield of the Peasants' Uprising, he echoes two cries that may stand for all of Luther's anguish vis-à-vis his indefatigable adversary: "I'll kill you, Satan!" and "Lord have mercy with the German people!"

Scene 6, the most philosophical of the opera, features Satan in four impersonations: as the famous humanist, Erasmus of Rotterdam; as himself, Satan; as a "false Christ"; and as Death. Erasmus and Luther, both engaged in pointing to the ills in the corrupted Roman Church, had originally been regarded as striving toward the same ends. Yet they parted company on some essential points of theology. Erasmus argued that humans could not be entirely devoid of free will; only with a certain degree of freedom would their choices and actions have spiritual significance. Against this Luther insisted that humans were not capable of contributing to their own salvation; to doubt this essential helplessness would mean calling God's salvific plan and Christ's redemptive death into question. The gist of this dialectic is admirably captured in the libretto, as

[11] Cf. Marius (1999), 420–21, and Lohse (1995), 208 and 339.

the following excerpt may show:

> Luther: "[...] We are saved by the grace of God, not by our acts, so that no-one would boast. I am fond of weakness, distress, persecutions, for I am strongest when I am weak."

> Satan/Erasmus: "Why does the New Testament contain hundreds of clear commandments if it is not possible for a person to obey or disobey? Why are we, then, commanded to choose if we are incapable of choosing?"
> Luther: "Those commandments and exhortations are Law. The function of Law is to show guilt – sin – to a person and to crush his own opportunities before God and to drive him to Christ. Christ is the end of Law."[12]

When Luther, responding to Erasmus's question what makes him so sure of his interpretation, claims to have been "summoned, pushed, and driven by God to proclaim, counter to his own will and skill", Satan pulls off the cloak of Erasmus and attacks him brutally:

> Has the almighty holy God really summoned you, you vulgar drunkard? [...] You lead people to Hell!

Luther's anguished cry, "Help me, Christ! Lord, awake! I am afraid," is answered by Satan now in a Christ-like disguise, misquoting Luther's recent words when he exclaims:

> The function of Law is to show guilt – sin – to a person and to crush his own opportunities and to drive him to Hell!

When Luther demands to know whether this "eternal accuser" is indeed Christ and not Satan, the scene takes an even more sinister turn. The Devil changes back into Death and misquotes other essential Lutheran sentences.

In scene 2, Luther is the young monk who suddenly comprehends the full significance of Christ's life and death for the gift of divine mercy and exclaims joyfully: "Christ is mine! Christ is mine! I am alive, I am free!"

[12] The English translation of the libretto, which is quoted in this article, was provided by an unidentified associate of the composer's, supplemented here by my generous Finnish friend, Marja Heimonen. It was distributed at the premiere of the opera. The printed booklet did not contain any bibliographically relevant data.

Years later, when asked whether he supported the peasants in their unlawful uprising, the historical Luther had distanced himself from their violent measures of seeking justice, declaring that as long as they carried weapons and were intent on using them against their feudal lords, they deserved to be fought, but demanding that any peasant willing to lay down his weapons should be allowed to live. The princes had used the first part of the epistle to claim Luther's agreement with their war against the peasants (which in the opera is verbally captured by the ensemble and chorus's extended prompt at the end of scene 4, "Stab, strike, kill!"). Meanwhile, they had suppressed the explicit reservations, so that in his darkest hours Luther felt indirectly responsible for the inhuman butchery. Satan as Death, reacting to Luther's unwillingness to accept at face value his impersonation of a cruelly accusing Christ, strikes back with words of sarcasm that must wound his target profoundly: "Stab, strike, kill! Christ is mine! Christ is mine! You can all die, be free!"

The seventh and final scene, portraying Luther's last days, finds Satan turned into one of the operatic characters called "future theologians" – people who claim to be the great Reformer's spiritual heirs and interpret to the masses what they claim was Luther's *true* message. Not surprisingly, Satan's impersonation turns all that Luther fought for on its head when he declares,

> The Bible is to be interpreted according to the will of the Pope and the Church Councils. Do your best; then you can also trust in Christ's merits. First repentance, then conversion; away with false certainty.

The opera closes with Satan, returned to his favorite impersonation as Death, repeating his two prominent arias from scene 1, once more summoning all humans to the Dance of Death and scornfully commenting on all the great men he has slain throughout history – among whom Luther is now just one more name.

God Trusted and Doubted, Loved and Hated
Not only the young student and monk's life, but even the older Luther's everyday existence was a series of tribulations in which he doubted either himself or God – or, more often, both. The music-dramatic representation reflects this basic spiritual constitution, successfully portraying it as weakness and strength at once. The religious conflict is most pronounced in the two initial scenes, where the attentive spectator discerns it behind

the picturesque nature of the Dance of Death; yet it also echoes throughout the drama.

The operatic protagonist's very first sentence, uttered in reply to the evil confessor in the first scene, is the self-accusation

> I am not able to love God with all my heart, with all my soul, with all my strength, and with all my understanding, nor my neighbor as myself!

and a little later, "I am not able, I do not have the strength, I do not have love, my weak faith does not suffice." This drives him to a conclusion, which he expresses in the form of a strangely mistaken syllogism: "God hates sin. God hates my sins. God hates me!" The image of a stern God who demands the impossible – freedom from the sin of doubt and disbelief despite human weakness – is clearly in tune with the historical Luther's writings, while the Promethean scenario of God hating a single human being would seem to mirror the sensibilities of the post-Enlightenment period rather than those of the late Middle Ages. Yet the inner predicament played out in scene 1 is true to what we know of the historical Luther's thoughts: God exacts human love; knowing themselves unable to offer unrestrained love at all times but knowing also that requisitioned love is not possible, humans will feel cornered and end up hating God. As Tikka's young Luther expresses it in great distress toward the end of scene 1:

> I hate you, God. You demand and accuse. You're supposed to be merciful. You're a liar, you're deliberately crushing me! I'll kill you! I can't endure, I can't go on! [...] Why have you abandoned me, God?

While the rather extreme language of moral accusation is deeply disturbing, it soon becomes clear that Luther is suspecting the God by whom he feels thus oppressed to be a distorted rendition fabricated by the religious powers. In words that he will later echo when Satan appears to him as Christ, he challenges his invisible God:

> Are you God or Satan, you eternal accuser? Are you not God? Who are you, you unknown, horrible being? Who are you, reveal your face!

Luther comprehended the supreme importance of Christ as the mediator of divine grace in the context of this image of a wrathful God. The

relationship between humans and God will no longer be governed by acts and attitudes demanded but only insufficiently realized, but by grace offered and humbly if undeservingly received. Tikka's Luther expresses in touching words and music the relief experienced when a sinful creature comes to understand Christ as a brother and ally vis-à-vis God:

> Were you just here, Son of God, Jesus Christ? Did God abandon you, too? Were you, too, in Hell? You died, too.

In an answer to all the fears and terrors captured in the Dance-of-Death scenario of scene 1, Luther's great monologue of scene 2 overcomes his foes one by one. "Christ is mine!" (Christ has died for me, not generically but personally), "I am alive, I am free!" (He has freed me from the anxieties connected with the image of a punitive God), "Satan, you old serpent, who hides in different guises, your head is smashed, my Christ crushed it. He is your Satan, a much more stalwart Devil!" (While Satan may continue to reign in this time, Christ will defeat him in the final battle – reflecting Luther's fondness of apocalyptic thought). One by one, the operatic Luther declares Sin, Law, Death, and Hell, the devious assistants of Satan, defeated – if not yet perceptibly in the here and now, at least spiritually in God's time.

Luther's Message in Music of his Hymns
The Jesuits of Luther's time are said to have remarked that his hymns had won even more converts than his preaching.[13] Kari Tikka, the musician, clearly felt that this means of spreading the message of a God who is loving and merciful toward all who have faith should be made part of the operatic presentation. This feature, his inclusion of original hymns into the whole *gestalt* of his operatic portrayal of the Reformer, thus requires a comment before the discussion can turn to the composer's own musical choices.

Five hymns form a bridge between the operatic performance and the involvement of the audience – between the intellectual discussion on stage and the more sensuous mediation through participatory plainchant of the same or related thoughts to the people in the stalls. The first three

[13] Robin A. Leaver, Ann Bond: "Lutheranism and Music," the third segment of the article "Luther, Martin" in: Stanley Sadie (ed.): *The New Grove Dictionary of Music and Musicians*, vol. 11 (London, 1980), 367.

hymns function as interludes between scenes. Following the initial Dance of Death and Luther's anguished acknowledgment that in the eyes of God he is and always will be a sinner (scene 1), the audience joins the choir in singing the first four stanzas of the hymn based on Psalm 130, "Aus tiefster Not schrei ich zu dir" (Out of the deep I cry to thee). Luther's soliloquy in scene 2 with his joyful recognition of the hope extended by Christ is answered by stanzas 1–4 of "Christ lag in Todesbanden" (Christ was laid in Death's strong bands). The disputations about papal absolutism and the rightfulness of indulgences evokes a response with the last four stanzas of "Nun freut Euch, lieben Christen g'mein" (Dear Christians, one and all, rejoice). In each case, the text in conjunction with its simple and beautiful tune takes up the topic just witnessed in dramatic presentation. The fact that any audience members who might resent being co-opted as part of an ad hoc Lutheran congregation can good-naturedly explain the communal singing as an imaginative and fitting device of allowing time for a change of scenery, has its own helpful diplomacy.

The remaining two hymns are integrated into the scenic action; for this and other reasons, they seem more problematic than the first three. Scene 5 is devoted in large part to the marriage between Martin Luther and Katharina von Bora, with interspersed comments on the escalated Peasant Uprising and the stance Luther and his followers do or should adopt. Toward its end, the scene seems to take a rather jolting turn when Luther, playing as a loving father with his daughter Lieschen while his energetic wife is busy overseeing repair works in their home, implores her (and Christ through the baby) to "teach" him, upon which he sings the hymn "Vom Himmel hoch da komm ich her" (From heaven above to earth I come). It is certainly useful to be reminded that this very popular hymn, which the people of all Western nations associate with Christmas, was actually written by Luther. And yet, are we to associate the glad tidings about the child born to Mary with Luther's daughter? Or are we to recognize Christ being born ever anew through this and, presumably, every other child? The purpose of the hymn within the scene itself and within the opera as a whole seems unclear, and the total of seven stanzas sung alternatingly by members of the ensemble, the choir, and the audience brings the dramatic action to a grinding halt that is a little awkward.[14]

[14] The Bethlehemitic pageantry with which the original director attempted to fill the

Toward the end of scene 6, Luther is seen suffering a serious attack on his health following his dispute with Erasmus, his subsequent encounter with Satan masquerading as Christ, and the death of his daughter.[15] On his sickbed struggling between life and death, Luther intones what has become the quintessential hymn of the Church he founded, "Ein feste Burg ist unser Gott" (A mighty fortress is our God); in later stanzas of the hymn he is variously joined by the ensemble, the choir, and the audience. The discomfort results here partly from the uncertainty whether the Reformer is singing in this or the other life (only his participation in the final scene's hearty meal removes the doubt whether or not he is still alive), partly from the somewhat forced statement of sturdy trust at a moment of such utter vulnerability. As Luther scholars have documented, the "last words" that Luther, believing himself near death, spoke to his friend and confessor, Johannes Bugenhagen, on this occasion were full of anxiety. His old sense of sinfulness had returned; he felt dejected, exposed to debilitating assaults by Satan, and thus hardly certain of the shelter provided by the "mighty fortress" that is our God.[16]

Kari Tikka's Musical Symbols of Luther's Struggle
Kari Tikka's music for the opera *Luther* is cast in a language that is as simple as it is powerful. The apparent simplicity goes a long way to help the audience follow the theological thoughts; the composer speaks of having focused on structural devices that render good musicals so memorable. As I will try to show, the particular employment of these devices, as well as the derivation of the prominent thematic material, gives convincing expression to Luther's all-consuming obsession with Death and Devil.

Of the opera's seven scenes, two – nos. 1 and 5 – are conceived as rondos. In scene 1, the refrain is devoted to Death and the human fear of

stasis, confirmed the association of the hymn with Christmas, but did nothing to elucidate its place within the scene. Thus, for this member of the audience, it added to the jarring impression in that it introduced an element of sentimentality otherwise wisely avoided in the opera.

[15] The librettists have taken the dramatically convincing licence of re-dating these events. Luther's brush with death actually occurred in July 1527, months before the birth of his daughter and a year before her death.

[16] On this see e.g. Heiko Oberman (1982), 332–337.

it. It recurs four times, ever more contracted as parts of its material are accelerated to twice their original tempo while others, which originally follow one another in time, later sound superimposed. This development is interspersed with four episodes presenting three kinds of material. The first and third contain the aria of scorn sung by Satan-as-Death, the second, the farcical confessions exacted by Satan-as-false priest, and the fourth, Luther's confrontation with God – a reaction, as it were, to the terrors experienced in the forced confession. The coda features a stretto variation of the basic refrain material as a means of making Hell tangible (and audible, in the anguished shouts of the choir), while Luther experiences his own hell when he asks, "Are you God or are you Satan?"

The refrain determining the other rondo, in scene 5, may surprise listeners, for it is related to that of the opening scene. By using rhythmically, metrically, and tonally modified versions of the motifs, the composer musically suggests a hidden correspondence between the "Dance of Death" and the "Feast of Life", the two poles the conflicted man Luther fought so hard to bridge.

These thematic building-blocks play a role throughout the composition, both in that they are repeatedly quoted verbatim and in that their constituent elements combine in new ways to form other motifs with related spiritual signification. The cluster of motifs that opens the opera and recurs most frequently in its course consists of components that can be described as "the omnipresence of Death", "the recognition of Death", and "the call of Death". The first is a rhythmic feature, reminiscent of a gigue but requested *pesante* and *sempre marcato*, executed in persistent note repetition by the *tambourin provençal* (referred to in the score as *tamburo della morte*) and an inverted A-minor triad in the high strings. The second, superimposed over the first after two preparatory measures, enunciates the key phrase, "kuolema korjaa" (Death reaps). Combining the ensemble and choir with four gongs, some winds (bassoons, trumpets, and trombones), and the low strings in simple two-part texture, the majestically accented long notes form a B^b minor triad. Its tonal clash with Death's own A-minor triad brings home the terrible reality of the basic irrelevance for Death's immutable presence of the beautiful, much-supported incantation that hopes to keep Death at bay (see Ex. 1).[17]

[17] The same material recurs many times throughout the opera with either of the two initial wordings, "Death reaps" or "Hell devours," but also with two additional notions, "Let's get moving / Forward" and "Our sword will devour" (mm. 1395ff and 1456ff,

In the scene that celebrates Luther's bliss as a husband, father, and householder, these two elements recur in significantly modified form. Most notably, the metric and tonal discrepancies have disappeared.

EXAMPLE 1: Tikka, *Luther*, Death and its human recognition

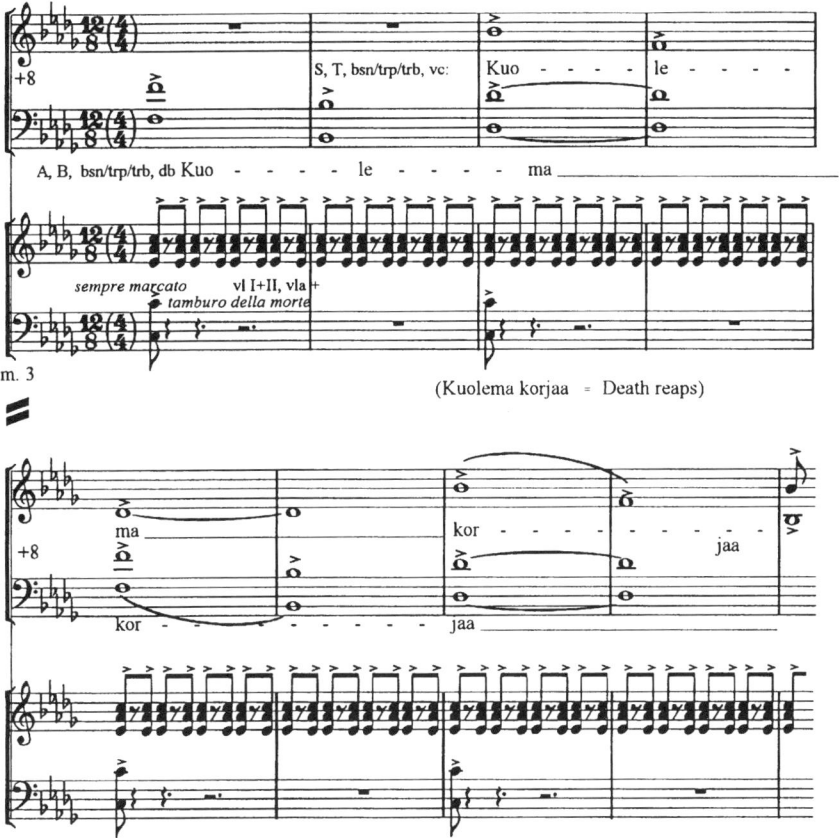

Both the repeated chords and the human voices asking God's blessing now sound in E major, and while the rhythmic character in each component is still what it was in the "Dance of Death", their tempi are now adjusted in such a way that one group of the gigue rhythm

both in the context of the discussion about what stance to take toward the Peasant Uprising).

accompanies one melodic note. The two layers are thus harmonized rather than symbolizing vastly mismatched realities (Ex. 2).

EXAMPLE 2: *Luther,* "The Feast of Life," quite another face of the "Dance of Death" (mm 1540-1548)

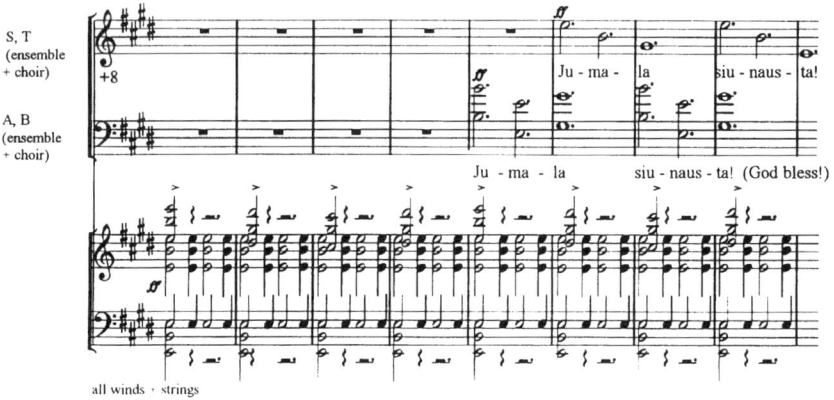

The third component in the refrain of the initial scene, sounding above and against the first two, is an aria sung by Satan in the garb of Death, "To this dance I summon you all." Very catchy with its syncopations, simple contour, and textual repetitions in melodic sequence, it establishes a tonal feature that will prove singularly influential throughout the work: the melodic ascent through a minor triad with major seventh (Ex. 3).

EXAMPLE 3: *Luther,* Satan's call to the "Dance of Death" (mm. 25-34)

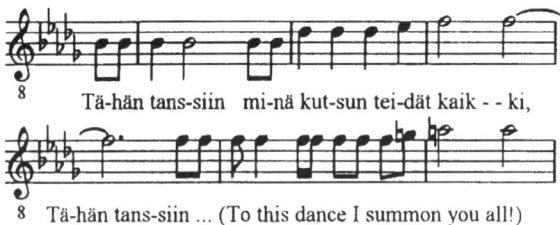

The melodic play with this ascent characterizes several of Satan's machinations. It is used most extensively in scene 3, when Eck, the theologian defending papal authority with regard to the interpretation of Scripture, much supported by Satan in the guise of Duke George of Saxony, clothes his deliberations in ascending and descending gestures of B^{b}-D^{b}-F-A?, belatedly supported by the chorus imploring God, the apostles, and the saints.[18]

In slight variation, this chord also governs another aspect of Satan, viz that of scornful superiority. In the first and third episodes of the initial scene's rondo, Satan-as-Death, still accompanied by the gigue-rhythm in strings and small drum, exposes – in a tune based on an ascending G-minor chord with minor (not major) seventh – how laughably ephemeral even great men are once they meet him. When Satan-as-Duke-George later greets the assembled dignitaries at Leipzig, he does so with a variation of the same contour (Ex. 4).

EXAMPLE 4: *Luther*, Satan's scorn (mm. 716-720)

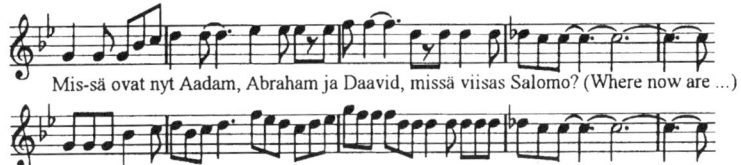

(Especially fine, summery weather embellishes the town of Leipzig on this day of the great disputation.)

One of the most memorable motivic gestures in the composition, the enthusiastically (if not fanatically) reiterated assertion with which the sectarians in Luther's group, the later Anabaptists, insist that "God is Spirit", also draws on this variation of the ascending seventh chord (Ex. 5).

[18] See mm. 765–780, 792–798, 826–833, complemented by Satan-as-Duke in mm. 807–809; chorus mm. 852–869, "| | : Arise, o Lord! : | | : Arise, o Peter! : | | : Arise, o Paul! : | | "

EXAMPLE 5: *Luther*, Satan-as-zealot and his followers (mm. 1291–1295)[19]

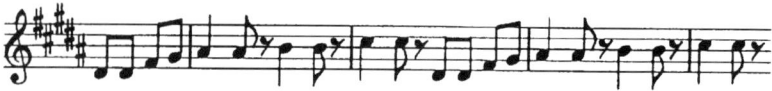

Ju-ma-la on hen-ki, hen-ki, hen-ki, Ju-ma-la on hen-ki, hen-ki, hen-ki, etc.
(God is Spirit, Spirit, Spirit, ...)

Interesting further variations of Satan's defiant gesture are heard first by Käthe, then by Erasmus. Toward the end of the depiction of family bliss and pragmatism in scene 5, Luther, who cannot decide whether he is responsible for the carnage inflicted on the peasants because of his condemnation of their use of force or whether God, having "ordered" his actions, is to blame, is admonished by his wife with the same tune now underlying the words "A loan has to be paid back with interest, it does not turn into a gift." And at the beginning of the correspondence between Erasmus and Luther in scene 6, the great humanist (impersonated by Satan here, to be sure) sings his principal objection to Luther's teaching, "You have free will!" to another quotation of the enthusiasts' "God is Spirit". Particularly in retrospect it may seem that even Käthe, clearly her husband's ally, wants him to acknowledge liability for human actions, as does Erasmus.

All these melodic gestures, lest it be forgotten, are direct developments of the third, "Satanic" component in the refrain of the initial "Dance of Death".[20] The second component, the two-part, triadic "Death reaps" in

[19] For recurrences of "Jumala on henki" in this mode see, still in scene 4, mm. 1291-1307, 1386-1394, 1447-1453, and in scene 7, mm. 2784-2796. In both cases, Karlstadt, the iconoclast and advocate of lay Protestantism, subsequently transposes the tune to the relative major and entices the choir to follow him; see in scene 4, mm. 1307–1315, and in scene 7, mm. 2796–2804.

[20] Two others are more remotely derived. The disputation at the Diet in Worms opens with an intensely emotional *Andante* phrase in the strings whose five parts, before settling on the open-fifth chord that statically underlies the recitations, derive the pitches of their echoing viola and cello parts from the juxtaposition of thirds from the A-minor and B^b minor chords in the "Dance-of-Death" refrain; violin I then complements the cello's B^b-D^b with F-A into Satan's ascent of defiance (mm. 986–991, with various recurrences, cf. particularly Luther's vocal version, "I cannot and will not retract," mm. 1044–1047). In a similar mood and with a similar purpose, the controversy with Erasmus in scene 6 begins with a *pizzicato* phrase – also in the strings, also *Andante,* also very emotional – whose eight bars are launched with the notes of the ascent used in "God is Spirit" and in Erasmus' "You have free will."

B♭ minor with which humans respond musically to the omnipresence of Death, also spawns further developments that become increasingly poignant. Three variants can be made out, in which not only the musical material, but also the human attitude it represents, reveals its frightening potential.

In the coda of scene 1, the reiterated cry, "Hell devours," now stripped of its object and thus horribly generalized, affords a first hint at Luther's belief that this Hell may not be a place in the netherworld but a state in this life. Toward the end of scene 4, when the followers of Müntzer have declared their resolve to fight with the peasants, the rhythm in both the A-minor and B♭ minor chords is broken up, while the words are changed to the chilling battle cry, "Stab, strike, kill!" Finally, at the end of Luther's exchange with Satan-as-Erasmus, the choir interjects an anguished counter-version of the battle cry, "Seek, turn, mend your ways, come, beseech, be watchful, wary." Death's *tamburo della morte*, in the original gigue rhythm, is no longer supported by a clashing A-minor triad in the strings. Instead, the orchestral instruments have joined the choir in the B♭ minor utterances of hope against all knowledge of human weakness (Ex.6).[21]

EXAMPLE 6: *Luther*, the human chain relation of Hell, murder, and atonement

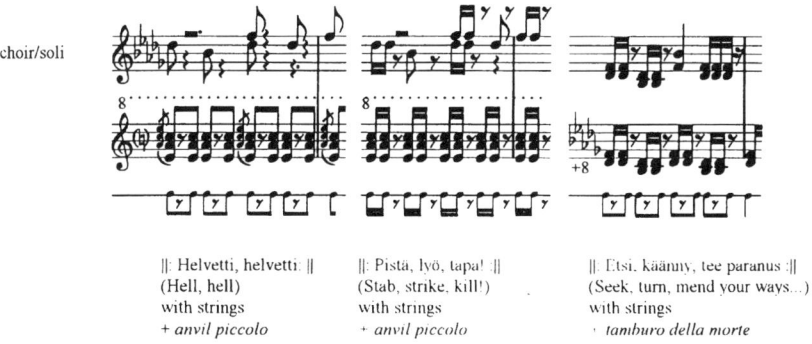

||: Helvetti, helvetti :|| ||: Pistä, lyö, tapa! :|| ||: Etsi, käänny, tee paranus :||
(Hell, hell) (Stab, strike, kill!) (Seek, turn, mend your ways...)
with strings with strings with strings
+ anvil piccolo + anvil piccolo · tamburo della morte

[21] For this first form, see scene 1, mm. 361–402, with reminiscences in Luther's soliloquy (sc. 2, mm. 527–534 and 593–612) and in answer to Müntzer's invitation – phrased in words and a tune recalling Satan's call to the Dance of Death – to join the holy war of the peasants (scene 4, mm. 1421-1427). For the second step, see scene 4, mm. 1467–1486, with Luther's painful reminiscence in scene 5, mm. 1874–1909. The third version is introduced in scene 6, mm. 2303–2310. All three variants recur when Satan challenges Luther's presumption to have been summoned by God and then appears to him as a false Christ; see scene 6, mm. 2345–2416.

These then, are the musical emblems of Death, Hell, Satan. Two characters are still missing in Luther's allegory of evil: Sin and Law. Law, ideally represented in the decalogue Moses received from God, the commandments added by Jesus, and the more dubitable amendments formulated by various popes and church councils, nevertheless struck Luther as an instrument of torment – a weapon wielded by the Church to keep its congregation in line by means of fear and thus fostering the worst sin, the lack of faith. In Tikka's opera, Law and false belief have taken possession of one of Christianity's principal liturgical items, the *Credo*, which appears sarcastically transmuted into an oath to the very power whose faithfulness to God's mandate Luther doubted: the papacy. The text sung by the chorus is worth quoting in full:

> I believe in a pope who binds and releases,
> I believe in canonical justice.
> I believe in the forgiveness of sins through indulgences.
> I believe in the resurrection of the body
> into an enjoyable life prepared by our Holy Father the Pope.

This cynical *Credo*, also thrown back and forth between the orchestra's winds and strings, is presented with the solemnity of four-part polyphony, whereby the two female voices sing the six lines in stretto imitation while the two male voices supply a kind of ostinato counterpoint (also in stretto) reiterating the words "Holy Father Pope, Holy Father Pope." The intervallic distance of each voice pair is launched, significantly enough, with the *diabolus in musica*, the tritone, but later settles on the perfect fourth (Ex. 7).

EXAMPLE 7: *Luther*, Law as captured in a misunderstood Credo

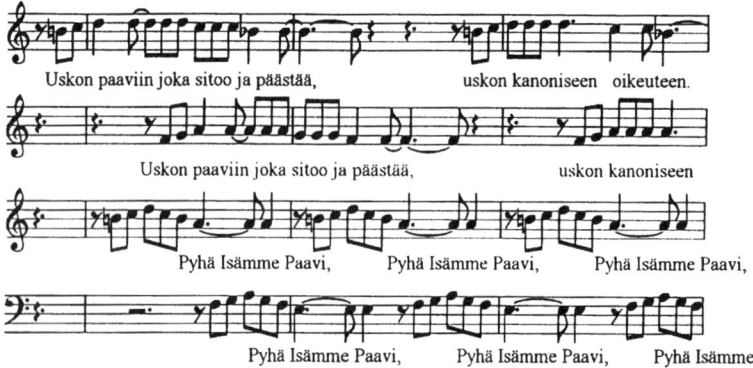

Compared to this abundance of motifs spawned by the imagery of evil, the musical signifiers pertaining to Luther are few. Three impress themselves on the listener: an instrumental motif accompanying the protagonist when he is deep in thought (first heard at the opening of scene 2); his jubilant assertion that Christ died for each human (the repeated and often varied refrain of his arietta capturing his understanding of the Bible), and the follow-up insight – later taken up separately and much expanded – that we may be free. The first two favor slowly descending steps and thus contrast starkly with the broken triads, ascending seventh-chords, and note repetitions of the material that characterizes the dark realm. The third, the "freedom flourish", stands out as one of the very few melismas in the composition. The arietta tune, which in its original context marks Luther's revelatory insight into the beneficence of Christ's sacrifice for each individual human sinner – and thus into Christ's love – is recontextualized in the fifth scene as a joyful expression of the love between Luther and his wife, and their freedom as resulting both from Christ's promise and their own mutual support (Ex. 8).

EXAMPLE 8: *Luther*, the reformer in thought: saved through Christ, and free

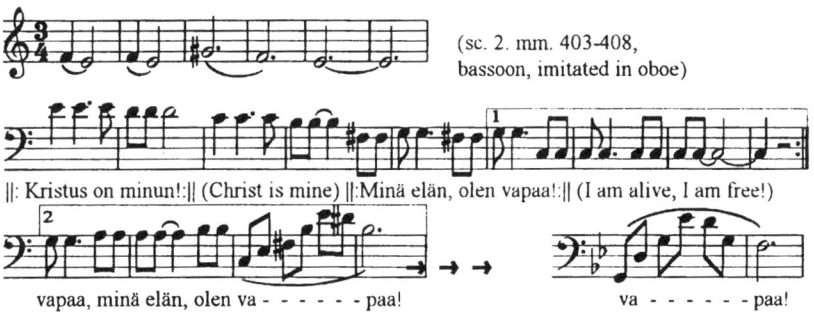

As one traces Luther's emblems in relation to those of Death and Satan, one suddenly comprehends that the entire opera is a giant rondo, with the "Dance-of-Death" as an ever-recurring refrain (see the grey areas in the diagram below), supplemented by the irreverent *Credo* (in black). Luther's contemplation, hope, and joyful if transitory sense of freedom are

interspersed in an overpowering play of darkly threatening forces (as shown in the bracket). Life, then, appears as mere set of episodes within this *dance macabre*.

FIGURE 1: *Luther*, the opera as an overarching rondo

Siglind Bruhn (born 1951) is a musicologist (Dr. phil. Vienna 1985), concert pianist, and interdisciplinary scholar focusing on questions of musical hermeneutics in the repertoire of the 20th century. A Life Research Associate at the University of Michigan's Institute for the Humanities, she is the author of eleven book-length studies and numerous academic articles and chapters in anthologies, as well as the editor of four collections of scholarly essays and the co-editor of the book series INTERPLAY: Music in Interdisciplinary Dialogue (Pendragon Press). Address: (during semesters) 1105 Spring Street, Ann Arbor, MI 48103, USA, (during summers/semester breaks) Heimecker Str. 2a, D-79183 Waldkirch, Germany